FOR HENRY R. HOPE

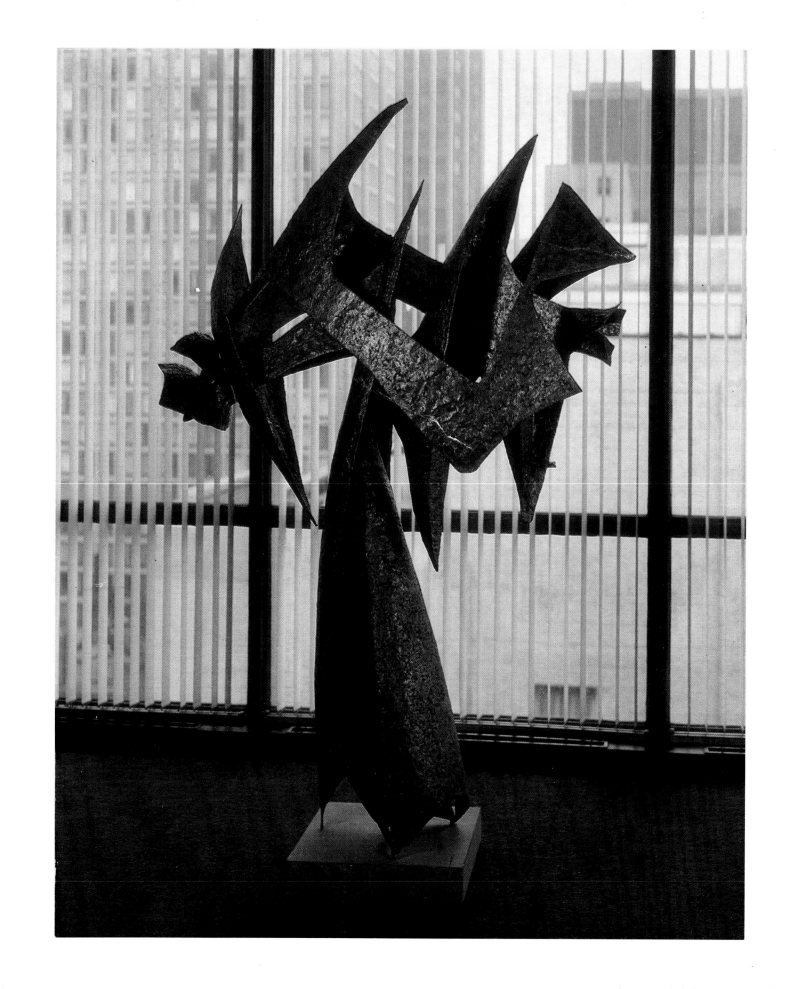

TEXT BY ALBERT ELSEN

1. *Study for* HERO. *1957*

SEYMOUR LIPTON

HARRY N. ABRAMS, INC., PUBLISHERS, NEW YORK

The passage from *The Hero with a Thousand Faces* by Joseph
Campbell, Bollingen Series XVII, is reprinted by permission of Princeton
University Press. The lines from Dylan Thomas's poem "In the Beginning"
are quoted by permission of the publishers of *The Collected Works of Dylan Thomas*,
New Directions. Unless otherwise stated, all quotations from the
sculptor were drawn from interviews or correspondence or from his
personal notes, written between 1959 and 1965.

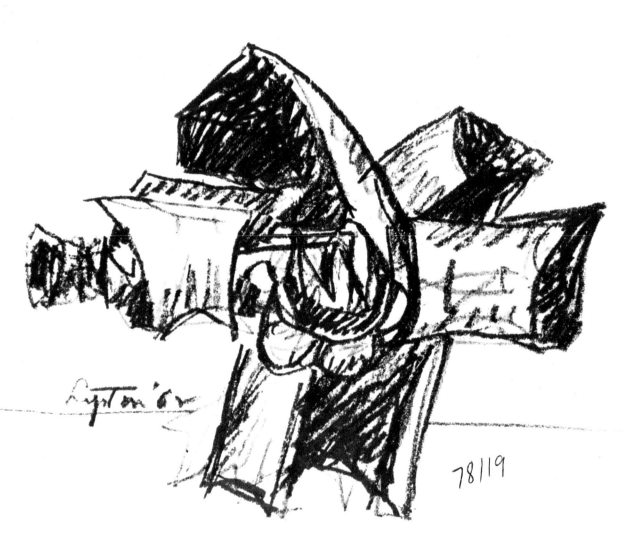

2. *Untitled drawing. 1962*

CONTENTS

LIST OF ILLUSTRATIONS

*Colorplates are marked with an asterisk**

Unless otherwise specified in the captions, works are in the collection of the artist.

*Frontispiece. HERO. 1957. Nickel-silver on Monel metal,
height 90". Inland Steel Company, Chicago

1. Study for HERO. 1957

2. Untitled drawing. 1962

3. Untitled drawing. 1961

4. Study for MASK #2. 1965

5. Study for SEA GNOME. 1952

6. Study for FOUNTAINHEAD. 1957

7. Study for DEFENDER. 1961

*8. PROPHET. 1941

9. Study for EMPTY ROOM. 1964

10. Untitled drawing. 1963

11. Plasticene models: MOLOCH #3, CERBERUS, MOLOCH #2

*12. SWING LOW. 1942

13. Study for SENTINEL. 1959

14. Untitled drawing. 1961

15. Untitled drawing. 1963

16. Untitled drawing. 1957

17. Untitled drawing. 1961

18. Study for CLOAK. 1951

19. Study for EARTH LOOM. 1958

20. Study for DESERT BRIAR. 1955

*21. ARGONAUT I. 1961

*22. ARGONAUT II. 1961

23. Study for PROPHET. 1957

24. Lipton at work on PROPHET

25. Study for SORCERER. 1957

26. Lipton at work on SORCERER

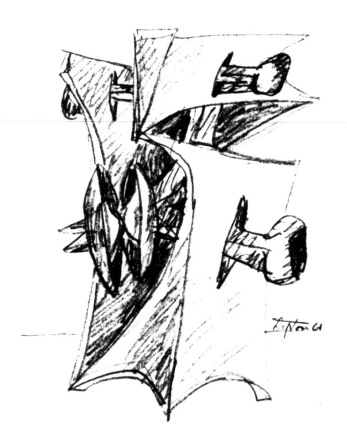

3. *Untitled drawing. 1961*

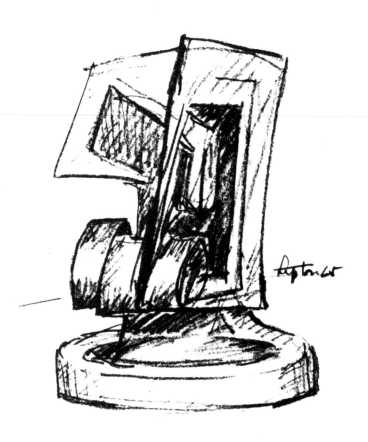

4. *Study for* MASK #2. *1965*

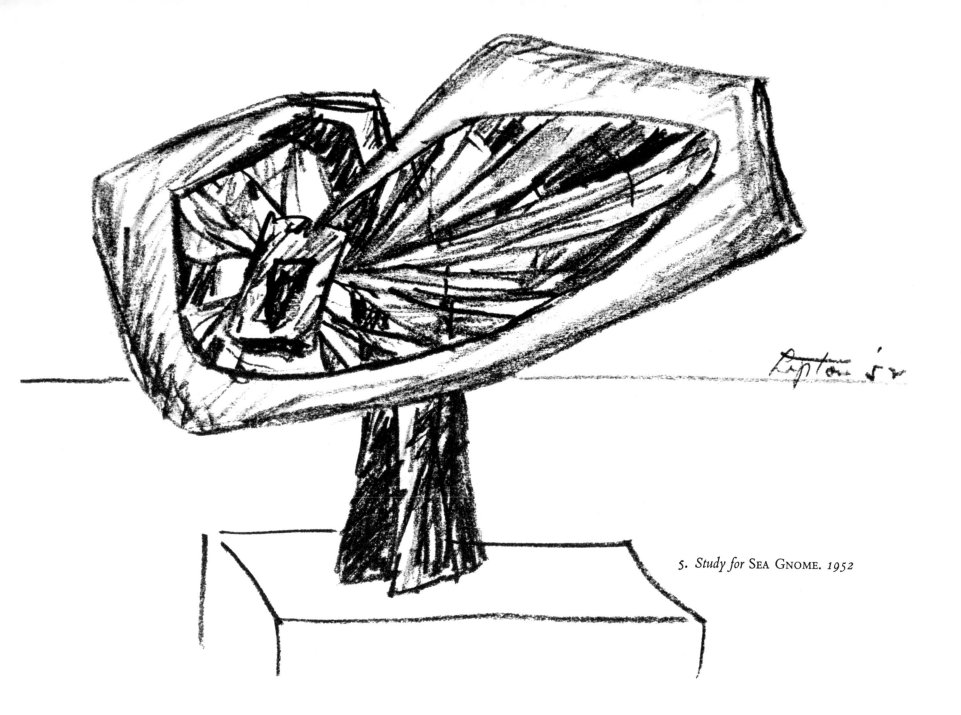

5. *Study for* Sea Gnome. *1952*

AUTHOR'S NOTE

I am particularly grateful to Meyer Schapiro for his comments on my first article on the sculpture of Seymour Lipton and for sharing with me his observations in general on Lipton's work.

Acknowledgment is due Jerome Weidman for his assistance in the preparation of the Biographical Outline and the Selected Bibliography.

THE SCULPTURES OF SEYMOUR LIPTON are imaginative objects that passionately dramatize the life of man. Metaphorically and by intensely unified forms Lipton stages the grinding collision of opposites that makes up a personal vision of what life and nature are all about. The resulting drama is not about persons or places, but rather about the relentless interaction of mutually alien processes, forces, and concepts. The creative and destructive impulses in life are permanent and inseparable, in Lipton's view, and are as much the province of the sculptor as of the philosopher, writer, or scientist. Lifelong preoccupation with the dialectic of dualities has produced simultaneously the distinctive shape and meaning of his art.

No American sculptor has shown a greater inventiveness in the conceiving and making of shapes than Lipton. By contrast with the present emphasis upon reductivist or rejectivist sculpture, Lipton's liberal imagination conceives of any object or form that he encounters as the potential basis for imagery; but his own ethical stance is that the source must be transformed in order to take its place naturally in the context of a highly personal art. This attitude couples with a mind richly informed in the history of culture. Each new discovered or invented shape is exposed to the fused forces of taste, feelings, and ideas.

Since Rodin, it is Lipton who, among sculptors, has thematically created the world that is most poetically analogous to our own in scope and depth. Rodin effaced himself before the human to achieve an art that had the look of the natural. He re-created and personalized his society. Lipton depersonalizes his subject, asserting the dominance of his thought and feeling and assuring breadth of reference. In his art the human interacts with nature and technology but is not subordinate to them. "Sculpture is used by me to express the life of man as a struggling interaction between himself and his environment. Sculpture itself is part of this interplay." Thematically his world is varied and violent, restless and urgent. Formally it is composed and contained. It is relevant both to the moment and to the remote past before good and evil came to human thought. Lipton's art re-enacts dramatic phenomena involving strident confrontations between law and lawlessness. He has made sculptural glosses upon history, myth, and religion, given voice to tragedy and hope, powerfully manifested the painful pressures of time, the elements, birth, growth, dying, and rebirth. He has always sought an imagery that preserves the intensity of his themes and imparts to them dignity and nobility.

The lesson of history, nature, and art that has shaped the sculptor's world is that life in all forms and at all times must continually resist and triumph over destruction. This eternal dialectic has led to sculptures that are meditations on elemental forces of the earth and mind, and, like medieval Last Judgments, are epiphanies of the eternal powers of light and darkness. Morality is not the subject of Lipton's art, as it is of cathedral sculpture, but it is the basis of *how* he works and of his views on beauty: "Beauty is the effort toward cohesiveness through artificial means that brings unity into an essentially irrational chaos of events." More recently Lipton has written: "Beauty in a work of art is the inner excitement generated by the interplay between formal structures and their implications. This dynamism operates most successfully when the experience engendered is rich in revelation of reality beyond the work itself." The world thus acquires significant meaning, feeling, and order as the result of the artist's striving to

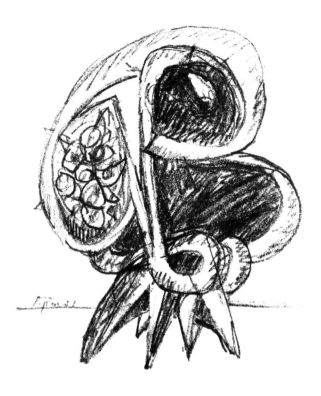

6. *Study for* FOUNTAINHEAD. *1957*

create a perfect work of art. By achieving an integration of thought and feeling that does not otherwise exist, outside of art, the sculptor may have the role of redeemer: "Sculpture has for me the implied moral force of joining things: as they are and as they should be. The plastically evolved image does this when the evil and irascible energies in man are redeemed through order, through a controlled equilibrium of form that suggests ever outward movement, adventure, and freedom" (1955).

As with Rodin, who was its first important exponent in modern sculpture, the ethical approach of Lipton demands fidelity to his own experience in a personal style affirming the identity of means. This essay is a partial and imperfect study of how Lipton achieves these aims.

Seymour Lipton was born in 1903 in New York, where he has lived and worked all his life. Neither the art of other sculptors in his generation nor the city prepares us for the look of his style and the compass of his themes. Paradoxically, without these contacts Lipton's art would not be the same, if it existed at all. He once casually remarked that had he lived in Europe he might have been a rabbi. The relation of the man and his art to his environment is analogous to a wheel, with the sculptor as the hub. The spokes converging toward the center are not all smooth, shiny,

clean, and straight. They are forged by the stimulation and frustration, the exhilarating competition and intrigue of the New York art world; they are trued by the city's intellectual life, news media, bookstores, and libraries but are warped by that same city's indifference and brutality; some are made durable or renewable by all manner of machine and of plant and animal life.

But these experiences are also available to hundreds of sculptors whose work is totally unrelated to his. For Lipton, however, all these resources are welcome as potential bases for images, as he has shown for more than thirty-five years. The simultaneous, vehement coexistence of these sources largely accounts for the variety in his work of a single year. He does not deal literally with the urban, but this environment has helped shape an urbane mind, keenly associative, which sees endless and multiple relations among various objects and varied phenomena. What makes his art emotionally disturbing, intellectually challenging, and aesthetically satisfying is that these relationships are often based on antagonisms, are not obvious, and resist complete paraphrase in other idioms.

The achievement of Lipton's personal art required long and steady search, a reception and rejection of previous art, including his own. To the Cubists and to his own study of internal anatomy he owes the precedent of breaking open the closed solidity of the human form, destroying the claims of external appearance, and integrating the body with objects in a common aesthetic structure. From the German Expressionists came the precedent of exteriorizing personal anguish, a compassionate attitude toward human suffering, and the recognition that truth may not be beautiful. From the Constructivists came models of precision and disciplined formations of shapes and space in open form, as well as a respect for the mechanical as form and meaning. Inherited from the Surrealists were the use of spontaneous free association, internal body imagery, and exposure of the unpleasant and destructive. To French art in general the sculptor owes good taste such that, regardless of his song, we may always enjoy the artist's voice. From museum art of African, Oceanic, and Pre-Columbian societies and the societies of ancient and medieval times came interest in myth and metaphors of brutality, the horrendous, and death. Out of American art of the 1930s came distrust of the topical and veneration for the craft of sculpture, and in the art climate of the 1940s in New York arose the incentive

to be boldly individualistic and seriously to rival his European as well as his American counterparts. All the foregoing buttressed the artist's conviction that important sculpture should again be relevant to its time ideologically, psychologically, and emotionally.

But once environmental influences have been accounted for, it is necessary to emphasize that the scope and profundity of Lipton's art issue primarily from the inquisitive and meditative character of his mind. I know of no other American sculptor whose work, by the scope of its themes, is as broadly reflective of the varied intellectual interests of its creator: the Hero series rests on Lipton's philosophical and historical reflections and on his reading in sociology and anthropology; *Fountainhead* relates to his study of internal anatomy; the Bloom and the Ring series result partly from knowledge of and fantasies on the internal anatomy of botanical life; *Manuscript* encodes meditation on books, law, and violence; and *Archangel* reflects intense moods evoked by music in a form that counters the deficiencies of its architectural environment.

Lipton is a rarity in modern sculpture in that his sculpture is good not in spite of but partly because of his learning outside of art. He permits moods, feelings, and ideas engendered from broad cultural experience to work into a sculpture's formation, "though not always on a conscious level." His art thus has meaning but not the content that in older art meant public existence antedating the work of art, which then became its illustration. Feeling that in recent years too much stress has been placed upon the artist's obligation to resist inspiration drawn from visual, literary, or intellectual experience, Lipton has commented: "The error here stems from the notion that the intellectual and philosophical involvement presupposes literary and representational projections in works of painting and sculpture. I believe a work today can and should be characteristically 'abstract' in its plastically and metaphorically expressive values, but this should be arrived at through a total creative involvement, both conscious and unconscious."

Comparing a photograph of the artist with a photograph of his *Defender* (1962) enables the reader to sense the spiritual portrait character of the sculpture. To be with either the man or his art is to feel the simultaneous presence of strong dualities. The sculptor's personality is a fusion of contradictions, an interweaving of

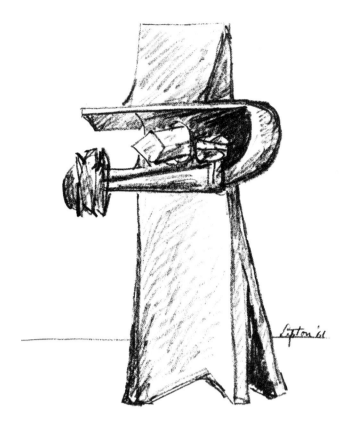

7. *Study for* DEFENDER. *1961*

the passionate and the analytical, of aloofness and involvement, the loving and the bitter. His physical movements are a curious blend of the graceful and the angular, and the similarity of the elbow gesture in the artist's photograph to that in *Defender* is not surprising. Both man and sculpture are impressive and irritating in their constant intensity and vehement expressiveness. Ironically, the conflict caused by these contradictions produces the impression of the durability of the artist and of his work. In the man and, to an even greater degree, in the sculpture, the will to form and clarity of statement triumph over indecision. One would be hard put to it to select any single sculpture as the artist's *impresa,* since each is in a sense a vital piece of the artist's self.

Seymour Lipton does not have about him the makings of the legends or myths that in many cases have enhanced or inflated the reputations of modern artists. He is not an immigrant; he did not have to work in the art programs of the WPA or struggle for a living as an artist. He is not from the Far or Middle West, does not shut himself off in a studio in the woods or in Greenwich Village, and is not, although he has good friends among artists, an art-group joiner or habitué of the "in" bars. He is accessible and articulate, and lives a well-ordered life. He has worked long enough to fulfill his promise many times over. His reputation is

13

all above ground: his ability was recognized in his first show, in 1938. International eminence as a sculptor has been solidly earned by work which for the most part has received modest attention from the major art magazines and critics in New York. But he has always exhibited regularly in important galleries and museums in this country and has been extensively shown in Europe and around the world. Over the past fifteen years his art has been increasingly in demand and has been acquired by many of the most discriminating collectors, museums, and architects in this country. For seventeen years, from 1948, he was with the Betty Parsons Gallery and more recently has been with the Marlborough-Gerson Gallery.

Discouraging, too, to mythmakers is the fact that Lipton, who is married and lives in a brownstone near West End Avenue in Manhattan, looks and talks like a typical New Yorker. Without his sculpture, his biography would be indistinguishable from those of millions of other New Yorkers. He never disguises himself as an artist when he leaves his house. He has a New Yorker's aggressiveness and volubility. Unenthusiastic about travel, he is openly dismayed by aspects of the city he lives in but would rather die than live anywhere else. As if all these things were not enough to daunt any prospective biographers, he first earned his livelihood by dentistry and for years made his sculptures not in a loft on Eighth or Tenth Street but in an apartment on the Grand Concourse in the Bronx.

Young and future artists will get no inspiration from Lipton if they are looking for a Giacometti type of "anguish" over seeking the impossible. Lipton agonizes over his work but reaches his goals and then sets new ones. He takes pleasure in finishing drawings, models, and large pieces. The notion that artists must endure prolonged periods of inactivity gets no support from him; while creativity is not effortless, he has always been productive. Since this is an essay about Seymour Lipton's sculpture, it will deal, as such, with what is historically most important about him as a man. But the human interest that should concern us is welded and hammered into his sculpture. I would extend my previous generalization and say that in scope and depth no other American sculptor's work is as directly and as broadly reflective of its creator's complex personality as that of Lipton.

To be a part of and meaningfully to extend the history of sculpture is this sculptor's obsession. Along with serious study of the history and origins of form, he has long reflected on the uni-

fying functions of art in Western and Eastern cultures. The historic roles of sculpture in the rituals and propaganda of Church and State are not continued by the best modern sculptors. Where past patrons sought to unite men by use of the artistic emblem or conventional symbol, Lipton seeks to unite himself with others by use of modern and private sculptural metaphor. In remote times heraldry and insignia were employed by rulers, families, and guilds publicly to signify ancestry, prowess, honors, virtues, totemic analogies, tools, or instruments of office and occupation. Common to the old insignia was a concentrated reductiveness of ideas and shapes in a clear, succinct formal expression. The old emblems, crests, and flags rallied human allegiance or instilled communality on the basis of patriotic, familial, or professional associations. While preserving certain qualities, such as formal compactness or terse statement, Lipton avoids the symmetry and other devices of the world of rank found in old insignia. He discovers and invents shapes having long universal histories of identification with the tragic and the heroic (the grave, the book, the shield, the arrow), to which, even when largely transformed in his sculpture, other individuals will intuitively respond. They are thus united in a non-partisan, non-clanlike way by sharing experiences of suffering, striving, and hope or by marveling at the mysteries and power of creation. Lipton's art consists of emblems for Everyman, for Everyman is in a real sense eligible for the source and interpretation of his imagery:

Walt Whitman's "Song of Myself" is about Everyman, his experiences, his body, his spirit, his divinity, etc., in the processes of time and history, past, present and future. This is a theme, a point of view as a metaphor for a poem. It is a selective totality. Similarly my sculpture is a selective totality. I empty the room of chaos and introduce a totality of form, a perspective of how things are for myself, for Everyone, as a divine totality, the thing called life. I see man as a divine process; good and evil, ugliness and beauty, body and soul, happiness and pain, are aspects of this divine totality. I want my sculpture to present this sense of "totality" (*Art Voices,* Spring 1965, p. 89).

FROM ITS BEGINNINGS LIPTON'S SCULPTURE of the thirties and early forties generally professes concern with the anguish of men and women visited by disaster but sustained by strong spiritual drives.

He was drawn to the working class and to minority groups—those whose precarious existence depended upon use of the hands and body. He particularly responded to their unschooled gestures of work, play, prayer, and distress. The subjects do not participate in sophisticated society but in joys of their own making—folk songs, playing the blues, parents' love of the child—or in spontaneous activities involving strong emotion and deep concentration. His sculptures take their rhythms from physical labor, improvised pleasures, and recurrent despair. Obliquity of form may signal restlessness, élan, or the painful drive for self-preservation. The early hero is John Brown, or a type such as the soldier or striker. Living is reduced to elementaries: to suffering, reaction, love, and hope. Moments of weakness, as seen in *Cotton Picker,* where there is a breakdown of body and spirit, assumed for the artist the stature of classical tragedy.

In the most obvious way the sculptor's themes and forms are of the Depression and relate to the social consciousness of the New York art world of the thirties. Like many other young American sculptors of this period, Lipton felt the urgent need for a subject and a rhetoric that were of and for his time, with which to bond himself with the masses. The challenge was to achieve a synthesis of the topical and the timeless. As advanced European sculpture became increasingly known to Lipton during this period, the pitfalls of the topical approach and the need for broader reference were soon revealed. Instinctively inclined to the dramatic, he strove for pathos through posture and, as he put it, "violent formal play." He was drawn to the work of Lehmbruck and Barlach and to primitive sculpture. Their example, along with his own instinctive feeling for good form, prevented his sculpture from being subsumed under the topical, maudlin, or caricatural.

Lipton's first exhibited work was titled *Lynched.* Its subject, along with the scarcity of opportunity for exhibition, accounts for its inclusion in a group show held at the John Reed Club in New York during December and January of 1933–34. The exhibition was organized about the topic "The World Crisis Expressed in Art: Sculpture, Drawings and Prints on the Theme, Fascism and War." Lipton has described himself in the thirties as a "Morris Cohen Liberal and a Roosevelt Democrat." As he put it, "I read all the left-wing literature and the *New York Times.*"

In 1934 he again exhibited with the John Reed Club, entering his *Bread Line.* The exhibition was called "Revolutionary Front." It was not until 1938 that Lipton had his first one-man show,

which was held in the ACA (American Contemporary Artists) Gallery. The list of titles he exhibited is in itself revealing: *Bread Line, Strike, Shoeshine, Flood, Celebration, Air Raid,* and *Straphangers.* The sculptor's sympathies with the Spanish Loyalists (among whom were personal friends) and his strong reaction to war manifest themselves in his anonymous stricken figures. In response to questions about the possible reforming intent of his work, his hoped-for audience, and concern about the fate of his work, the sculptor wrote:

Back in the thirties I never believed my work would help enact social reform. The sculptures were never felt as overt, explicit instruments for social change. They reflected an atmosphere of social discontent on my part as an aesthetic catharsis of my disapproval of many things occurring in the thirties. I never thought of where the sculpture would end up. My work was never shown outside of New York. The pieces were not made for money or with thought of sale. I still have almost every piece I made then. (Not all were unhappy themes.) My prices were ridiculously low, but nobody had any money in the thirties. I just made sculpture because I had to. It was as natural as breathing for me. I never thought in terms of museums. To show, yes. The ACA was the stronghold of social art.

I always felt myself to be not a social activist, not an artist, but a person who carved pieces for his own pleasure by making works of beauty and meaning as he felt them. I regarded myself as an amateur. I'll never forget when I first saw my name in print, in 1934 in the art review of the *New York Times* of a piece called *Lynched,* my first wood carving. It was referred to as "plastically superior and deeply moving." Maybe then I became permanently infected with art, with all that this implies in terms of ego, professionalism, and compulsion.

On several occasions during the past ten years, the sculptor has been asked to set down his recollections of the art world of the thirties in terms of what he reacted to. These notes read substantially as follows:

The atmosphere of the art world in the thirties that I was familiar with was largely influenced by the political and economic climate. . . . In the thirties there was no daring sculpture that I can recall having seen in New York. Zorach, Chaim Gross, and the academicians were being shown. At least for me there

never was any common grouping or school or organized group in terms of an art approach. It was that each artist separately breathed the same air of the Depression years. . . . Hans Hofmann had his school in the ACA Gallery building in 1938. I met him and he liked the quality of movement and open interlocking forms in my work and I liked his enthusiasm and his ideas on "pictorial realism," which had to do with art as an aesthetic object having its own reality and reason for being. . . . His pictorial realism later became in some way a catalyst for me and my views of "sculptural realism," with its implications of abstract spatial architectonics as a field for inquiry. . . . Such people as Barlach, Orozco, and Lehmbruck were artists I deeply respected, probably for formal, social, and moral values. I liked Barlach's interest in the folk. His *Avenger* interested me, as did his primitive qualities. Orozco's paintings and drawings affected me deeply. The mystic desert loneliness of his peons and Indians I responded to . . . but even then I saw a man like Orozco and his work in terms not only of social revolution but of cosmic mystery, life and death. In fact even though my early works were given socially conscious names, the subject "man" I felt as an individual in a frightening world he didn't make and didn't understand, with in between moments of peace and blindly searching for peace. The German Expressionist painters and Barlach affected me deeply because of their violence and their spiritual struggle. . . . The more subtle factors such as the need for plastic invention of forms adequate to a wider, deeper human experience in some measure were subordinate for me. People such as Miró, Matisse, Velázquez, with emphasis on irrational, sensuous factors beyond moral, social humanism, were outside my major concerns. I felt then as now that art must deal with something more than the pleasing or sensuously exciting.

Strangely enough, in the thirties I experimented, now that I recall, with extreme abstract formal ideas. I remember using the musical symbol of the clef as an ideograph in three-dimensional sculpture. I remember in about 1936 making a 10-inch-high plasticene piece of this nature. This suggests to me now a strong need at the time for abstract stylization of deep-seated emotional experiences of form which had nothing to do with social, moral, humanistic experience. I also did such things as a small fountain, a Leonardo da Vinci holding a bird aloft, and a formally Cubist head of Johann Sebastian Bach—all in plasticene, and since lost. I listened a great deal to good music and was particularly moved by Bach's Toccata and Fugue. . . .

I used to go to the Metropolitan a great deal. . . . I became interested in the art forms of Guatemala, Peru, the Northwest Coast Indian, and African sculpture. Somehow primitive arts interested me more than Italian art, although Leonardo fascinated me and still does. The monumental, magical directness of primitive art still moves me more than Western sculpture of Greco-Roman realistic derivation. I was interested in Pre-Columbian sculpture and Gothic bestiaries, all that involved extreme anatomical distortions for expressive needs. . . .

Lipton, like many other American sculptors of his generation, is self-taught, and his breadth of artistic interest was and is considerable. Throughout these early years he steadfastly strove to resist the influence of other artists living in New York, in order to find his own way.

The attitude of complete permissiveness about means and mediums evidenced by today's sculptors makes it hard for us to understand the hold that "direct carving" and the ethic of "truth to the medium" had upon American sculptors of the pre-World War II period. Lipton, although he did some modeling at first, was an ardent disciple of direct carving. Usually no preparatory sketches or models were made; relying upon his extensive training in anatomy, he worked out his conceptions on the final scale from the block of wood itself. The wood's particular properties of grain, color, hardness or softness were considered in relation to the theme, as illustrated by the choice of oak for *Flood* and teakwood for *Prophet*.

Each sculpture was given a uniform texture: these range from small faceting in *Lynched* or deep gouges and broad inflections in *Prophet* to the polished surfaces of *Swing Low*. Barlach served as inspiration for Lipton's roughly finished surfaces but not for his compositions or handling of space: "Lehmbruck affected me by his poignant poetry and dignity in handling the figure. I liked his architectural handling and formal resolution of the figure—its elegance and simplification. These things probably influenced my *Cold Man* piece" (1968).

Primitive sculpture also encouraged the artist to seek textural uniformity. By this means, the artist was convinced, his sculpture would maintain its independence of painterly qualities, and this remains today a constant of his style and reasoning. While some of the smoothly fashioned pieces of the thirties resemble in finish

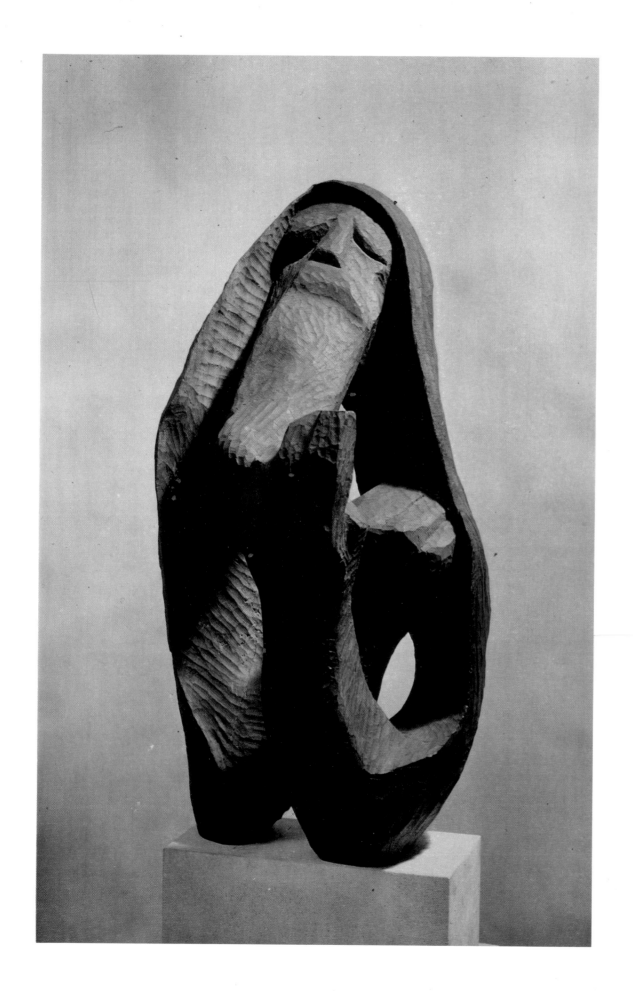

8.

PROPHET. *1941.*
Teakwood, height 38".

9. *Study for* Empty Room. *1964*

Already in these first sculptures there are prophecies of Lipton's style in the years to come. He imparts a personal lyricism to the most tragic theme, and a bittersweet mood runs through many works. Most of the figures have one point of view from which their identity is clearest, although the forms are not relief-like. Silhouettes are distinct and strong and continually curve into depth, forcing the beholder around the sculpture. There is an oscillation between compacted forms, such as the self-compressed figure of *Cold Man,* and more open and extended configurations, as seen in *Swing Low.* Most of these early pieces are open at some points, and in many, *Prophet* for example, there is "violent formal play" in the form of the interpenetration of hollows.

The full figure is a rarity in the sculptor's work. In 1937 Lipton made his first partial figure. This deviation from the norm of the body's visual appearance, which had become a frequent one in modern European sculpture by the 1930s, was to lead to important new formal and thematic developments in his art of the ensuing decades. (Just how these early partial figures are ancestors to the Hero series of the fifties, and even to other recent work, can be seen by comparing *Cold Man* with *Sentinel* of 1959, and *Straphangers* with *Empty Room.*) Before Lipton carved *Flood,* in 1937, the partial figure had a sculptural history in the United States limited to a number of works produced by Gaston Lachaise in the 1920s (segments of his wife's abundant body), and a few torsos by Zorach. Unlike these sculptors, Lipton, when he adopted the partial figure, did not alternate it with images of the body intact. The partial figure in *Flood* seems to have derived from a desire for dramatic focus upon the head and arms, and the title, or situation, makes plausible the omission of the lower half of the body.

In the following years the evolution of the partial figure was roughly one of continued subtraction, rephrasing of body parts, and then inversion of focus from the exterior to the interior. In *Prophet,* of 1941, all the torso and neck have been cut away, and the old man's arms seem to grow logically from the mantle that also hoods his head. Never does segmentation imply mutilation, as one might expect. But it does add to the pathos of certain works. In 1942 the bound slave of *Swing Low* is given a second pair of arms, which extend upward like wings. Still in the mood of Negro folk music is *Spiritual,* of 1942, in which the arms emerge as if from the cheekbones—a contracted and imaginative body image in which focus and fusion relate to those parts of the

18 Henry Moore's work at the time, it was not until after Lipton's first exhibition, in 1938, that he saw the English artist's sculpture. For some critics and for Lipton's socially oriented admirers, this uniform finish and reductiveness of facial features endowed the figures with a family resemblance and, by implication, a class unity.

body most directly involved with the mood. After this break with anatomical completeness and sequence, the next step seems logical in retrospect, namely, the opening up of the body, its partial skeletonizing, and the accentuation of the pelvic area, with its embryonic tenant, in *Cradle,* of 1941: "I sought to give an expression to man's interior. Having done extensive actual anatomical study, I knew the viscera, bony cavities, etc. Together with preoccupations with anthropology, Freud, and primitive magic, I became aware first of man's inside and then that of nature."

What the sculptor learned from the partial figure was new ways of organizing and interpreting the body that still preserved its identifiability while opening up new formal and expressive ideas and meaning. To make plausible these new personal interpretations of the body, he maintained then and thereafter the semblance of a viable physiology, whereby even in the multiplication of limbs or the relocation of body members everything seems organically related, as if the forms grew out of one another and were capable of movement. The incentive to do these things came in part from advanced European art of the time:

The partial figure in the thirties began to reflect my interest in the Surrealist breakdown of the classical, anatomically complete and recognizable figure. All through the thirties I sensed an inner need for formal invention, reorganization of the figure in terms of humanistic expressiveness. Sculpture as an art in space, sculpture as an aesthetic object interested me even then. I just had not broken away enough from my more direct social and moral humanistic expressionism. The School of Paris, the idea of taste did not concern me self-consciously. I believe I felt unconsciously a need for dignity of organization (1965).

That the themes of the early forties remained those of the Depression years is explained by the artist's written notes of about 1942, in which he set down his hopes for the future of American art:

Art in America to grow vigorously must of necessity be inseminated with techniques and ideas from abroad to give it potency, just as sixth-century Greek art was invigorated formally through its commerce with Egypt. It is a mistaken notion to look hopefully to the future of American art only as a further

10. *Untitled drawing. 1963*

development of, let us say, the School of Paris or the Italian Renaissance. To look rosily only to the outside for guidance and nurture is to deny the basic folk substratum and teeming life and history of America, which should be the soil for a rich tradition of art in America. . . . The local and the universal, the sectional and the national, the national and the international are necessary polar infusions for the healthy growth of art in America. . . . What we need is an art that gets unsentimentally at the core of America, its basic folk substratum. It would be commemorative of its myths; meaning would be moralistic and heroic along the mainstream of history. The heterogeneous life of America could be welded into a communal mood and direction. . . . Such art would retain the flavor of the folk, the mood of a section, imaginatively broadened into natural and universal human significance.

Lipton's sculptures *Soldier and Mandolin,* of 1937, and *Folk Song,* of 1944, best illustrate what he had in mind. All during these years Lipton was concerning himself with questions about art detached from political and social or nationalistic themes. Notes written in 1941 suggest still another way of examining these early sculptures. The philosophical approach of Morris R. Cohen, Nietzsche's ideas on art, and a general admiration for the scientific method account for the tone as well as the content of these writings. Over twenty-five years ago, Lipton became convinced that both the making and the viewing of art involve the concept of polarity—opposites that involve each other and are "functionally interdependent":

In general we may say of a work of art that its dominant qualities are several of many possible polarities in varying degrees. That is, it may have a high degree of aesthetic unity and a small degree of diversity, a high degree of generality and a small degree of particularity, a high degree of personal intensity and a small degree of social breadth. . . . In no work of art where one aspect of a polarity occurs is the other entirely absent, though there may be an extreme difference in degree of emphasis.

Prophetic of his own art in the years to come are such statements as:

Sometimes artistic visualization occurs entirely before an artist actually undertakes his work. More often it occurs through the polar interplay of the artist engaged directly with his medium, with additional polarities entering into an uneven, sporadic experimental activity. The very use of the medium may afford "chance" the opportunity to become a factor of considerable influence. . . . The suggestibility of chance, trial and error, will often give new imaginative direction to a work in progress. . . . This is due to the fact that "necessity," the polar opposite of chance, is never a factor in art as it is in science.

Lipton's long sculptural preoccupation with the conflict of oppositions is made more understandable by these early recorded reflections. It was to take him many years, however, fully to realize in his own sculpture the implications and artistic possibilities of polarity as a life view as well as an aesthetic.

The difficulty in assessing the worth of the early sculptures is that they must inevitably be seen against Lipton's later art, with its many individual peaks, its sustained excellence, and its resistance to influence from other sculptors' work. As a group the wood pieces (*Prophet* and *Swing Low,* for example) display inspired and impressive carving and a selection of themes and formal ideas that are seminal to what follows. Set against other figural sculpture of the thirties, Lipton's work is good: sound of craft, strong in rhythmic design, and manifesting a sculptural intelligence that resists sentimentality in the way the complex forms are shaped, and surely interlocked, in three dimensions. What seems to have set Lipton apart from his contemporaries at the time was the highly personal and imaginative body imagery evolving in the partial-figure series, indicating his growth as an artist. Lipton's own assessment is modest: "If only my work to 1945 survived, I feel it would be viewed as that of a personal, expressive craftsman with no special originality that I can see now. There was a personalized style in the simplification of anatomy which later led to more radical simplifications of form, planes, etc. The great emphasis was upon human moods in daily life . . . feeling for pain, pleasure, tragedy was in those early pieces."

CONVINCED, BY 1945, THAT SOCIALLY ORIENTED and anatomically restricted imagery tended to inhibit the scope and form of his art, Lipton expanded his ideas and his aesthetic, and extended the reference of his sculpture to broader biological themes. Eliminated were Depression iconography, obvious rhetorical manifestations of sentiment, and the earlier stylized handling of the human form. From 1945 until 1947, when he set aside the body as an explicit theme for some years, he did fewer, but harsher, figural works. The human form as the exclusive vehicle for the sculptor's imagination was replaced by a new species of life—bestial forms possessed by mordant fury. In contrast to previous work the ferocity of these new forms was unbridled. In 1949 Lipton said: "Gradually the sense of the dark inside, the evil of things, the hidden areas of struggle became for me a part of the cyclic story of living things. The inside and outside became one in the struggle for growth, death, and rebirth in the cyclic renewal process. I sought to make sculpture as an evolving entity: to make a thing suggesting a process." His savage new conjurings issued first in bronze and then in lead constructions, for the associations these beings created

and their formal intensity required a supporting medium with capabilities beyond those of wood and stone.

Lipton's fantasist, or Surrealist, phase began in about 1945, when his sculpture was increasingly tending to invented hybrids and mutants seemingly governed by invisible drives toward remorseful self-destruction. At first glance some of his complex sculptures suggest a fantastic symbiosis, but unlike symbiosis in nature, where two different organisms support each other, in Lipton's art it threatens mutual annihilation. This incompatibility suggests the uneasy coexistence of order and disorder in man and nature: "Thorns, bones (ancient and modern), sharp tensions, tusks, teeth, and harsh forms develop and grow together in varying ways as new beings of sculptural existence evoking images and moods of the primordial insides of men, all toward a passionate intensity underlying the meaning of modern man."

World War II seems to have confirmed for many artists that the human capacity for self-destruction was timeless. Discussions with the sculptor on the background of his changes in form and meaning around 1945 brought out his quest for a broader and more ahistorical world view, and his preoccupation since 1940 with Freudian ideas about "the iceberg character of human personality: evil, unconscious drive, selfish and animal needs that may exist below the level of consciousness." The conditions of the external world on a biological level became the basis for a more powerful and intimate expression than he had achieved previously. Writing in 1947 about what he observed in men, Lipton shed light on his own nature: "The tensions in man as an individual and social being, the blind energies and sudden momentary clairvoyance, all struggle along to achieve a fruition, some balance, some steady vision. These harsh tensions, dramatic or lyrical, are a basic reality in man. This is the realism I am trying to get in sculptural language." To these concerns were joined personal disillusion with political partisanship, with society's attempt to liberate itself socially and politically, and with the stupidity that leads to war and the arrest of civilized progress.

The sculptor's preoccupation with disorder and destruction as seminal themes in a new creative mode received ample reinforcement from Surrealist art as well as from developments in American painting and sculpture in New York during the early 1940s. He saw countless exhibitions during these years, and despite the continued strength of Social Realism he was most impressed by examples of Surrealist art that showed "taste and expression" and

that were based either indirectly or not at all upon the human figure. In his own work before 1948 Lipton seemed unready to contemplate sustained exploration of pure abstraction. He attended meetings of the New York Expressionist artists, few of whom he knew before the later 1940s, and saw all the shows at the Kootz Gallery after 1946 as well as those held by Peggy Guggenheim in her gallery Art of This Century. He frequented the Buchholz-Valentin exhibitions, where he admired the German Expressionists, especially Schmidt-Rottluff and Kirchner.

While teaching sculpture at the New School for Social Research in 1940, Lipton had seen an exhibition of the black-and-white images of Miró and Masson. He was intrigued by what he refers to as Masson's "microbiological" images of sexual conflict and the rich implications of the interweaving of erotic motifs such as ovum and sperm. It was clear to him that Miró's work was not innocent or naive but was involved with serious brutality. In 1961 he remarked: "The metaphysical evil of Miró of 1928 I was sympathetic with, but I had to invent my own controlled space. His free-floating forms in a spaceless world were not for me. Floating dream sequences were replaced by time and space, real entities in the life of man."

Miró and Masson, with their asymmetrical compositions, "the absurdity of their shapes," and their private symbolic involvement of form and content, helped introduce Lipton to a whole world of formal and expressive possibilities. Further, the example of the School of Paris artists in exile in New York contributed to the incentive for a break with Social Realism: "Art became for me a process of rejection. What remains is you!" By legitimizing free association, aggressiveness, and otherwise uninhibited expression, Surrealism showed Lipton the way to canalize his most private intellectual and emotional concerns into his sculpture, so that in 1947 he could write: "On an instinctive level, I explore new worlds of three-dimensional form, making drawings and small plasticene models preparatory to finished work. This is a withdrawal into a subjective, imaginative, and almost automatic world of formal invention and discovery. It is reaching for formal equivalents to the substance of experience. It is also a realm of free play of forms for the sake of forms. It is not an anarchic world, however, because it is guided, somewhat subconsciously, by the compass of previous experience."

Lipton could not surrender unconditionally to Surrealism's seeming lack of discipline: "Surrealism was based on a free-

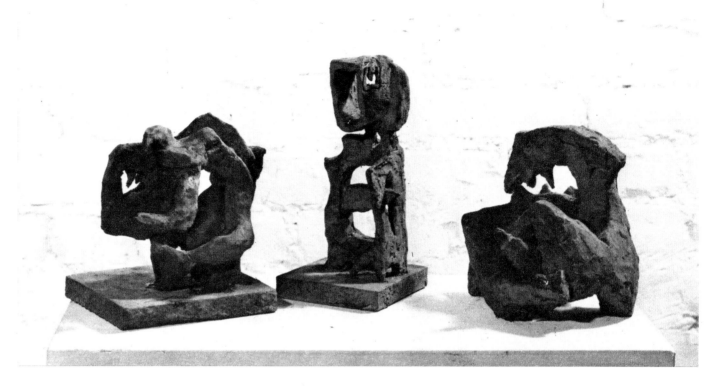

11.

Plasticene models.

Left to right: Moloch #3,

Cerberus, Moloch #2

wheeling automatism of symbolization. This was not completely satisfying to my temperament. I had a self-conscious critical awareness of the spatial problems of sculpture. I tied up an unconscious feeling for symbol with the architectonics of space." Automatism was used to tap previously untouched resources within the sculptor, but always he felt it imperative to achieve a coalescence of the waking and the dormant experience. The barbaric qualities of his new imagery are not due in the final analysis to external artistic influences but are indicative of a more direct entrance of the sculptor's personality into the work. "Of necessity such work cannot be sweet, nice, ideal, or always pleasant. Meeting the challenge of contemporary art and life, it must in the main be provocative, searching, harsh, and tragic."

Where his earlier imagery had proceeded largely from hopes and goals involving cultural regeneration, founded upon a faith in the common man and a return to American folk traditions, after 1946 Lipton—like his contemporaries Pollock, Gottlieb, and Baziotes in painting—was to move farther back into history for his sources and for an understanding of his own time, to a mythical, uncivilized existence. The titles of his sculptures—*Ceremonial, Moloch, Ritual, Battle of Gargoyles*—lead the viewer's thoughts back to early religious history, rule by superstition, aberrations of the public mind, primal fear, frenzy, and sacrifice.

In the early 1940s the sculptor's interest was aroused by dinosaurs, bats, and horrific animals of the air and the sea: hawk, eagle, vulture, shark, and octopus. No longer were these subjects museum specimens and artists' reconstructions for the *National Geographic Magazine.* The sculptor saw them partaking in a formal language and space. These forms "suddenly became meaningful expressively," owing perhaps to the artistic climate of the time, in which other artists were taking up these themes. In the *Magazine of Art* in 1947 Lipton wrote: "In these past two years a new development, unplanned, has grown from the substance of past work and experience. I have been finding the paleozoic in man. The dinosaur and its bones have come alive to me. The bud, the core, the spring, the darkness of earth, the deep animal fountain-

head of man's forces, are what interest me most, as the main genesis of artistic substance. The old bones are moving again in a new body, a new organism."

Prehistoric and primitive sculpture exerted an indirect formal influence on his art, as the artist stated in a letter he wrote in 1960: "Primitive sculpture fascinated me always for its appeal to the magic insides of man's life and reality. Its direct geometric simplifications to state strange and deep motivations of man had a big hold on me. The sculpture of New Ireland in the Pacific still haunts me in its inventiveness and savage poetic expression."

By the late thirties and forties American artists like Pollock, Rothko, Motherwell, Gottlieb, Roszak, and Ferber supported the view that important art was to be founded upon myth, symbol, and (for some artists, such as Morris Graves) Oriental mysticism. With respect to Abstract Expressionism, Lipton recalled in 1968: "Until 1946 I was not familiar with the painters who later were known as Abstract Expressionists. I was evolving from my own needs. In their basic approaches Abstract Expressionists were concerned with ends alien to my needs of presenting formal experience of concrete reality and metaphorical equivalents of the processes of reality. Later, though I recognized their formal contributions, I always shunned their approach to art as incomplete. I knew nothing of American painters' and sculptors' attitudes toward myth and art until about 1948."

In this country during the thirties many artists were influenced by the murals and paintings, at once topical, epic, and mythical, of Orozco and Rivera. Lipton had worked from such American legends as that of John Brown in an attempt to find the basis of a specifically American modern art. The interest of the European Surrealists in the Minotaur myth abetted, but did not originate, the involvement of American artists in this area.

Lipton recalls that one of the things which prepared him to work with personalized mythical conceptions was his encounter in the early forties with a meteorite on view in New York City: "*Ominous Directions* of 1942 was based on the exploded shape of a meteorite seen in the Museum of Natural History, which spurred my interest in primordial, prehuman existence. This work was of signal importance for me as opening new areas of formal abstract possibilities and new thematic material leading to enclosed spaces, mythic conceptions, projecting forms, etc. It was an icebreaker that showed me the way to express myself in nonhuman terms" (1968).

What seems to have interested American artists such as Pollock, Lipton, and later Roszak was the violence and fantasy that these myths evoked in their own as well as European art. It was not so much the stories themselves or the characters in the myths that seem to have had the most telling influence in this country. It was the precedent of forceful, instinctive creation, mystery, ambiguity, eroticism, sadism, and all the passionate forces that myth and symbolism can release to appeal to the collective subconscious of a universal audience. And it should be kept in mind that the socially oriented art in America of the 1930s was also strongly involved with suffering and brutality. In those years, however, the public was made aware of the specific social, political, and economic forces responsible for human degradation. Largely disillusioned or dissatisfied with the limited and often journalistic objectives of their own art, many American painters and sculptors after 1940 absorbed and increased their earlier violence in the timeless, placeless ambience of the pseudo myth. After 1940, it was the artist responding to his own feelings who was largely the source for violence, even though his work could still be partially construed as commentary on the state of the world.

IT IS POSSIBLE, USING *Thorny Shell*, OF 1946, one of many strong sculptures of the critical three years 1946–48, to summarize Lipton's style of this period. While it is apparent that his vocabulary is no longer dominated by direct references to human anatomy, there are, nevertheless, basic shapes and expressive gestures that are traceable to the figure sculptures of the early 1940s. The artist's favored shapes derived from the mouth, cranium, and bony skeleton of human and animal forms. The hook or horn shape is used severally, appearing as beak, jaw, tooth, tusk, wing, claw, thorn, barb, and phallus. Commencing with *Argosy* and *Warrior #1,* Lipton introduces the screw motif that becomes prominent in the next decade. The crescent occurs repeatedly within a single sculpture, invariably as the termination of a tapering, always curving form. These forms consistently diverge in axis and in degree of curvature, size, and proportion. It is misleading to write of parts or to imply distinct separation of solids within these sculptures. There are edges, but no clearly defined joints. Thus, physical fusion of components results from the artist's

23

search for an organic structure that evokes growth and change. All planes, for instance, are in transition to or from concavity and convexity. As in *Thorny Shell,* they often appear to spiral out from around the hollows. These openings within the silhouette are rough variants on skeletal interstices or shell cavities, and are usually crescent, oval, triangular, or boxlike shapes. The cut-out areas appear to be made by force. The nonhuman sculptures do not radiate from a solid central core, nor are they arranged about a dominant, clearly defined single shape. A convoluted skeleton or shell-like configuration is preferred, in which the center is a pierced or compressed hollow. This persistent actual or implied interpenetration of shapes and space, the piercing of valves and asymmetrical compositions, preserve the self-involved or anarchic qualities of the theme.

Several compositions, *Thorny Shell* among them, suggest a coiled spring. The common rhythm of Lipton's arrangements is that of an energetic extension and contraction. There is no clear separation between inside and outside in these sculptures. As with the Möbius strip, or single-surface curve, one feels that a hand uninterruptedly traversing the whole surface of *Thorny Shell* would inevitably return to its starting place. (This characteristic was already evident in the earlier wood sculpture *Prophet,* of 1941.)

There is, as has been noted, a general uniformity of surface texture in each sculpture which prevents a dilution of the form's over-all impact. These surface treatments vary, having what is analogous to, but never is literally, a leathery or worn bony quality, roughly modeled or scored and dented all over by file and hammer. Rarely does Lipton impart a sensuous, untroubled smoothness to his works, preferring the implication of surface formation by external or internal pressure, torsion, or battering.

The rapid and extreme transformation of the human form in the sculptor's work in the years prior to 1947 is partially explained by his working simultaneously on nonhuman sculptures in which a new form language and comparative anatomy were evolving: "*Harvester* and its three scythes is a metaphor of the cosmic scavenger of death reflected in the toll of World War II. That is what I felt. This was no ordinary farmer. The body is a primordial large-boned beast" (1968). *Harvester,* of 1945, shows the figure still relatively untouched by animal and botanical ideas. It is a fusion of the human and the machine-made object, with the sculpture's form deriving from Lipton's viewing of prehistoric skeletons. The backbone resembles a dinosaur's, since he sought to model a resemblance to paleozoic bones. Seen frontally, the sculpture's base has the appearance of a plowshare. The worker's image has shed the pathos of the thirties, and the artist has assumed a more detached view of his subject. The body has been reshaped in more open fashion, with strident, spiraling rhythms. There is nothing ominous in this work, and yet within a year's time, in the Bird and the Moby Dick series, the artist will beat the sickles into instruments of torture.

In 1946 the crescent shape was again utilized in *Homecoming,* whose theme was inspired by the war. In this work the man and the woman share a common body, with the female pelvis serving also as the sculpture's base. The rare tender and optimistic mood "is also related to the deep inner bone feelings of war and its tragic memories." The main structure, which in *Homecoming* was a ribbed bond of unity, becomes in *Mortal Cage* a sign of self-imprisonment. The persistence of the romantic motif of élan and constraint is apparent when *Mortal Cage* is contrasted with the earlier *Swing Low,* of 1942, and *Invocation,* of 1948.

Except for a few earlier maternal themes, the feminine form is not frequently found in Lipton's sculpture. Its most memorable treatment is in *Dissonance,* of 1946. "Both *Dissonance* and *Travail* are stylized skeletal structures of man as animalistic and ritualistic phenomena. They are reclining simply because they are both human and animal and are unrelated to the biomorphic pre-Hellenic open-holed forms of Moore" (1961). *Dissonance* impresses, nevertheless, as an antipode if not an antidote to Henry Moore's endless self-assured reclining women, who seem related to landscape through their rhythmic sensuality. Lipton's woman has ties with cityscapes or industrially shaped topographies; there is a sadistic and erotic impulse manifest in Lipton's re-formation of the body that mocks the languid voluptuousness in Moore and in Lipchitz' *Benediction I,* of 1942. Lipton's paraphrase of the body contains devices employed by these two sculptors, such as the merging of the arm with the head, the repositioning or elimination of limbs, and the use of openings in the body: "One cause of open forms in these early works stems from the opening in the pelvis of man and the spaces between the ribs. In *Dissonance* the hole is straight anatomy. But the opening is later varied and complicated in sexual and biological implications, all mostly at the

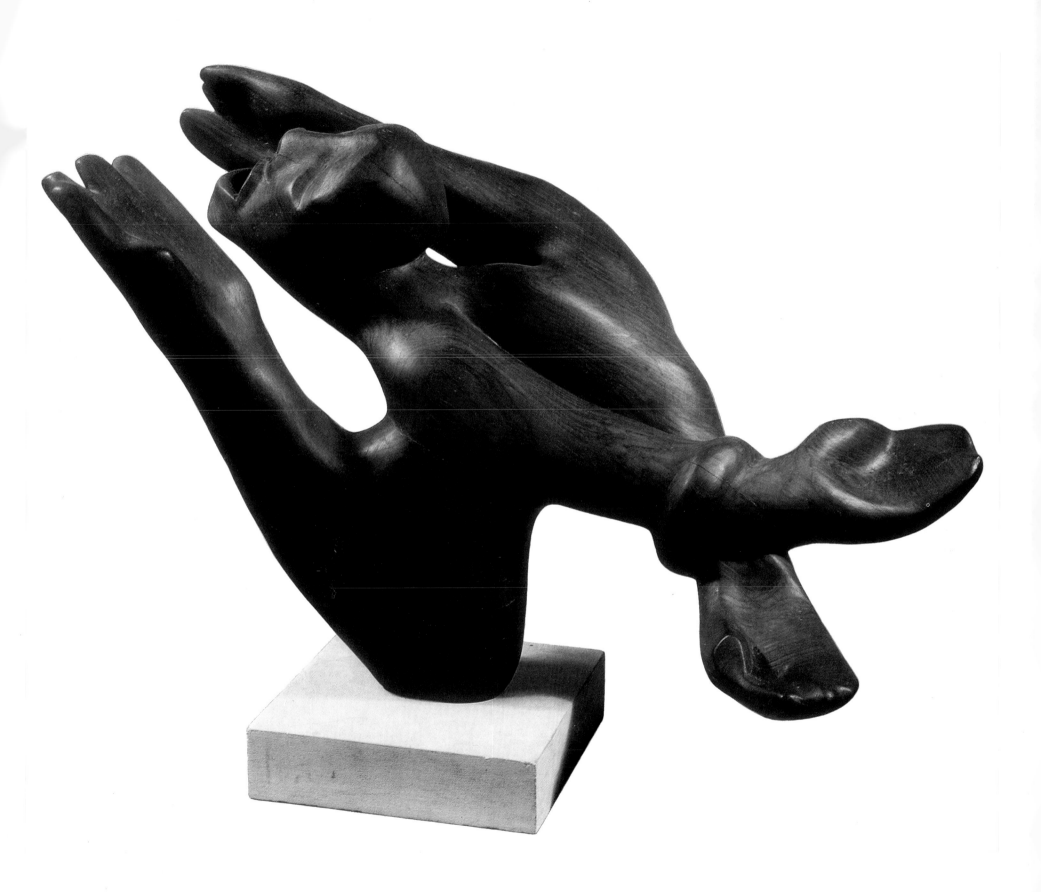

12. SWING LOW. *1942. Rosewood, length 24".*

unconscious level. In most cases all these forms happened after the intuitive feeling of their emotional suggestiveness" (1962).

Lipton has more than skeletonized the body. The rib cage of *Dissonance* is transformed into a series of worn-out machinelike disks, the hands into claws; the head is a link with the predatory craniums of the Moby Dick series. *Dissonance* was probably a rebellious gesture against an overworked and sentimental image of womanhood both in the art of others and in his own, but he never chose to develop these ideas further.

Witches' Sabbath, cast in bronze in 1945, was one of the artist's new imagistic pieces. An amputated horn rides above the splayed concave shape beneath. This V form is assimilated into the later style but is never again to receive such a dominant emphasis. Its existence in *Witches' Sabbath* calls to mind inverted spread-eagled figures found in Matta's paintings of the time and in Goya's prints. Miró's small sculpture *Bird,* of 1945, also shows a crescent form mounted on a bird's back, but the whole has a soft, docile quality in comparison with *Witches' Sabbath.* The terminations, protrusions, or growths in the latter are hard-pointed and knobby bone endings, predicting the bird-headed forms seen later in *Horned Dancer.* The sculpture is a hostile object, repelling touch and aggressively claiming its place in space. Its components meet in raw junctures. The vehement intonation and menace of the piece originate in the counterplay of straight against curved shape and bulge against hollow.

Because it indicates his willingness to depart radically from the figure and produce an aggressive conceit, *Witches' Sabbath* is critical in the sculptor's evolution. It may also have played a part in his decision to begin the series of bird forms: *Strange Birds, Prehistoric Birds #1, Birds of Prometheus, Wild Earth Mother, Horned Dancer,* and *Firebird #2.* It was in 1946 that Roszak produced his first images of violent bird forms, *Anguish* and *Scourge,* which were followed by *Scavenger* and *Spectre of Kitty Hawk,* of 1946–47, and the sexually symbolic *Raven,* of 1947. David Smith had done his *Cockfight* in 1945 and *Royal Bird* in 1948. In the 1930s Lipchitz had metamorphosed bird and harp in *Harpists,* and made the vulture Prometheus's victim. (Lipton did *Birds of Prometheus* in 1945.) Gorky had made fantastic bird images in the late thirties, and in the same years Morris Graves had begun his bird series, inspired by Mark Tobey's work of 1934. Graves's paintings were exceptionally popular in the New York art world in the early forties, when his shows sold out and were highly praised. His imagery seemed personal; it could be readily grasped and yet be mystically remote from prosaic Social Realism.

It is difficult to pinpoint the reason for this simultaneous avian interest among advanced artists. Although Roszak's *Scourge* was shown at the Museum of Modern Art in New York in 1946, Lipton has written: "I didn't see anything by Roszak until about 1948 and did not meet him until later. . . . Things like *Harvester* and *Witches' Sabbath* cast in bronze and using horn and bone forms in 1945 were exhibited in the Sculptors' Guild and the Clay Club. . . . As far as I know, I used bone, pelvis, horns, and knife forms never having seen such elements in anyone else's work. I exhibited a hollow, knifelike, explosive work in cast bronze in 1943, *Ominous Directions,* at the St. Etienne Gallery, and had been making plasticene sketches along the above lines since 1942" (1961). Regarding other influences the sculptor has said: "It was the Museum of Natural History and what was suggested there for new formal ideas that affected my efforts. Of this I am certain. I carefully avoided any influence by other artists, jealous of my own personal development" (1962). What compounds the coincidence of Lipton, Smith, and Roszak working simultaneously with the bird motif is that all employed primeval and fantastic birds as pessimistic metaphors of destruction, probably inspired by the use of air power during the war. Their respective approaches form an ironic contrast to Gorky's optimistic Newark murals of 1935–36, in which the airplane symbolized freedom of vision and the exploration of new spaces.

Of greater importance than the question of which sculptor was the first to deal with the prehistoric bird theme is the strong stylistic individuality manifested by each. Lipton's bird images, unlike the others, were, with one exception, all bronze-cast and show the results of modeling by hand. The coarseness of these modeled surfaces, as seen in *Prehistoric Birds #1,* never overwhelms the total form or competes with the expressiveness of contours. The forms in the series are complexes of self-conjugating angular protrusions that impart a muscular rhythm to the silhouette. At times the interplay of two bird forms within a single work lacks strong resolution or gives rise to ambiguity and, rare for Lipton, a slackness in design. While this series is not the strongest in the artist's production, he learned much from it. Unlike the Moby Dick series, the bird images lack the subtle disclosure of the idea in form and

meaning. *Horned Dancer* is a good example of the strong and the weak points in the series. The energizing and explosive qualities of the form are offset by an obvious alliteration of the hooked motif. Lipton's birds seem more in the tradition of late Gothic, northern European sculpture than of Mediterranean. Closer in time and spirit to *Horned Dancer* is André Masson's *Mantis,* of 1942. Lipton, as was noted earlier, knew Masson's sculpture, and he still admires it today. Its small scale and open, aggressive skeletal form were comparable to what Lipton was doing in the mid-forties.

The fertility of thought and energy with which Lipton worked in 1947 is displayed in a project remote from the Bird series. *Exodus #1* (at one time called *Panorama of Judea*) is a departure from the sea-monster and reclining female forms, for it is a cryptic landscape: "The *Exodus* pieces were part of a tragic mood of history and reality that has always concerned me. The pyramids, the fiery furnace used in these works were related to the horns and primordial forms used in the Molochs. It is possible that Israeli history and emergence entered. I don't know really. . . . The underlying mood is tragedy, and the main concern was for a model for an outdoor wall 30 or 40 feet long, a kind of wailing wall monument to human suffering" (1961). The unrolling of *Exodus #1* suggests a type of ancient calligraphy punctuated by mystical signs, as if the whole was a grim pictogram or morbid cartouche of a tortured terrain that has survived by indomitable toughness. The amputated fist–tree stump at the left, for example, is a defiant avowal of survival. Its quality of inelegance is exactly the strength of *Exodus #1*. The form of this sculpture shows that Lipton was not a limited, repertorial artist content with transplanting the same gestures and motifs from one work to another, regardless of theme and mood.

In 1945–46 Lipton began his Moloch series, which in turn spawned his Moby Dick sculptures. Common to these series is the grim disembodied head with voracious open jaws. The like had not appeared in serious sculpture since the Hell Mouth or sea monsters' jaws in medieval Last Judgment relief sculptures. In medieval sculpture and painting the open jaws of a monster became an outlet for secular and private aggressive fantasy. Paradoxically, while artists in this century did not depict the Last Judgment, their fascination with evil and death led to a revival of one of the most typical symbolical forms of Hell and punishment in religious imagery.

There is no modern precedent in sculpture for Lipton's particular aggressive type of oral imagery. There is, however, a rich history of comparable types in painting since the 1920s, Surrealism in particular. In several of Picasso's paintings of the late twenties leading to his *Crucifixion* of 1929, fantastic figures are headed by gaping jaws with pointed teeth. In the thirties Picasso's bull and horse series, which culminated in the *Guernica* studies, and the *Weeping Woman* series seem to have prefigured Lipton's work; the crayon drawings of the latter series focus exclusively on the head, seen simultaneously inside and out, and transformations include that of the tongue into a knife form. Miró's imagery of the late twenties and thirties has multiple references to threatening jaws in the gigantic amorphic heads of men and women. These conceptions are always of a potential danger; we do not see actual biting and tearing by the teeth. Exceptional in Henry Moore's sculpture is his *Three Peaks,* of 1939, which alludes to the palate of a mouth possessing a moist, slippery lining. The closure effected by the three tusklike points renders the whole more sensual and more passive than the comparable image in Picasso or Lipton. Also in the late 1930s Paul Klee based several fantasies on demonic head forms armed with closed yet fearsome jaws. For a 1944 cover of the magazine *VVV,* Matta designed a monstrous mouth agape, ringed by a hairy collar. Also from Surrealist painting had come the hybrid animal, the Minotaur, and the monsters that romp or rip through Max Ernst's paintings. None of the foregoing, however, exhibit references to sea life as do those of Lipton.

Lipton's own recollections are that he was most susceptible to formal influences from "twisted, tortured relationships" found in Bosch, from Gothic bestiaries, and from animal motifs on the columns in the Cloisters in New York, seen in 1944. He further remembers being excited by seeing, in 1945, bronze castings from South American ritual objects with "enclosed cagelike forms" and by the crudely powerful Mayan and Aztec iconography related to Hell and sacrifice: "Around 1945 I became interested in Mayan and Aztec death ritual sculptures, Molochs, and other historical deadly devouring imagery. They became important to me in terms of the hidden destructive forces below the surface in man. War always seemed to break out against the logic and necessity of peace."

13. *Study for* SENTINEL. *1959*

The war, art, deep personal feelings, the pertinence of his readings in early history, religions, and anthropology provided fertile sources of inspiration for the Moloch series in 1946. The name derives from the artist's reflections on blood sacrifice and the violence of early religions and modern war: "Moloch, a god of Eastern human sacrifice, I probably felt related to the war." The basic shape of *Moloch #1,* with its hidelike surface, resembles the open-jawed, horned head of a rhino. Fused to this is a second, three-part shape, the middle edge of which is serrated and then curves back upon itself to form the eye. The whole suggests a grim trap whose potential for movement is deceptive, owing to the unaccented pivots and the diversity of conflicting axes in its makeup. Even when dealing with the monstrous, the sculptor is still impelled by his nature and background to contrive a credible physiology.

Cerberus, which intervened during the Moloch sequence, was an outgrowth of both the Moby Dick and the Bird series. It is one of Lipton's most frequently reproduced sculptures, but it is not the best of the period. Two pierced, irregular boxlike hollows, vertically disposed, are flanked by asymmetrical silhouettes. This form of self-penetration is also found in Miró's *Personage* paintings and in David Hare's needle-like sculpture *The Thirsty Man,* of 1946. *Cerberus* is the first in a long succession of works on the guardian theme (culminating in *Sentinel* of 1959) that Lipton was to undertake.

In 1946 the sculptor returned to the Moloch theme and hammered out a second version in soldered lead sheets. This shift in method was to overcome the expense of casting as well as to permit a more direct contact with the metal. Unlike that of Saul Baizerman, who for many years had been hammering flat copper sheets into large, vibrant, but peaceful images of the nude, Lipton's surface working added to the impression of the monster's scarified history. In *Moloch #2* the morphology of body parts has been changed, and the tusk also suggests a phallic form. The emergence of the dominant crescent augurs the climactic hooded shapes of the late fifties.

About *Moby Dick #1,* which he made in 1946, Lipton wrote: "Moby Dick consumed my interest at the time, but only because it rang bells deep in my being. It was the symbol of destruction and the anti-Platonist conception that evil is at the center of the universe" (1960). In contrast to the coordinated slashing of *Harvester, Moby Dick #1* turns its weapons against itself, impaling

its own inner space. The alliterated thorny silhouette joins an increasing skeletonizing of the theme. The lower part of the jaw forms a bony pelvic girdle for the interior. The greatest richness and mystery of the sculpture is now to be found almost completely within the roughly diamond-shaped silhouette seen from the side. *Moby Dick #2* was more than a simple distillation of previous form. It was a new gesture.

Last in the Moloch series is *Moloch #3,* of 1946. It was perhaps the most ferocious image in modern sculpture up to that time. Because of its strong union of form and meaning, and the power of its presence, it is as convincing and effective as the best of the European Surrealist art having a comparable theme. At the same time that it is one of Lipton's most passionately inspired sculptures, it is also one of his most carefully controlled and intelligent, revealing all that the artist had learned up to that point A more profound and taut ordering reigns in the number and phrasing of solids and voids. Tusk and elbow shapes are more rugged, having been partially flattened and roughened in surface. The over-all surface has become a crust suitable to a beast that appears to be the oldest and most durable of the leviathans. Compositionally, the bold projection of the jaws beyond their support results in a more assertive thrust of the sculpture into space. A pervasive stiffening and angular compactness of silhouette impart a blockishness to the whole and give the impression that *Moloch #3* is a meditation upon a skull.

Characteristically, to this most uncivilized of his themes Lipton imparted an almost classical restraint and a disciplined technique. None of his subsequent works are as unrelievedly ominous or achieve the brute power of *Moloch #3.* It is as if within this sculpture Lipton had accomplished a final catharsis of the theme. He had the integrity not to persist with the Moloch idea once the inspiration had passed. *Moloch #3* is one of the very important sculptures of the 1940s.

Summarizing his objectives from about 1946 until 1949, Lipton has written: "The drive was toward finding sculptural structures that stemmed from the deep animal makeup of man's being, and that when finished had their own reason for being. The ferocity in all these works relates to the biologic reality of man; they are all horrendous but not in any final negative sense, rather they are tragic statements on the condition of man, thereby ironically implying a courage needed to encompass evil, indifference, and dissonance in the world of man" (1949).

THERE ARE NO SIMPLE BREAKS or clean starts in Lipton's work that permit his evolution to be neatly packaged into periods. Old preoccupations linger on while new ones bud, and within the same year different modes may alternate. By 1947 a new interest that centers on biology and botany, accompanied by continued speculation on good and evil, the ugly and the beautiful, can be sensed in the sculptor's work. A motif that notably gives form to this shift in interest toward the hidden, unexplained inside of things, new life emerging within the old, is that of *containment.* In formal terms this meant the necessity of reducing bulk and mass to shell-like enclosures. The *Moby Dick, Moloch, Thorny Shell,* and *Cerberus* works had been characterized by enclosed forms, but in the 1948 *Sentinel* and in *Portrait of a Poet,* of the same year, shapes independent of the enclosure occur for the first time. This *Sentinel* is related to *Mortal Cage* in that, like the earlier work, it has a coil-like lower element that penetrates into a shell of sheet lead. Within a brief period, however, this separation between container and contained became "too static" for the artist, and the interpenetration and semienclosure achieved by one continuous form seemed more personal and viable.

This is the period of Lipton's boldest experimentation and chance-taking so far. One of the most brilliant fantasies from these years is *Portrait of a Poet*—offspring of the moods that had nurtured the prior primordial sea-monster heads, with their savage animality. Still responsive to the urge to image the "unconscious raw stuff of existence," the sculptor struck a different form. Within a hard, file-scored metal housing can be seen, through two jagged openings, bristling thorny clusters. Their secretive ambiguity of reference contrasts with the open and explicit starkness of the outer shell. For the sculptor the exterior carried the associations of "a mask," behind which are analogues for "centers of thought and creativity." The hard outer casing became an exteriorization of "inner toughness." Of surprising irony is that portion of the sculpture which suddenly discloses the outer shell cut away, rawly revealing some of its private parts and intimating the organism's vulnerability. *Portrait of a Poet* is an afterimage of the bestial craniums, particularly in its jawlike cavity and its eye forms.

A year earlier, in *Predator,* Lipton had shown an interest in integrating unenclosed space into his designs. *Predator* is one of the first works in which he abjured volume and mass, building his form out of flat copper sheets, with exposed soldered joints.

Extending the militant mood of the time, *Predator* consists of cut-out, flattened shapes that suggest a stalking beast. Its upper parts obtrude through a flat, solder-textured oval plane. Previously, massive crescent shapes were ironed out into polished but ragged-edged planes. The entire angular configuration, with its use of strong spacings and lateral disposition, is unique in Lipton's style.

Involved with the possibilities of construction in space, the sculptor drew upon symbolical architectural shapes that were manipulated into a type of environment sculpture, albeit on a small scale. *Pavilion* has the equivalents of a roof, canted walls, interpenetration of space and building planes, bizarre perspectives, an arcuated belfry replete with clapper, a pendant trilobed cluster that coincidentally recalls the medieval and Renaissance practice of suspending objects such as ostrich eggs in church apses, a perforated pyramidal roof support, and it has a streaming issue of nickel-silver wire terminating in a surprising flowering. The whole has the illogical and oracular obtuseness of the cult shrine, as if *Pavilion* were a modern House of Mysteries. In retrospect, Lipton wrote in 1968: "It was a rejuggling of a building . . . of a roofed area, a pavilion of the spirit: the wires, the internal complex all winding and leading to hope, the flower. The sculpture is not a closed building but open to reality—both interpenetrating each other." While Giacometti's *The Palace at 4 A.M.* comes to mind, the possibility of its influence on *Pavilion* gains no support from the sculptor.

From the foregoing it is apparent that the artist was seeking a new, fresh involvement with "the architectonics of space." The horrendous and brutal had begun to pall; "tragic horror had reached a point of no return." More attractive to him was "taste, plasticity, the pleasure principle of the School of Paris . . . art as an object of pure pleasure based upon the sensual and the spatial." His reaction was against what seemed the too overt symbolism and weightiness of his own forms. As with *Pavilion*, experimentation began with diverse mediums, hard casings, flat planes, entangled wiry forms, new textures, and methods of joining that involved first soldering and then brazing with the torch.

Contrasting with the socially oriented series of the early forties, Lipton's work from then until the present has not been focused upon the conscious interpretation of subject matter in the familiar sense of the term. Neither titles, themes, nor clearly defined images preceded the first drawings or models of his sculptures. It was around 1945 that Lipton began to utilize drawings to fix impulse and intuition into tangible forms, always felt in terms of the final medium, metal. Previously, small clay models were occasionally made. The drawings accelerated and expanded the emergence of intuitions. Meaning worked into the sculpture during its creation. The sculptor, like advanced painters of the time, came to rely—rather than upon previous experiences or something read—upon experiences during the working out of his sculpture on paper and in the metal. His preoccupation with new means and aesthetic experimentation assisted in this transition: "I experimented with new materials and techniques, first for the excitement and experience, also to achieve greater inside-outside formal moods, and then to express through formal means a new preoccupation; that is, the biologic life cycle, a new hope, the bud, the core, the womb were emerging."

The work that perhaps comes closest to what might be termed a linear purist position is Lipton's *Odyssey,* which the sculptor considers a momentary experiment not fulfilling his needs. The same might be said of the "ghostlike" configurations made around 1948. This open, somewhat graphic, or linear, mode was soon abandoned because it held no mystery and had too little reference to what persistently haunted the artist: that which is hidden behind reality.

Following the war, Lipton was one of the first American sculptors to work in non-illusionistic sculpture on a large scale. Vertical gestures absent since the 1930s and not seen in works such as *Famine* reappeared in his work, culminating in *Cloak* in 1951. Such constructions as *Prisoner,* with its implications of restraint, and *Imprisoned Figure,* with its Promethean presence struggling to be unbound, exemplify this renewed involvement with rising, ascending imagery. The artist was shaking off his postwar pessimism; by 1950, perhaps through greater immersion in aesthetic problems, his feelings for aspiration and growth strongly countered themes of destructive struggle and evil.

Starting with the 5-foot-high, Picasso-inspired sheet-lead figure of *Famine,* of 1946, Lipton moved to the lighter mode of his tall cage and open-form constructions of 1948–50. The jagged, saw-toothed pieces in Lipton's work are flattened and attenuated versions of the arsenal motifs of the sea-monster series. His wrestling with the problem of more actively integrating the armature with the contained elements can be seen in *Prisoner,* of 1948, where quadrature is less apparent and the framing lineaments flex in conjunction with the inner spiral.

The cage theme stems originally not from Giacometti's work of the thirties but from Lipton's earlier preoccupation with the polar idea of internality-externality in living organisms. Adding emotional weight to this theme was the war reality of the concentration camp. It was only after the close of World War II that stories about the concentration camps and photographs of them circulated in New York.

The bronze and lead *Prisoner* signified the caging of the human spirit. *Pavilion* in its openness implied the breaking down of the prison. The sculptor feels that his recent sculpture *Trap,* although its formal theme is different, is in spirit a continuation of the morbid cage pieces of the late forties. (*Trap* is for him a tragic statement of a "great cosmic bird of death—the great gathering bird in primitive mythologies which comes to pick up the souls of the dead and bring them to a nether land.")

Before 1950 many American sculptors became involved with a greater affirmation of space as a positive and prime element of sculpture, made possible through the use of welded metals. Lipton's distinctiveness lies in his treatment of space: he cupped, enmeshed, pierced, graphed, and measured it out in stiff chords. It is an interesting feature of the evolution of modern sculpture that when a group of artists simultaneously arrive at new but similar techniques and possibilities of form, there is an overlapping of ideas that influences the titles, if not the actual conception, of their works. At the end of the forties and in the early fifties there were a number of open-form constructed sculptures produced by such artists as Lippold, Lassaw, Ferber, and Roszak that allude in form or title to astronomy, mystical ritual, the totem, and mysterious immobile personages, or "sentinels." In less than a decade American sculpture had passed from topical social imagery to the universal implications of myth or cosmic allusions—and then, for many, to abstraction. The destruction of the particular and the shunning of explicit reference, joined with the rejection of monolithic or solid form, in the 1940s, were necessary for this evolution,

Following his *Prisoner,* the next step for Lipton was to break open the cage and to use its strut components more actively, either for supports or for the penetration of crescent, globular. and shell forms. *Equinox,* with its lunar crescent bayoneted by a pendulum shape, was induced by "sensations of time, the organic, and the mechanical."

Family and *Invocation #2* are exceptions to the rule in Lipton's art because of the absence in them of an implied capacity for movement. Although fragile in appearance, the earlier sculptures necessitated greater structural strength than the lead sheets afforded. The artist's evolving technique first consisted of covering sheet steel with lead by soldering. Then, in 1949 and 1950, he took up the oxyacetylene torch and brazed the steel with brass. It was thus, in 1951, a short step to replacing lead by brass. Brass-covered sheet steel made the sculptor feel that he could make "any organic shape at will," with the maximum structural strength.

WITH THE EXCEPTION of a few cast pieces of the forties, Lipton has always engaged in what are known as "direct" techniques—carving, cutting, hammering—rather than in reproductive techniques. Since 1951 Lipton's method of making his sculptures has changed as basic technical problems have been solved. From lead on steel in 1948, and then brass on sheet steel in 1950, he turned later on, in 1956, to brass and nickel-silver on Monel metal. The sheet-lead pieces of the mid-forties were apt to break in shipping. The decision for steel as an armature base was part of a solution to a complex problem. What was necessary was greater strength, lightness, and durability. The problem was partially solved about 1948 by soldering lead on thin sheet steel; in 1950 greater strength was achieved by the use of oxyacetylene heat to braze sheet steel on brass rods. Subsequently the technique was expanded to include the brazing of nickel-silver rods on sheet Monel metal, to vary color and texture. The Monel, being a white bronze alloy, was rust-proof and would not deteriorate out of doors. Through these changes Lipton achieved the means by which to give freer play to his sensibility to structure and space.

Although he does not always find them necessary, since the early fifties drawings have usually provided the basis for small working models cut out of thin-gauge Monel metal. Lipton's basic shapes, not unlike those of a dress designer on the uncut fabric, are drawn on the metal sheet. Cut out with heavy shears, the malleable metal shapes are bent by hand or with pliers into the basic forms and then spot-brazed together at the joints. Once translated into three dimensions, the initial ideas of the drawing begin to change: "Chance, thought, and feeling" attend the birth of the object. The preliminary drawings set the frontal view of the sculpture. Rarely are additional perspectives made. The artist allows this front view to suggest surprise solutions to the side and

rear forms as the model takes shape. Studying the small metal model, he begins to project his ideas mentally into different scales until the appropriate one is found. He does not make full-scale drawings or models. Although intuition guides his decisions on the final work, Lipton may work from measurements taken from the smaller model. The pattern drawing on metal, its cutting and joining, are then repeated on the final scale. The pliancy and toughness of the metal allow for critical changes all during the formative process.

When he has finished the basic sheet-metal armature—and since 1959 it has tended to be composed of fewer pieces than previously—the sculptor begins to braze the sheet metal by melting $\frac{1}{8}$-inch bronze or nickel-silver rods with an oxyacetylene torch, which gives a more variable finish to the surface (their lower melting point allows these metals to be applied to Monel metal). He has in fact referred to himself as a "modeling Constructivist." Hammering of the sheets, after brazing, is often necessary to correct heat-induced warpage. Sometimes a chemical is applied to the brazed surface to bring out its color or to darken it. Since about 1960 Lipton's taste has run more to dark and somber patinas, replacing the earlier and sometimes brassy or nickel-like finishes of the mid-fifties. When the entire outer surface is covered, Lipton makes a "lining" of a second set of matching brazed shapes that go inside the outer layer. This lining is then inserted, creating a four-layer skin that contributes weight, structural strength, and variable thickness to the whole. In the last few years his sculptures have tended to take on a greater thickness more appropriate to their large scale and the peculiar nature of their shapes. It is particularly at the edges that Lipton exercises critical judgments, from point to point, as to the degree of thinness and curvature which can be effected by additional brazing. When finished, the sculpture will be restudied over periods that run from weeks to, in some cases, years. The artist is not averse to making changes on a piece completed two or three years earlier.

Until 1961, when he moved into a more spacious brownstone house in Manhattan, Lipton worked in a relatively small room in his Bronx apartment. To visitors it was a shock to open the French doors to this room and see gas tanks, an anvil, shelves lined with models, piles of rods, and often floor-to-ceiling sculptures. When asked about the suitability of this room as a studio, Lipton replied: "I have always felt that the workshop of the artist is in his heart, mind, and stomach. I've always welcomed the challenge of the physical limitations of actual working space. People visiting my place naturally have commented on the small room I work in, particularly when a ceiling-size sculpture was standing around. Bohemian poverty, pain and its romance, or faraway country places are irrelevant to creativity. . . . The will, the need, the love and hate, the vision are central to the call of art, whether in royal court, loft, or crowded middle-class atmosphere. I've done all my work since 1939, with all its changes, in this room. I've become accustomed to the place and emotionally relaxed here" (March, 1960).

THE EXIGENCIES OF WRITING ABOUT LIPTON'S ART encourage artificial separations between style and theme. When his signature style is analyzed, however, the beholder is taking a direct route to the sculptures' meaning. Put another way, the meaning of a sculpture by Lipton, the what and how of its being, depends upon its style. This indivisibility of form and theme is owed to the sculptor's lifelong resistance to the seductions of being a stylist only, and of the antithesis of this, being a literary illustrator. Fundamental to the understanding of Lipton's art, which since 1951 more thoroughly withstands comparison with the work of other contemporary sculptors as to sources of influence, are the sculptor's unwavering premises that the unity of life is the viable basis for his art and that to make sculpture is necessarily to transform. A crucial characteristic of his intellect and artistic imagination is *analogizing*, philosophically and artistically a transforming act. As with words in a dictionary, the sculptor finds plural significance and multiple overlapping associations in the life of the many forms that interest him for their sculptural negotiability. Analogy assists the artist to see unexpected relationships between differing entities, be they animal, vegetable, or mineral, which can be made meaningful and persuasive to his audience through his sculpture. Aptness for sculpture always tempers his selection from his environment or from sketches made automatically to preserve the freshness of instinctive analogizing. Preference is given to shapes that have rich ambivalence, for the artist begins by accepting the condition that the work's implications will flourish in proportion to the sensibility, or "meaning," the viewer can bring to it. As with poetry, the more we familiarize ourselves with the artist's works, his vocabulary, syntax, and idioms, the closer we

come to the general area of his intent and the more we sharpen our own sensibilities to individual pieces.

Lipton's importance as a sculptor rests in part upon the variety and imaginativeness of his shapes, any of which in isolation would be identifiable as having come from him. For artistic and moral reasons he cannot accept into his art the object as it is given. Because his artistic world is a poetic analogue of our own, a distinguishing characteristic of his style, already mentioned, is *transformation,* whereby each object used must undergo change or metamorphosis. The nouns used below to describe Lipton's shapes, as a convenience for discourse, are deceptive, since they imply a more literal relationship between the sculptured shape and its root than is the case. The sculptor feels that a form of tension in art is engendered by the immeasurable distance between a shape in nature, technology, or geometry and its offspring in art.

During the first half of the 1950s the families of shapes found in Lipton's sculptures show less overt affinity with the zoological—specifically, with bone or skeleton. The tusk is supplanted by the flowering bud, for instance. Allusions are more consistently made to the botanical, mechanical, and anthropomorphous. The pod, leaf, and bud shapes have a generally pliant quality and strong recurvature, leading to a semiclosure of form. After 1956 appear the arsenal shapes of helmet, shield, and dagger, which are peaked, hard-angled, stiff, or ruggedly resilient. A third grouping, encountered more frequently since 1960, consists of irregular and rectangular semienclosed volumes resembling box, book, and coffin. Akin to these forms are the slit-vertical-shaft and armored-trunk types of convex-concave surfaces. Since the late fifties there have also appeared flat sheets, undulated or rolled, that evoke sails, wings, leaves, or pages. The involuted or evoluted barb, knot, or radial bursting form is a transformation of Lipton's own shapes from the late forties, such as were contained in *Portrait of a Poet.* These bristling shapes may imprison a vertical shaft, as in *Pioneer,* or explode through flat sheets, as in *Manuscript.* Comparable in their aggressive connotations are the spiral screw-drill shapes, descendent from the forties, which in turn have their less militant twisted or raveled scroll-like counterparts.

During the last fifteen years Lipton's form language has developed a sculptural alphabet of shapes that fall into two broad groupings. (His lost plasticene sculpture of the musical clef, of the late 1930s, seems in retrospect the forerunner of these unconsciously developed letterlike motifs.) The first set consists of shapes, such as V, W, M, L, whose stems are jointed at one point by an acute angle; in the second group are shapes, such as C, U, O, that approach closed rounds and have no hard, angular hinge. Although deeply interested in Oriental calligraphy, Lipton did not consciously imitate writing as such in his search for elemental ambivalent shapes adaptable to the specific needs of varying contexts. Coupled with the foregoing shapes are others having a strong signal character, such as the extended hand of *Gauntlet* and the frequently used arrow.

Much of this abbreviated inventory represents transformations of figural gestures and zoological and skeletal forms of the thirties and forties, and the same process underlies Lipton's compositional habits. We can thus understand one of the sources of his continued growth as a sculptor by observing the continual compulsion to transform his own art.

Rarely are sculptors written about in terms of their abilities in composition, but Lipton must be ranked as one of the finest composers in modern sculpture. The dialectical nature of his thematic material coexists with his thinking about formal order. Getting to the core of his ordering style must also involve consideration of his meaning. Asked to set down roughly the organizing principles of his work, the sculptor formulated them, without indication of any priority of sequence, as follows:

The thought of struggle and strife in the sense of opposition: Forces oppose each other in the effort for supremacy, creating tensions. The resolution of such forces results in dramatic counterplay of forms and spaces. Usually one line of force wins.

The concept of centrifugal movements, of ever-opening vistas, ever-widening experience, but always controlled through centripetal movements of containment. This sets up a situation that is contrary both to the normal downward response of forms to gravity, and to the suggestion of upward organic growth. It is an interweaving, autonomous cosmos with no beginning and no fixed end, and yet with its own logic of determinate relationships. It is a three-dimensional plastic organism with an exterior-interior continuity—spaces and forms interlacing in continuous and discontinuous relationships.

The idea of interlocking connections, yet withal a sense of organic coherence and continuity.

The idea of the vortex, the knot, etc., as struggle, as tragedy—these are examples of the formal fiction I create.

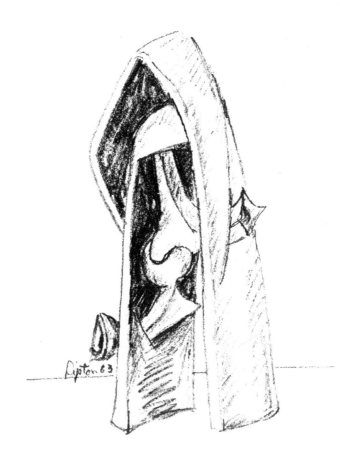

14. *Untitled drawing. 1961*

15. *Untitled drawing. 1963*

34

The idea of sharply defined lines, planes, and forms, as opposed to amorphous or naturalistic organic forms. This stylization sets up an esoteric opposition to suggestions of natural forms from perceptual experience, thus intensifying the tensional opposition between form and content. The forms are not contrary to or in isolation from content but bound in opposition and therefore paradoxically in union with sources of derivation and unconscious spontaneous reference.

The attitude of complexity within a sense of economy.

Since the war the conceptual models Lipton has evolved to interpret reality in his art have dealt with the invisible, mysterious, dualistic inner life of man, nature, and the machine. Giving form to these private models has meant building upon analogy, and since 1945 (*Witches' Sabbath* and other winged exploding forms) he has developed his personal version of the sculptural metaphor that earlier appeared in Brancusi, Duchamp-Villon, Arp, Lipchitz, Moore, and, in the second half of the forties, Smith and Roszak. For Lipton the sculptural metaphor is a set of correspond-

ences that, avoiding direct resemblance, uniquely join together by structure, feeling, or gesture seemingly unrelated entities. Structures of things rather than their intellectual associations generally initiate the idea for a sculpture, and it is the twin demands of intense formal and thematic structure that then generate its evolution:

In the course of its making the image of a work usually crystallizes around a structural metaphor. The structural metaphor is what integrates a work of mine. . . . A flower, a man, a machine, a boat, a sea form, a bird, etc., is the central beginning. This correspondence is not that of direct resemblance so much as a mood or an echo. This beginning occurs . . . in the shape of schematic drawings. . . . I seek to intensify the mood of external and internal symbolic feeling and meaning through rearrangements of the forms by the addition, elimination, and editing of parts not necessary to make a sculptural living entity. . . . My work is the result of an ironic tension between something in nature and technology and something that is the

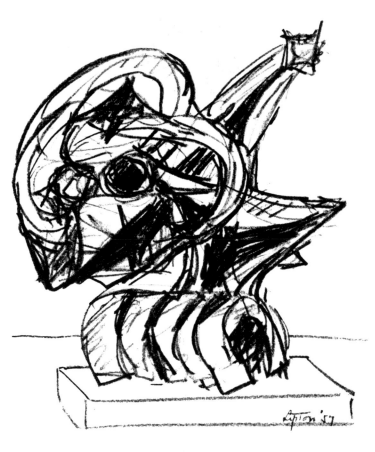

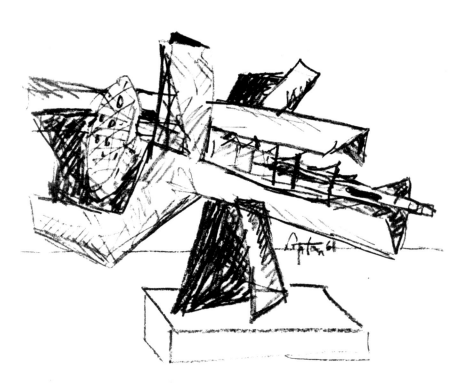

16. *Untitled drawing. 1957*

17. *Untitled drawing. 1961*

form of sculpture as an isolated object. . . . The souls of nature and the machine are married to the body of sculptural form.

Basic to the modern sculptural or painting metaphor is the seemingly absurd conjunction of disparate objects by free association that nourishes the faculty of image formation. The artist, sensitive to the potential expressiveness and suggestiveness of all forms, has at his disposal uncircumscribed aesthetic possibilities to go with what in this century have become limitless means for their realization. Imaginative associative response on the part of both artist and viewer is imperative for the sculptor who would join the inner and outer worlds of experience, feeling that there is somehow an interrelatedness of events in one's private and one's public life. Lipton belongs to the tradition of modern imaginative art that believes in the universal validity of the artist's attentiveness to his subjective state and the transcendent unity of all life.

As used by Lipton in such works as *Earth Force #2,* the sculptural metaphor joins together aspects of seemingly unrelated objects. The objects are transformed and fused together, losing their separate identities. The whole is therefore greater than, and unpredictable on the basis of, its parts. The selection and transformation of the objects is dictated by what the artist refers to as "some general mood of sculptural reality and formal expressiveness." At the work's outset, for example, the sculptor invites a sensitized state of mind, encouraging the free flow of suggestions through drawings. The black crayon drawings, made on uniform-sized white paper, help him to shake loose the seed of an idea. The lines not only seek to capture elusive shapes but graph the directions of forces and the changes and intensification of the conception. The crescent form becomes an interweaving of ideas on many levels, and so ingrained is the artist's dialectical method that he cannot make a shape or a force vector without instantly thinking of its opposite. Thus two or more counter themes may develop in a single sketch. The drawing has its own evolving logic of interrelationships that encode his feelings for expansion, closure, penetration. The emergence of form and meaning must be simultaneous. The sculpture's genesis in the drawings is not, however, exclusively an effluence of impulse. Intuition and intellect fre-

quently operate as a fertile duality in correcting drawings and models. His critical background, sense of his times, and awareness of what he has done before operate in his study of each new work. Art's tradition is both guide and antagonist, "in terms of respect and love of areas of human heritage: yet countered with the will and need for new and valid imagery." In the style of both the drawings and the sculptures we are made aware of the artist's willful imposition of his own lucid formal rhetoric upon the original unarranged, unrelated, other-shaped sources of his inspiration. The durability and exhilarating shock of his art rest upon the generation of a current between an illogic of events and a logic of form.

The meaning of the sculptural metaphor is open-ended, as its sources have had their own meanings or associations interpenetrated. Meaningful ambivalence and ambiguity, the precise evocation of the vague, permits the sculptor to arrive at images that exteriorize his own complex inner life of love, hate and anguish, and peace. The metaphor serves as a stimulant or irritant to the imagination of the viewer. The work will appear differently to different audiences and to the same audience at different times. Lipton regards this life of his sculpture as an eventful and important continuum.

There are risks in the viewing and the interpreting of this type of sculpture. The viewer must be willing to accept the absence of likeness or imitation of appearance, of paraphrasable meaning, of a decorative and soothing aesthetic. For his part, the artist must have faith that through his art the audience will become aware of new areas of beauty and mystery in the world. Lipton tolerates misinterpretation of his intent so long as the sculpture itself is the source of the viewer's conjecture. Aware that his own psychological makeup partakes in what he has described in Freudian terms as the "iceberg character of human personality," the sculptor not only understands and accepts that he cannot recall all his intentions during the creative process and that he cannot fix the limits of meaning, but rejoices in the independent life his art leads as it is confronted by others. "The hidden, the underneath, may thus become an area of communion."

Lipton does not consciously seek to be cryptic: his metaphors are revelations of the hidden, beckoning the viewer into areas of mystery, even into the obscure. Nor does he produce sculpture that has no discernible connection with what it represents. Each sculpture should first be looked at for what it is in terms of its verifiable characteristics. Each sculpture instantaneously betrays —manifesting perpetual strife that serves both form and theme— a clash of contraries. The curved or angular character of the shapes implies their formation by internal and external pressures. Never do they seem to have been passively formed; nor is their union without analogies to organic processes in nature. In numerous works, *Cloak* and *Sea King* among them, conjugate shapes are linked in series, recalling metameric segmentation in zoology and botany—cellular multiplication or the string arrangement of chromosomes, for example—as Meyer Schapiro pointed out to me. Other links with nature are the arris, or sharp edge, formed by the angular juncture of two plane or curved surfaces, and the dactylate motif, in which, as seen in *Gauntlet,* forms radiate outward from a common spine.

When a metameric sequence is employed, it is on a single straight axis of the sculpture, usually seen against one large continuous concave form, such as a hooded or cloaklike shape. These framing or partially containing shapes are not passive with regard to their neighbors, and frequently there is the suggestion of painful piercing of larger by smaller forms.

Continuing from the very first works in wood is the sculptor's emphasis upon self-supporting structures. In recent years sculptures, such as *Altar,* dealing with death tend to have a dominantly horizontal orientation, and the resultant more passive relation of the work to its base has obvious implications. Otherwise the sculptures push off or spring from the base, and pieces such as *Sea King* induce the impression of having their own means of levitation. Resistance to the horizontal achieved by torsion, and asymmetry in the total compositions suggest the sculptural organism's resistance to the idea of death. One reason for the effectiveness of Lipton's diagonal compositions is that gravity and élan, heaven and earth, life and death are in tense equilibrium.

Still another poetic characteristic of the sculptor's imagination is *inversion*. In his art Lipton challenges our notion of the familiar and unfamiliar and will see inside where we see outside. Things begin for him where they end for others: he feels pressure where we accept passivity, pain in what seems insensate. Where there appears separation he senses unity, and conventional categories dissolve so that the mechanical and the organic interchange. He animates and discloses secrets of soil and sea *(Earth Loom* and *Reef Queen),* cell and sepulcher *(Ring* and *Séance).* The fixed forms of a metal fan, Chinese bronze bell, and pagoda meet with mutations

in *Earth Bell* and *Pacific Bird*. The Oriental pagoda, which derived from the royal parasol of India, is an old precedent for such transformation. Lipton may invert the microcosmic and the macrocosmic, scaling large the bifurcating cell of *Ring,* compressing in *Gateway* what could have served as an ancient mythical entrance to the universe.

Linked to the foregoing traits is the sculptor's capacity for *imaginative displacement,* whereby he enters the machine and the book, the cells of life and of imprisonment, the tomb and the womb. In *Gateway* we are made to feel as well as to see a crescent orb twisting in its parental socket. His open form is both a stylistic and a thematic imperative, for only in this way can the continuum of the sculpture's external and internal life be manifested.

Lipton's sculpture is, like his titles, at its best when it has a virile compactness. The basic configurations of each sculpture are largely pre-imagined in the artist's mind, and subsequent modifications reinforce its capacity to be carried away in the beholder's thought. Though ample and permissive of growth, his formal vocabulary in each work is restricted, to heighten the ambivalence of every element. Each new context keys the implications of shapes, pointed, shell, cell, or box; repetition and conjugation of shapes impart movement, and their cadence sets the meter of meaning, as in *Pacific Bird* and *Séance*. When we see compositions having the effect of great compression, or of explosive extension that tears the sculpture's center, we have begun the act of interpretation—even before reading such titles as *Labyrinth, Rider, Empty Room*. The solid monolithic form is inconceivable to a man for whom life's power is indomitable, to an artist who sees space as resulting only from unbridled forces that stab, slash, tear, rip, batter, thrust, and erupt. Comparable in logic are the scarified surfaces that evidence the action and that are lightened or darkened according to the mood or character of the finished work as it impresses itself upon the artist. The over-all texture of this brazed skin, preferred to the smooth prefabricated metal, is consonant with the imagistic nature of Lipton's art, for it preserves the vividness and memorability of the large configuration. Brazed is preferred to raw metal, for brazing helps to give the sculpture a second poetic existence, to bring the metal to life and overcome its passive-object character:

The surface is left rough in the sense that Rodin in his last works self-consciously sought the truth in crude natural finishes in bronze. Like Rodin, I avoid the smooth, polished surface. To say that my surfaces are lovely, ugly, or gilding the lily, or gratuitous is to miss the point. The surfaces belong to the work and to my attitude in sculpture. I want a surface that is homogeneous, neutral, unmachinelike and that as a sensuous experience will not operate against the three-dimensional formal experience that is most basic in sculpture. The rough physical surface gives actual structural strength but also has suggested overtones of the irregularities of nature that so concern me.

DESPITE OBVIOUS STYLE AND THEMATIC CHANGES, there are many strong constants to Lipton's art and thought. While he likes to work on various groups of works, or series, revolving around a certain formal and thematic idea, what unifies all his sculptures is a feeling that they are "celebrations of life: its irony, absurdity, and tragedy . . . living the excitement of man . . . a celebration of what is possible within the span of life." For this reason he admires the work of Miró and Dubuffet. Since 1951 Lipton has developed several such groups, including the Bloom, Hero, and Codex series. The artist gives us his own central perspective on what unites these disparate groups:

Basically "man" concerns me in all the various things I make. I find "inner spaces" of man in things outside himself; in the sea, under the earth, in animals, machines, etc. . . . When I made *Sanctuary,* for example, I felt among other things a sense of guarding hidden secrets, probably painful ones. We guard these personal things by letting other experiences develop. The work as a whole suggests a flower. Yet botanical nature was of secondary concern. Man was primary. This is true for me in such an apparently remote thing from man as *Earth Loom*. For me this work involves the forces of energy, of potential, of the subconscious, operating and weaving patterns of experience that may later become overt and conscious. This is true throughout nature, but most directly I feel its application to man even though the work suggests a botanical machine form. Whether or not I use the gesture of man, or forms other than man, all the works in a fundamental way concern human life— are an expression of what I feel about myself and others. This can happen because of the interrelatedness of all biological nature and broad laws applicable to all life.

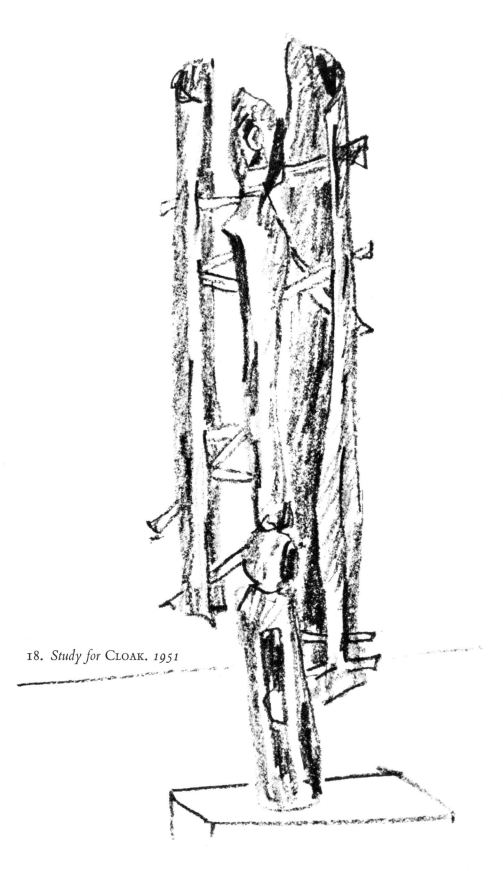

18. *Study for* CLOAK. *1951*

Nowhere is this statement more relevant than to Lipton's first major work in brazed steel, *Cloak,* which is severally seminal to what he has done since 1951. Confrontation with *Cloak* imposes on the beholder the sense of an awesome, elusive presence. Initially it may suggest a figure that is shielded in mystery yet torn within. There is a curious ambivalence in the sculpture's obvious symmetrical and rigid frontality and the multiple irregularities forcefully introduced to achieve this posture. *Cloak*'s painful dualism takes in rigidity and movement, inertia and change. Metaphorically it conveys the artist's concern with "the dark, evil inside of things . . . forces that grow from within." Unlike the apparent, even literal, menace of the works in the Moloch and Moby Dick series, *Cloak* derives its fearsome aspect in part from what is implicit. This totemic image may also be looked upon as having a flowering inner life, and on a second level may be a metaphor of organic evolution. It is possible that Lipton discovered, as a result of his earlier work with the partial figure, that when parts of the human form are reduced to a certain point, they become interchangeable with other forms of life as well as with objects, and the reverse. *Cloak* is a reminder of how scant a vestige of human attributes such as verticality is required in sculpture to call the presence of the human form to mind, and of how the artist is thus able poetically to confirm in sculpture his belief in the "interrelatedness of all biological nature." *Cloak* may be read as a sculptural statement of what it means to come alive, to resist confinement—of how living things can wound and reheal themselves.

Just as the Egyptians used the papyrus column as a cultural symbol of the regenerative forces of nature, so in this century Lipton—and, earlier, Arp and Lipchitz—has sought to find a personal ideogram for the idea of growth. By contrast with Arp's, Lipton's view of growth is not that of tranquil, unblocked pressure, nor can Lipton resort to the more obvious device of near-feminine personification that Lipchitz used in *Blossoming*. The prongs that penetrate and rip in *Cloak* give a disquieting edge to creative force, and the pierced pods may have derived subconsciously from thoughts of "painful barbs breaking through protective armor."

To Lipton's interest in "biological man," *Cloak* bears witness. Nothing that happens in this sculpture continues the tradition of Classical Greece and the Renaissance that celebrates the mind-body relationship through external appearances or the culture of

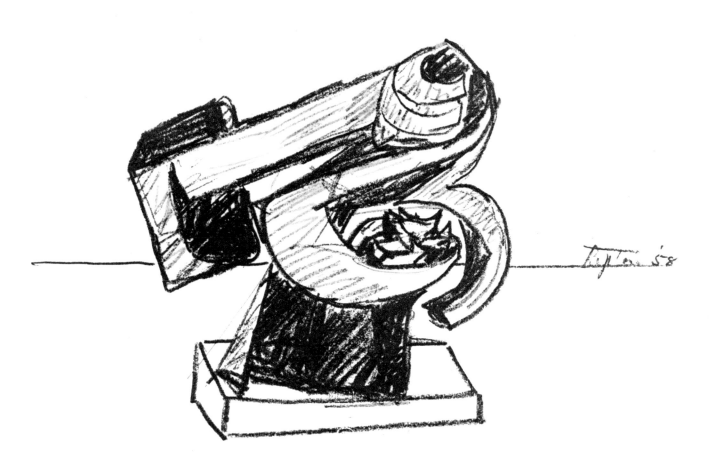

19. *Study for* EARTH LOOM. *1958*

gestures and facial expression. Where these past civilizations emphatically proclaimed the superiority of man over nature and championed the glories of the human body, Lipton's conception belongs as much to the philosophical and scientific thinking of this century as does his use of welded and brazed steel. All his work is, by its conception and making, testimony to the achievement of the mind as well as the hand. Modern art has frequently departed from showing us what makes a being appear human in the fullest sense, and in our time humanism can also be found in what the human makes. The aesthetic rightness of *Cloak* results from astute judgments about proportion, surface qualities, spacing and counterweighting of shapes and tensions.

Lipton feels that in important art the viewer is not always aware of the medium. He cannot take a formalist's delight in astounding us with amazing displays of welding. Yet privately, as the seed of an idea roots in his consciousness, the medium's potential and the conception cross-fertilize each other. Brazed steel helped further to liberate his imagination at the turn of the 1950s. Its viability encourages fresh metaphors of essentially the same basic themes. This is repeatedly illustrable by the theme of germination during and since the fifties; two of its most potent metaphors date from

1955 *(Earth Forge #2)* and 1959 *(Earth Loom)*. Of the first of these Lipton wrote in his notes: "It is a new consciousness of the wonder of the regenerative processes in nature, yet seen through and incorporated in its polar opposite, science and technology. This work suggests a nostalgia for nature in a frame of technological vision. What results plastically is neither, but something new, consistent with the will and courage deriving from a new and tragic cultural situation. It is a new metaphysics for man. We cannot return to virgin nature, nor allow destruction by the machine. Somewhere in this polar tension lies the plastic solution for sculpture as I see it."

In the actual sculpture was sought the effect of a simple horizontal enclosure enveloping a mechanical, screwlike core. In the back of Lipton's mind as the work evolved was the idea about the hidden areas in the earth where life is sown, the bud still contained within the soil, with the as yet unfulfilled promise of opening. Unlike *Cloak,* with its serial alignment and shaping, *Earth Forge #2* is a single open cell resulting from irresistible generation. Its form is a model of concision; along with so many other of his sculptures, it reminds us that if we take as our index a high quotient of power over means, Lipton's sculpture can be elegant. What

gives his work a unique intensity—separating his style from that of Roszak, for example—is that frequently his forms, as in *Earth Forge #2,* are both centripetal and centrifugal, evoluting and involuting to achieve what he refers to as formal "economy" but also intensifying the composition's cross pulls.

When Lipton has achieved a successful composition for a metaphor, he may often entirely rework its structure, as was the case with *Earth Loom,* done four years after *Earth Forge #2.* The presentation of an "organic machine" is more explicit here, for interwoven in the sculpture's structure are suggestions of a fan belt, a revolving gear, a flower. In general terms, what was sought was something rounded yet boxlike—self-contained and suggesting "internality." *Earth Loom* could just as well be called *Earth Womb.* For the artist the title conveys the idea of something born in the cosmos. The reworking was also caused in part by a desire for greater dramatic excitement, which was realized by the use of flat sheets against curved forms, horizontal as opposed to obliquely crossed movements. Lipton wanted the effect of a "rip tide." While respecting, as he put it, "Brancusi's involvement in the world," he felt the "quietist" imagery of that artist to be alien not only to his own preference for the activist or dynamic but to Western art and thought in general. Where Brancusi's art is a refuge from the world's violence, Lipton's art makes violence one of its principal subjects; only by this exposure, he feels, can peace of mind through understanding existence be achieved.

All during the fifties the Bloom series mingled with works based on the theme of germination. In his apartment studio Lipton cultivated a fantastic sculptural garden with roots in the tropics, the sea, the desert, and the city parks of New York. His growths are hybrid issues from an imagination fertilized by such sources as childhood memories of local parks, the Museum of Natural History, the New York Botanical Gardens in Bronx Park, and the *National Geographic Magazine.* Individually the Blooms belong to no single phylum: not sought were mimicry of appearance, ideated images, or an essence of nature. They are botanically inspired fantasies, variations on the artist's idiomatic commentary on life's unity. The Blooms are hopeful subjects for the most part, perhaps in private atonement for earlier pessimistic images of destruction. As an instance, the Moby Dick tusk gives way to soft evolutions of nascence. With the exception of Calder, no previous sculptor can be said to have undertaken so extensive an exploration of floral possibilities for sculpture, or made his discoveries so central to the most important phase of his art, as Lipton.

The ductility of thin sheet metal and Monel metal encouraged the pliant character of such works as *Sea Gnome, Jungle Bloom,* and *Sanctuary.* The popular conception that steel must be used in rigid forms to take fullest advantage of its properties is belied by its isotropic makeup—as well as by the working experience of Lipton, who found it susceptible of use, in ways unprecedented in older sculpture, as thin surfaces having complex curvatures and spatial interaction. In the context of his remark about finding "'inner spaces' of man in things outside himself," works like *Sea Gnome* and *Sanctuary* in the Bloom series assume added dimensions of reference. The pulse of visual attention to the various aspects of each sculpture is activated by the tension between interior and exterior. From the structures of plant life came sculptural ideas about containment, stance, the rhythm of folding and unfolding, repetition or multiplication, and response to environment. Lipton's flora pass through multiform stages, both in the sense of imagined changing growth and in the way they live by interpretation.

Sea Bloom induces recollections of undersea plants and creatures but also vaguely refers to internal human anatomy. *Sanctuary* and *Sea Gnome* secretively cradle mysterious shapes. The opening in *Carnivorous Flower,* which also resembles a head, gives no clue to its interior but imparts a somewhat ominous feeling. *Dragon Bloom* has a heraldic quality, embracing references to helmets and to prehistoric vertebrae. The life gesture of *Desert Briar* is an aggressive, angular stance, defying death. The most complexly splendid in the series are *Chrysalis* and *Diadem.* The former, like *Desert Briar,* has a serrated proliferation which focuses upon a gaping orifice. *Diadem* is explosive, an ecstatic radiant burst, like a final flowering, or perhaps it is a metaphor of an eclipse. Just as there is a variety of floral types, so the modes of Lipton's style vary, ranging from an almost Rococo proliferation to an austere and nearly brittle crispness. The two most elegant pieces (as elegance was defined earlier) are *Dragon Bloom* and the completely unpretentious *Sundial.* Despite the latter's small size, it shines as one of the artist's finest works. In no other sculpture of his are the spatial intervals so strongly felt as decided shapes, almost interchangeable with the metal forms that frame them. Implicit in the outline of the whole is a squarishness that contributes to the com-

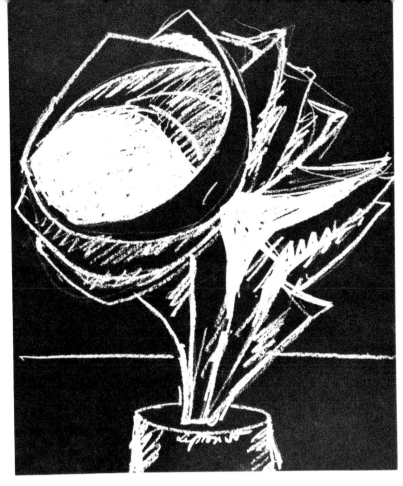

20. *Study for* DESERT BRIAR. *1955*

pactness and intensity of the design. Deceptively simple, the four basic parts relate and differ in such subtle ways as to compel repeated re-reading.

Earth Forge #1, Night Hunter, and *Thorn* have a toughness and knotlike structure that separates them from the rest of the Bloom series. Their tortured self-involvement recalls the Moby Dick series, adding to their painful connotations. Lipton has referred in his notes to the act of creation as demanding the cutting of the artist's personal Gordian knot, and such sculptures as *Thorn* may indeed be private metaphors for his own creative anguish.

The sculptures that best exemplify the internal continuity and self-transformation of Lipton's style are those which might be grouped as "propulsive images." These sculptures are united in their common possession of a driving, usually upward, diagonal as a compositional and thematic fulcrum. The titles give the span of the artist's associations: *Dark Chamber, Thunderbird, Storm Bird, Jungle Bloom #2, Viking, Seafarer, Avenger, Crucible, Mandrake.*

The sculptor thinks of *Dark Chamber,* which dates from 1949, as his "first oblique, interior-exterior propulsive image, violent yet contained." Yet forceful obliquity drives *Swing Low* and *Night Rider* (a slate horse and rider of 1945), and his first *Mortal Cage,* of 1946, has interior-exterior relationships. The diagonal core varies from a discontinuous but general alignment of shapes to a raveled spiral, to a ramrod, piston, or arrow shaft. These inner drills impart connotations of warlike, aggressive thrust, sexual penetration, and the force to spring life from its confinement. *Storm Bird* hatched from plural sources. The artist saw a photograph from the *New York Times Magazine* lying inverted across the room. A quick impression of it was sketched before its identity as a spiral staircase was recognized. The new image was inseminated by meditations on the wings and flight of dragonflies and on the destructive potential of the airplane. This welter of references was willfully, but not programmatically, synthesized into a fresh image that suggested an ominous spiraling-upward charge.

Viking is an important work in that it was the sculptor's first departure from convoluted forms. It came from the felt need for oppositions to roundness—hence the new use of sheetlike shapes, possibly suggested by sails or leaves. Along with the new angular shape with its "vulgar irregularity" came the device of explosive opening, which was to lead to *Manuscript* (whose title came after the form was finished), and Lipton's recollection of the "early violence of Viking sailings, adventure, excitement, and thrust into the unknown."

The "propulsive image" series is open-ended and has more variants than are here cited; since 1960 we have in sculptures such as *Earth Bell* still another life given to this persistent configuration lodged in the web of the sculptor's consciousness.

In 1953 Lipton was asked by the architect Percival Goodman to design and execute three religious sculptures for Temple Israel in Tulsa, Oklahoma: *Menorah, Eternal Light,* and *Fruitful Vine.* The menorah, the Old Testament seven-branched candlestick, symbol of the tree of life, was a subject that coincided with the artist's botanical interests of this period, and the commission enabled him to extend, rather than change, his thinking and problem solving. With the tree of life concept the sculptor associated unlyrical qualities of strength and force. His work was intended to suggest

21. ARGONAUT I. *1961. Nickel-silver on Monel metal, length 109″. IBM Watson Research Center, Yorktown Heights, New York*

an evolving process of struggle and growth that culminated in the buds which are the terminals of the seven branches, and which to the artist implied hopefulness. The base of *Menorah* augurs that of *Earth Forge #2* and *Pioneer*. *Eternal Light,* with its suggestion of angels interlocking wings, was motivated by the Book of Genesis. Both *Menorah* and *Eternal Light* permitted the sculptor to continue work begun previously in sharp angular forms with mysterious interior space. The pointed gesture of the latter sculpture coincides with that of the six-pointed stars (Shields of David) seen in the window behind and above the ark; thus the expressive qualities of this most important Hebraic symbol are linked with those instinctively arrived at by Lipton. *Fruitful Vine,* suspended horizontally over the tabernacle, expands laterally in rugged movements echoing those of the earlier *Exodus #1* but with more overt botanical references.

Somewhat related formally to *Fruitful Vine* is the wall-suspended *Menorah* on the exterior of Temple Beth El in Gary, Indiana, in which vine and candelabrum shapes fuse in a knotted configuration. While recognizing that he was designing religious objects, the sculptor looked upon these works as the solving of problems that were independent of religious implications. The celebration of the human spirit had been his objective since the first sculptures. Like many artists of the last one hundred years, Lipton had transferred to mankind those feelings of mystery and reverence that in the great religious art of the past had been consigned to Christ and the saints. Further, the emotion which these objects were capable of inspiring cannot be sharply distinguished from that inspired by his best purely secular works done before and after the synagogue commissions. It has always been his hope that his work would be looked upon or communed with in the

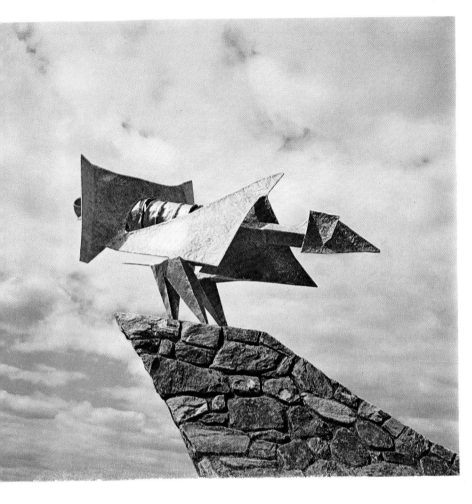
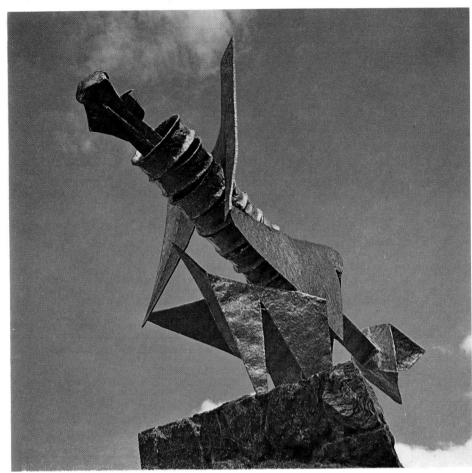

22. ARGONAUT II. *1961. Nickel-silver on Monel metal, length 109". IBM Watson Research Center, Yorktown Heights, New York*

same intense fashion that people in bygone eras meditated upon religious objects in church and temple.

While working on the synagogue sculpture, in fact all his commissions from architects, the sculptor was never moved to alter his basic style in order to approach more clearly that of the building within or against which his art would be seen. Sculpture he regards as an autonomous art, and the sculptor, he believes, should insist upon just those unique properties that separate the two mediums. The integrity and force of Lipton's work were given recognition by the late Eero Saarinen in the commission for two large sculptures, *Argonaut I* and *Argonaut II,* to be placed on specially designed fieldstone ramps in front of the IBM Watson Research Center in Yorktown Heights, New York. Neither sculptor nor architect made any concession to accommodate the style of the other. The impressive effect of the conjunction of

building and sculpture comes from their basic contrast. Lipton created thrusting shapes that connote aggressive exploration into the unknown and the adventure of discovery. Against the severely formal, mechanical public façade, the sculpture serves as a reminder of the private creative resources, the handmade, of which individuals are still capable.

The handsome model of *Winter Solstice* represents a commission (1956) that, for reasons beyond the sculptor's control, was never consummated. The work was originally planned as an outdoor environmental sculpture, 16 feet high and 20 feet wide, for the campus of the Massachusetts Institute of Technology. The sculpture was to have been an autonomous project, independent of any architectural armature. It was to have served as an individual "sanctuary," in which a person, having entered through the base and mounted the stairway, could, within the birdlike form, give

himself up to meditation. Responding to the curving space of the sculpture's interior, or viewing the world through its intriguing framing planes, he could feel himself part of the work.

Twin imperatives in Lipton's thought are that sculpture must in a meaningful way deal with man, but that it must not deal with man solely in terms of the external appearance of the human body. In a panel discussion held at Woodstock, New York, in 1955, he made the following comments:

> The human body is still central. Philosophically, emotionally, man is concerned with the world in terms of himself. The body remains man's egoistic concern.
>
> The twentieth-century revolution in various disciplines—physics, psychology, anthropology, to name a few—has brought about a situation in which anatomical man as such is too limiting a means to express the complexities of contemporary life and sensibility.
>
> Western art has brought us to a point of no return in rendering the figure. A new plastic language invented by the Cubists, Dadaists, and Surrealists stems from new areas of intellectual and emotional experience and consciousness in this century. These ideas were explored first in painting and then in sculpture in terms of *interior anatomy*. Dealing with interior anatomy—or in my case the life below anatomy—offers the possibility of presenting a harsh, existentialist mystery and life of man. The human body and gesture can still serve as a kind of frame in and around which the life of man can be presented in an imaginative plastic language, and one that is most deeply real to a contemporary point of view. I don't want, for example, to make sculpture as Aeschylus or Nietzsche would have seen it. Their philosophies and art are ancestors. I seek the meaning of the interior life of man, but not exclusively as it is related to his external appearance. My work is based on new interpretations of physiology. . . . Social and philosophical man interest me . . . but for many reasons I believe that physiology or human functioning is more basic in determining behavior, especially in art. I've come to believe, not cynically, but realistically, that biological forces are ultimately in the driver's seat. Most everything else is pleasant rationalization.
>
> Human ideals, struggles, dreams . . . can find symbolic transformation in non-anatomical forms that include man's life in particular and in general. . . . Man and his destiny do not lose stature through the recognition that he is a single element among millions in a world that is not anthropocentric. In this recognition I believe man gains in strength, dignity, humility, and understanding. This is a broader view of humanism, a wider view of man and reality. It invites his democratic right of excursion into these worlds of new experience. There is a growing consciousness of organic interdependence of man and nature. . . . In a sense, this is the revolution in art of our time. It is the reorientation of man in a world of relativity, of organic process, of evolution and cosmic mystery.

About the time in the mid-1950s that Lipton began thinking about and making the Hero series, he was also reading Joseph Campbell's *The Hero with a Thousand Faces*. Campbell not only articulated the sculptor's own beliefs that the essential mystery today lies in man himself, but also presented the challenging problem facing the artist who would seek to extend into modern times the traditional artist's role of imaging the heroic:

> The problem of mankind today . . . is precisely the opposite to that of men in the comparatively stable periods of those great co-ordinating mythologies which now are known as lies. Then all meaning was in the group, in the great anonymous forms, none in the self-expressive individual; today no meaning is in the group—none in the world: all is in the individual. But there the meaning is absolutely unconscious. One does not know toward what one moves. One does not know by what one is propelled. The lines of communication between the conscious and the unconscious zones of the human psyche have all been cut, and we have been split in two.
>
> The hero-deed to be wrought is not today what it was in the century of Galileo. Where then there was darkness, now there is light; but also, where light was, there now is darkness. The modern hero-deed must be that of questing to bring to light again the lost Atlantis of the co-ordinated soul.
>
> Obviously, this work cannot be wrought by turning back, or away, from what has been accomplished by the modern revolution; for the problem is nothing if not that of . . . making it possible for men and women to come to full human maturity through the conditions of contemporary life. . . .

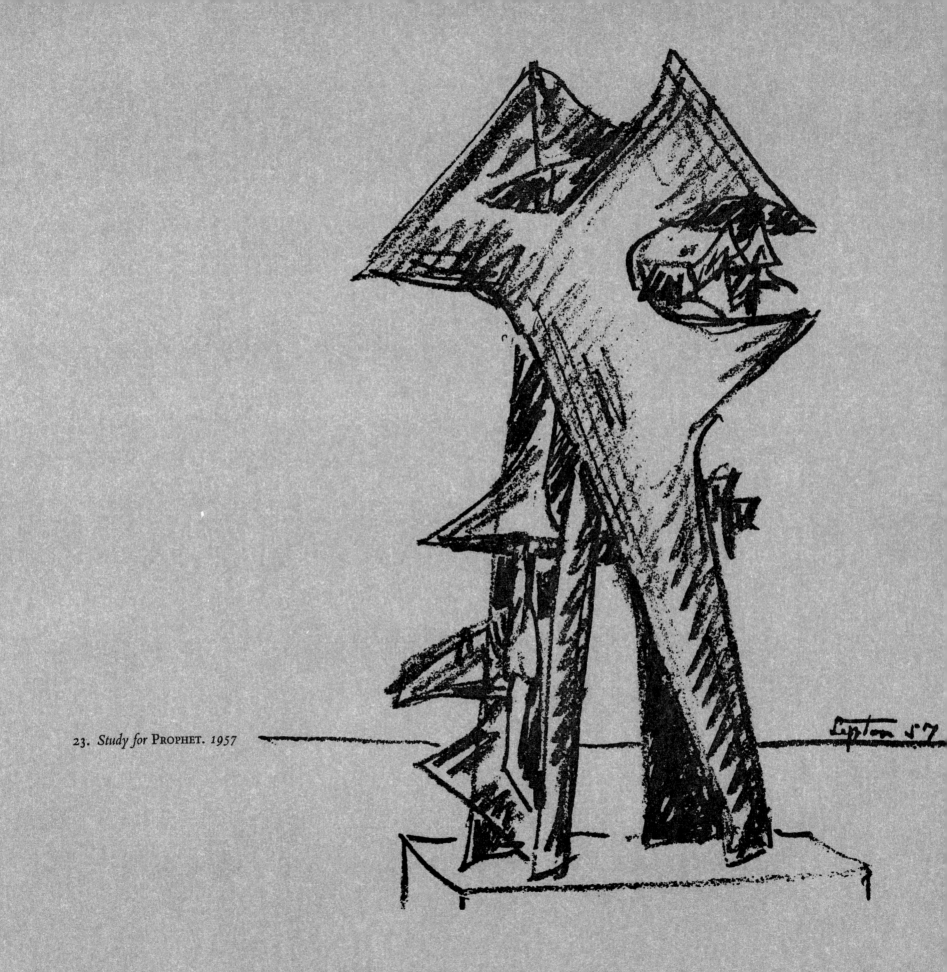

23. *Study for* PROPHET. *1957*

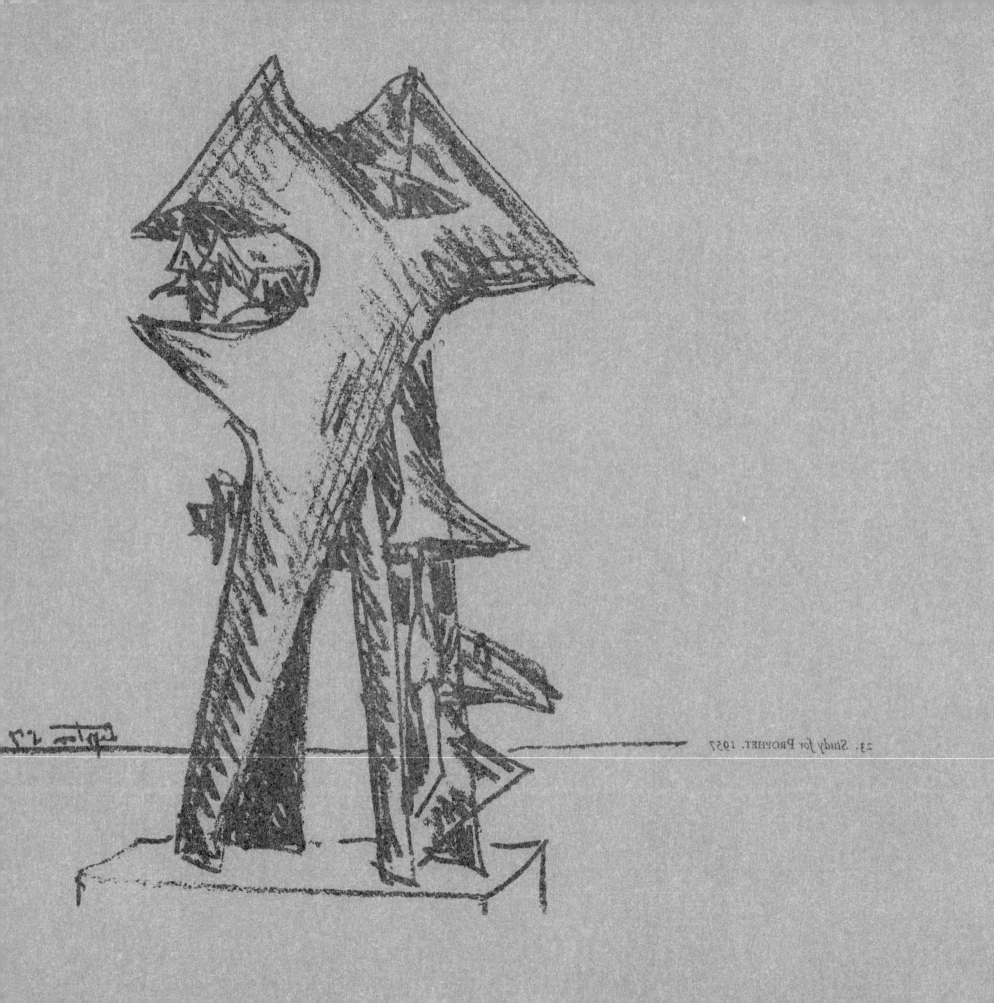

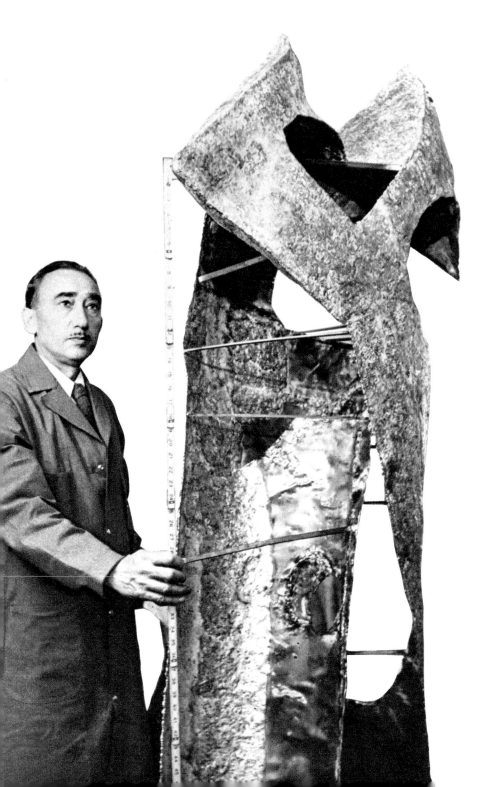

24. *Lipton at work on* PROPHET

And this is not a work that consciousness itself can achieve. Consciousness can no more invent, or even predict, an effective symbol than foretell or control tonight's dream. . . .

But there is one thing we may know, namely, that as the new symbols become visible, they will not be identical in the various parts of the globe; the circumstances of local life, race, and tradition must all be compounded in the effective forms. Therefore it is necessary for men to understand, and be able to see, that through various symbols the same redemption is revealed. . . . A single song is being inflected through all the colorations of the human choir.

Read consecutively, the foregoing statements complement each other, with Lipton extending Campbell's observations into the immediate problems of sculpture. Lipton does not naively expect all of society to accept his symbols. Today an artist's statement may be rejected out of distaste for the aesthetic form in which it is expressed, or its style may be admired and the implications of the theme rejected. In our time no artist, no matter how great, will achieve for his sculpture the communal, unified response enjoyed by Phidias, Michelangelo, or the carver of the central tympanum of the Royal Portal of Chartres. But today the sculptor, in his lifetime, has potentially an even greater and more international audience, and thus has contact with numbers of men and women undreamed of in the past. Most important, however, is it that the sculptor make his work primarily for himself, thereby to fulfill his own humanity. From the foundation of his own perspective and feelings, Lipton is hopeful that he will reach others. His themes, which Sam Hunter has aptly called "some of the great commonplaces of human and natural existence," are universally experienced. What Lipton equates with "heroic" is not the traditional overcoming of external obstacles by physical feats: his hero images are ahistorical. He sees a timeless undercurrent, its beginnings in the remote past, and still running strong, which he speaks of as "some kind of hidden drive, search, and anxiety in Everyman through which it is possible to transcend our human condition. . . .

"The life cycle in man, the season cycle, are basic archetype myths in the Hero and the Blooms. . . . The images of my work emerge from forms in life and in technology consistent with my belief in an unhistorical biology together with an awareness of historically changing art traditions. I celebrate the life, tragedy,

and transfiguration of contemporary society with images belonging to this time."

Bearing out what Campbell had prophetically written, Lipton's method in the series was not consciously programed, nor were his symbols rationally thought out in advance. The series continued as long as some undefinable compulsion demanded. Neither its beginning nor its interruption were clearly predicted in the artist's mind. He remembers that after the making of certain zoologically and botanically suggestive forms, such as *Sea King,* in 1955, the vertical human configuration was indirectly decided upon. From engagement with his own sculptural form he sensed the emergence of a certain drama and expressiveness that seemed right for the reappearance of the more explicitly human in his art.

The idea of portraying a prophet did not consciously precede the sculpture of that title. The motivation was to make "a self-confident, challenging human being." The finished, purposive, hermitic figure baptized itself. *Prophet* of 1959 continues the lineage of the *Winged Victory,* the *Isaiah* at Souillac, Rodin's *John the Baptist* and *Walking Man,* and their offspring, Boccioni's *Unique Forms of Continuity in Space.* The last two differ from *Prophet* by their emphatic physical energy but anticipate its stress on bodily functioning as well as its employment of the partial figure. Boccioni's figure violently but physically interacts with space, and this exchange is manifested on the body's exterior. Lipton's imagery, while poetically opening up the body, or inverting focus to the invisible from the visible or to the interior from the exterior relationships of the body, has an important historical precedent in another work by the Italian artist, the *Development of a Bottle in Space.* Lipton's great contribution lies in part in his evolution of a new physiological form of sculptural movement, which in *Prophet* is seen in the crossed vectors that no longer depend directly or implicitly (as did Boccioni's figures) upon muscles and skeletal joints. The object that seems analogous to *Prophet* in this respect, and that subconsciously may have influenced Lipton, is the tin- or metal-cutting shears so often in his hand. *Prophet* moves away from the petrified or semaphoric movement so prevalent in the 1950s among other sculptors.

Rodin's talk and writing were filled with comparisons between the human body and inanimate nature. As a result of developments in modern sculpture that began even while Rodin was alive, such as Duchamp-Villon's *The Horse,* it has been possible for Lipton and other sculptors actually to assimilate nonhuman references into the body. In the case of *Prophet,* while presumably this was not done consciously, it may be that by instinct Lipton wanted to portray a figure such as John the Baptist, and the germinal idea of using tin shears or hooked vectors may have subconsciously fused with the shape of the shepherd's crook, which in older art was an attribute of John the Baptist. Thus the poetry of *Prophet* was perhaps shaped by John's own symbol; or, to the extent that this is partly a self-portrait, it is the artist re-formed by one of his own metal-shaping tools. There are other object references in this sculpture, such as the helmet form that cradles a "flowering head," maybe an echo of the earlier *Portrait of a Poet.* The view inside the head, with its pointed-shaped space, reminded its maker of Gothic vaulting. While working, the artist was aware of religious and militant associations of the Gothic. The posterior spinal column's rhythmic shapes came from Lipton's own previous floral and heraldic conceptions. *Prophet*'s phallic spiral serves both to fuse and to drive the vectored form, giving this figure a suggestive self-sufficiency. One has to go back to Rodin's sculptures to find a comparably complex and intense mood in a single figure. Added to these qualities, *Prophet*'s crescent openings, in which are darkly hooded mystical secrets, and the indefatigable mechanical stride that scissors time and distance give this sculpture unrivaled mantic power.

The most recent sculpture in the Hero series, *Explorer,* is a renewed version of a striding figure "suggesting man's holding a globe, glass ball, an alchemist's stone, and yet with hands extended for help in understanding. The plumed helmet form looks darkly ahead." What may give *Prophet* more excitement and durability by the sculptor's own yardstick is a greater tension between the look of the thing represented and the actual sculpture. The brilliantly conceived curving continuity of the external shell of *Prophet* from top to bottom gives it more "organic" unity and convincing evidence of propulsion.

Sorcerer, done a year before *Prophet,* was an entirely different approach to the vertical figure for the artist. It arose from his practice of creating series of sketches whenever possessed by some arcane formal idea. Even in drawing Lipton has an ingrained resistance to exercises in design:

What I avoid making . . . is a thing, an object. The preparatory drawing must embody a sense of lived experience and be not merely an arrangement of pleasing or exciting or challenging

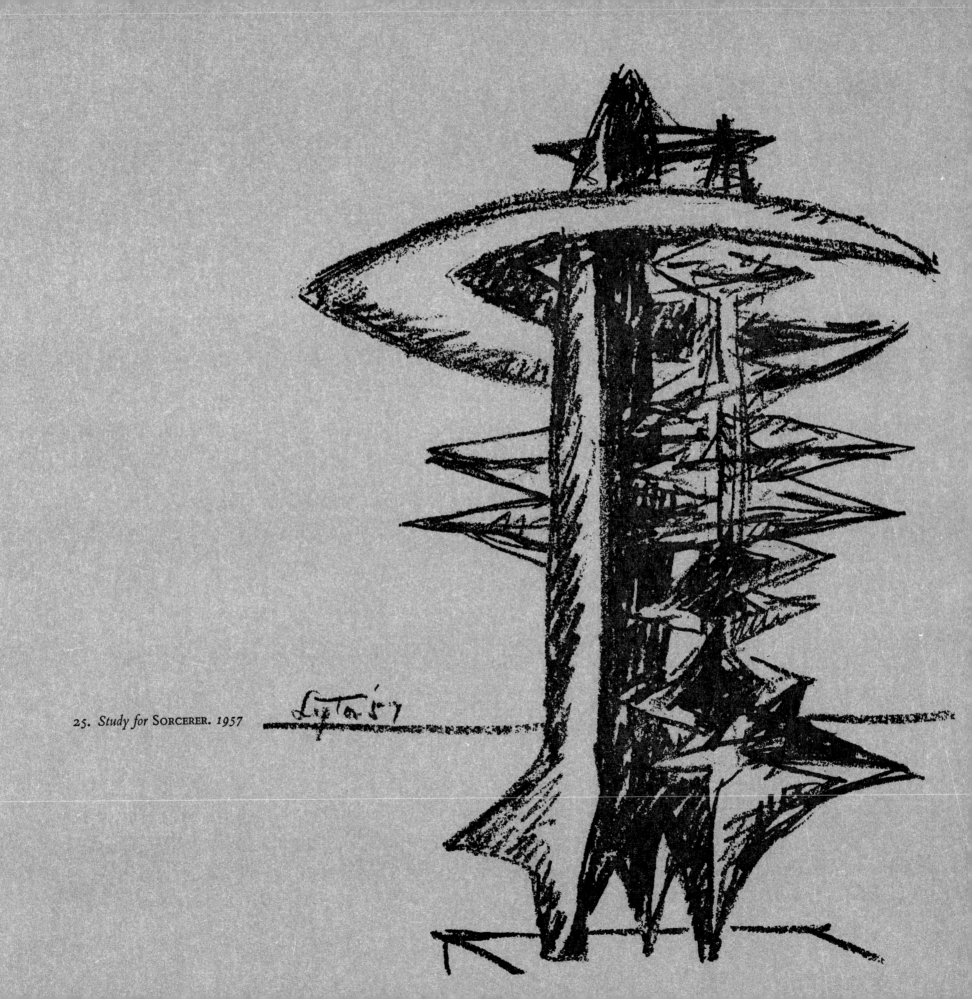

25. *Study for* Sorcerer. *1957*

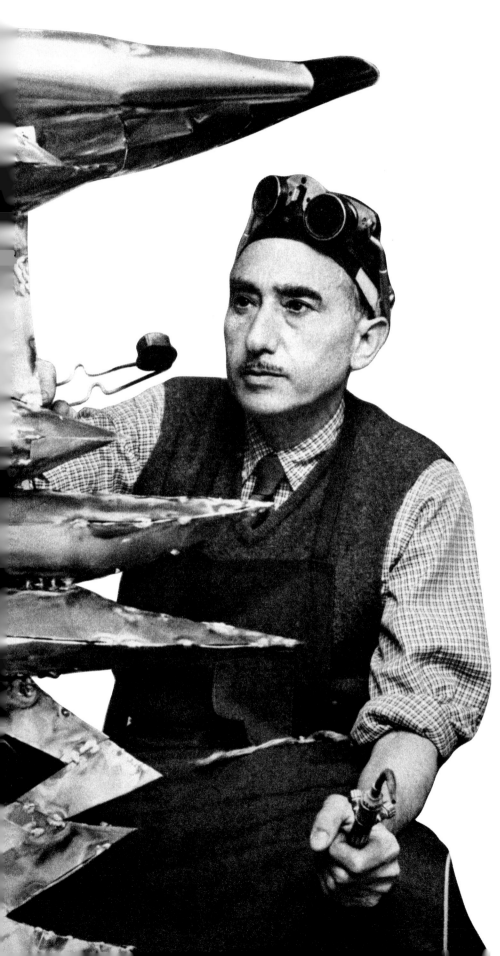

forms. The drawing must suggest a presence, a transmuted existence of its own. All phases of total experience should in some way enter the anatomy of forms to make it pulsate, at least in my eyes. Art is more than visual, it is more than forms derived from conviction. It is visual about something and has conviction about something. Feelings, attitudes, ideas, principles, aspirations, etc., must reside in the forms, otherwise the work that results from the drawings is abortive, or at least delimited (*Art Voices,* Spring 1965, p. 89).

Sorcerer began as "a type of formal play," specifically, a preoccupation with a curving vertical shape cut by several horizontal pointed forms. This linear construction was in turn initiated by an earlier sculpture of striking rhythmic beauty, *Sea King.* Comprised of a number of knife-edged disks encompassed within a long, hollow shell, *Sea King* terminates in what seem like the open jaws of an animal. (Lipton recalls that the Loch Ness monster was in the news at the time.) The entire horizontal form is held in space by an asymmetrically placed U curve, descendent from the supporting elbow of such early wooden sculptures as *Prophet.* In 1956 came the urge to rework the *Sea King* conception vertically. With the new vertical crayon drawings came associations with a personage: "first a feeling of dignity" led to a totemic suggestion that then catalyzed the surrounding elements, such as the curvilinear shape at the top, which in turn took on the meaning of "arms in ritual incantation." The erect stabilizing form became body and head; the sharp disks re-emerging through the back on one level resemble vertebrae. *Sorcerer* stands also as the artist's private metaphor of the yin and yang principle. The Hero aspect of *Sorcerer,* which occurred gradually to the artist during intervals of its working, lies in its expression of "tragic crosscurrents in man."

Working in aggressive hollow-steel forms made it inevitable that Lipton should undertake compositions based upon medieval armor, so richly available to him in New York. *Knight,* of 1957, a deceptively small work (30 inches high), joins in new combination some of the *Sorcerer* and *Prophet* motifs, with the partially sheathed spiral shaft greatly enlarged to assume the dominant dramatic role. Like a fantastic Gothic siege engine (combining reference to battering ram and sapper's tools), it seems protected on one side and vulnerable on the other. Its clean, decisive silhouette and easily readable composition make it possible to picture it

26. *Lipton at work on* SORCERER

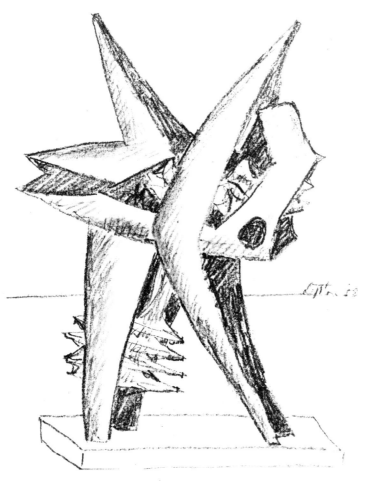

27. *Study for* KNIGHT. *1958*

on a medieval pennant or shield or on the escutcheon of a warlord.

Two years later, in 1959, *Herald* was commissioned by the Reynolds Metals Company for the R. S. Reynolds Memorial Award for Architecture with Aluminum. In commenting on the meaning of *Herald,* Lipton explained the common purpose of this work and the two others based on armor—*Hero* and *Knight*: "This small aluminum casting is called *Herald* because it stresses the forward, striding gesture of a man in announcing new and positive possibilities of his place in the world. Spiritual and material struggle, as suggested in the left frontal lobe-like area, are crowned to the rear and above by a flowering form. Furthermore, this image is part of a varied series dealing with the hero concept in Everyman. Each human being is struggling in some way to encompass and transcend his own limitations. The architectural rendering of the image, I feel, is consonant with the occasion of its making."

Lipton's phrase "architectural rendering" refers to his conscious designing of surfaces to interact with space; we may also apply it to the lucidity by which all areas are fused and efficiently function as a unit. He has used metals not only for their malleability but with great awareness of their tensile properties and the advantages of the high strength–weight ratio so much prized by architects today. As with the best of the architecture utilizing materials such as aluminum, Lipton's designing has not been by substitution, wherein forms that previously appeared in wood or lead are repeated in steel and aluminum; the over-all growth of configurations and component shapes of these figure sculptures ensue from the sculptor's conversion to lightweight metal.

The most spectacular of the Hero series to display this development is the piece of that name. Seven feet in height, *Hero* has the swaggering armored arrogance of a conquistador—the hero militant—the strife-stamped veteran of history's force of arms. Gilgamesh, Hector, Roland, and the Arthurian valiants stiffen its stance, but its references to buckler, greaves, and cuirass also fit the Roman legions, the anonymous, eternally recruited armies of all continents. *Hero* is the steel of human resolve to live despite all danger; we would miss the sculptor's intent by reading this bold, Baroque sculpture as only an *hommage* to the warrior. Who among us that since childhood has revisited the Metropolitan Museum of Art has not been drawn repeatedly to the hall of armor and spun fantasies based on these brilliant empty shells? (David Smith overlooked armor when he wrote of steel having no art history.) *Hero* is the soul of armor, but also the armored soul. Set against examples of armor of the late Middle Ages and the Renaissance, *Hero* displays marvelously imaginative shapes that in many cases synthesize two or more plates from steel armament: greaves and cuisse, pauldron and skull, for example. There are even counterparts to the bevor, the lance rest, and the shield's umbo-boss with spike. It is precisely because literal matching has been avoided, in contrast to motionless museum armor, and because of *Hero*'s mergence, flow, and rhyme of shapes that this contraption breathes, as seen in its greater openness. The excitement of *Hero* comes from our being forced by the sculptor's art to sense its containment of a spiritual presence. Rents and gashes in the metal, countered by a tautly bowed erectness of the trunk, dramatize the soul's imperviousness to mortal wounds.

Adding to the interest of *Hero* is its history as a commission by the Inland Steel Company of Chicago, in whose building it stands today at the end of an office-lined hall. The knight's image was made for a modern captain of industry without the artist's compromising his medium, style, or philosophical outlook—a re-

minder that even so militant an image as *Hero* can serve as a model for the civilized uses to which steel should be put, and that good sculpture can bring architecture to life.

When Lipton takes up an idea from the history of religion on his own initiative, as in the case of *Pioneer,* he, like Chagall and Lipchitz, does not limit himself to the Old Testament. As early as 1943 he carved a *Man of Sorrows* in mahogany; seen against this, *Pioneer,* of 1958, is an eloquent expression of Lipton's artistic transfiguration. The Hero of Christianity is now viewed in a sweeping, nonsectarian, polymorphous view of history, susceptible of imaging by bitter metaphors, just as his death serves as a metaphor for all death and rebirth:

The main cluster of forms suggest for me the upper part of the body of Christ on the Cross in an asymmetric arrangement of twisted pain. I regard this work as a modern Crucifixion and a "Golden Bough" of modern science and life. The *Pioneer* is a work of tragic violence in the sense of agonizing death. But this mood is offset by the hope, the aspiration, of new life. The seed within and the form rising above the twisted forms are in ironic contest with anguish, a basic polarity in the condition of man.

The *Pioneer* evolved from the simple idea of a twisted barbed wire as a symbol of pain, of tragedy. But this idea of a knot had been used as something that interested me previously in *Moloch #2.* Also in the *Pioneer* I wanted a monumental image. I set this twisted form aloft as a trunk of a tree or man. The finished image became a cross of the agony of Christ in a moral religious sense of death and transfiguration. But also on a different level, that is of biologic nature, the work suggests the tree of evolution, of growth, struggle, and higher aspiration and of rebirth.

An important basis of this work is the un-Cubist treatment of squared forms. The squared elongated shape I felt was a development from Cubism without returning to the geometric character of Cubism. This is a breaking away from Cubism in a manner that the *Horse* of Duchamp-Villon did not achieve. These squared forms were suggested to me by the need for masculine strength, restraint, and aesthetic distance implied in Euclidian shapes (forms anti-voluptuous or sensual). But the un-Cubist variation came from squared cactus forms I had seen. The splitting open with scarifying sharpness of the squares at various points is also from botanical nature as seen in the

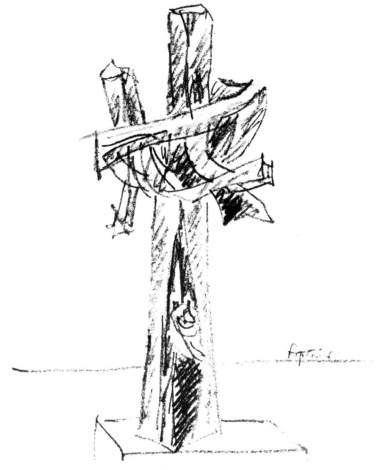

28. *Study for* PIONEER. *1957*

squared seed pods I had seen splitting open. The sharp edges I felt were necessary to carry through the mood of refined pain and refined rebirth (the sense of death and transfiguration).

Dramatically rounding out Lipton's purview of the meaning of being human, although not in the Hero series, is his *Fountainhead,* which originated as a commission from the Sperry Rand Corporation, manufacturer of UNIVAC, for its exhibition "Progress of Computation," held at the Franklin Institute in Philadelphia, beginning in 1958. Impressed by similarities between the function of digital computers and the workings of the human mind, the artist decided to draw upon his anatomical training to make a sculpture of the brain. It seemed logical to him to make a work that "encompassed a kind of flowering of human intellectual possibilities. The convolutions of the human brain are the inner mirror of the human soul as much as the face is its outer mirror. This sculpture is a study of what goes on, what spatially happens inside the head of a man. If what is seen in a face is emotion, sad, happy, or thoughtful, here in the brain is the inside of this mystery. The enigma of the soul still remains; . . . the inside

49

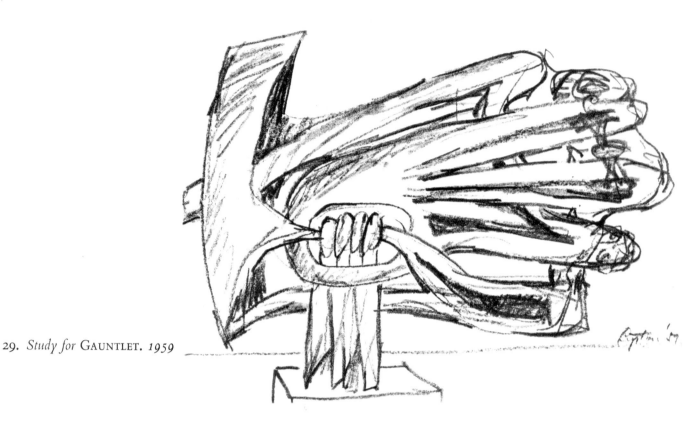

29. *Study for* GAUNTLET. *1959*

anatomy is an interesting subject permitting and suggesting new plastic solutions. I used nervelike forms to interpenetrate the caverns of the mind. Here are antennae of growth, feeling, and perception. Here is the fountainhead for adventure in thought, for searching out the meaning of life and reality" (1962).

In modern painting and sculpture there are numerous examples of artists working out fantasies upon the inner organs associated with sex or reproduction. Such works come to mind as Masson's *Antille,* Miró's *Maternity,* Picasso's *Girl before a Mirror,* Giacometti's *Woman with Her Throat Cut,* and the sculptures of Arp and Noguchi with their visceral and bone connotations. *Fountainhead* is the only work in the history of sculpture to be exclusively concerned with the human brain. It forms a measure of the evolution of modern sculpture to contrast *Fountainhead* with Rodin's *Thinker,* where the tensions of concentrated thought, garbed in a muscular body, are the theme. Unlike Lipton's own *Portrait of a Poet,* with its suggestive, visible nucleus, *Fountainhead* deals with the completely disembodied brain, seen as an autonomous object. Its sculptured forms themselves convey the sense of container and contained. Viewed against the mechanical and repetitive forms of the UNIVAC computers, *Fountainhead*—with its

sensuous and irregular shapes that contrive a growing organism in which what happens is not susceptible of programing or objective analysis—created an ironic contrast. In a visual way *Fountainhead* is an antidote to technology, and on the conceptual level it is inspiring in its affirmation of the ultimate mastery of the human over the mechanical.

Having drawn extensively from the partial figure and contrived a fantasy on the brain, Lipton turned, logically and consistently, in *Gauntlet* to the use of the human hand. The preceding works based on armor enabled him to interpret the hand without encountering the problem of treating flesh, since the medieval gauntlet, itself a metal shell, was consonant with his style and metaphorical thinking. Paradoxically, the traditional protective function of the armored glove is set aside, along with literal references to medieval armor, in favor of enacting a complex drama involving the hand. *Gauntlet* lives enigmatically as a "bird of prey and a rancorous gesture." Its challenge is flung despite the brutal intercourse of the human and the mechanical (the shaft that spits the palm). The violence that occurs within the hand has not caused its severance from the arm, so that thematically and formally the work is self-sufficient, as is the gauntlet when flung down. The

slitted, podlike fingers have obvious ancestry going back to *Cloak* and foretell the phallic, clublike protrusion of *Sower*.

Gauntlet stands in the same relation of transformation to Rodin's *Mighty Hand* as *Fountainhead* to his *Thinker*. It was Rodin's daring in convincing other artists that completeness in art need not depend upon the showing of the entire body that prepared the way for such works as Lipton's *Gauntlet* and Giacometti's *Extended Hand*. Mood, style, and diverse preoccupations with invisible events and external appearance separate these last two sculptures. Giacometti's work results from perceptions of an actual limb, disembodied not by force but by optical focus, which often inhibited him from grasping a complete figure. Giacometti said that he had enough trouble seeing what happened on the outside of a figure to worry about what was going on inside. To reverse this statement for Lipton would be too simple, for he studies external evidences in a variety of life forms as a base for explorations of their interior being. Giacometti comes closer to Rodin in his concern with fidelity to experiences of seeing the human body, and Lipton comes closer in his inquiry into the reactions of the spirit as man is confronted by modern life.

Between 1958 and 1963 there were four additions to the Hero series: *Ancestor, Sentinel* of 1959, *Defender,* and *Explorer*. The first and the third of these, for example, markedly contradict one another in configuration. *Ancestor,* which, Lipton notes, "intrudes into the present through sharp edges and is a faceless figure like an ancestor," inverts the convex shapes of *Hero*. For the artist it also possesses a feeling of "medieval panoply and adventure." It belongs to his many flowering pieces, but the sharp terminations give it a dangerous appearance. The considerable height and generally inverted nature of *Ancestor* impart an aloofness and inscrutability that help us to comprehend the artist's selection of its title. *Defender* seems conjured from a tool for cutting metal apart or pinning it together. It is less elastic in form than *Ancestor*. *Defender*'s movements, as in the elbow-piston shape, appear mechanically angular. Its physical form has an encasing effect, unlike that of the softer, more skeletonized, involuted *Ancestor*.

Both personages are imaginative offspring of Lipton's reflections on how, throughout history, there have been born from men's minds mythical identities by which their creators have sought to come to terms with the unknown, to project themselves into conceptions of the deity or the spirit world, thereby achieving a double expression—of their own ego and of their dread. *Ancestor*

and *Defender* are not personal statements of religious belief, for they are by a sculptor who does not believe in the supernatural. They are his sculptural commentaries on the record of such beliefs and what they tell us about the history of man's irrational and subconscious life and the mysteries of being. One can admire and enjoy Hellenic religion today without being a devotee of Apollo or Dionysus, just as Seymour Lipton can image Christ without being a Christian. *Defender* may symbolize the human protective instinct that takes physical and immaterial shape in all forms of expression. What Lipton is engaged in is enlightened exposure of what in the past, and present, has been shrouded in darkened obscurity, taboo, or superstition, and is considered to be serious but unpleasant. The ugliness of aberrations issuing from the public mind can also have strains of beauty, and the artist would demonstrate that through sculpture the harsh and the lyrical conjoin. Lipton is the first to admit that he has neither the training nor the systematic approach to truth to be a philosopher. His work does not embody philosophy; rather, he has selectively drawn from readings in philosophy, history, and many other fields, insights that buttress what should be called a life view, which he can fully express only in sculpture. This perspective bores into himself and the present, but, like a beacon, pivots into the past to search its darkness. "As an artist I sense my problems and conflicts are the stuff of the cosmos. The only purpose I see for art is that it releases new revelations of the artist as a lonely viewer who adds to the values of society."

Lipton feels that in our age the artist should be aware of tragedy as in the nineteenth century men were obsessed with the idea of progress: "My concern with 'tragedy' is not that I despair but rather that I recognize the reality, as everyone does, of almost insurmountable difficulties in our lives. . . . I am concerned with the trial and the struggle to overcome, to fulfill man's potential with dignity and nobility. My work partakes in some measure in this reality by showing the nature of this trial. Through the life of forms in conflict I hope to present the mood of struggle toward peace, sensuously, lyrically, and dramatically. . . . Pain in life, tragedy in art are the roads toward individual salvation in the chaos of infinity. It is only in the head-on, open-eyed confrontation with pain, death, or tragedy that man, with courage, can transfigure life, make it livable and even in some measure beautiful and noble. . . . All my works, from *Sentinel* of 1959, with its austere confidence in meeting the dark antagonists of the world,

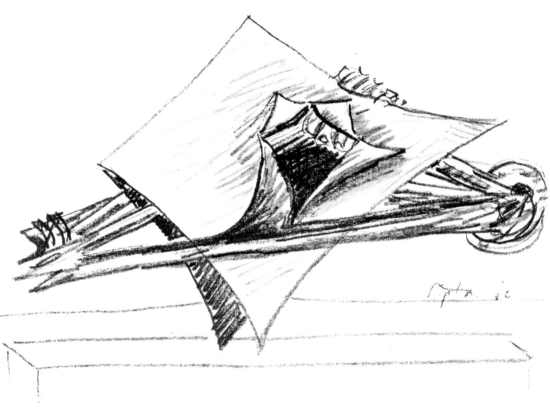

30. *Study for* VIKING. *1956*

to *Empty Room,* with its suggestions of the vital spirit of life triumphant over death, are optimistic."

In searching out "the problems of living," the past is part of Lipton's purview. It has taught him that men need courage to meet the brute facts of existence. Truly creative sculpture must help meet this challenge; violence in sculpture, he feels, should not be just "nervous plasticity," purposeless or done for its own sake, but should have implications relevant to life's meaning.

Flanking the decade of the fifties are *Cloak,* of 1951, and the 1959 *Sentinel,* landmarks of the sculptor's unquiet artistic odyssey. There is a certain familial resemblance between the moods of these two major pieces. *Sentinel* presupposes *Cloak* and all the intervening works, in which Lipton had learned how to achieve the awesome with greater economy, while yet drawing upon broader formal resources. Despite its greater width, for instance, the later work conveys a stronger impression of contraction than the earlier one. Because of the use of fewer and larger architectonic forms *Sentinel* achieves greater compression and total impact than *Cloak.*

Preliminary drawings for the 1959 *Sentinel* gave a rough set to a few vertical interpenetrating forms surmounted by a V-shaped hood, so that from its inception the sculpture resembled a warrior shaped by his own spear. (As with *Prophet,* subconsciously the object attribute became the man.) The artist aimed at a "talismanic presence," a brooding power that betrayed the potential for demonic force. Models following the drawings provided the armature on which to work out force lines, interlocking shapes, and eventually the suggestions of human gesture. The emblematic silhouette of the finished work has some of the "feel" of Chinese calligraphy, so much admired by the artist. *Sentinel* is Lipton's private calligraphic character for the awesome mystery of the inner life, its alternation between calm and wildness contained "within an emotional coat of arms." Fused in the vertical shaft of the configuration are ideas about body, armor, coffin. The battering-ram–bandaged-fist shape and looming visor-battlement-prow apex generate a fugue of push and pull. Where the mood of the earlier *Hero* had been expansive, its mode convex, sensual, thin-surfaced, and bright, this *Sentinel*'s mood is more darkly introverted, owing to a style that now favors constriction, hardening or stiffening, thickness, angular spacings, and the solemnity of dark-toned patina. While there are references to metal shapes, both of these sculptures reveal forms and compositional habits derived from the botanically inspired metaphors.

The *Sentinel* of 1959 is one of Lipton's most inspired pieces. It

did not come as a bolt out of the blue, as his own sculptural history shows; it resulted from an exceptional effort of synthesizing passionate feeling, strong intellectual convictions, and a biting desire to reach new heights of sculptural drama by making a work more richly concise than any that had gone before. Not only is *Sentinel* unsurpassed in American figural sculpture; it ranks with the best works of modern sculpture, indeed in the history of art. It contradicts the dogma, historically recent, that inspiration from sources outside art, or nonsculptural references, inhibit formal excellence and true self-expression. *Sentinel* successfully challenges the pessimism of the dictum that the modern sculptor cannot say something meaningful about mankind without betraying the highest abstract formal demands. By *Sentinel* and many other works Lipton asserts the continued presence, relevance, and achievement of the artist whose learning influences the form and theme of his work.

A testament to Lipton's artistic integrity and inventiveness is his next work, *Manuscript* (Museum of Modern Art, New York), in which he avoids the obvious temptation to use the momentum of *Sentinel* for subsequent themes and variations. The artist's thought and style are, in the present phase of his career, more viable than ever, and rigor has not replaced vigor. Working on drawings, he sensed the need for a new sculptural experience, a fresh visual and emotional shock that would differ from the verticalism and oblique force lines of previous years. Wanted were new dimensions and a new sculptural mood such as could be found through the piercing of large-scale horizontal and flat areas:

Manuscript was an outgrowth of previous works such as *Viking* and *Seafarer*. Both smaller sculptures had major flat forms enclosing other elements. I had long felt the need for developing works of pierced flat areas that were more than frontal. So much work was being done in that ambiguous space between painting and sculpture. My primary preoccupation has always been a world of three-dimensionality. It was only natural to find an image of three-dimensional planal tensions. It was also in the cards for me to work out a sculpture along these lines: my concern with leaflike forms in nature, unfolding sheets of growth and life, a feeling for broad cosmic and historic sweeps as metaphors in terms of books, pages, etc., I believe, influenced me here. Also such things as the Dead Sea scrolls, all had a cumula-

tive effect in bringing out a broad preoccupation with planal, parallel forms in spatial tensions. But these tensions always occur to me as moods of suggestion about the forces of nature, man, and the world.

The life of such forms suggested a family of possibilities of which *Manuscript* was my first major effort. There naturally followed others . . . books, codices, scrolls, all pervaded with openings, cracking, splitting moods, some gentle, others violent. These works hopefully convey new formal lines for the never-ending truths of struggle and growth, tragedy and hope.

There are several advantages in this new family for my way of working. First, the flat areas provide a convenient broad background for irregular smaller elements contrasted against them. This helps satisfy my sense of drama. But second, such use of space forces spectator response, forces the viewer to walk around the piece and perhaps wonder what is occurring in between and behind the sheets. Thus surprise may enter the experience. . . .

As used in *Manuscript,* the undulating planes come close to the appearance of bas-relief, but when the work is actually seen, the impulse to move about the form (not felt when the work is experienced through photographs) is strong. *Manuscript* was never intended for architectural use; nor is it a space divider. Rather than requiring a fixed frontal viewpoint, the final work has become three flexible planes joined at one side of the whole and radiating outward, not unlike the leaves of a partially opened codex. The planes stand in partial tension to one another, thus encouraging circumambulation and inner search of the sculpture. The great metal sheets seem the fitting background; against them are polarized violently irregular, lawless forms, one on each side but operating through the work. The front element was felt by the sculptor as "a wild stroke of lightning," but its full significance remains unspecific. The unfolding action implied for the artist "the unfolding sheets of growth and life . . . broad cosmic and historic sweeps," while the posterior erupting element, which seems to grow, held vague connotations of contrasting lawfulness. As was so often the case, this sculpture was born of momentary intuition after years of peripheral involvement with an idea. It served to integrate thoughts about the fateful dualities of hope and frustration, destruction and rebirth, contingency and necessity.

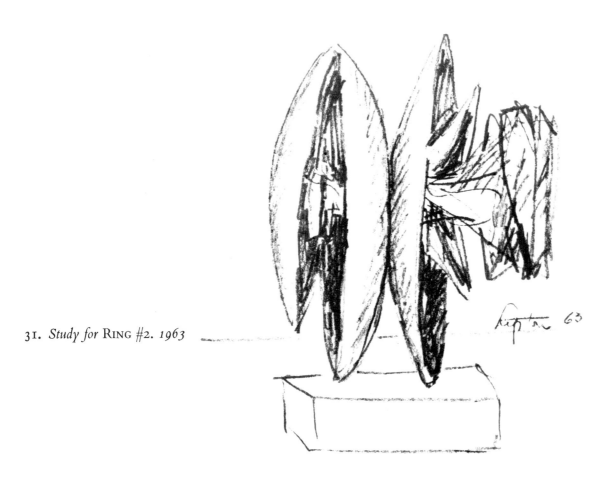

31. *Study for* RING #2. *1963*

54

HAVING LONG AGO WELCOMED THE CONFLUENCE of what was within and what was outside himself as right and fruitful for good sculpture, Lipton has since 1960 predictably and appreciably added to the population and character of his world without subtracting from the fertile density that has marked each of his works. His sculptures still observe and dramatize the laws of unceasing motion, engendered by antagonistic impulses lying at the heart of a world where not even the tomb is terminus. Despite the introduction of fresh motifs and configurations, the constancy of his resilient style gives this newest imagery the quality of being of a piece with its predecessors; most of his new sculptures have their own Jesse tree in his work of the fifties and forties. Unlike many of the famous painters of his generation, Lipton still avoids the dangers and successes of making art about art, or settling upon a restricted aesthetic format. He is rare among sculptors in that having found an appropriate and permissive language, he can devote himself to the expression of wide-ranging emotions and thought, which continue to fuel his creative drive.

Lipton's sculptural world has evolved by an unprogramed pro-

cess, so that since *Manuscript,* which begot *Trap* and *Plough,* both of 1967, he has reworked earlier themes and explored new ideas as the spirit moved him. Old forms continue to beget new ones, as in the case of *Pioneer* and its related *Empty Room.* The victory of life over death is more frequently and explicitly encountered. Obsession with living and dying joins the sculptor with Dylan Thomas, whose words, more than anyone else's help us to experience Lipton's sculpture. Three recent pieces, *Séance, Ring,* and *Gateway,* evoke Thomas's conjurings of the "walking grave," the "forking monad," and "new life in the gateway of the loins." All three are essentially what Thomas would have called "fresh characters" in the sculptor's imagistic sign language. Although *Ring* and *Gateway* are distant descendants of *Cloak,* of 1951, they depart substantially from his familiar imagery of the fifties in having strong vertical-and-horizontal rather than diagonal structuring. All have his typical rich sensuousness and formal concision, coupled with meaning that appeals to feeling and intellect: *Gateway* poetically demonstrates that one plus one adds up to one; *Ring* proves that one can compound itself into two; *Séance* and

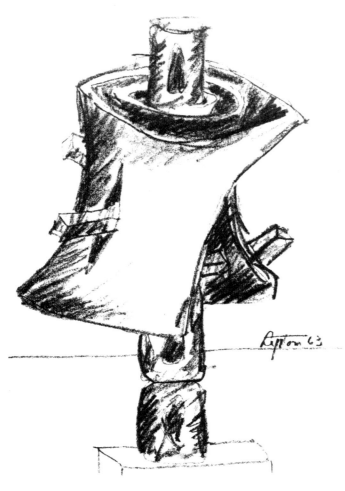

32. *Study for* EARTH BELL. *1963*

Empty Room multiply the fatal zero of the grave into the numbered living. The personal demonstration of these and other works is that for this existentialist sculptor triumph over death comes from a life used for constant vigorous creation.

As we have seen, for artistic and moral reasons Lipton cannot accept into his art the object as given. Objects continue to undergo re-formation and metamorphosis. Three recent works explicitly derived from varied objects are *Codex #2, Plough, Earth Bell,* and *Wheel.* The first continues the artist's reflections upon the book as an emblem of human history and of the struggle to encode restraint against violence. *Plough* is related to *Codex #2* in that a central wall supports two exterior elements. In the former "the mood is one of pushing, cutting forward; a sense of life movement pressing against the unknown." From another angle it also implies for the sculptor male and female forms locked in marriage. *Wheel* is bound up with thoughts about torture (St. Catherine), the Buddha (the Wheel of Life), the yin and yang inscribed within a circle, and the eternalizing of life. But this reads more pat than was its making, which was part of Lipton's

search, in his metal forms, for a revelation of his own identity.

Earth Bell takes off from a Chinese bronze bell of the Shang, now pinioned to a living core, where metaphorically new life resists incarceration. *Wheel* is one of the most terse and evocative metaphors of recent years, and for the sculptor it has the ambivalence of life and death, being at once a Wheel of Life (related to Buddha's teaching), and St. Catherine's wheel of human torture —the rack. Seen from one of its narrow sides, *Wheel* surprisingly resembles a soft, flowering form. Thus from changing viewpoints, those of seeing and those of imagining, different "moods of life" emerge.

Like *Earth Bell, Altar* derives from objects in the history of art, specifically several iron altars of human sacrifice that Lipton saw among the antiquities in the Louvre in 1958. The image of these sacrificial "beds" haunted him as an idea for new sculpture. Dissatisfied with a vertical model on which he was working in 1966, he turned it horizontally, and there, after appropriate changes, he had the answer to his interest in the sacrificial theme. The image suggests a human "on a razor edge and stabbed through the heart." Of all Lipton's references to sacrifice, *Altar* is the most chilling in its direct allusion to the practice of sacrificing life in order to ensure the renewal of life.

With undiminished drive and perceptiveness the sculptor continues as an adventurous explorer in the labyrinth of his own being. The Ariadne thread of his wanderings, the internal continuum of his style, is the steadfast focus on the forces of light and darkness. From this private quest came *Archangel,* on permanent exhibition in Philharmonic Hall of the Lincoln Center for the Performing Arts in New York. Lipton says of it: "This sculpture took five months and three assistants to make. It's in the Baroque spirit, having an angular upward thrust. The work is conceived as a human winged presence, but the wings suggest musical instruments. Music and sound, large sound, is primary in this work. Flowering nature, thrusting through, is another suggested metaphor. Life, and faith in life, emerges. The philosophy of the work is that the godhead in nature offers man the gift of life. Handel's *Messiah* and its tumultuousness is sought as a parallel."

In its look, feeling, and evocation of sound, *Archangel* is appropriate for a concert hall. Itself a performance whose large scale is right for the magnitude of the sculptural drama, *Archangel* enacts the triumph of freedom. The whole piece is a full orchestration of competing rhythms, variations on the themes of compression

and expansion, the clash of the sharply forked base with the cymbal-like disks that, in turn, respond to invisible vibrations. Set in a low-ceilinged section of the foyer, *Archangel* militantly roots itself in all directions and trumpets its presence. It bodies forth the exultant mood of its creator, who has found the sculptural equivalent of the triumphant high point of a great musical composition. *Archangel* is Lipton's "Hallelujah."

Ironically, despite its arrogant stance, *Archangel* is at war with itself. What gives the work its quality of exaltation is the breakthrough and release of a driving, blunt-headed, piston-floral form, which detonates its way out of the constricting dark labyrinth of the sculpture's internal geography. As with the sounding of the *Archangel*'s trumpet, the dead seem to rise from the grave for a second life, a new beginning. Such is Lipton's art that *Archangel* could have been inspired, consciously or subconsciously, by Handel or by such lines as those of Dylan Thomas's "In the Beginning":

In the beginning was the mounting fire
That set alight the weathers from a spark,
A three-eyed, red-eyed spark, blunt as a flower;
Life rose and spouted from the rolling seas,
Burst in the roots, pumped from the earth and rock
The secret oils that drive the grass.

At the time of writing, the latest major work completed by the sculptor is his *Laureate,* destined for the Milwaukee Performing Arts Center. In retrospect Lipton views it as belonging to the tradition of *Sentinel* of 1959 and the Hero series. *Laureate* is the splendid singer of a song of victory "through life over the forces that beset him." Fused into its structure are suggestions of legs in an open stance, throat or thorax forms, and a harplike head. Larger than *Archangel, Laureate* is more frugal as to shapes, clearer in its rhythms. As one walks around the sculpture, one notes surprising changes of shape and mergences of areas. Like *Archangel, Laureate* arrogates to itself light and space; to look up from below the harp form is to see how it will frame and chord the sky when it is out of doors. The sculptor feels this may be his most "classical" piece in its severe concision and lucidity of form.

Although but one of many themes, death and rebirth seems to have been most explicitly in the sculptor's mind these past few years. *Empty Room* may not have been intended as such, but it is like an unsentimental personal epitaph. There is no decaying relic, no resurrection of the body from the grave, no soul's ascent to heaven. From the sterile steel and void of the mausoleum, miraculously a treelike hand has clawed upward. Neither ritual nor theology, but rather art begetting art—just as his art once took shape from long-stilled hands—gives comfort and promise of continued life to the artist. Its title, as much as its form, seems to have haunted Lipton's imagination after the work was done, for he uses *Empty Room* as a personal metaphor of what art means to him:

What do I want? What have I said and done in my work? There are moments of peace, deep peace, and periods of harassed doubt and sleeplessness. Why am I doing sculpture? Does it express what I feel, what I would like to know? What is meant for me by spirit, God, order, absurdity? Does my sculpture deal with beauty, truth, and moral values? How can I make sense out of it all? Does it all happen through some primal will? Is it some inborn need for sensuous order that controls unconsciously everything I shape in the materials I work with? Perhaps it is a little of all these things and shifting pressures of circumstance that give varying results. I have a feeling it is largely guesswork. Is it a drive for ambitious power and recognition to compensate for hidden inadequacies and weaknesses? Even these words seem hollow.

The more skeptical I am about life, the more I become aware of happiness, order, peace as possible within certain limits. "Limits" I always return to as the key word. The artist can and should always cultivate his own garden within four stone walls. There is only true freedom that begins in the cage, the empty room; all else is confusion and meaninglessness. "Limits"—every artist works according to his own limitations, which may lead to nothing. I am here speaking of limits as realms of order, self-imposed yet real. They are arbitrary, hypothetical, but genuine as stone. If I say there is order in the physical world and there is chance and that man as part of this world inherits these characteristics in his behavior, what am I saying of "limits"? Frames of reference are prisons for the release of the spirit, for creative configurations. . . .

What am I looking for, not merely with my mind but with my whole being? Thoughts, feelings, instincts, reflexes, all reaching toward insights about life and reality. These insights

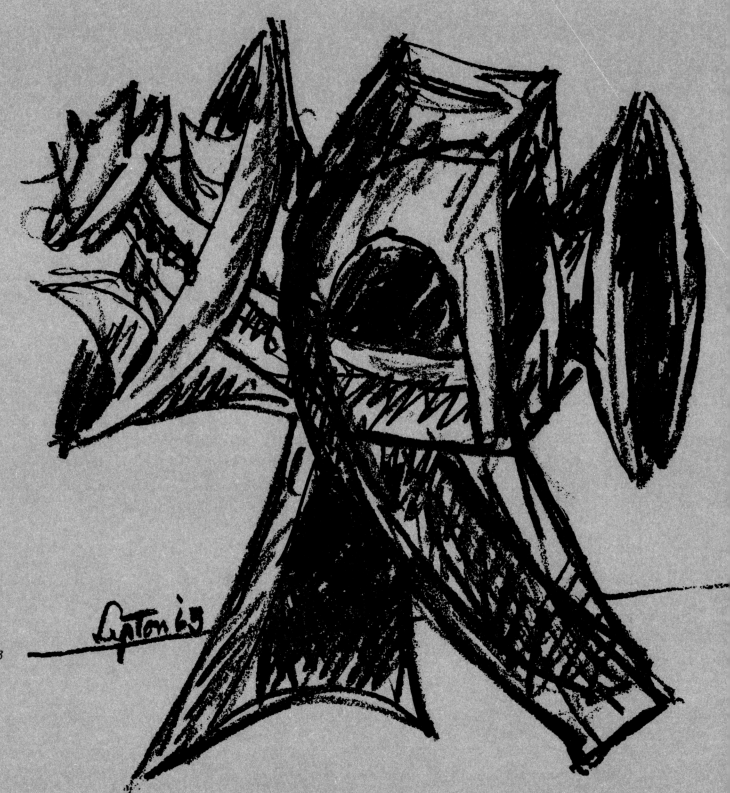

33. *Study for* ARCHANGEL. *1963*

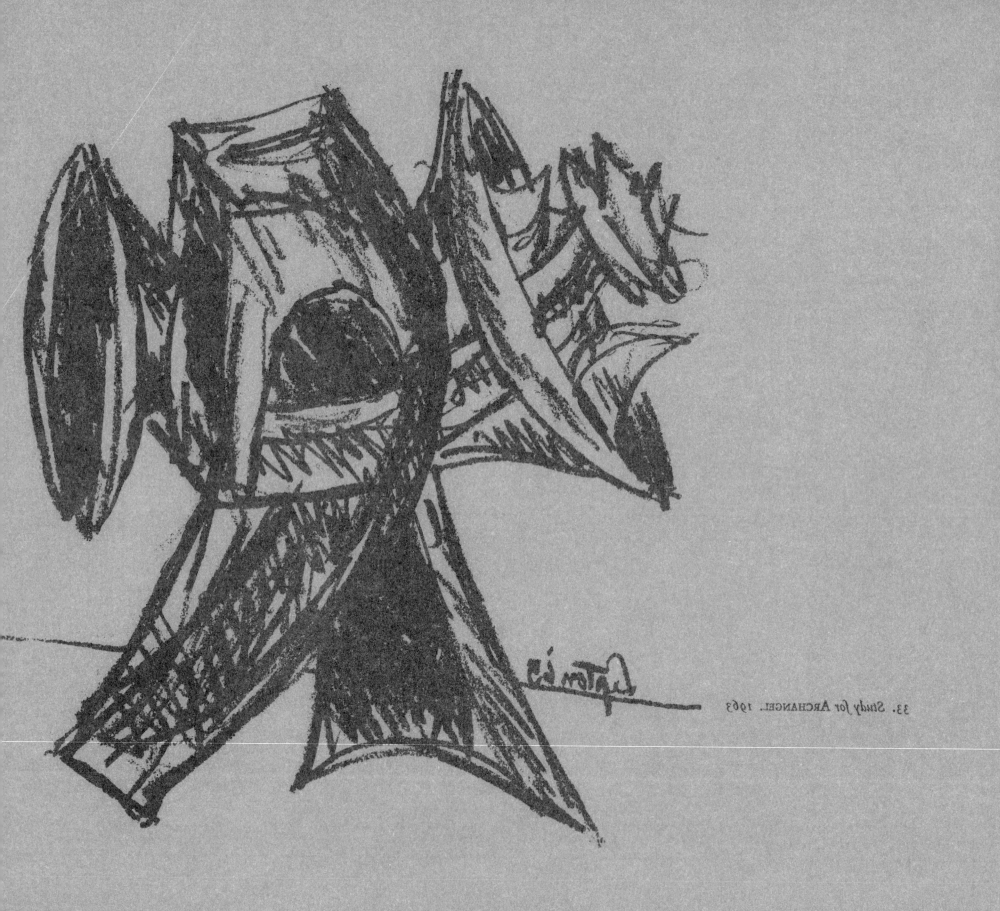

33. *Study for* Archangel. 1963

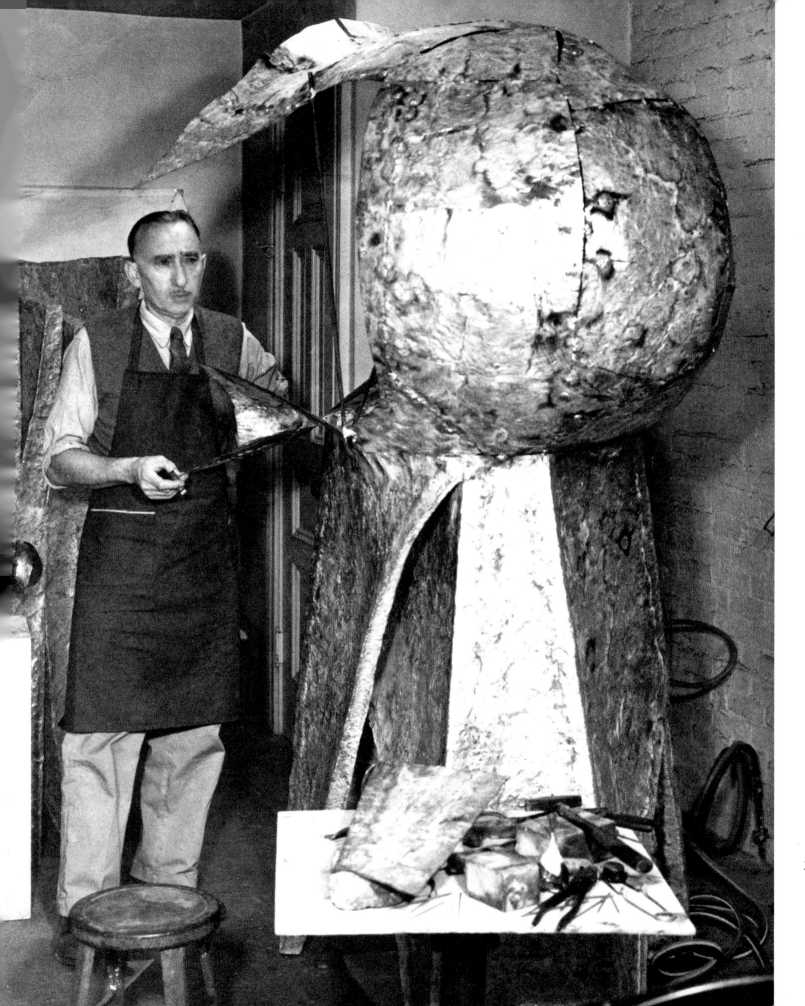

34. *Lipton at work on* ARCHANGEL

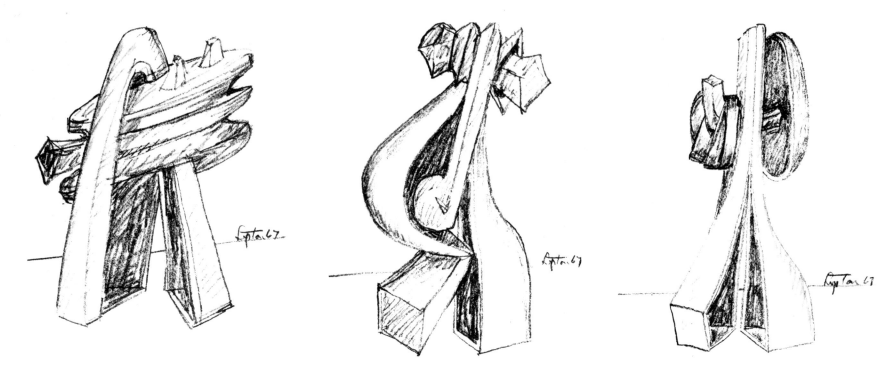

35.
Studies for LAUREATE.
1967

58

are sought consciously and unconsciously as organized forms in metal, as images that are both ugly and beautiful at the same time but in different ways. The images become, each, through a process of synthesis, through contemplation, presentations of pain and pleasure, of good and evil parts of living reality. Each work is a total view from some point of seeing. Each work has beauty in so far as it answers needs of balance, of organization in space. This is pleasure. But anger, even hate in some measure, enters into the over-all picture of mortality.

It is all very complex and in the last analysis imponderable because a sense of history, of retaining worthwhile values of the past, enters lovingly into the assimilated experience of image making. Yet, paradoxically, new and contrary interpretations of these old values are remade, transvaluated in terms of today. Conservation and rebellion occur together. The past and the future make the present. Love of art forms and meanings of the past are molded in terms of aspirations for the future.

I consider myself a realist, though my images come out abstract. Reality crowds about me like invisible walls of a room. Only in reality can I be free to find my imagery. Only in the reality of beauties, goodness, ugliness, pain, pleasure of the world of existence of past, present, and future can I operate freely. What comes out, what happens, is the final image of each work, each "total" and limited by the varied confines of sights, meanings, and feelings of reality.

Though "involvement" is an unfashionable word on the cur-rent art scene, it truly describes Lipton's style and thought. His involvement, full in a personal sense, is still to be fulfilled in terms of what he has yet to say. His relationship to his sculpture continues aloof from the market and from critics' views. Rather than feeling impelled to change with the times, Lipton has, in a more meaningful way, made the changes of time the continuing subject of his art. Unlike so much of recent sculpture, his last-year's works resist seasonal dating and never become "documents." Lipton's continuity of style is positive and productive, for with his fruitful language he exuberantly continues to discover fresh figures of speech.

Seymour Lipton is one of the few American sculptors who have earned international recognition as a major artist. The beneficiary of many ideas from European art, he does not, however, owe major indebtedness to individual artists. No other American sculptor has evolved so rich and varied a metaphorical art as Lipton, and the deep involvement of his intellectual and emotional life with his work has resulted in the creation of inimitable sculpture. As an inventive shape maker and composer, he stands second to none of his contemporaries. His bringing to sculpture ideas that transcend art and impart meaning and mystery to complex forms, and his "modeled" metallic surfaces place his work against the tide of current tastes and interests in "minimal" sculpture. Like Le Corbusier, Lipton does not feel that the artist who has something to say should restrict himself to exercises in grammar or the celebration of clichés. Lipton appears to be one of the last in

the tradition of the learned sculptor that includes Rodin—the tradition in which sculpture is still the vehicle of serious and far-ranging thought and feeling about history and life in all forms: "The sculptor who renders the tragic anxiety of the contemporary situation in terms of his aspirations as a human offers the richest form and meaning for today's audience."

Lipton's art since 1951 stands by itself, testimony to the way he has transcended his own sources of the thirties and forties as well as the forms in his environment from which he draws inspiration. Few of his contemporaries have produced as many works as individually memorable and profound as *Cloak, Sentinel, Manuscript, Archangel, Laureate, Empty Room*. If excellence in art continues to derive from command of craft, sustained imaginative performance in its variety, order, and interest, then the work of Lipton will still provide its measure.

Alongside the new and younger artists and movements of short duration that crowd the current scene stands the ongoing work of exceptional artists like Seymour Lipton who maintain the brilliance of their art. By the totality of his art as much as by individual new pieces, Lipton supplies what is lacking in much of recent sculpture: strong, sincere feeling and the will and intelligence to transform and say something important about one's environment in a heroic style, thereby reconfirming the dignity and meaningfulness of the art.

ALBERT ELSEN

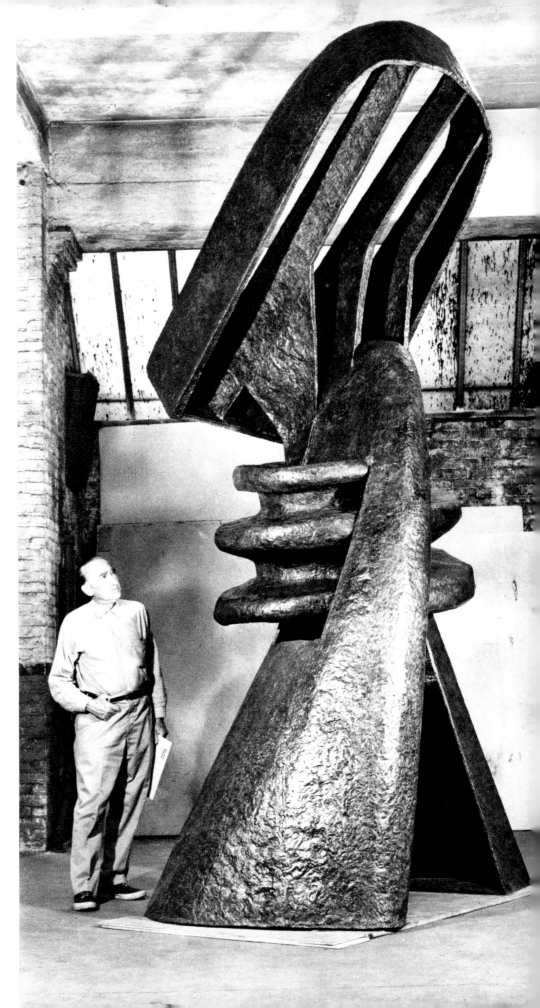

36. *Lipton with* LAUREATE

37. *Seymour Lipton*

BIOGRAPHICAL OUTLINE

1903
Born November 6, in New York City.

1921
Is graduated from Morris High School, where he has been active in drawing, poster, and art clubs, and school publications.

1921–23
Attends Brooklyn Polytechnic Institute, then College of the City of New York before entering Columbia University. Begins to read widely in art history and aesthetics.

1927
Receives D.D.S. degree from Columbia University.

1928–29
Interests concentrate on sculpture. Models clay portrait heads of friends and members of family. Carves a marble head in deep relief, also some ornaments in ivory and gold.

1930
Marries Lillian Franzblau, on November 16.

1930s
Devotes an increasing amount of time to sculpture, working on his own in direct plaster and in carving wood.

1933–34
Exhibits for first time in group show at John Reed Club Gallery, New York.

1935
Exhibits his first wood carving, *Lynched,* in group show at John Reed Club Gallery. First son, Michael, is born, in anuary.

1938
First one-man show (wood sculptures) at the ACA Gallery, New York.

1940
Exhibits at World's Fair and in the American Artists Congress show, New York.

1940–65
Teaches sculpture at the New School for Social Research, New York.

1941–44
Exhibits in the Sculptors Guild annuals, New York.

1942
Second son, Alan, is born, in July.

1943
One-man show at St. Etienne Gallery, New York, includes bronze castings in abstract metaphorical style. Participates in group shows at Buchholz Gallery and others in New York. Teaches at The Cooper Union, New York.

1944–46
Begins sheet-lead construction technique. Teaches at New Jersey State Teachers College, Newark. Exhibits in many group shows.

1946
Exhibits in Whitney Museum of American Art Annual Exhibition of Sculpture and Drawing, New York. (Has exhibited in all subsequent Annuals to date.)

1947
Begins working in lead-soldered sheet steel and also in combined wood and metal mediums. Exhibits in various museum shows, including the "58th Annual of American Painting and Sculpture" at the Art Institute of Chicago.

1948
One-man show at Betty Parsons Gallery, New York. (Other one-man shows there in 1950, 1952, 1954, 1958, and 1961.) Exhibits in museum shows in New York and throughout the U.S.

1949
Begins technique of brazing (melting) brass rods onto sheet steel by use of the oxyacetylene torch.

1949–52
Exhibits in various museum group shows.

1950
Arrives at signature, or mature, style.

38. *Study for* SANCTUARY. *1953*

1951
One-man show at the American University, Washington, D.C. Exhibits in "Abstract Painting and Sculpture in America" at the Museum of Modern Art, New York.

1953
Receives commission from architect Percival Goodman for three sculptures for Temple Israel in Tulsa, Oklahoma. Sound film, "Sculpture by Lipton," produced by Nat Boxer.

1954
Sanctuary acquired by Museum of Modern Art, New York.

1955
Makes transition from brazing on sheet steel to brazing on sheet Monel metal. One-man show at University Teachers College in New Paltz, New York. Receives commission from Percival Goodman for five works for Temple Beth El in Gary, Indiana. Works included in two Museum of Modern Art traveling exhibitions, one shown throughout the U.S., the other in Europe. Exhibits in Whitney Museum of American Art show "The New Decade—35 American Painters and Sculptors." 1954 one-man show at Betty Parsons Gallery cited by *Art News* as one of the ten best shows of the year.

1956
Exhibits in "12 Americans" at the Museum of Modern Art, New York. One-man show at museum of Munson-Williams-Proctor Institute, Utica, New York, where he is also visiting artist. Exhibits at various museums, including the Des Moines Art Center, Iowa, and the Musée Rodin in Paris.

1957
Pioneer acquired by Metropolitan Museum of Art, New York. Wins first prize (Logan Award) at Chicago Art Institute for *Cloak,* and top acquisition prize in one-man show at São Paulo Biennale, Brazil. Receives commission from Skidmore, Owings and Merrill for *Hero* for the Inland Steel Company Building in Chicago. Exhibits in the USIA worldwide traveling show "8 American Artists."

1957–59
Visiting critic at the Yale Art School, New Haven, Connecticut. Various commissions and museum acquisitions.

1958
One-man show at Venice Biennale, Italy.

1959
Exhibits in group shows, including Carnegie International in

Pittsburgh; two shows at Whitney Museum of American Art, New York, "Nature in Abstraction" and the "Friends of the Whitney"; sculpture show at the Galerie Claude Bernard in Paris; and the USIA "American National Exhibition of Painting and Sculpture" in Moscow (also later shown at the Whitney Museum).

1960

Receives Guggenheim Award; Architectural League Award for *Hero*; New School for Social Research Purchase Award for *Viking*. Exhibits at "Documenta II" in Kassel, Germany.

1961–62

Receives commission from architect Eero Saarinen for two sculptures (*Argonaut I* and *II*) for IBM Watson Research Center in Yorktown Heights, New York. These receive two Architectural League Awards: for best sculpture and for best sculpture in relation to architecture. Ford Foundation Award. Award from Perini–San Francisco (architects) for *Chinese Bird*. One-man show at Rensselaer Museum in Troy, New York. Exhibits in numerous group shows, including the International at Spoleto, Italy.

1963–64

Commissioned by architect Max Abramowitz for *Archangel* for Philharmonic Hall of Lincoln Center, New York. Sound film "Archangel" produced by Nat Boxer. Large one-man show of sculpture and drawings at the Phillips Collection, Washington, D.C. Various museum group shows.

1965

Manuscript acquired by Museum of Modern Art. One-man show at Marlborough-Gerson Gallery, New York. Exhibits in group shows, including the European traveling show "Sculp-

ture of the 20th Century," "The White House Festival of the Arts," Washington, D.C., and others in the U.S. and abroad.

1966

Exhibits in group shows, including "Art of the United States: 1670–1966" at the opening of the new Whitney Museum of American Art in New York and other shows throughout the U.S. Tapes interviews for Archives of American Art, New York.

1967

Receives commission from Milwaukee Performing Arts Center, Wisconsin, for large outdoor sculpture, *Laureate*. Is appointed sculptor member of the Fine Arts Commission of the City of New York by Mayor John V. Lindsay.

1967–68

Tapes interviews for Archives of American Art and for Archives of Brooklyn Museum of Art, New York. Exhibits in group shows in the U.S. and abroad. Various commissions and museum acquisitions.

1968

Wins first prize, George D. Widener Gold Medal, for *Gateway* in "The 163rd Annual Exhibition of American Painting and Sculpture" at the Pennsylvania Academy of Fine Arts, Philadelphia. *Imprisoned Figure*, 1948, is included in the Museum of Modern Art, New York, show "Dada, Surrealism, and Their Heritage." Exhibits in other group shows in the U.S. and abroad.

1969

Large one-man exhibition, Milwaukee Art Center. Exhibits in group show "The New American Painting and Sculpture: The First Generation," Museum of Modern Art, New York.

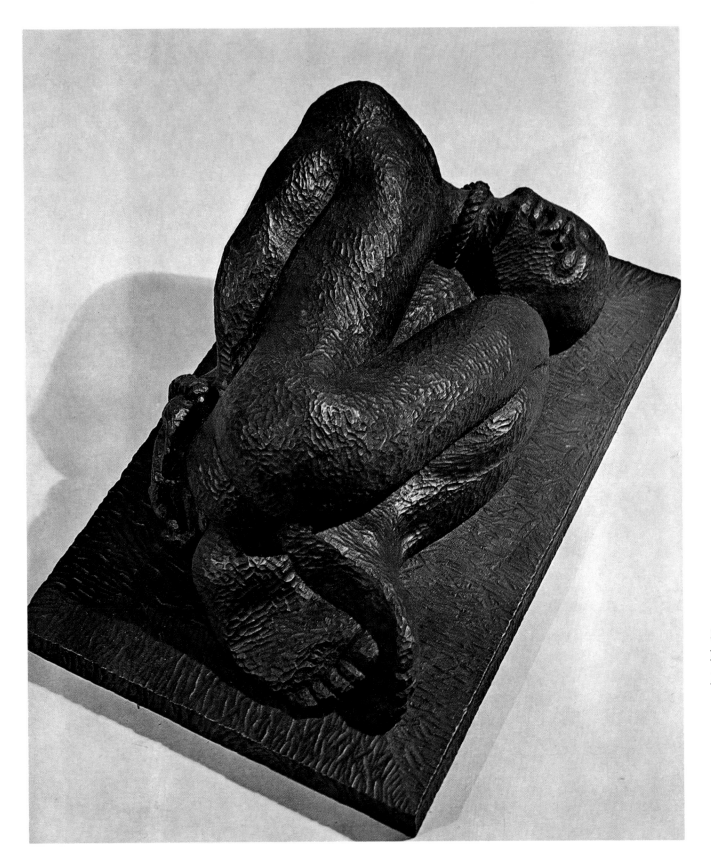

39.
LYNCHED. *1933.*
Mahogany, length 24".

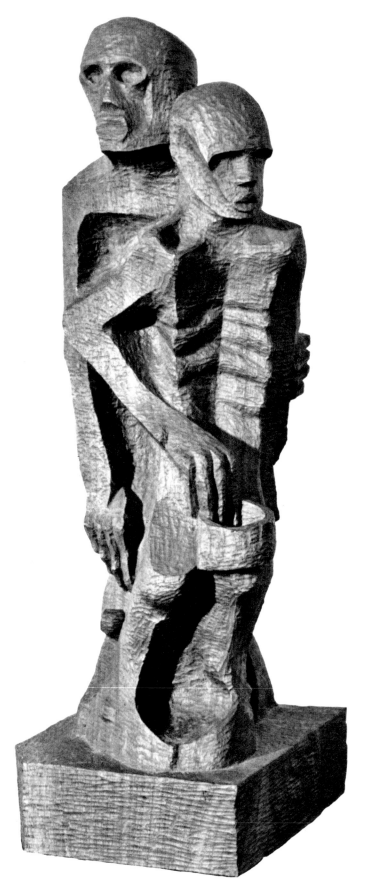

40.

SUBWAY BEGGARS. *1936.*
Walnut, height 19".

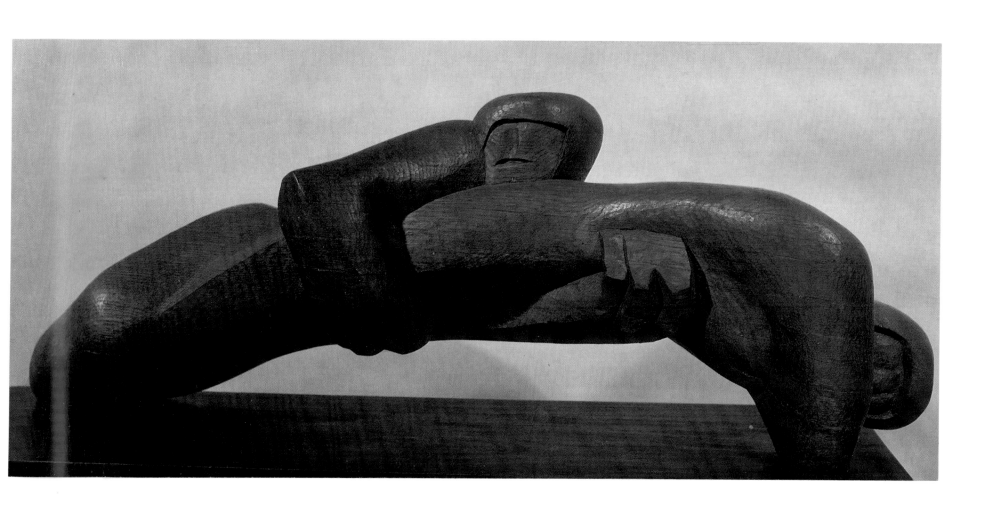

41. FOOTBALL PLAYERS. *1936. Oak, length 35".*

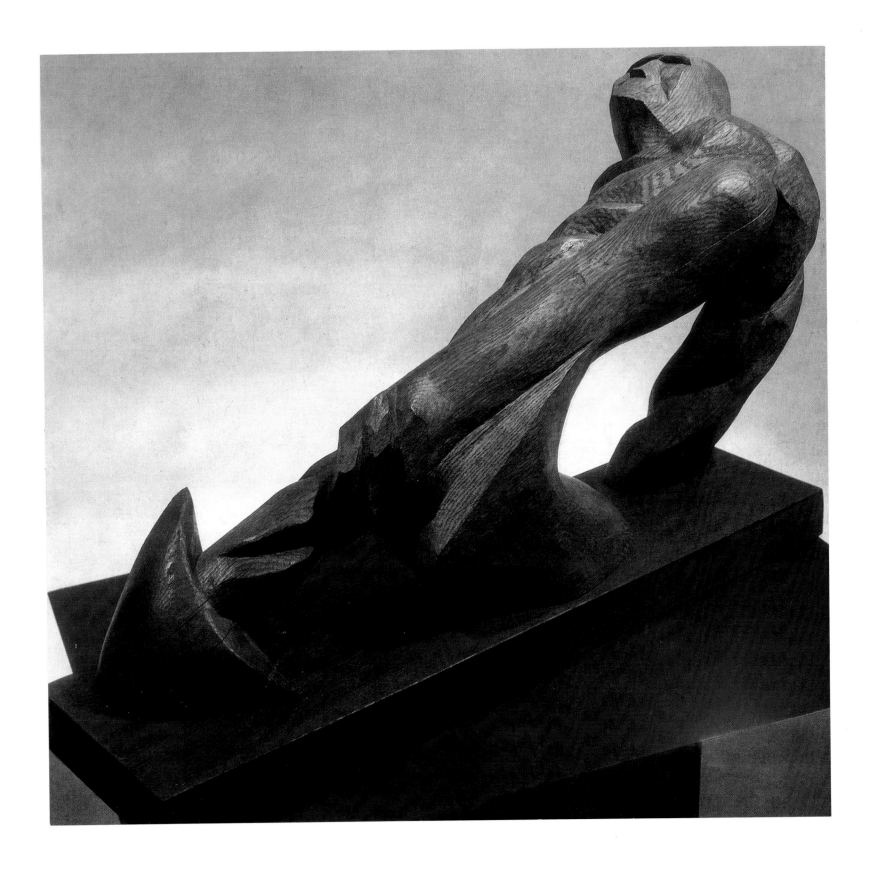

42. SAILOR. *1936. Oak, length 33".*

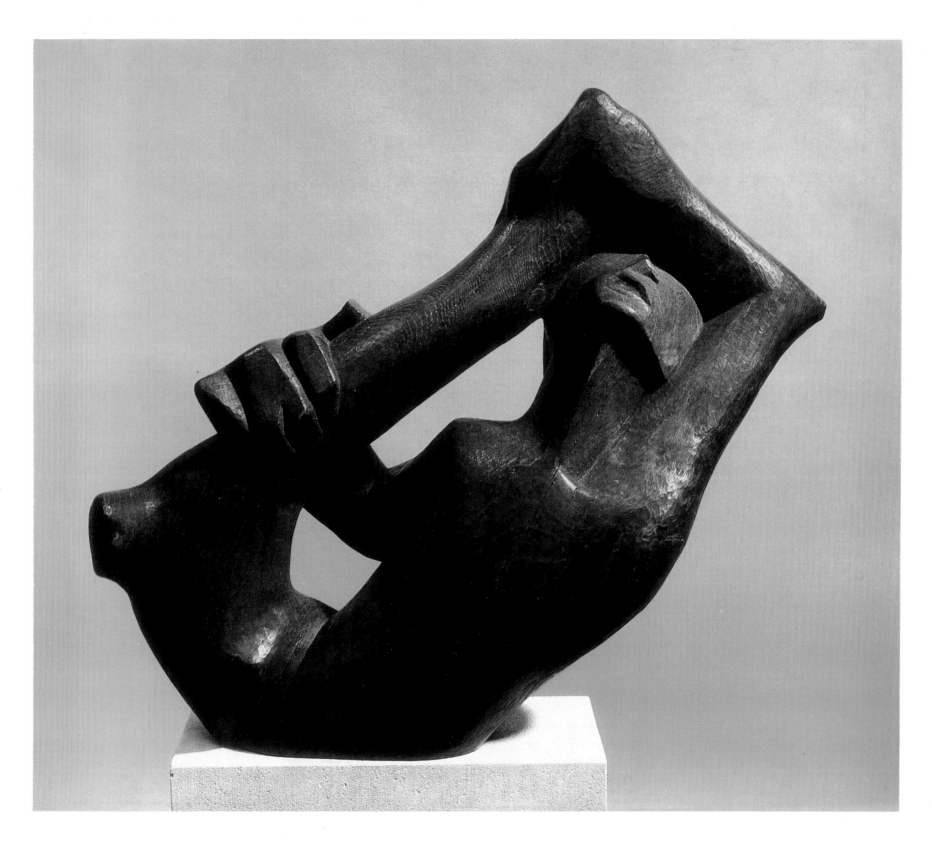

43. FLOOD. *1937. Oak, length 21".*

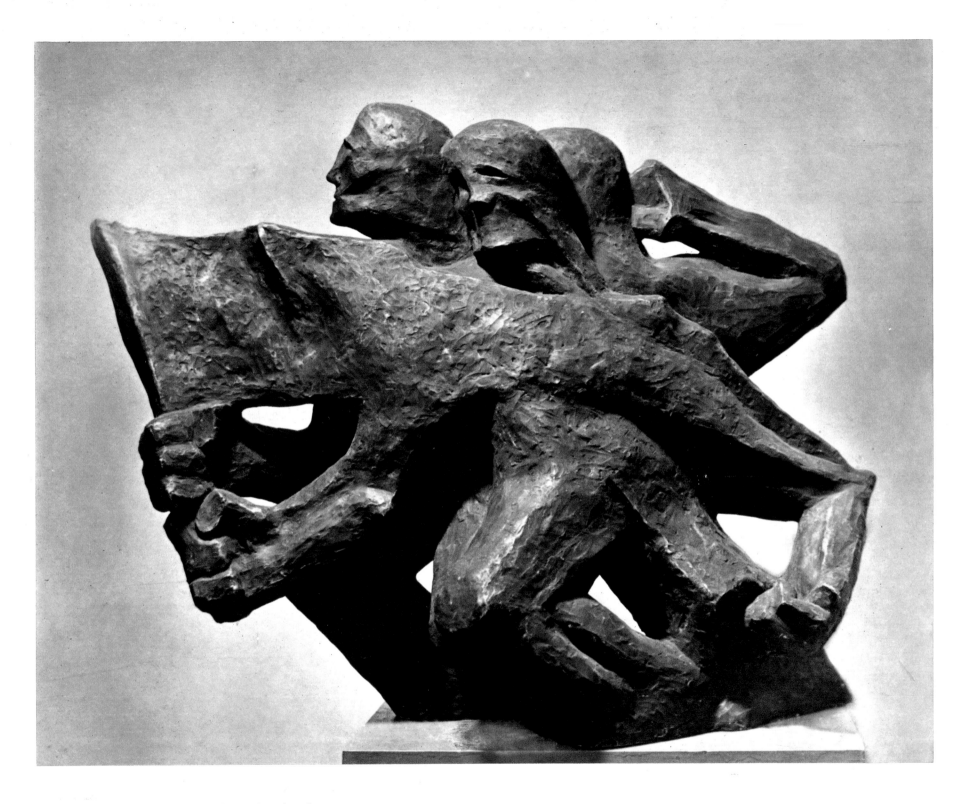

44. CELEBRATION. *1937. Direct plaster, length 40".*

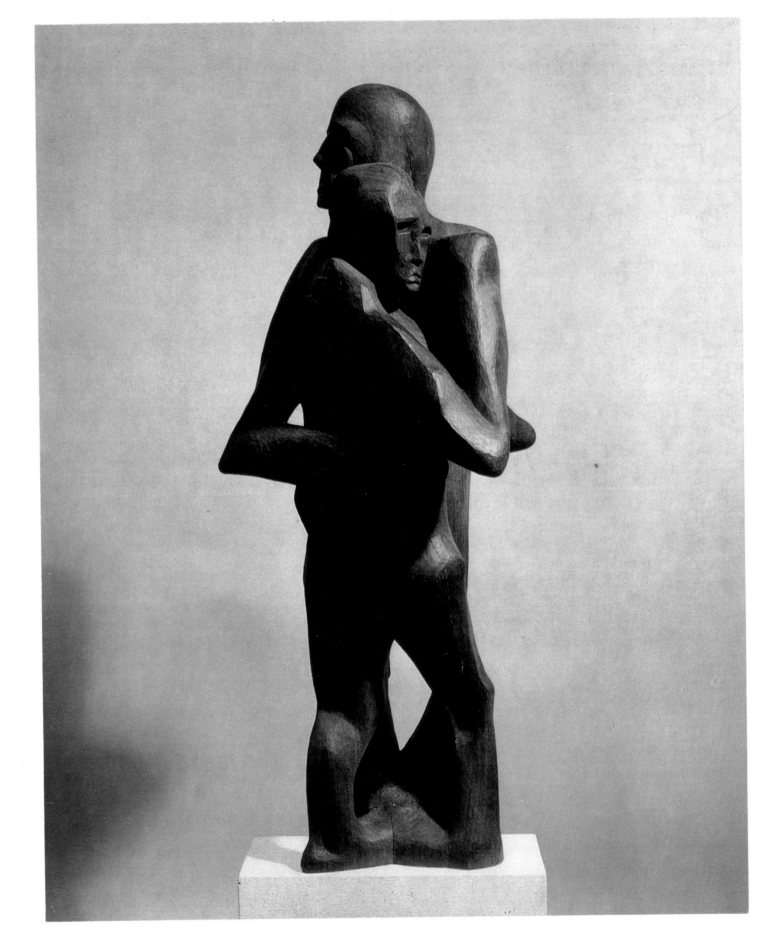

45.
MAN AND WOMAN. *1937.*
Sabicu wood, height 30".

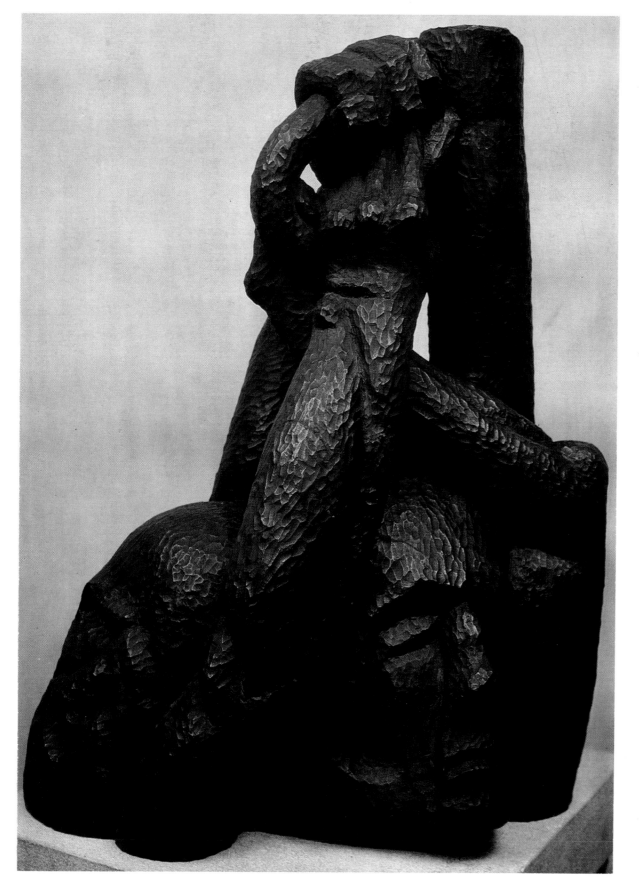

46.
STRAPHANGERS. *1937.*
Mahogany, height 19".

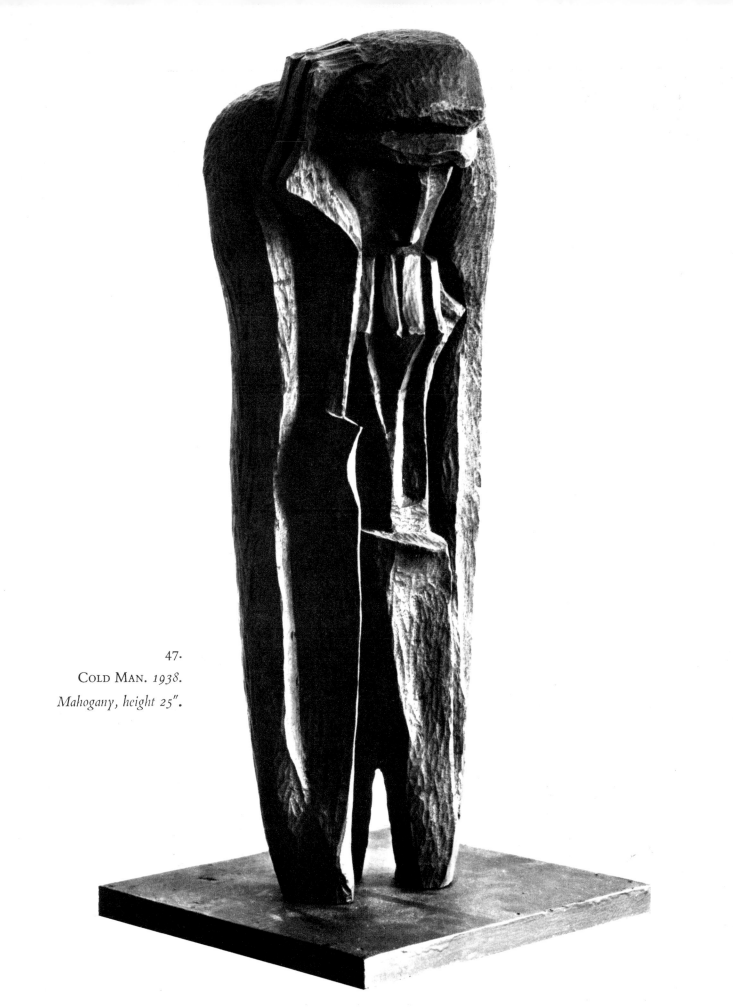

47.
COLD MAN. *1938.*
Mahogany, height 25".

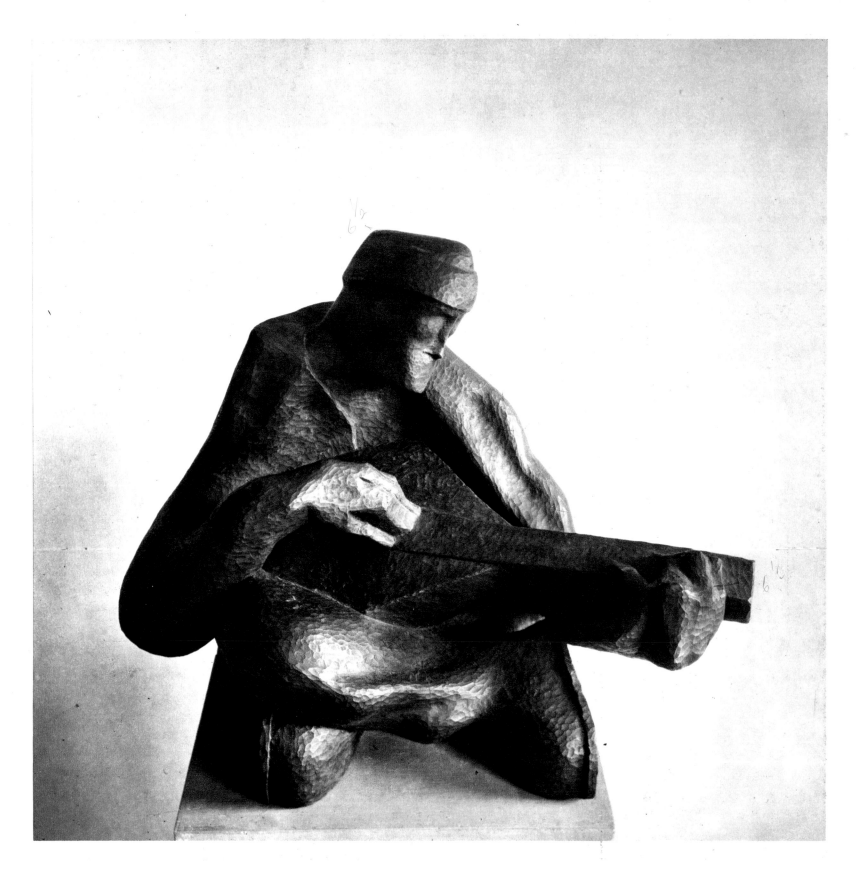

48. SOLDIER AND MANDOLIN. *1940. Mahogany, height 17".*

49.
COTTON PICKER. *1940.*
Sabicu wood, height 23".

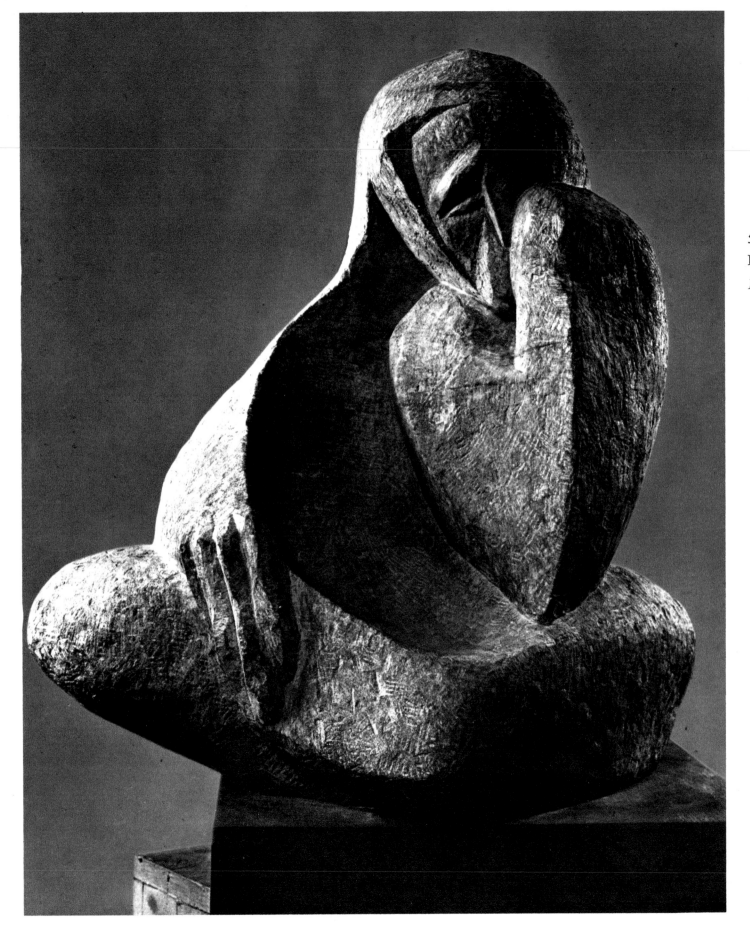

50.
REFUGEE. *1940.*
Limestone, height 24".

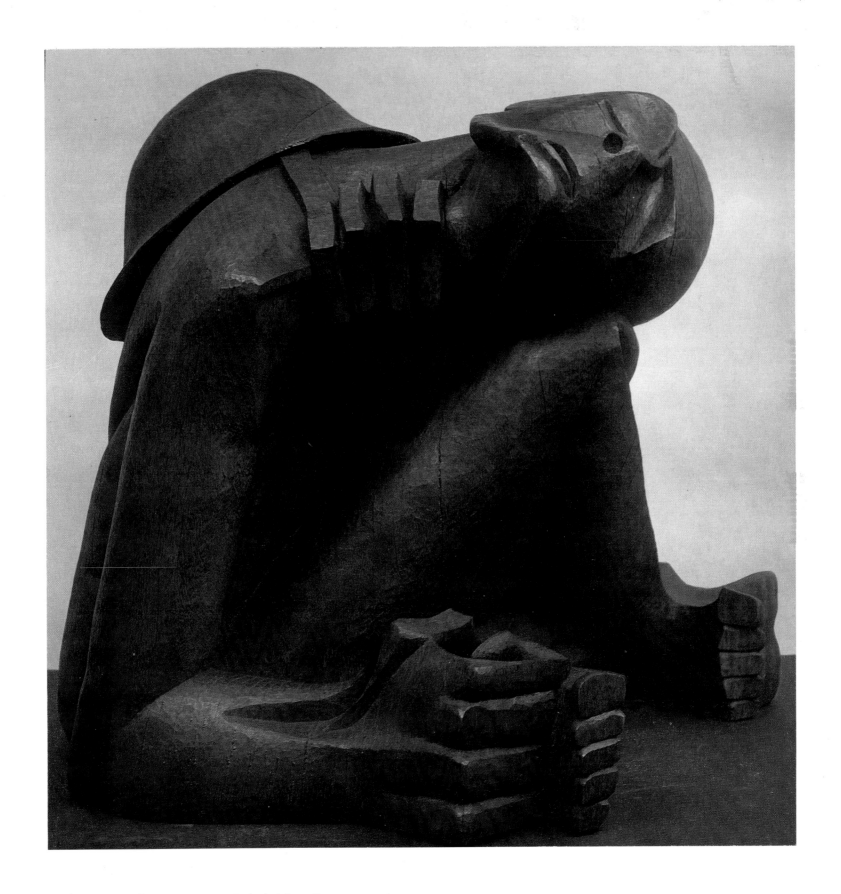

51. WOUNDED SOLDIER. *1940. Oak, height 17″.*

52. CRADLE. *1941.*
Mahogany, height 25".

53.
JOHN BROWN AND FUGITIVE SLAVE. *1941.*
Sabicu wood, height 33".

54. AIR RAID. *1941. Mahogany, height 34".*

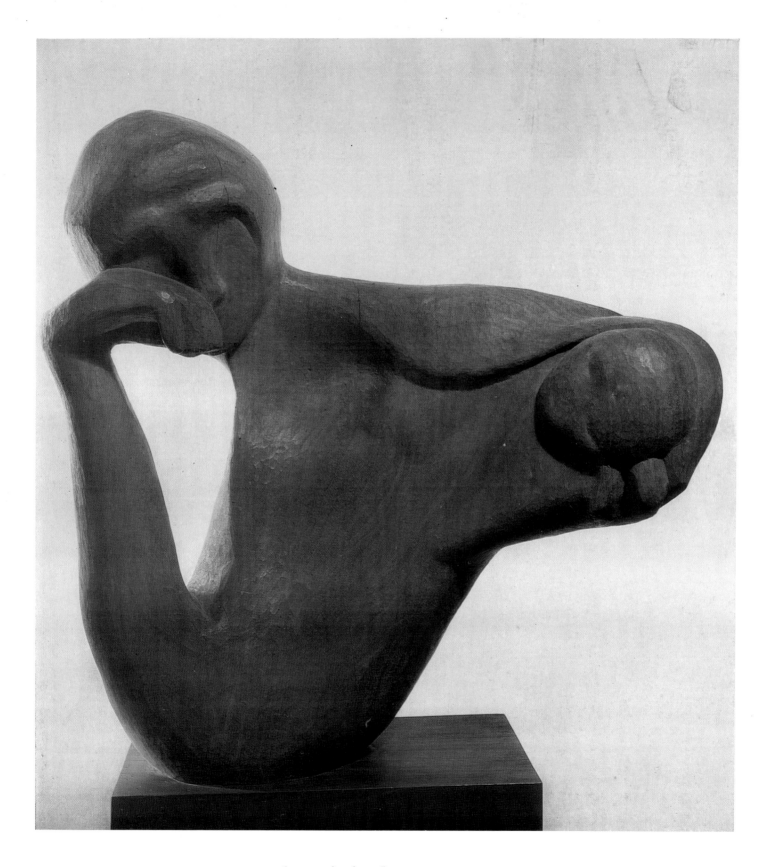

55. Mother Holding Child. *1941. Mahogany, height 21".*

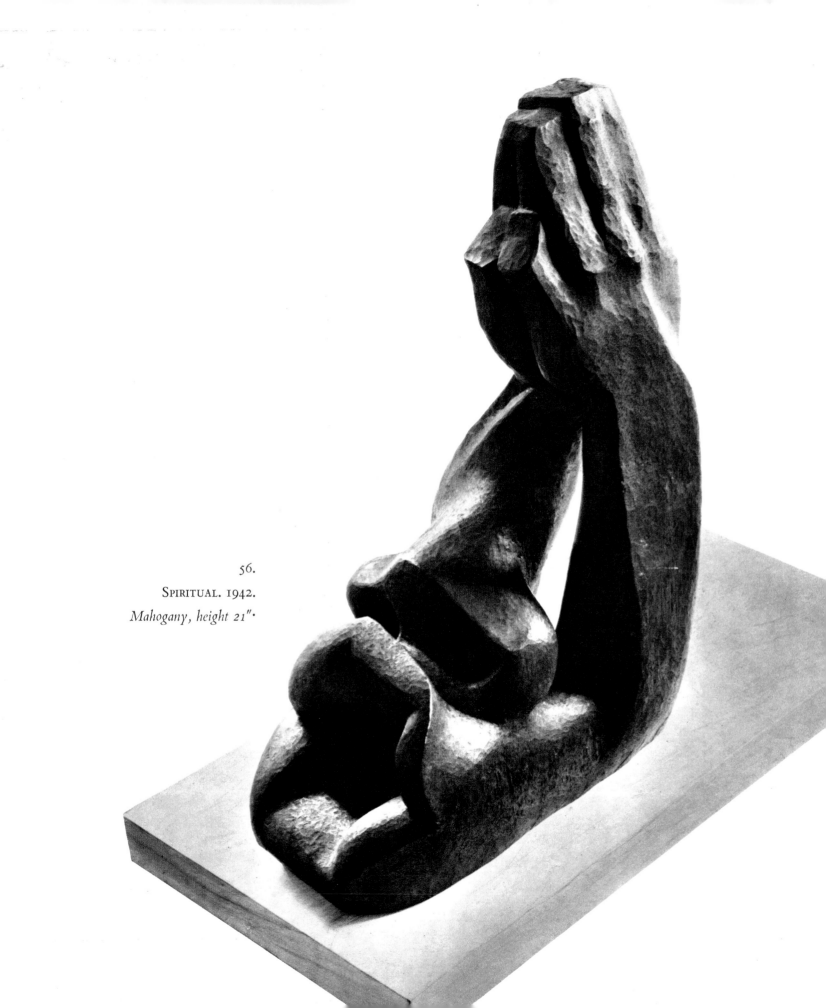

56.
SPIRITUAL. 1942.
Mahogany, height 21".

57.

THORNS. *1941.*

White mahogany, height 24".

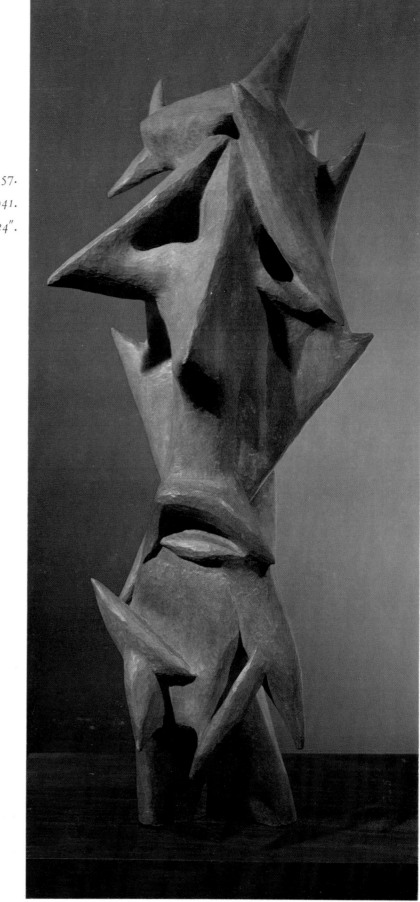

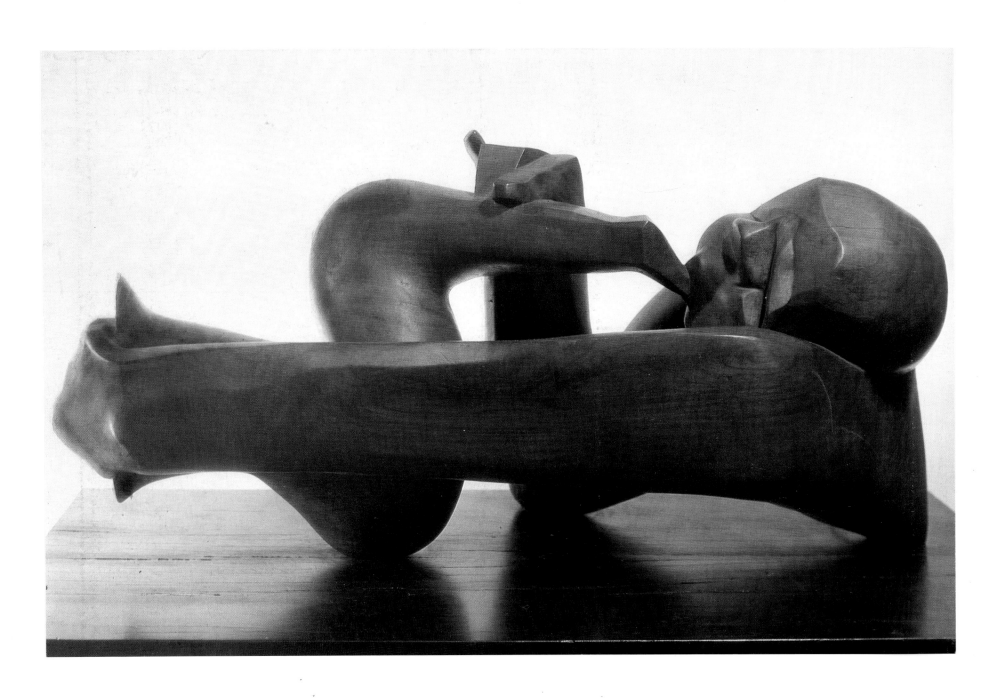

58. BLUES PLAYER. *1942. Walnut, length 24".*

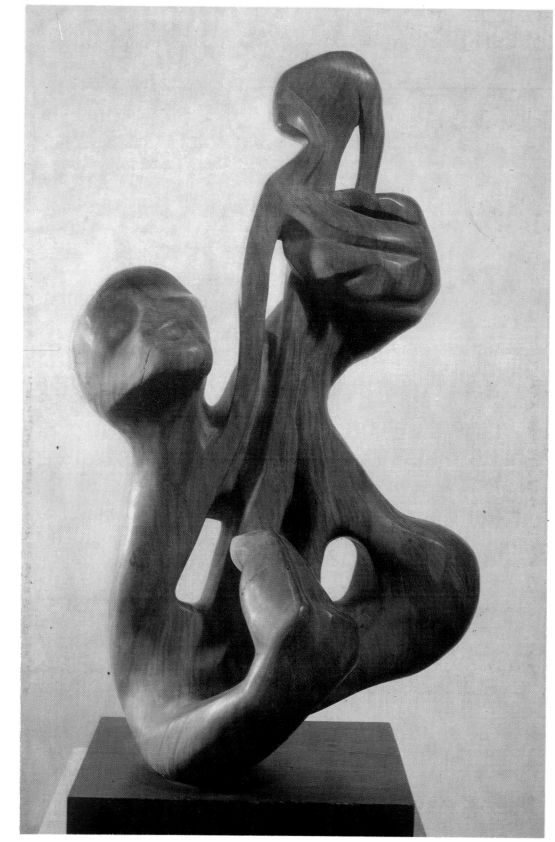

59.
FOLK SONG. *1944.*
Lignum vitae, height 22".

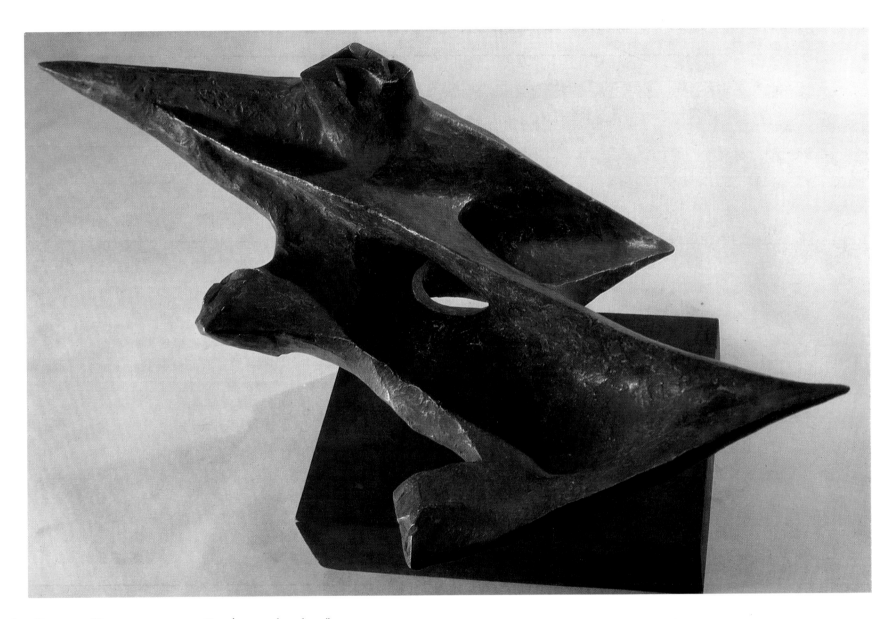

60. OMINOUS DIRECTIONS. *1942. Cast bronze, length 37".*

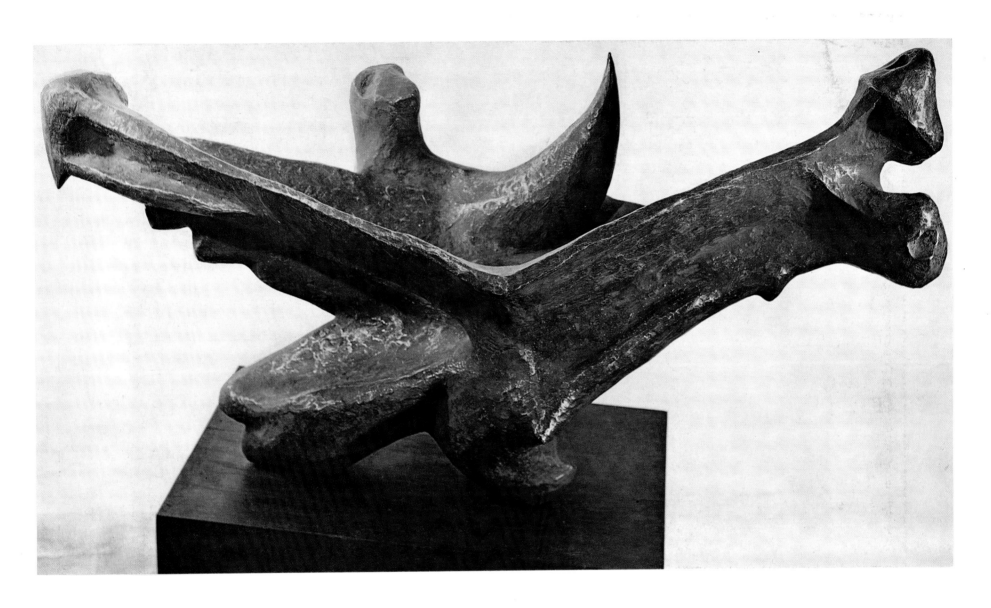

61. WITCHES' SABBATH. *1945. Cast bronze, length 26".*

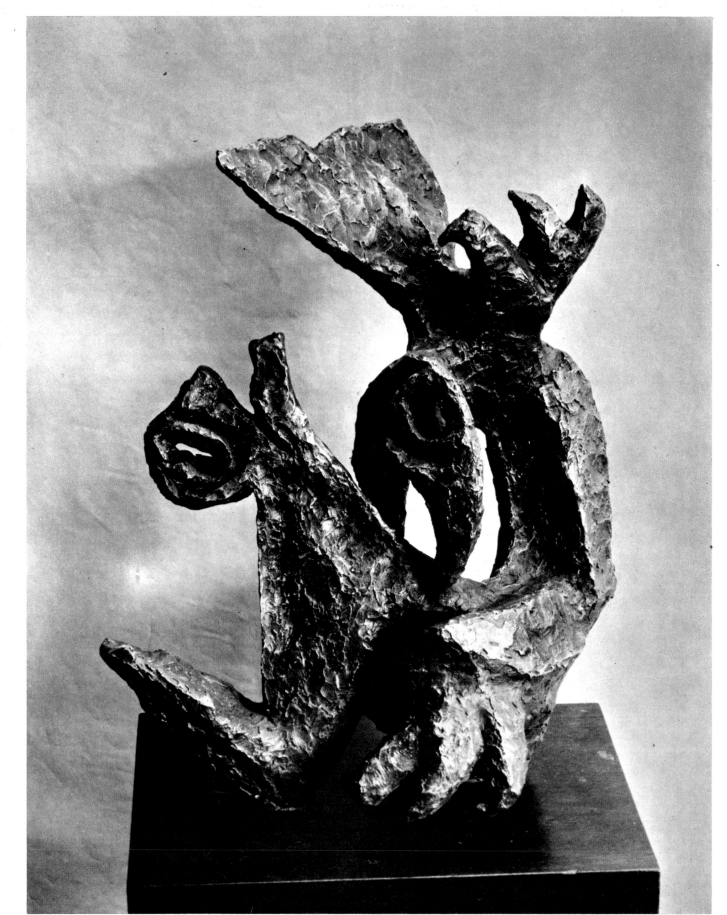

62.
BIRDS OF PROMETHEUS. *1947.*
Cast bronze, height 22".

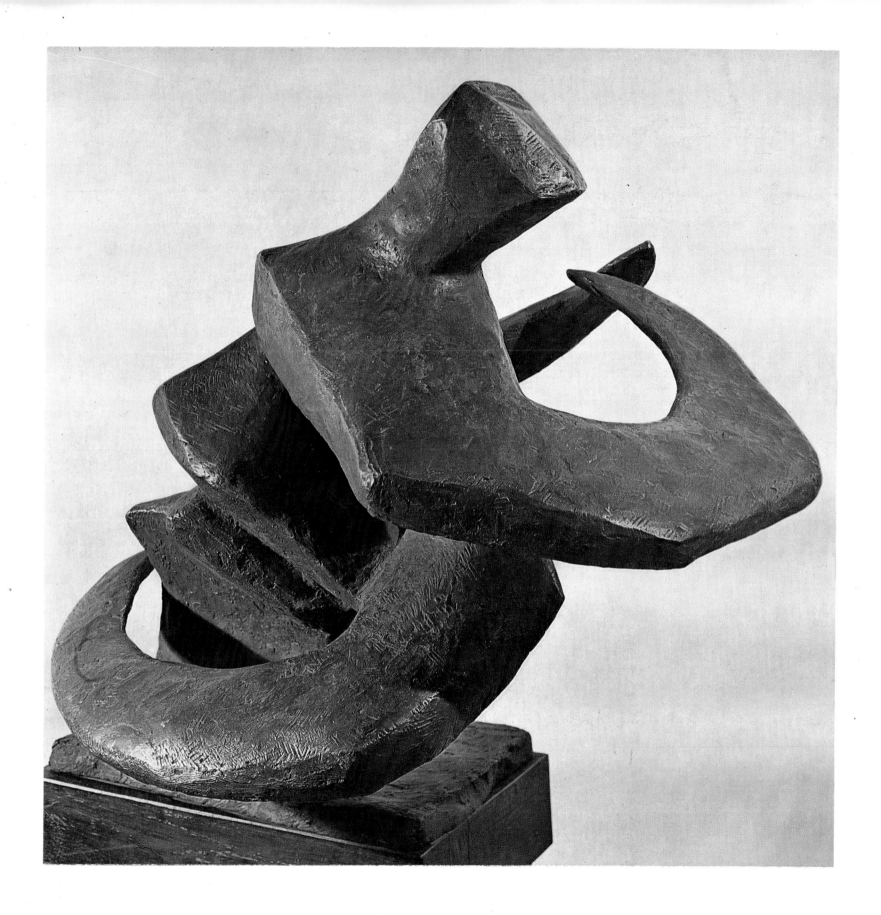

63. HARVESTER. *1945. Cast bronze, length 22".*

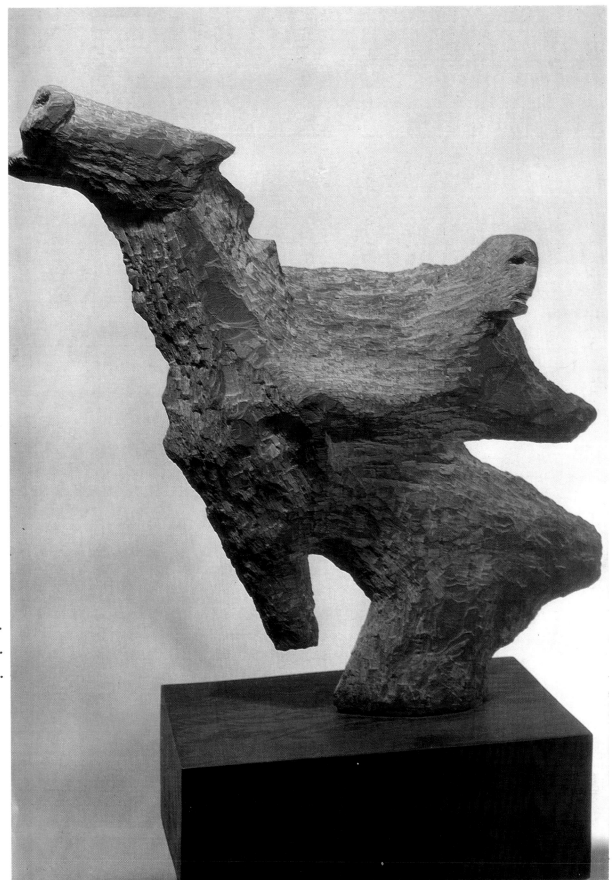

64.
NIGHT RIDER. *1945.*
Slate, height 25".

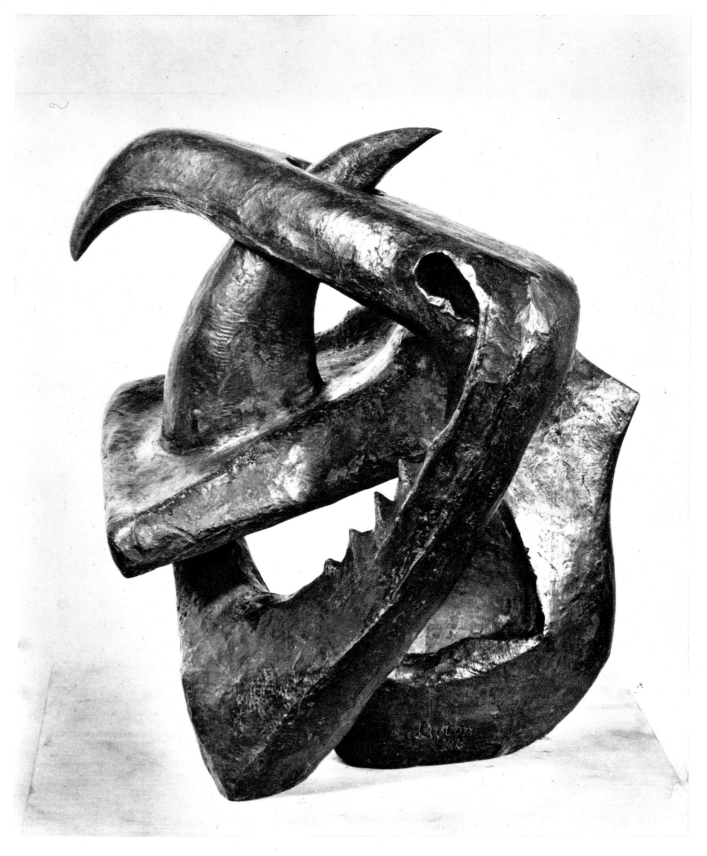

65.
MOLOCH #1. 1945.
Bronze, height 16".
Collection Wright Ludington,
Santa Barbara,
California

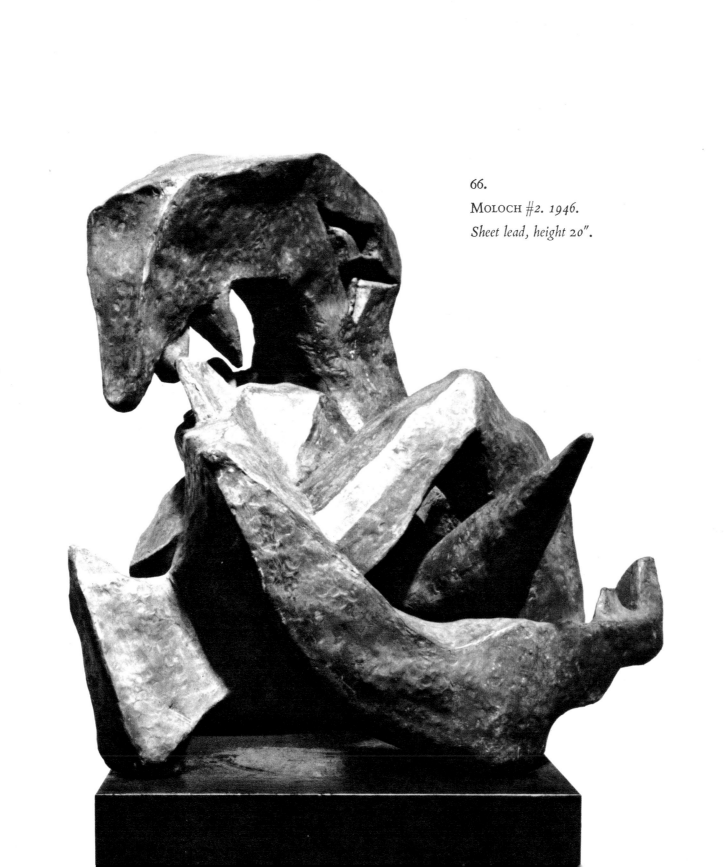

66.

MOLOCH #2. 1946.

Sheet lead, height 20".

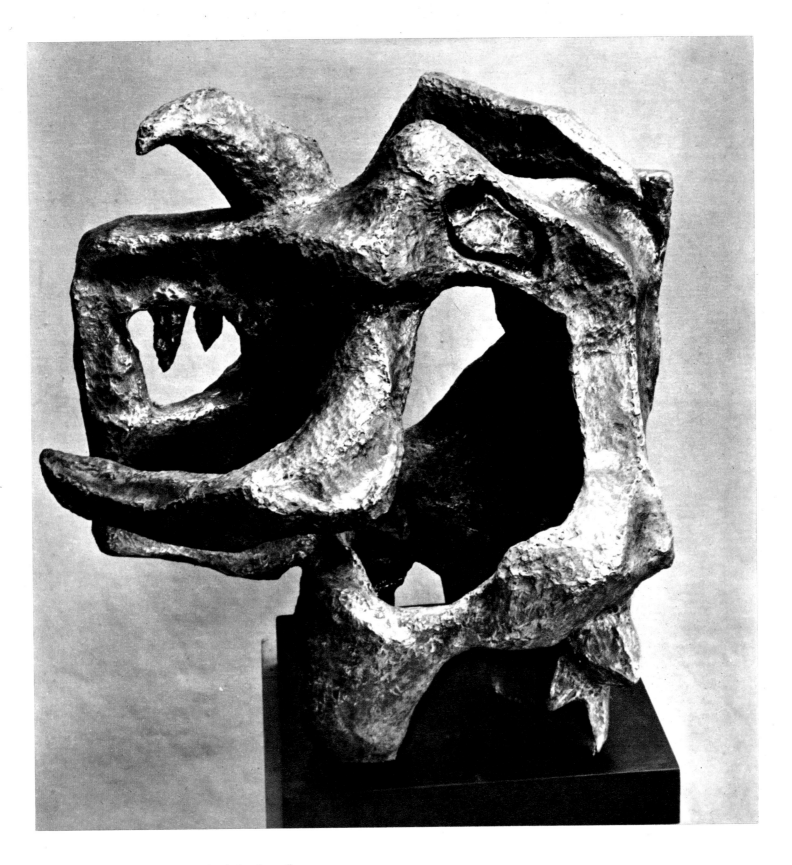

67. MOLOCH #3. 1946. Sheet lead, height 20".

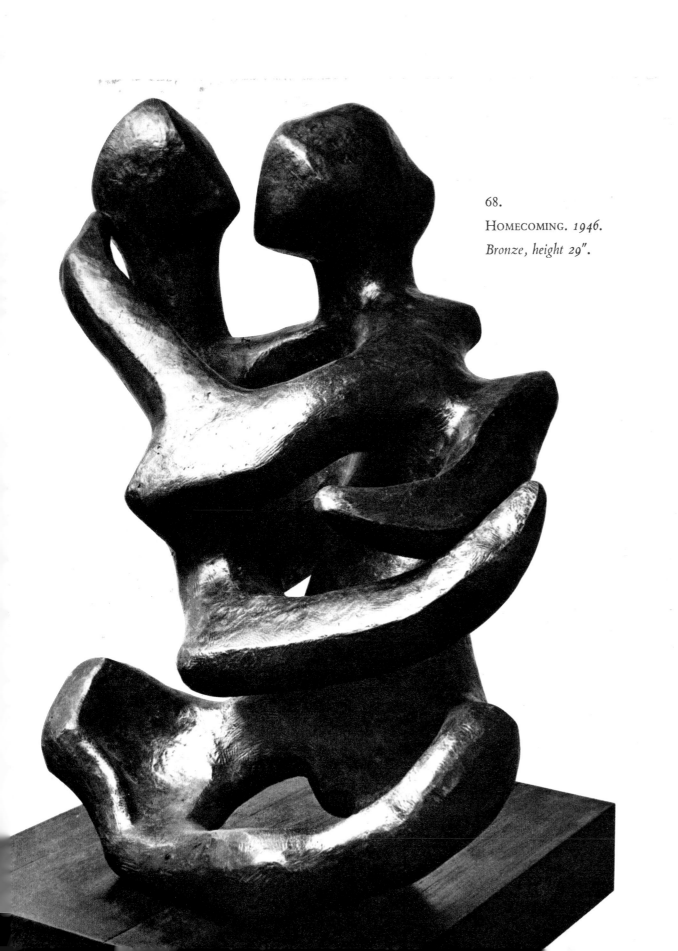

68.
HOMECOMING. *1946.*
Bronze, height 29".

69. ARGOSY. *1946. Cast bronze, length 29". New York University Art Collection*

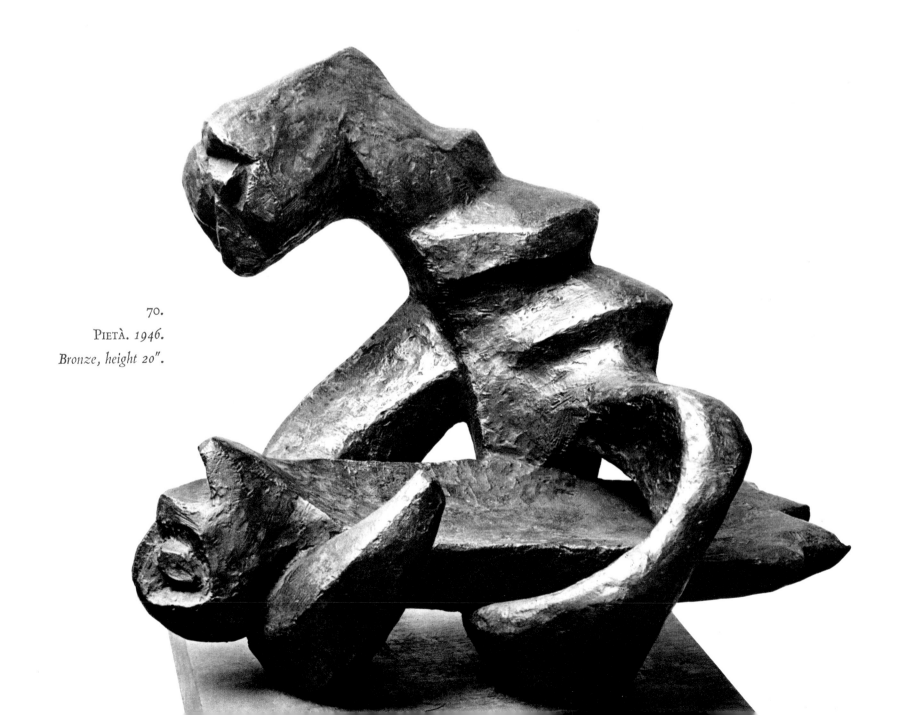

71.
CEREMONIAL. *1946.*
Sheet lead, length 20".

70.
PIETÀ. *1946.*
Bronze, height 20".

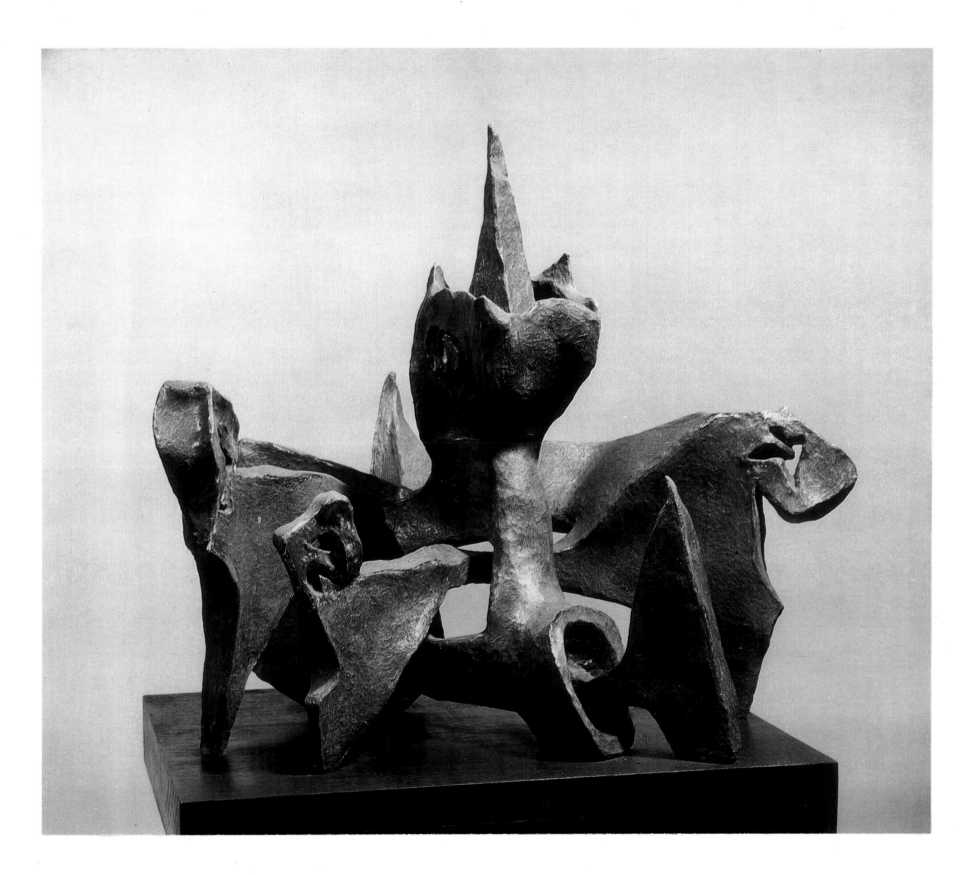

72.
MORTAL CAGE. *1946.*
Cast bronze, length 20".

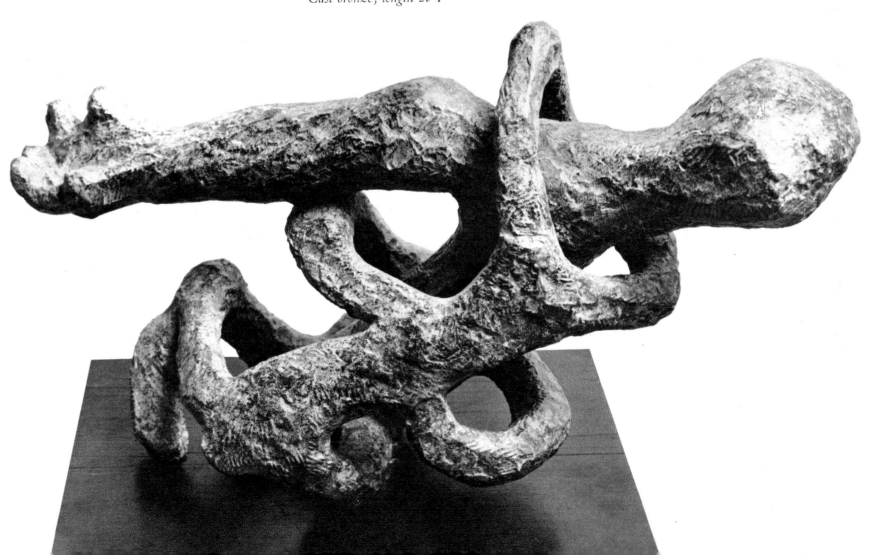

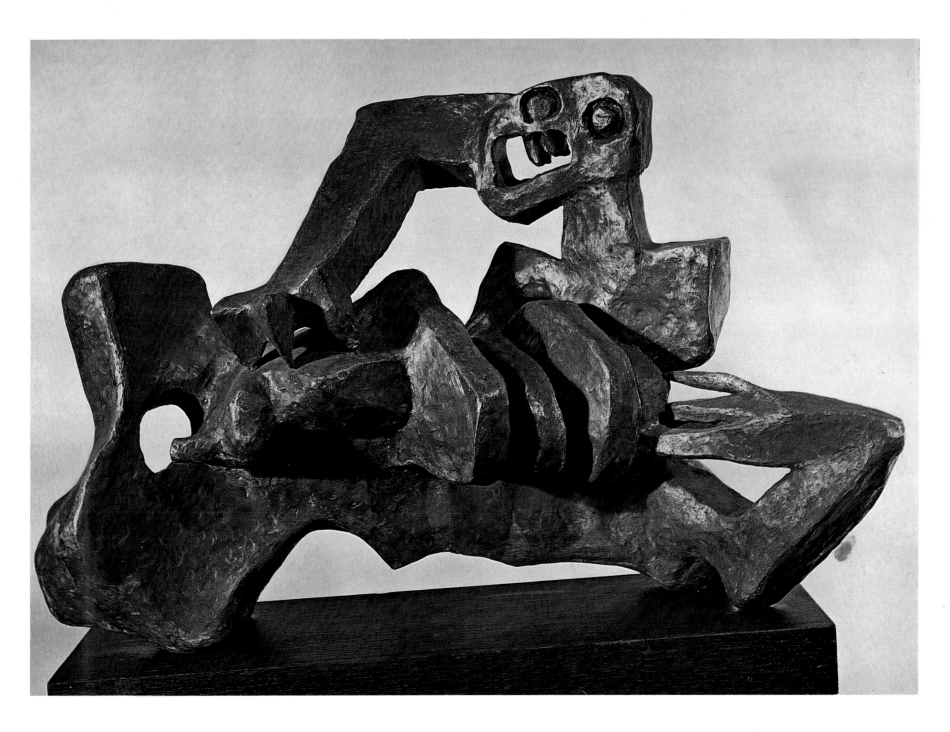

73. Dissonance. *1946. Sheet lead, length 24".*

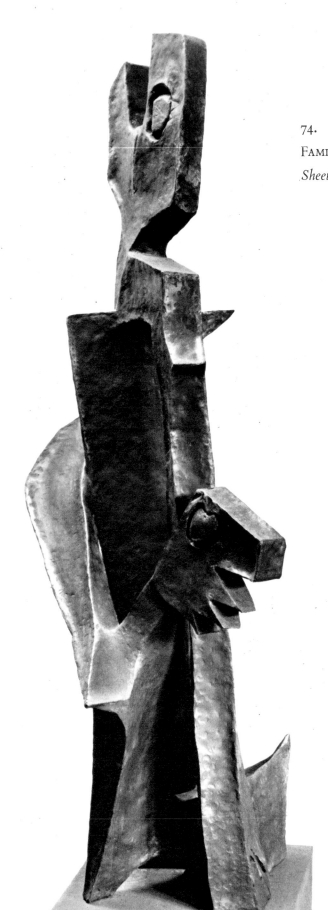

74.
FAMINE. *1946.*
Sheet lead, height 57".

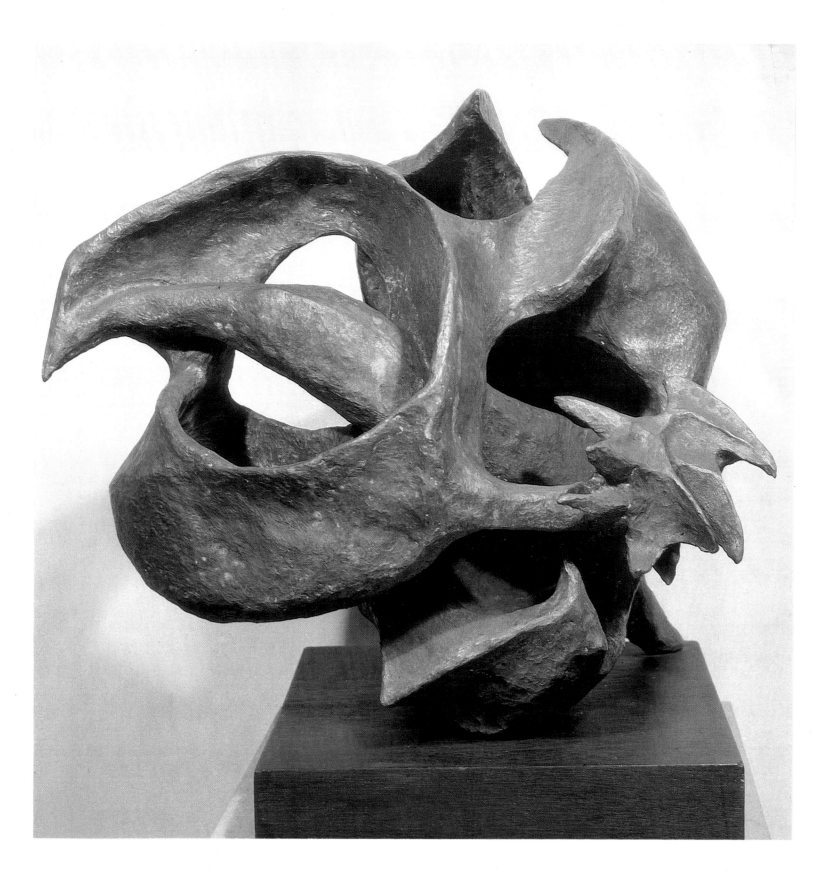

75. THORNY SHELL. *1946. Sheet lead, height 14″.*

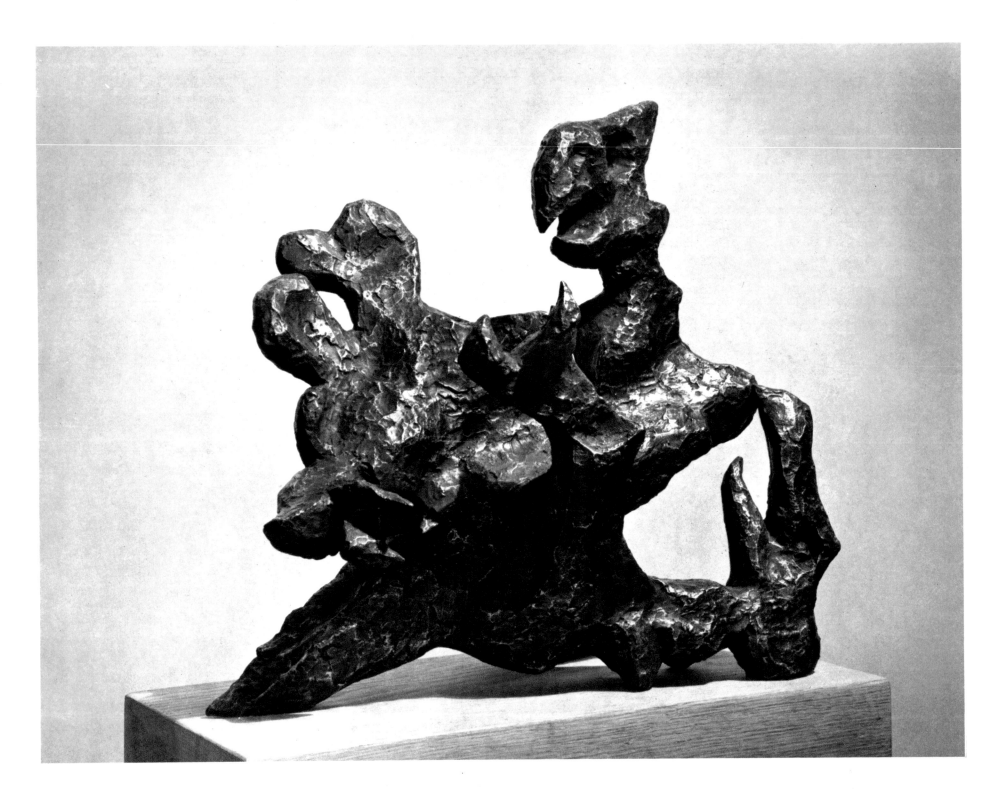

76. BATTLE OF GARGOYLES. *1946. Bronze, length 17".*

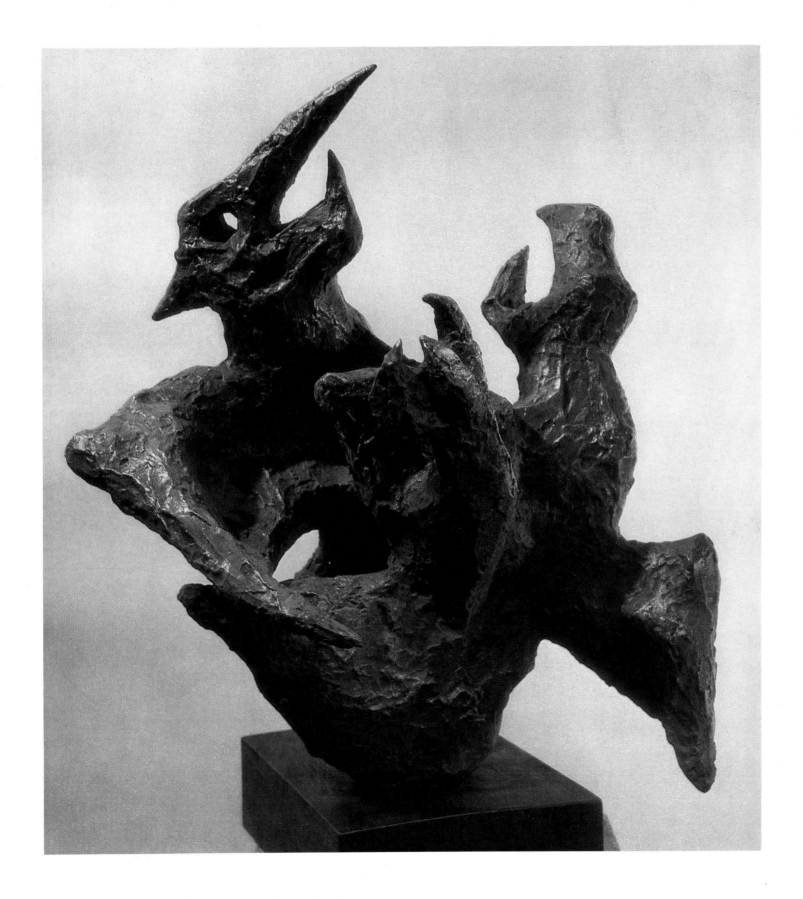

77. PREHISTORIC BIRDS #1. *1946. Cast bronze, length 18".*

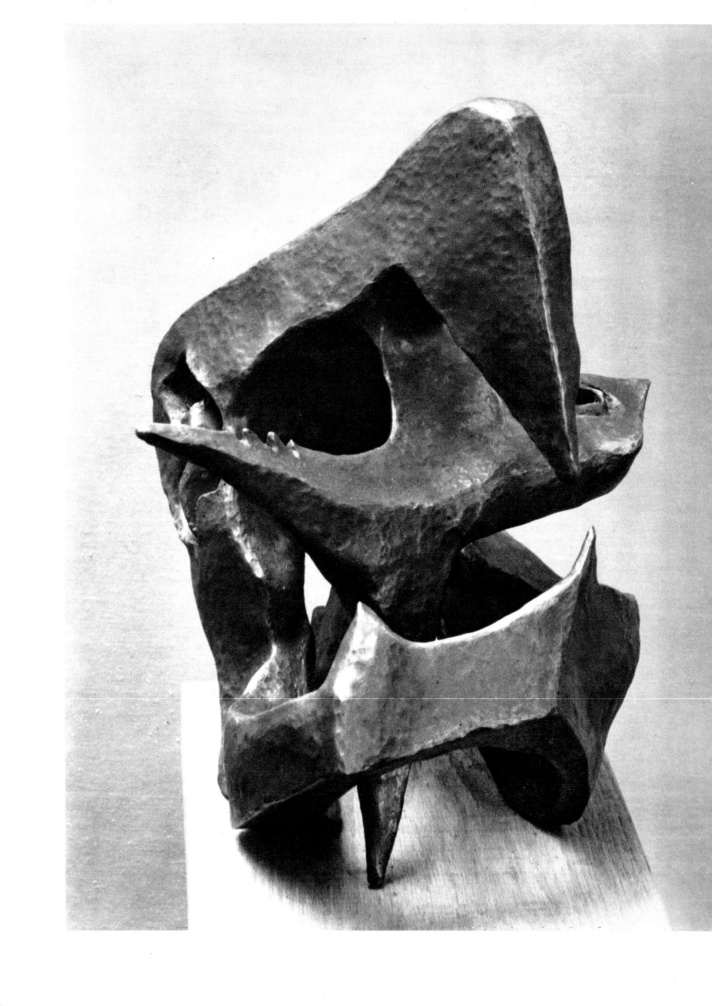

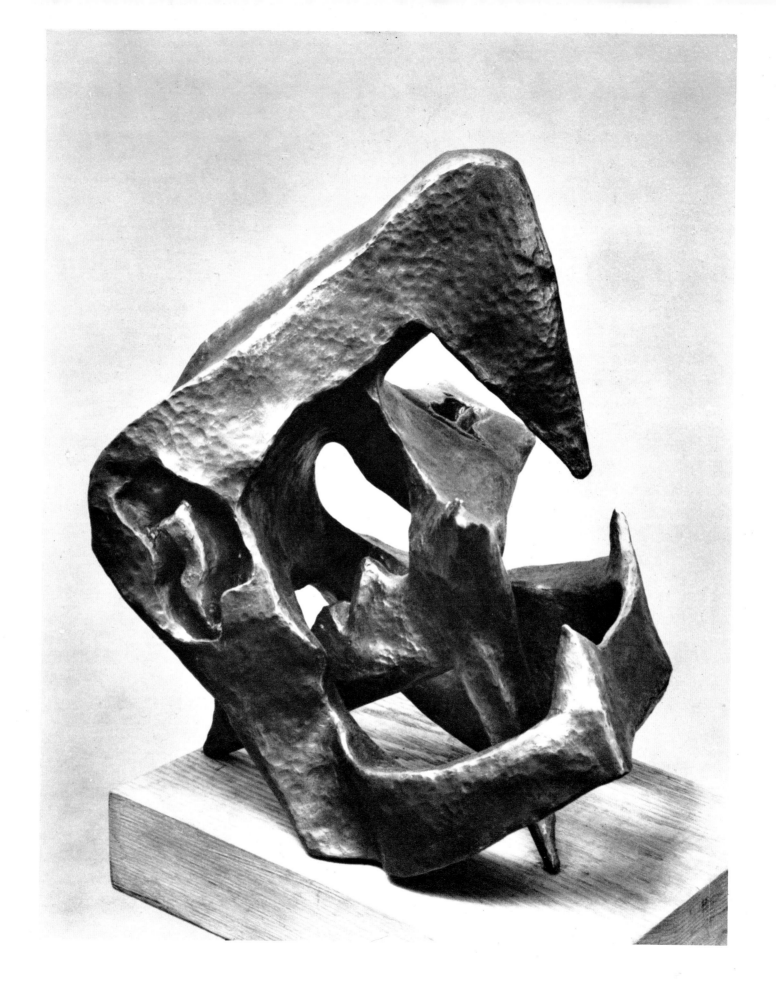

78, 79.
MOBY DICK #1 *(two views)*.
1946. Lead construction,
height 16".

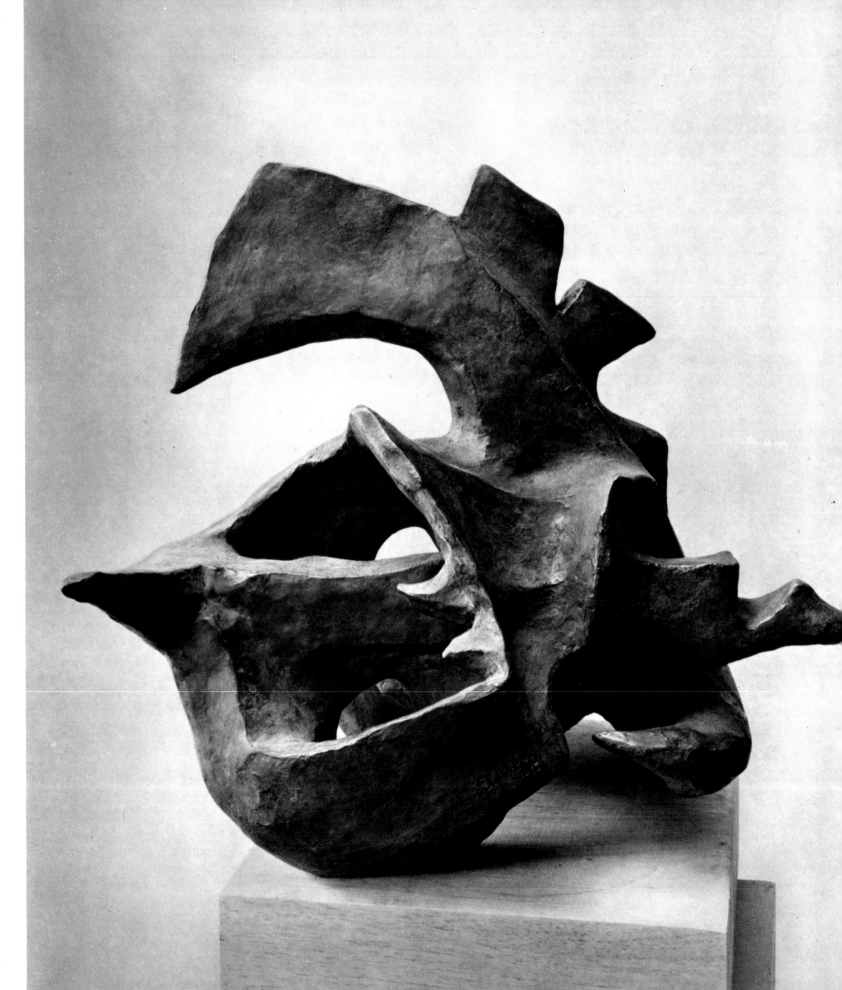

80.
MOBY DICK #2.
1946. Cast bronze,
height 17".

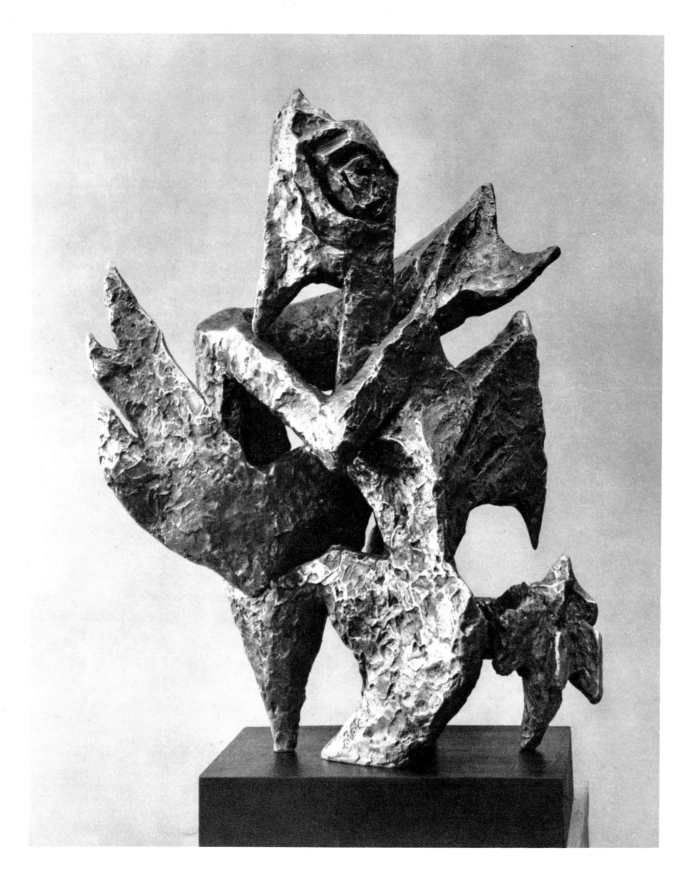

81. FIREBIRD #2. 1947. Cast bronze, height 22". Collection Dr. and Mrs. Jack J. Forest, New York

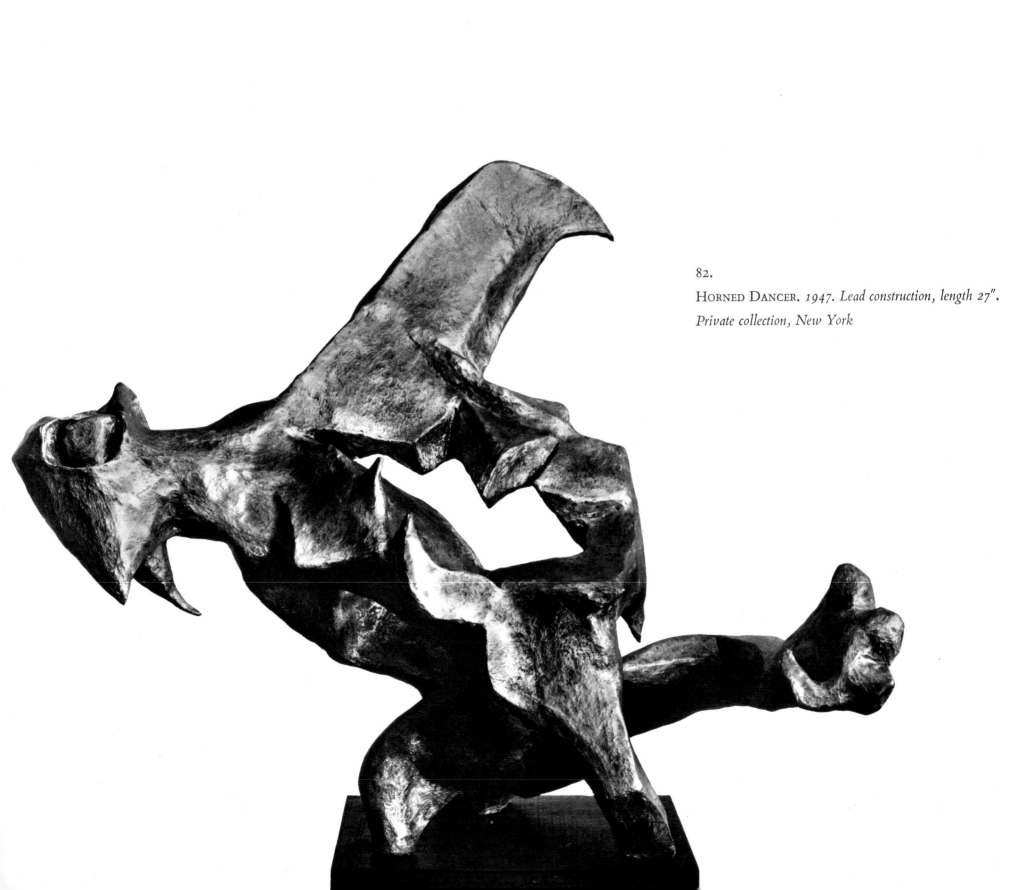

82.

HORNED DANCER. *1947. Lead construction, length 27".*
Private collection, New York

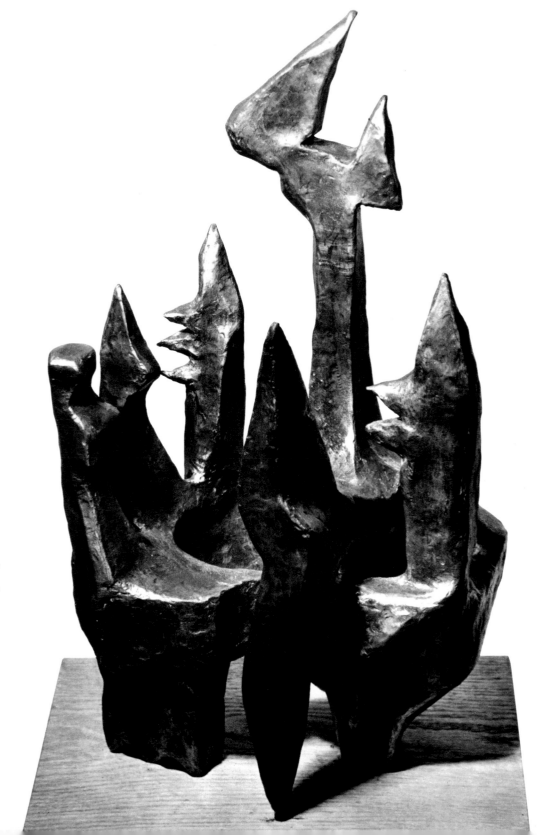

83.

COUNCIL. *1947. Sheet lead, height 16".*

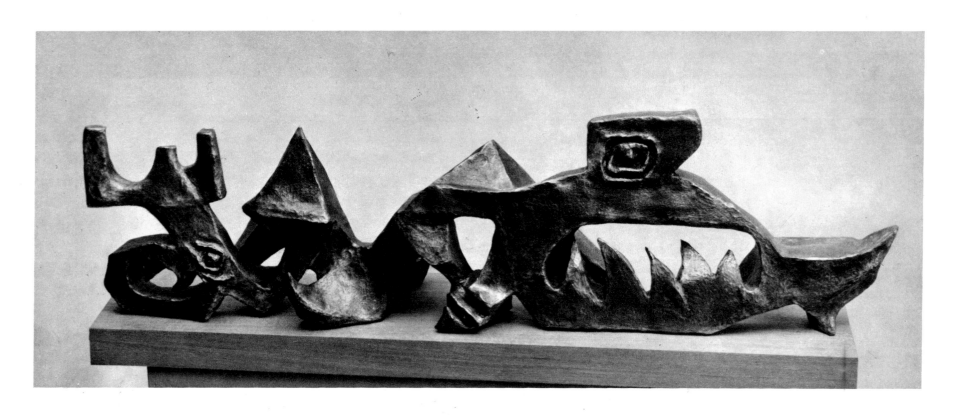

84. EXODUS #1. 1947. *Lead construction, length 33".*

85.
WILD EARTH MOTHER. *1947.*
Bronze, height 18".
Private collection,
Chicago

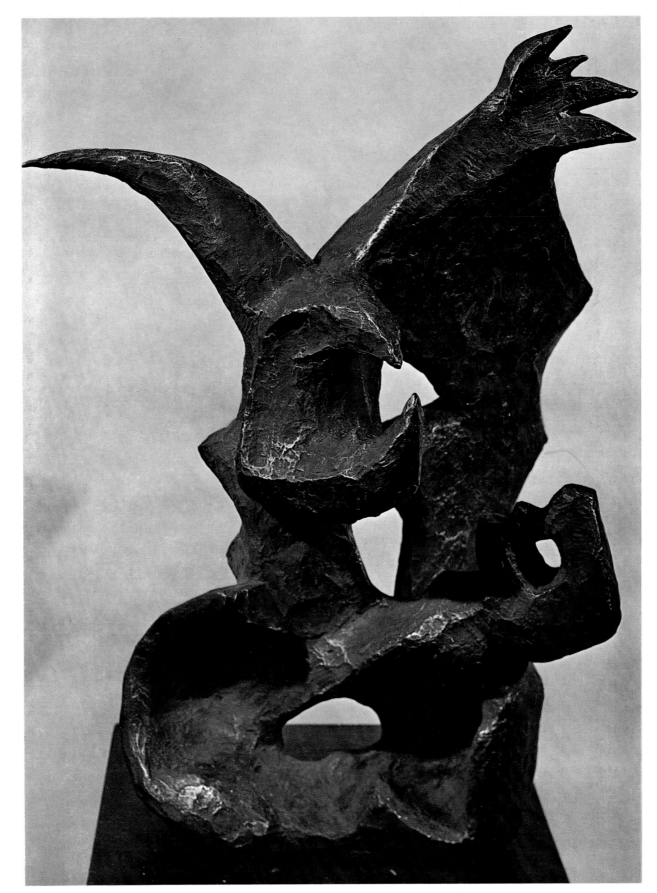

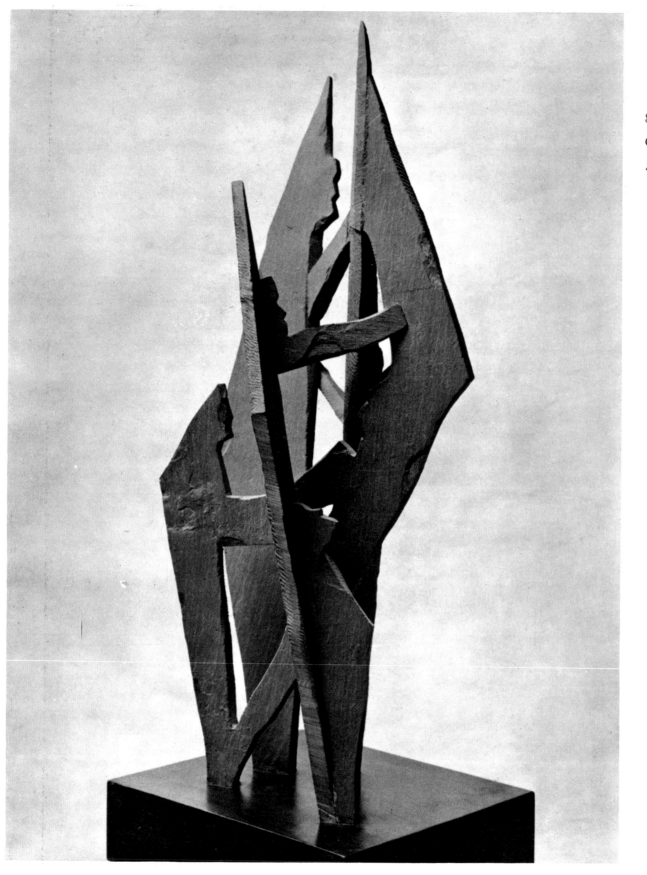

86.
CITY. *1947.*
Slate, height 26".

87.
CATHEDRAL. *1947.*
Sheet lead, height 23".

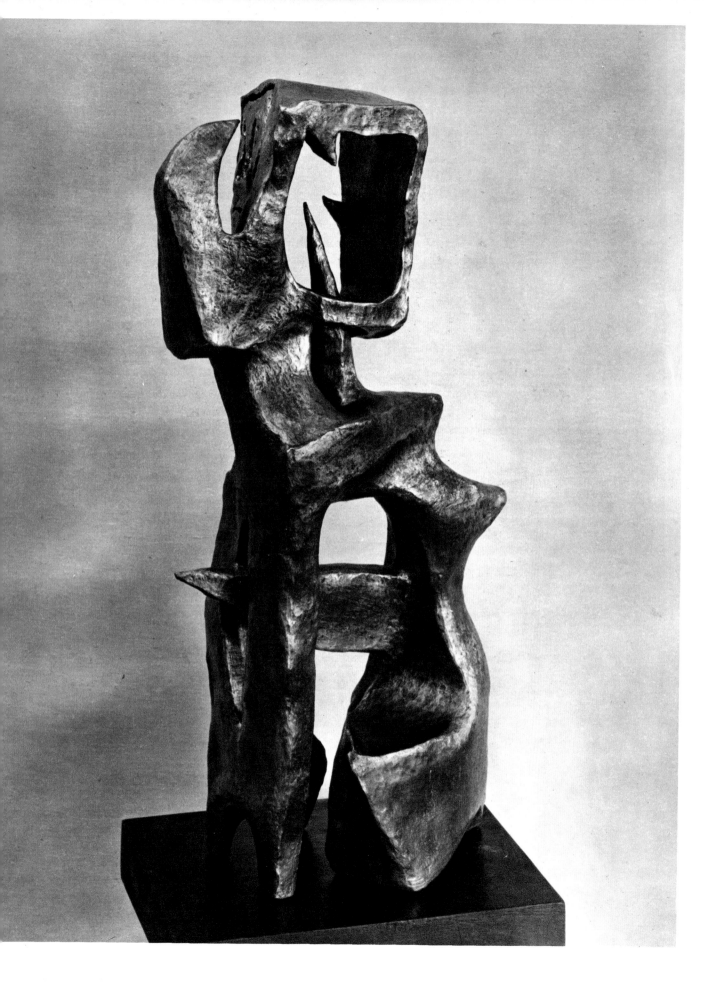

89.
CERBERUS. *1948.*
Sheet lead, height 23".
Collection Mr. and Mrs. Alvin S. Lane,
New York

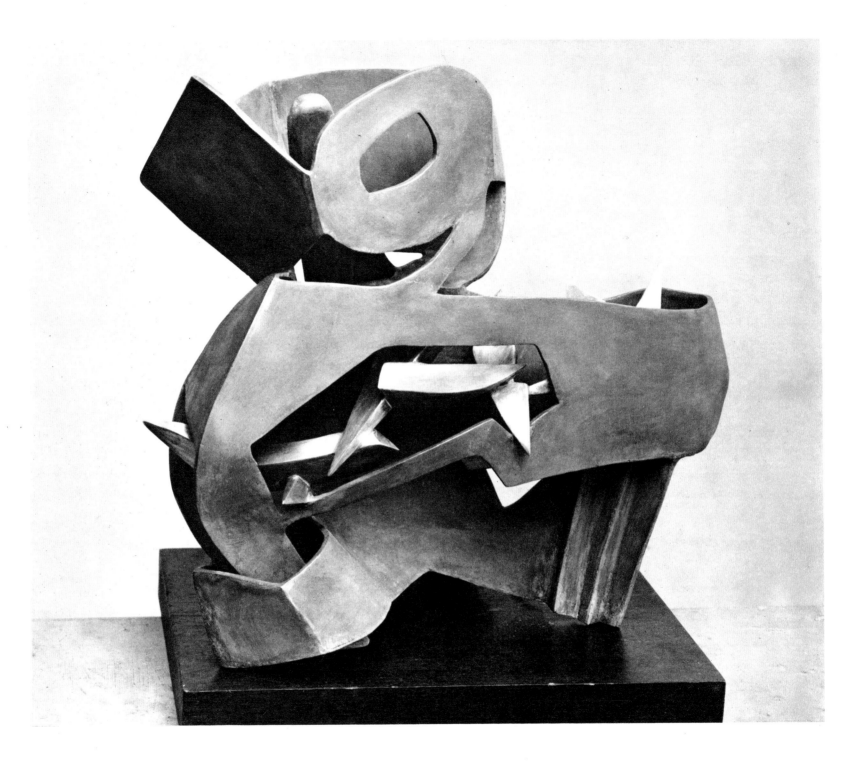

90. PIETÀ. *1948. Lead and brass, length 20".*

91. GENIE. *1948. Bronze and lead, height 21".*

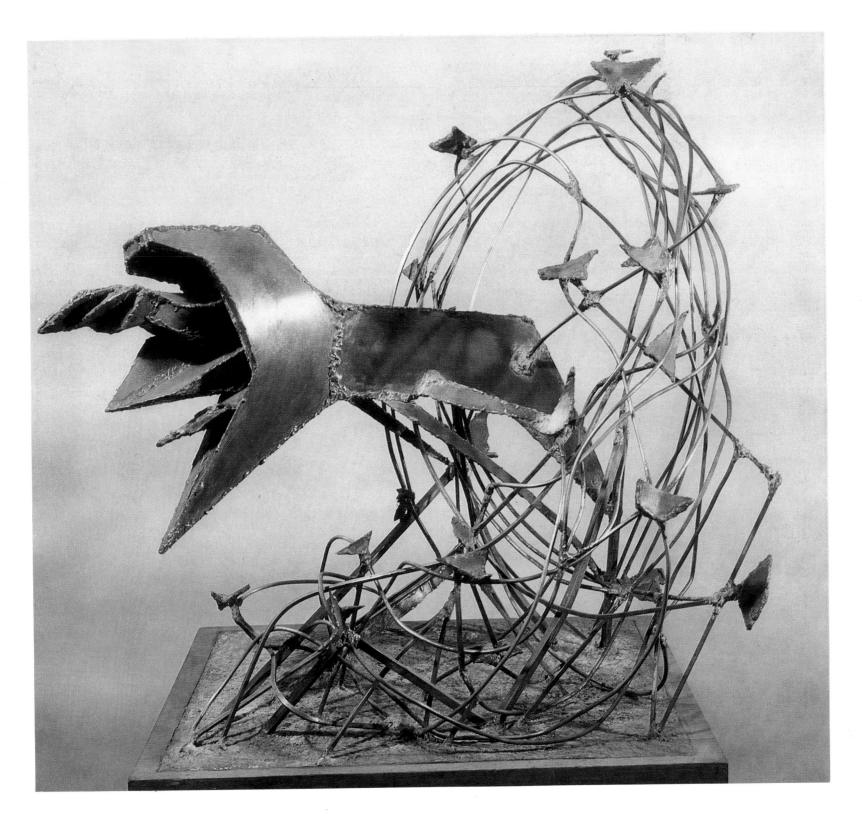

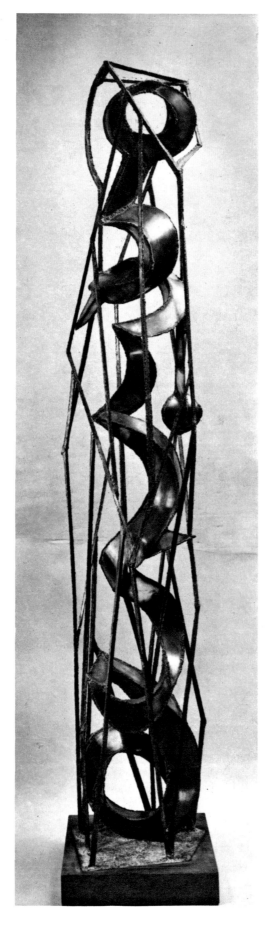

92.

PRISONER. *1948.*

Bronze and lead, height 78″.

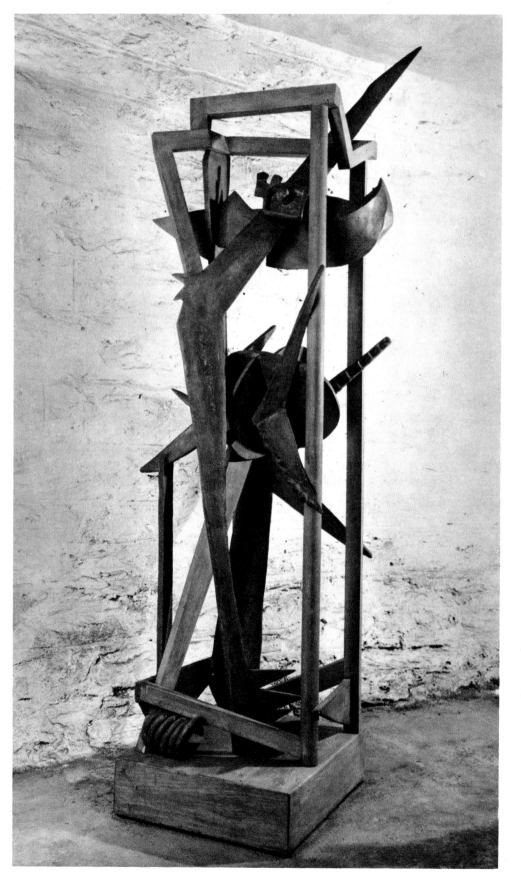

93.
IMPRISONED FIGURE. *1948.*
Lead and wood, height 80".
The Museum of Modern Art,
New York

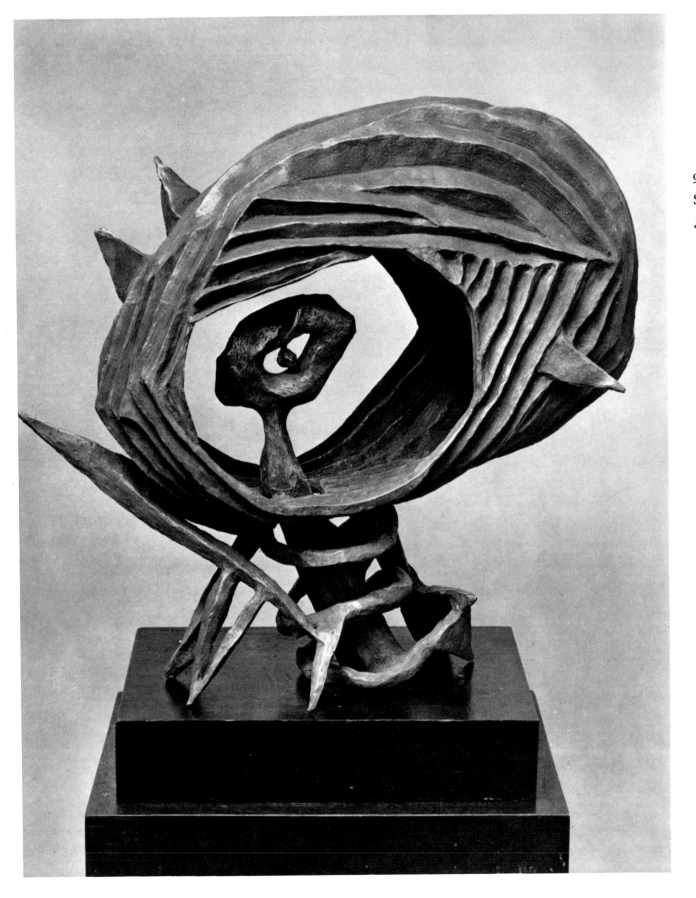

94.
SENTINEL. *1948.*
Sheet lead, height 16".

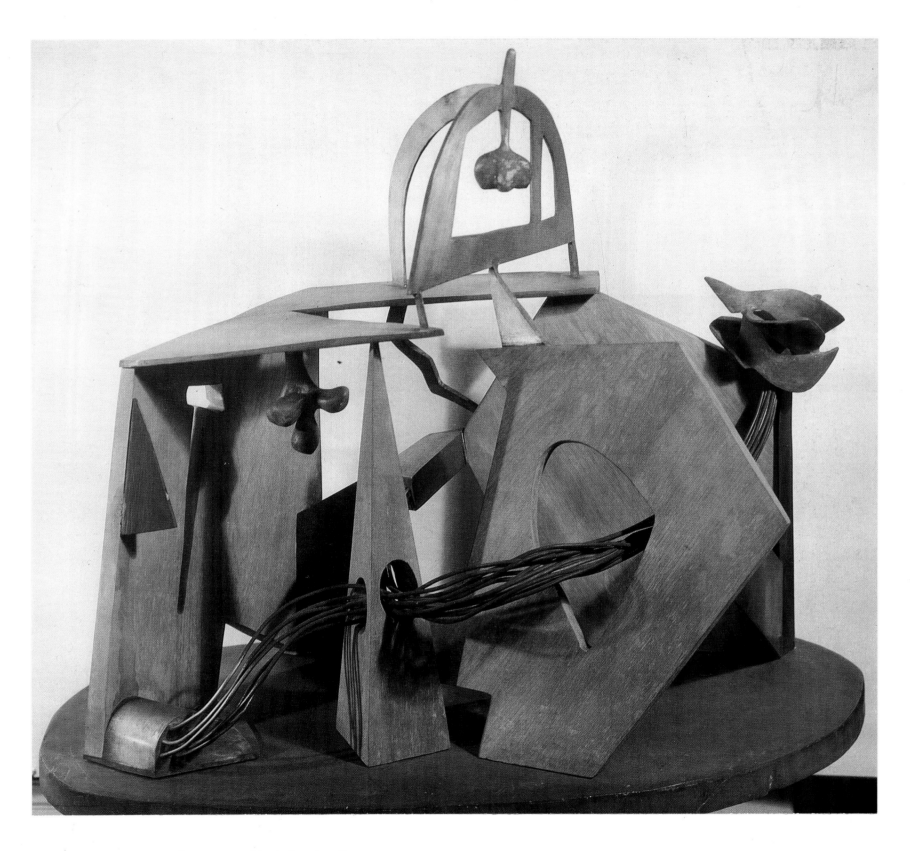

95. PAVILION. *1948. Wood, copper, and lead; length 25".*

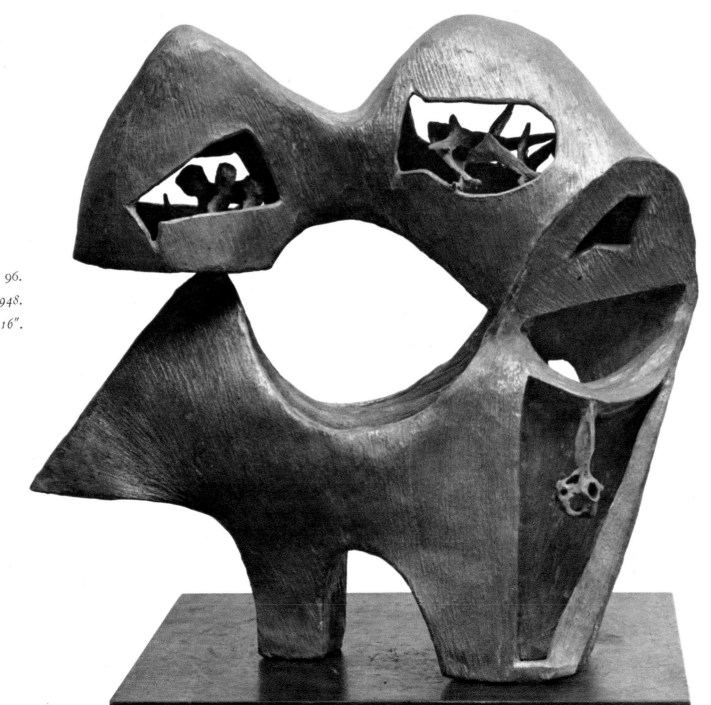

96.
PORTRAIT OF A POET. *1948.*
Sheet lead, height 16".

97. SQUARE MASK. *1948. Bronze and lead, height 18".*

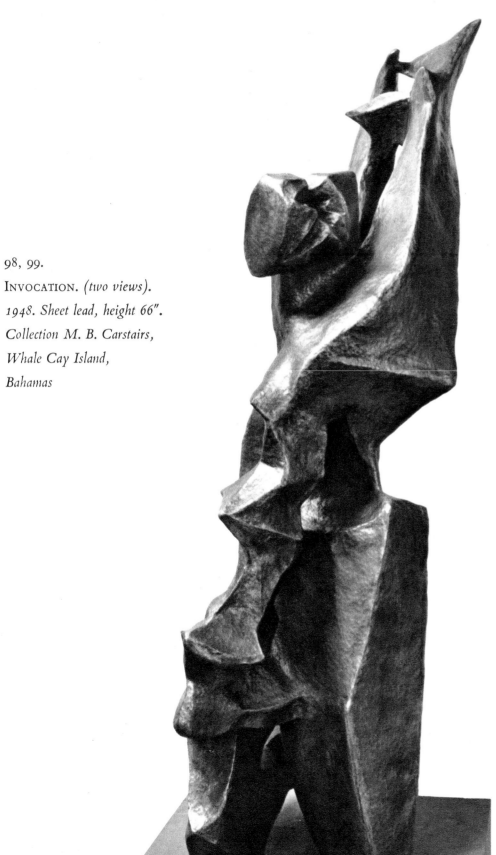

98, 99.
INVOCATION. *(two views).*
1948. Sheet lead, height 66".
Collection M. B. Carstairs,
Whale Cay Island,
Bahamas

100.
WARRIOR #1. *1948.*
Sheet lead, height 27".
Collection the artist

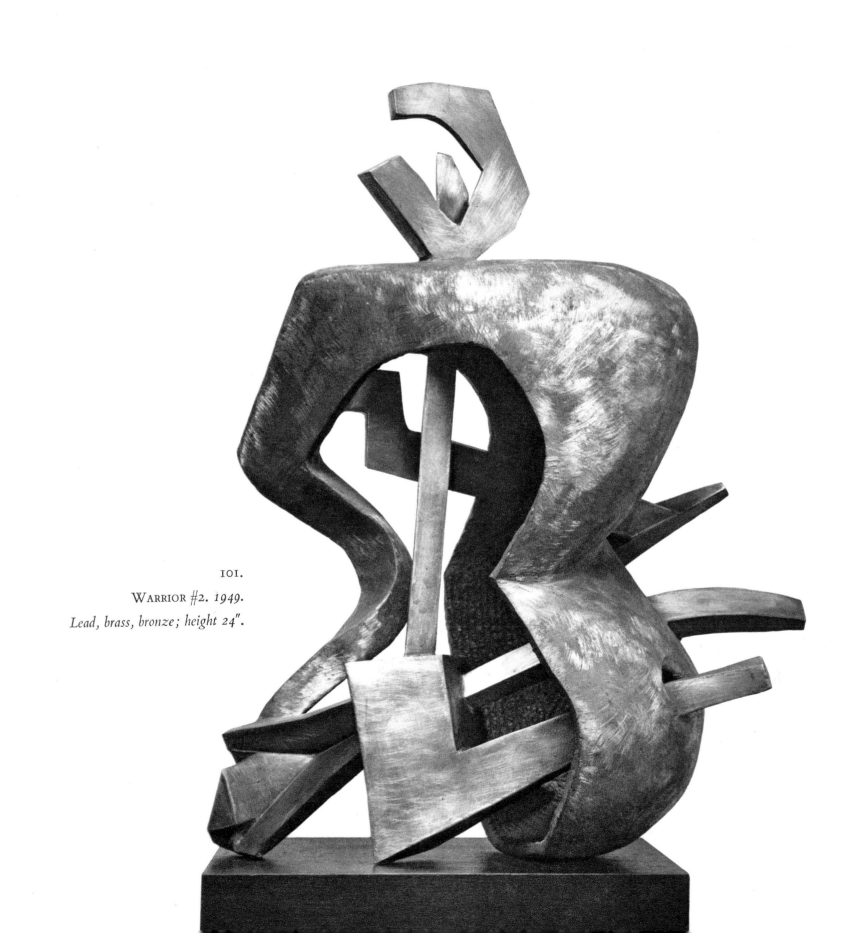

101.

WARRIOR #2. 1949.

Lead, brass, bronze; height 24".

102. MARTYR. *1948. Lead, iron, copper, glass; height 12″.*

103.
TRAVAIL. *1949.*
Sheet lead, length 20".

104.

Temple of the Mother. *1949.*

Lead construction, height 18".

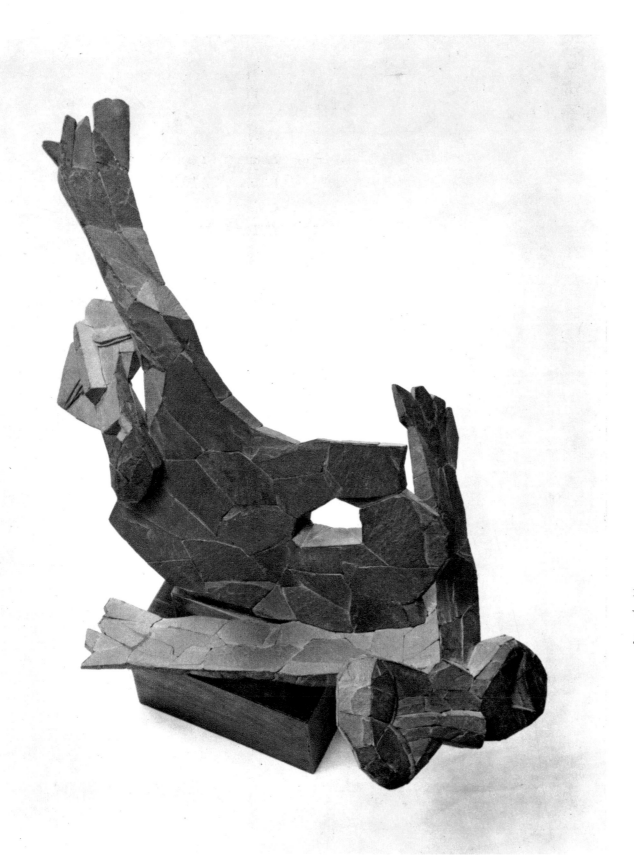

105.
WAR. *1949.*
Slate, height 19".

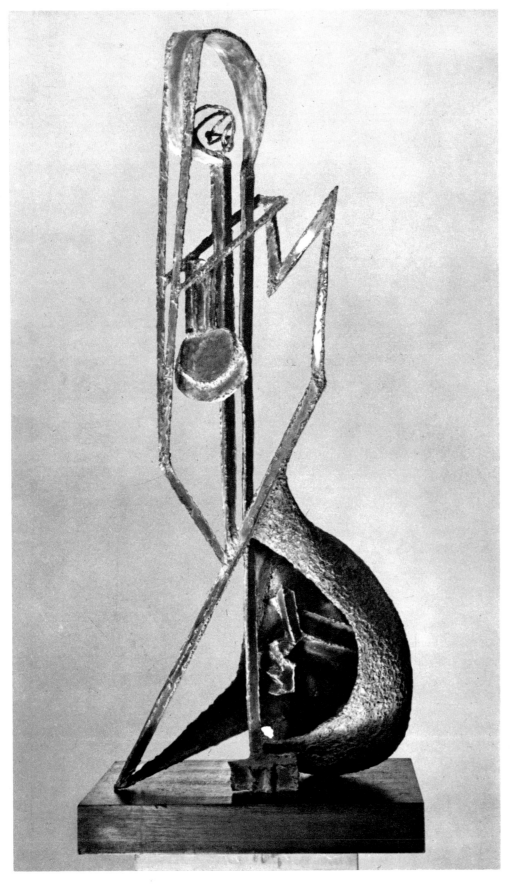

106.
PENDULUM. *1949.*
Brass, bronze, lead; height 33".
Collection Jerome and Pauline
Hellerstein, New York

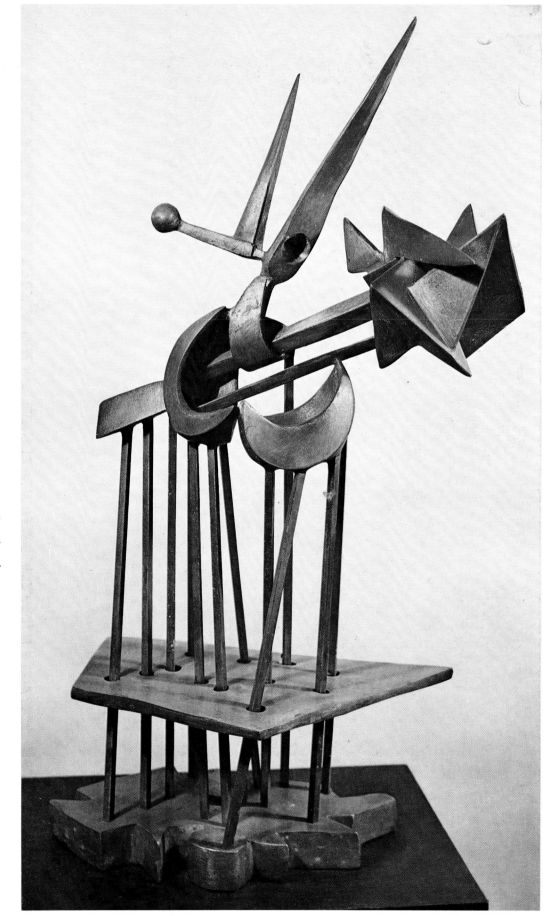

107.

MOON FLOWER. *1949.*
Brass and lead, height 19".

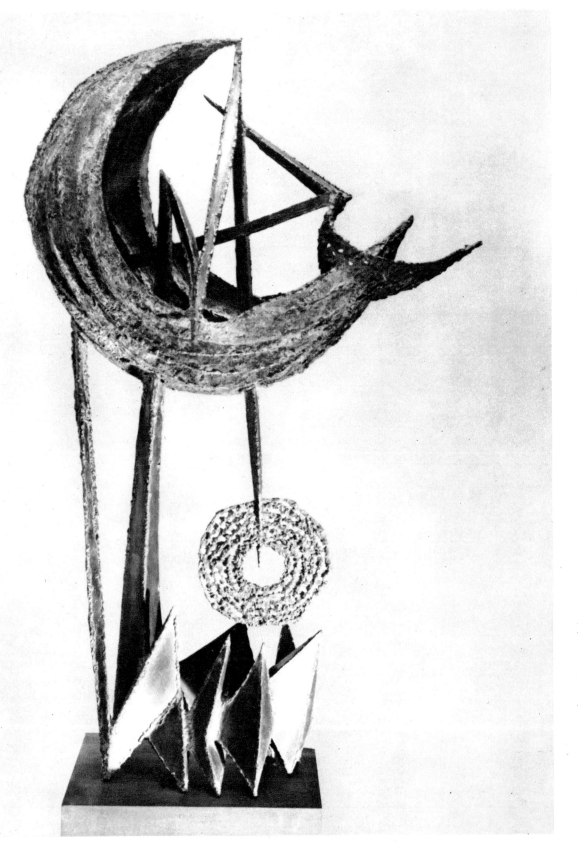

108.

EQUINOX. *1949.*
Sheet lead, iron,
brass, and bronze; height 32 1/2".
Munson-Williams-Proctor Institute,
Utica, New York

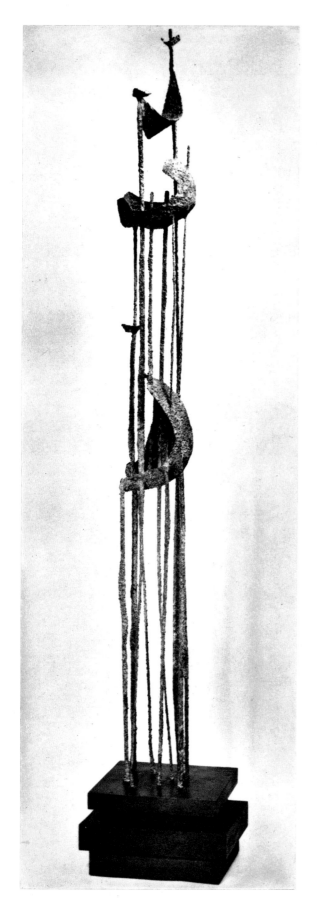

109.

INVOCATION #2. *1949.*

Lead and iron, height 81″.

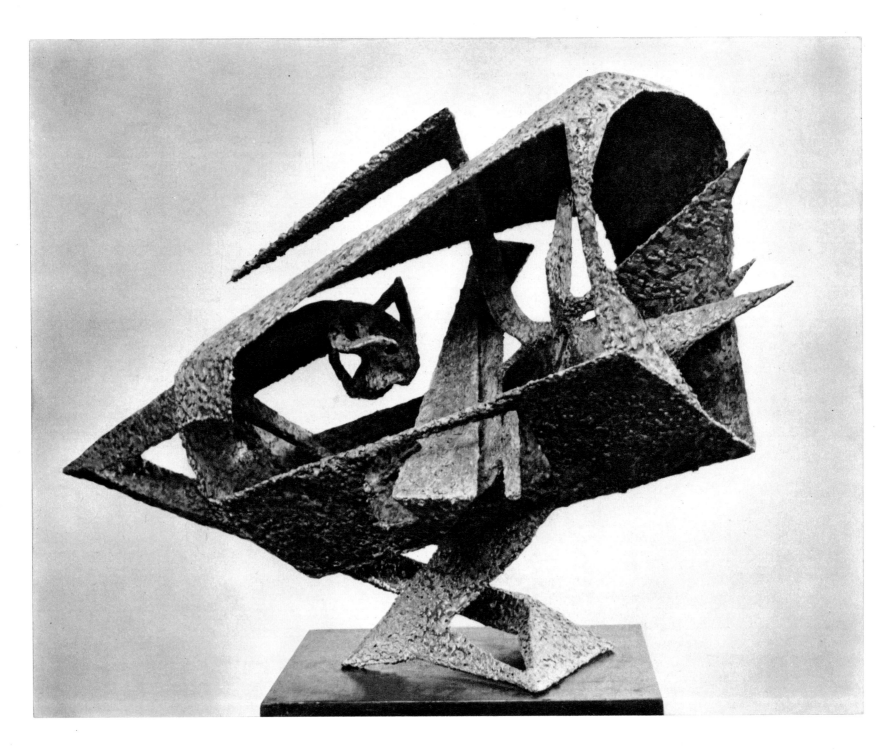

110. DARK CHAMBER. *1949. Lead on steel, length 38".*

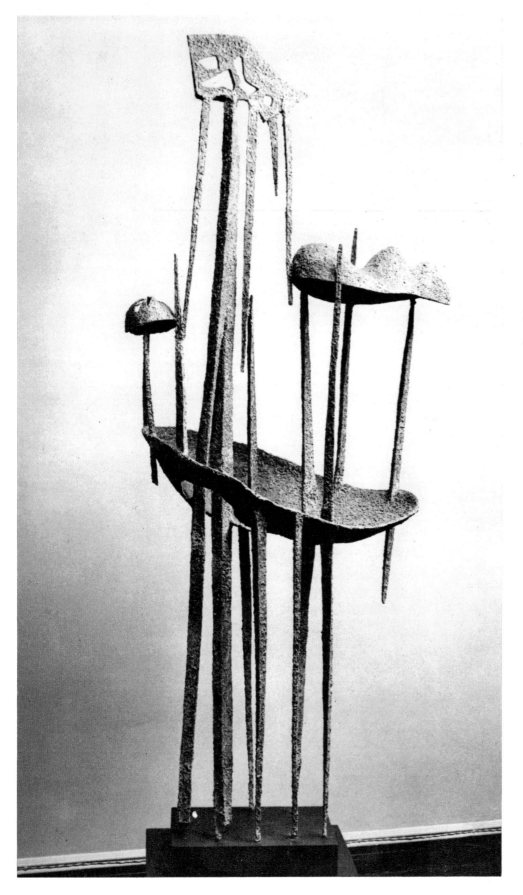

III.

FAMILY. *1950.*

Lead and iron, height 73".

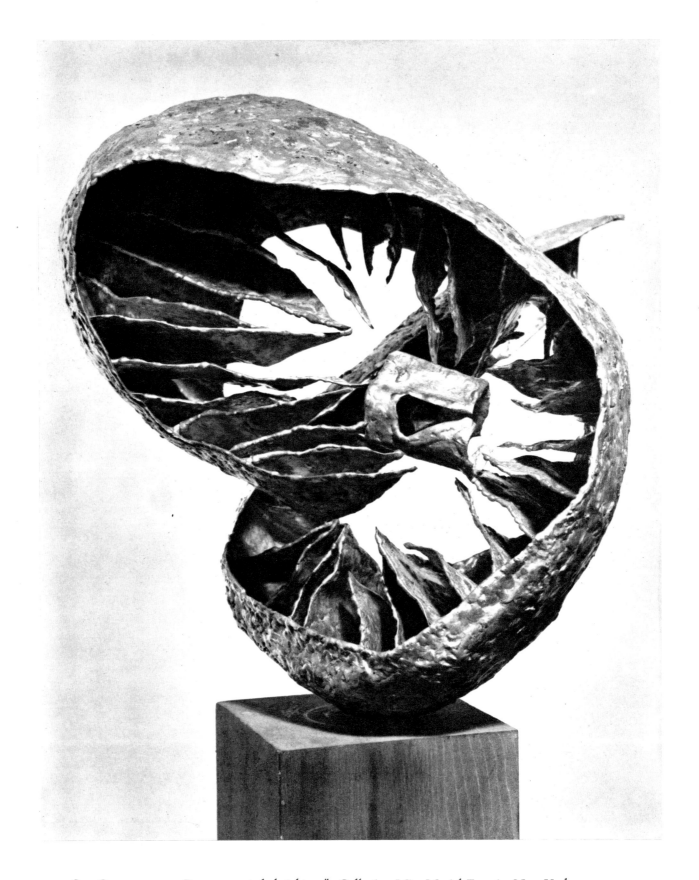

112. SEA GNOME. *1951. Bronze on steel, height 12". Collection Miss Muriel Francis, New York*

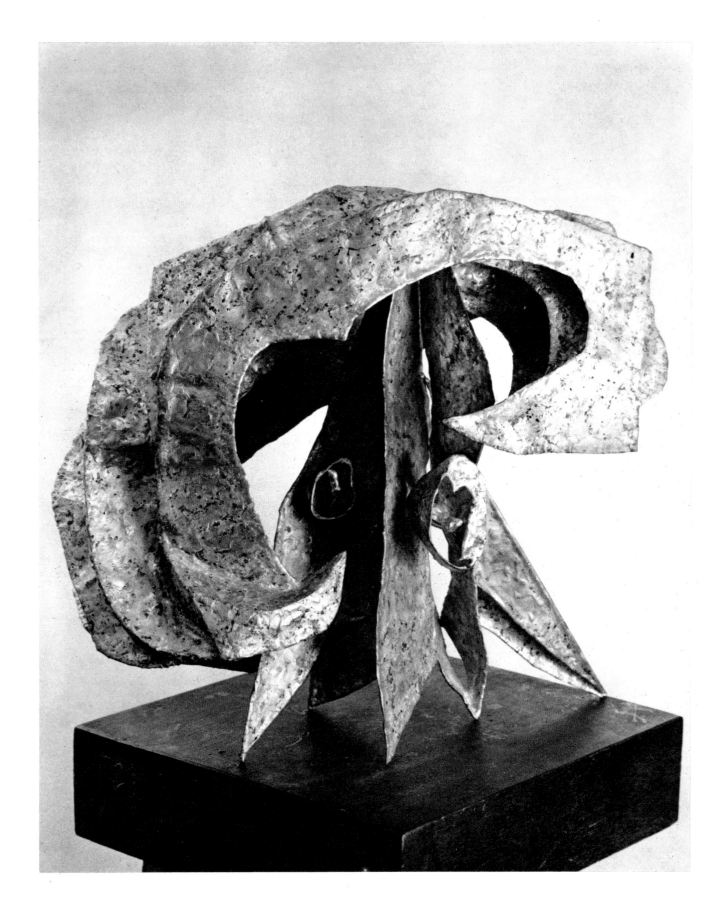

113. GUARDIAN #1. *1951. Bronze on steel, length 21".*

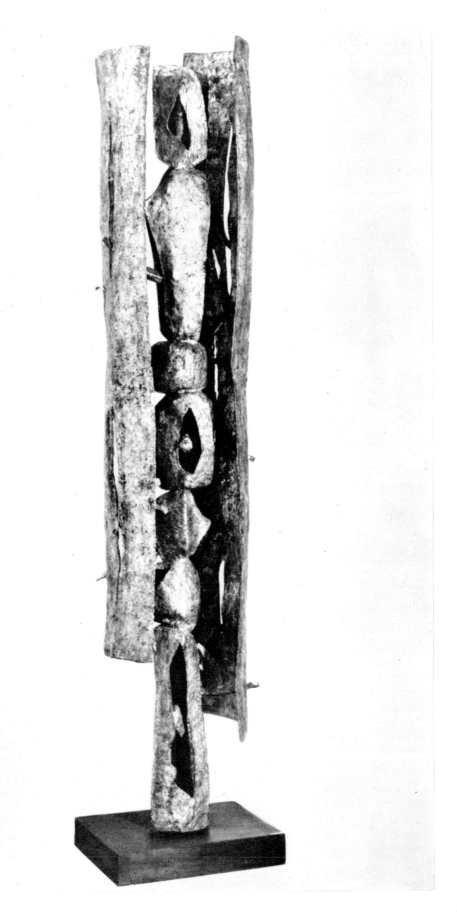

114.
CLOAK. *1951.*
Bronze on steel, height 96".
Private collection,
New York

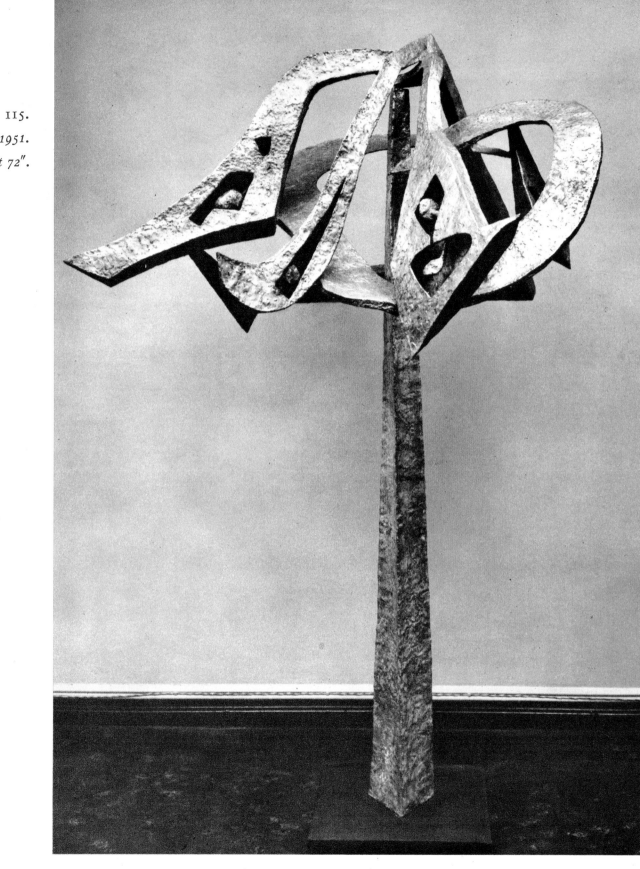

115.
SPRING CEREMONIAL. *1951.*
Bronze and steel, height 72".

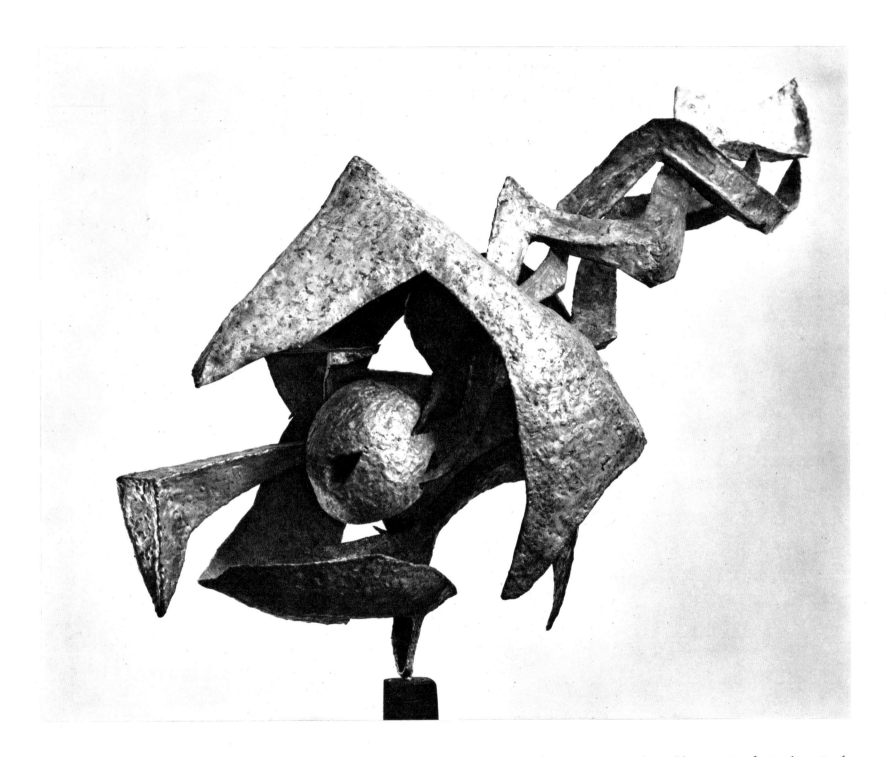

116. THUNDERBIRD. *1951–52. Bronze on steel, length 36 1/2". Whitney Museum of American Art, New York. Wildenstein Benefit Purchase Fund.*

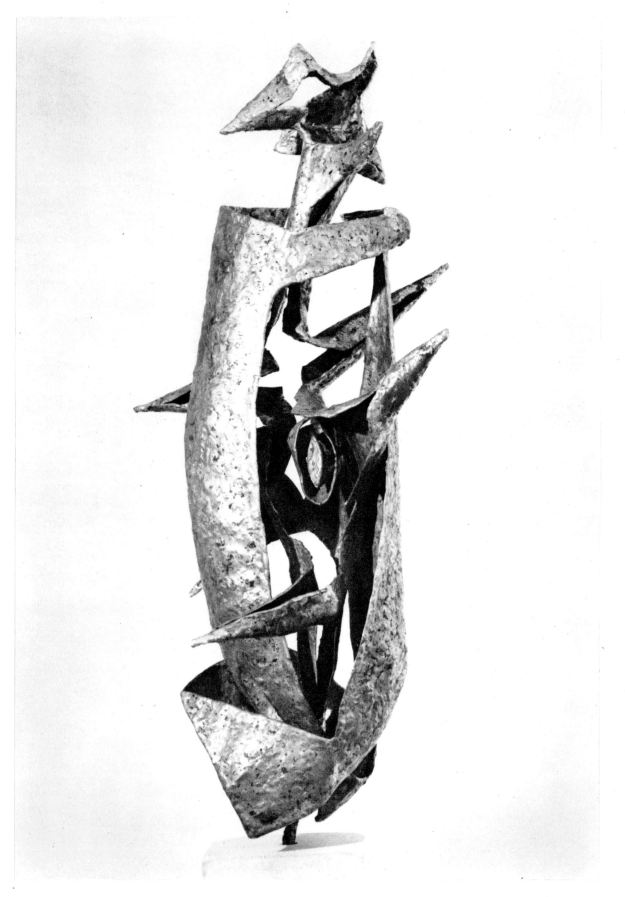

117.
EARTH MOTHER. *1952.*
Nickel-silver on
Monel metal, height 30".

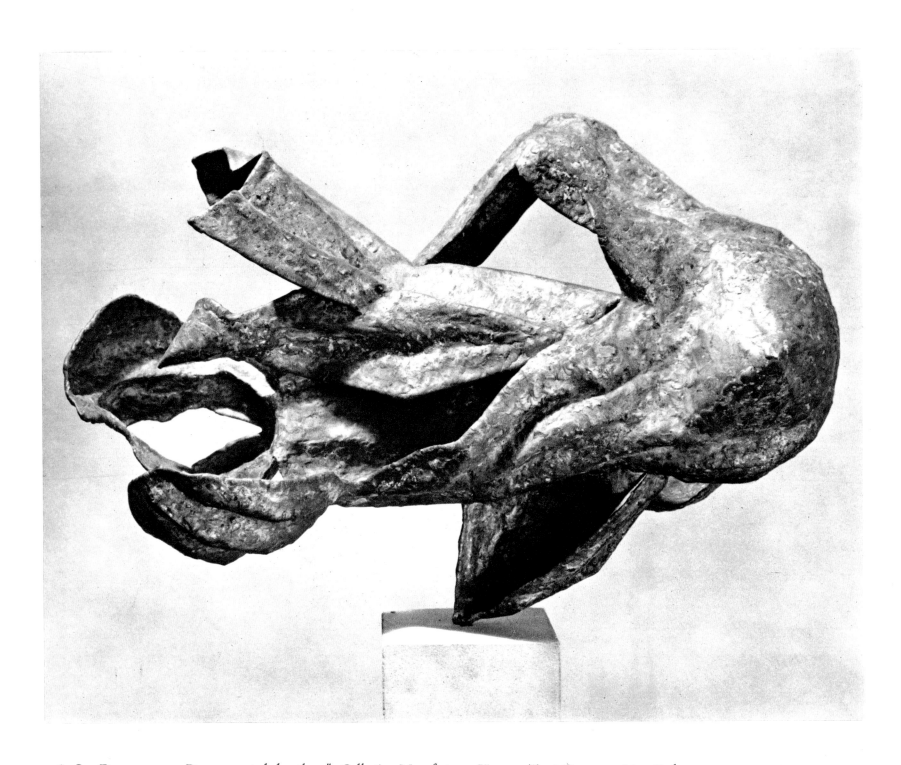

118. Sea Bloom. *1952. Bronze on steel, length 25″. Collection Manufacturers Hanover Trust Company, New York*

119.
CARNIVOROUS FLOWER. *1953.*
Nickel-silver on steel, height 30".
Collection Earle Ludgin,
Chicago

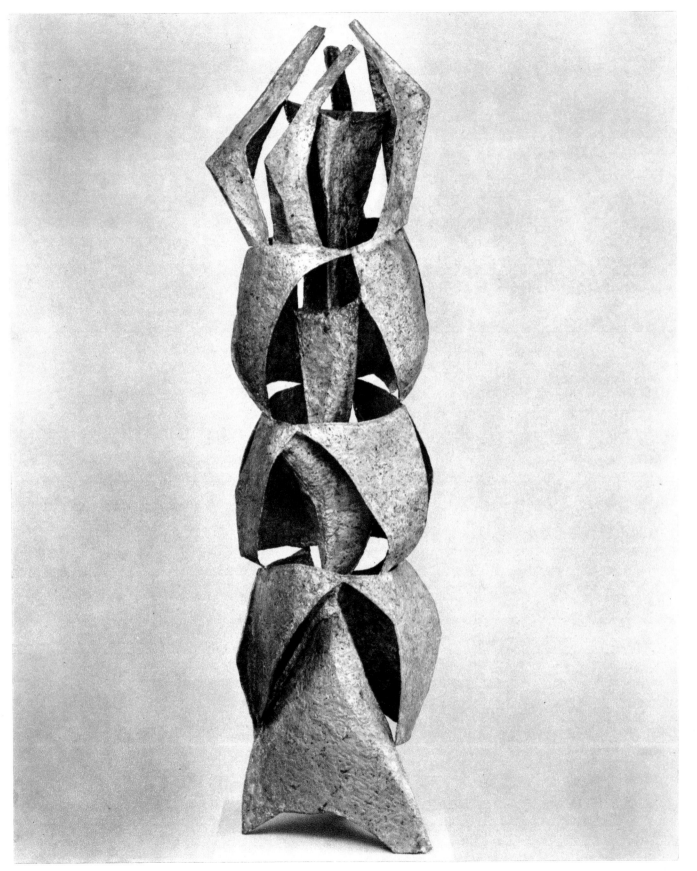

120.
GERMINAL #2. 1953.
Nickel-silver on Monel metal,
height 66".

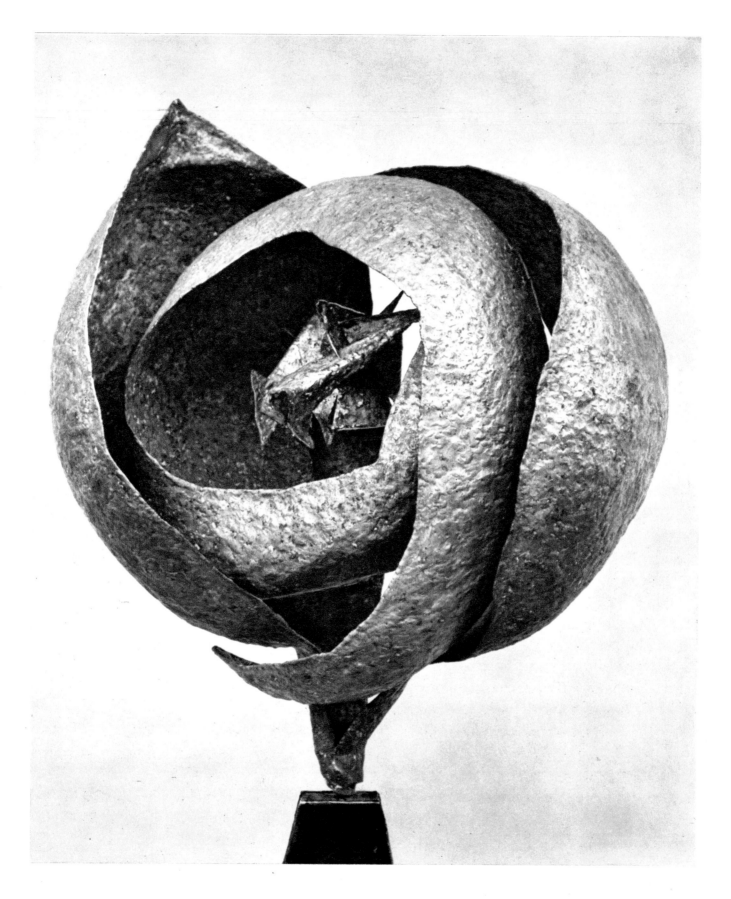

121. SANCTUARY. *1953. Nickel-silver on steel, height 29 1/4". The Museum of Modern Art, New York. Blanchette Rockefeller Fund*

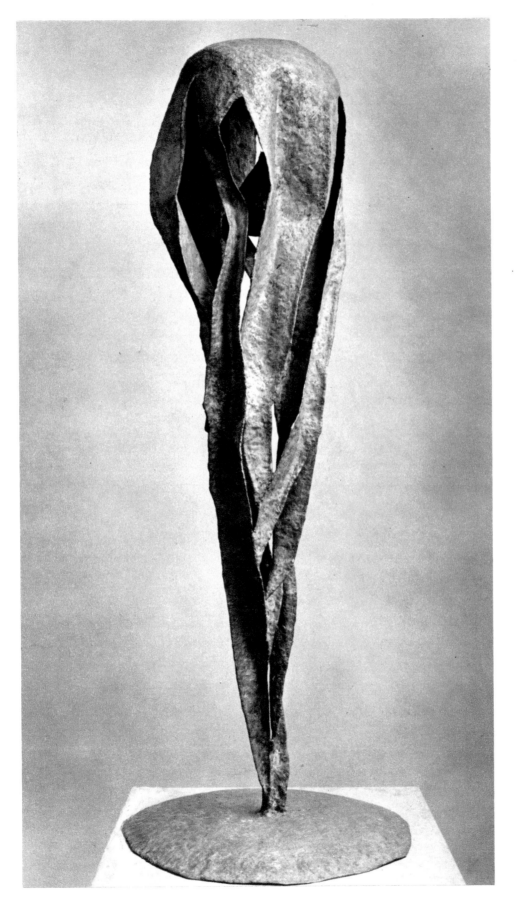

122.
PHOENIX. *1953.*
Bronze, height 60". Collection
Mr. and Mrs. George Mack,
New York

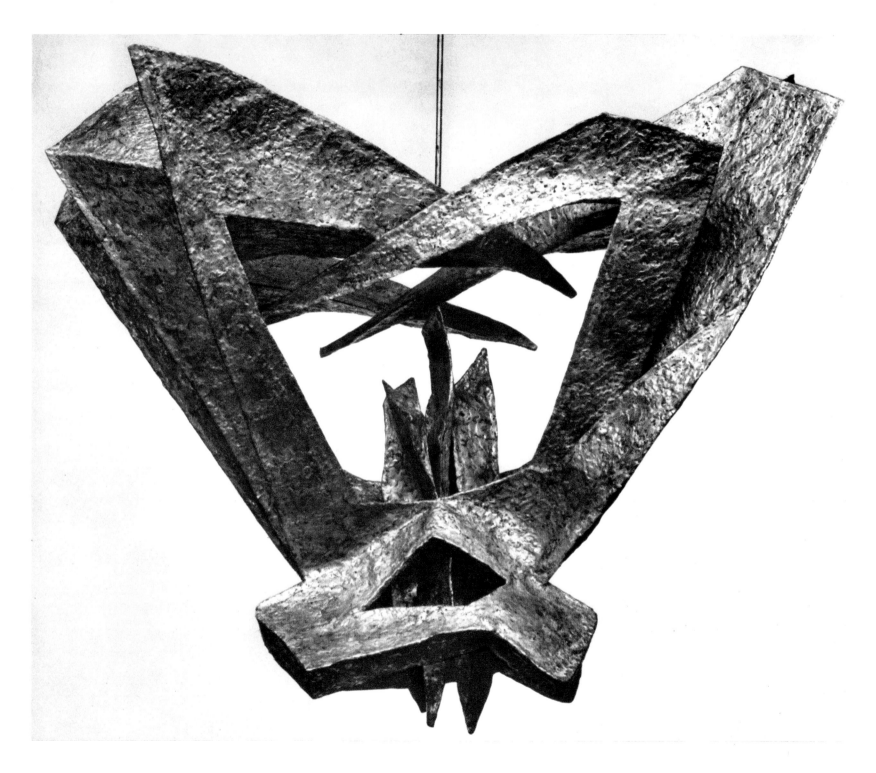

123. ETERNAL LIGHT. *1953. Nickel-silver on steel, 38×48″. Temple Israel, Tulsa, Oklahoma*

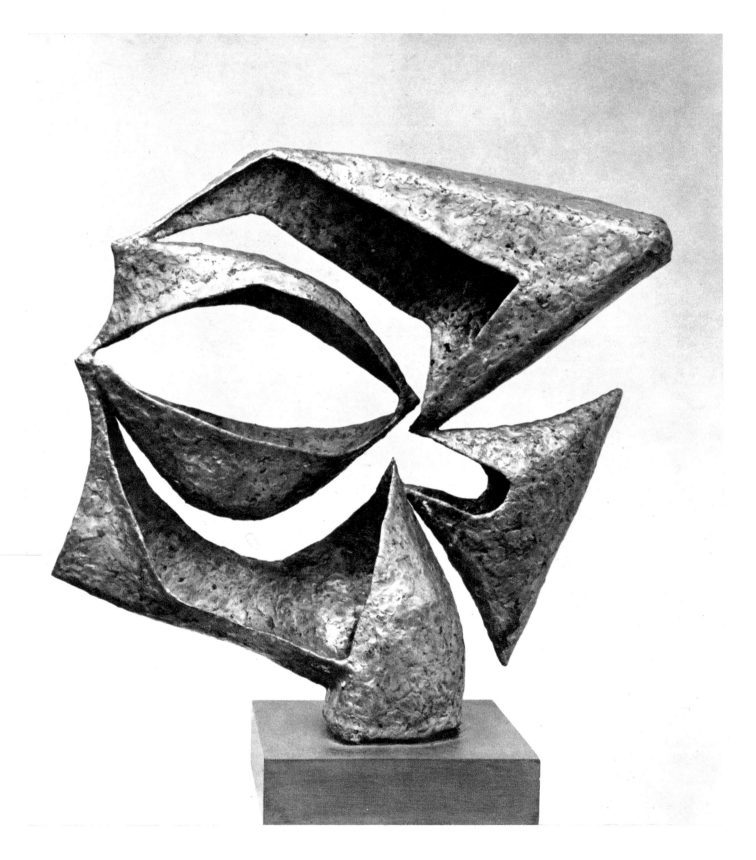

124. SUNDIAL. *1954. Nickel-silver on steel, 19×18×8". Collection Elinor Walker Ellsworth, New York*

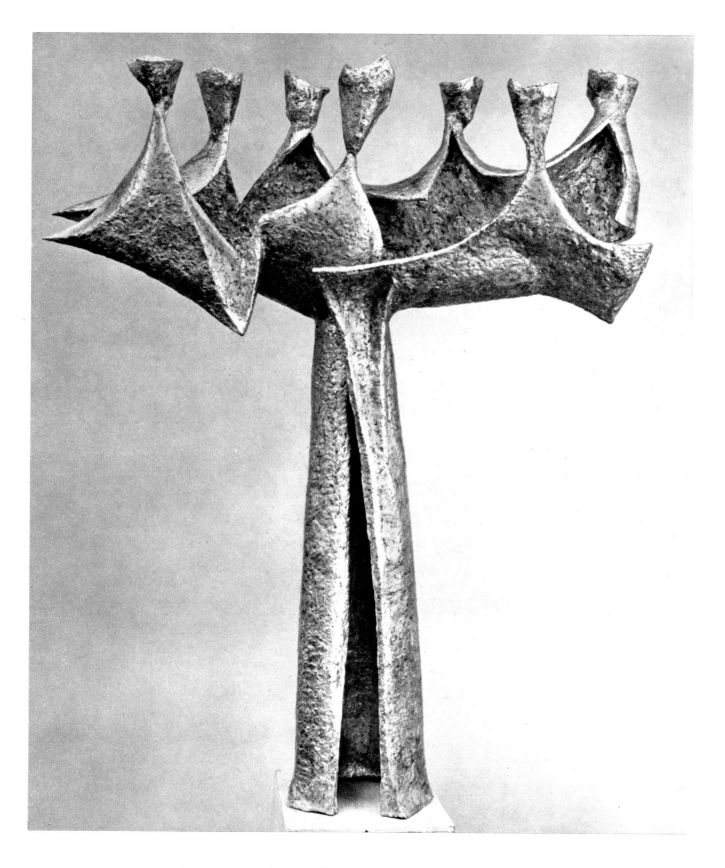

125. MENORAH. *1953. Nickel-silver on steel, 53×42". Temple Israel, Tulsa, Oklahoma*

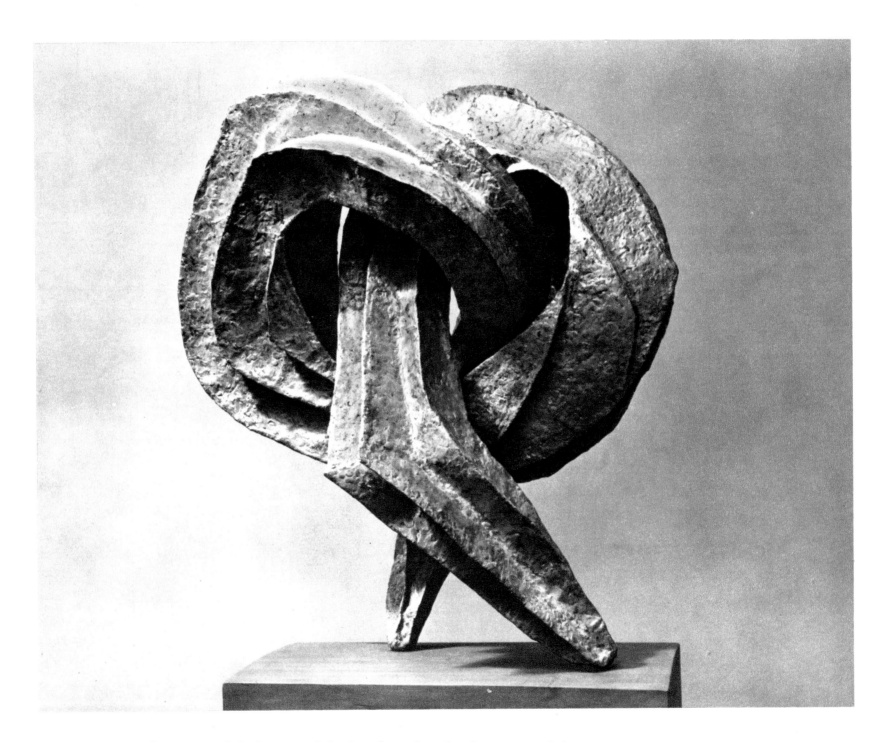

126. EARTH FORGE #1. *1953. Nickel-silver on steel, height 34". Wadsworth Atheneum, Hartford*

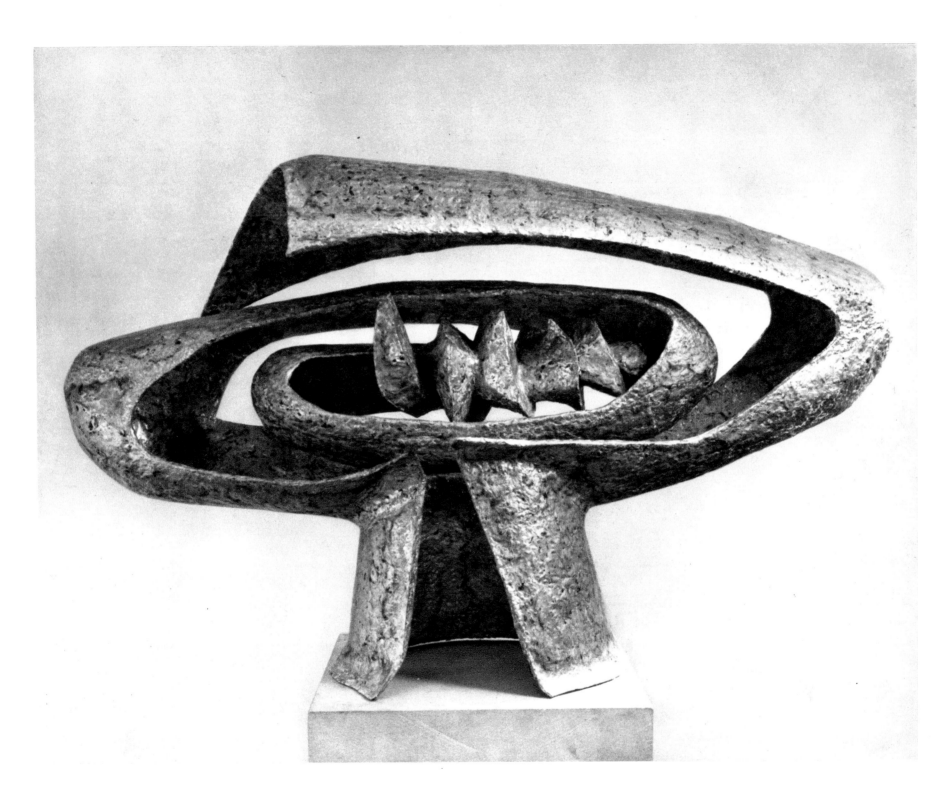

127. EARTH FORGE #2. *1955. Nickel-silver on steel, length 54".* The Brooklyn Museum, New York. Dick S. Ramsay Fund

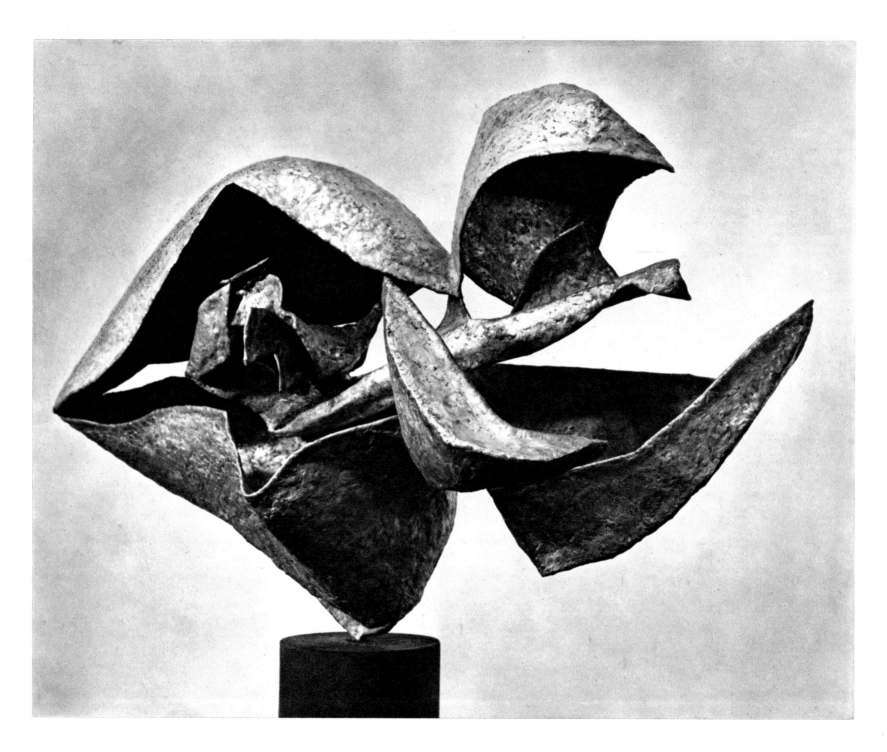

128. JUNGLE BLOOM. *1954. Bronze on steel, 20 1/2✕31". Yale University Art Gallery, New Haven. Gift of Susan Morse Hilles*

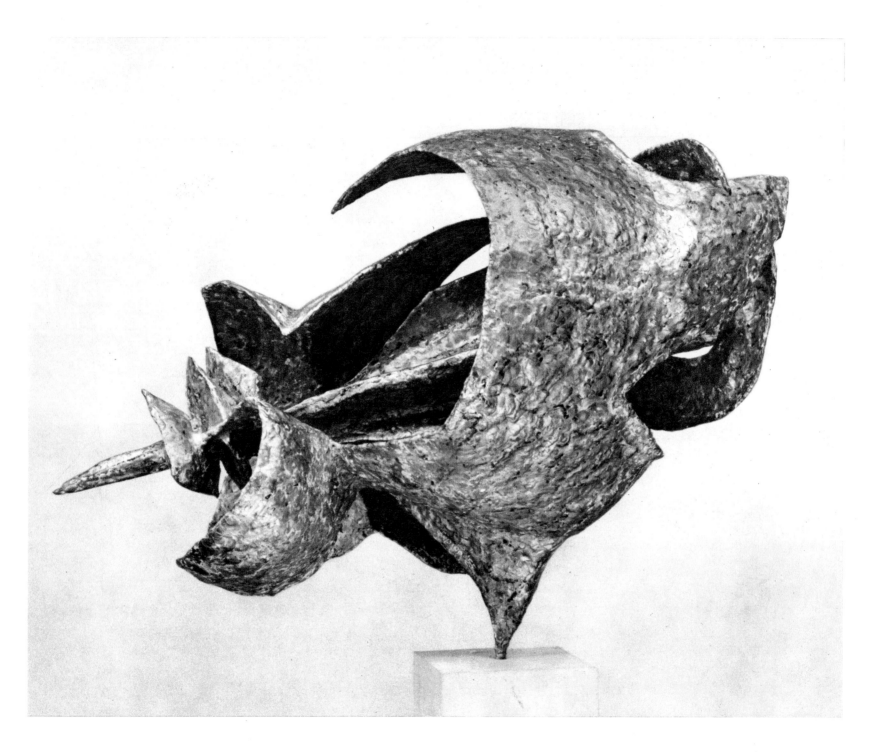

129. JUNGLE BLOOM #2. *1956. Nickel-silver on Monel metal, length 30". Collection Susan Morse Hilles, New Haven*

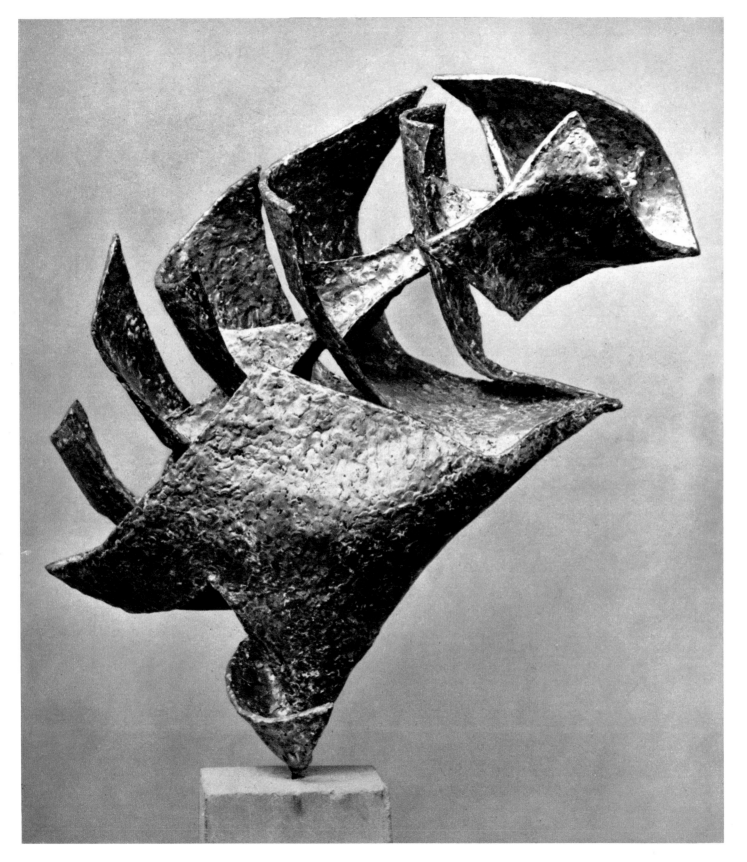

130.
DRAGON BLOOM. *1955.*
Nickel-silver on Monel metal,
height 34″. Art Gallery
of Ontario, Toronto.
Gift from The Women's
Committee Fund, 1958

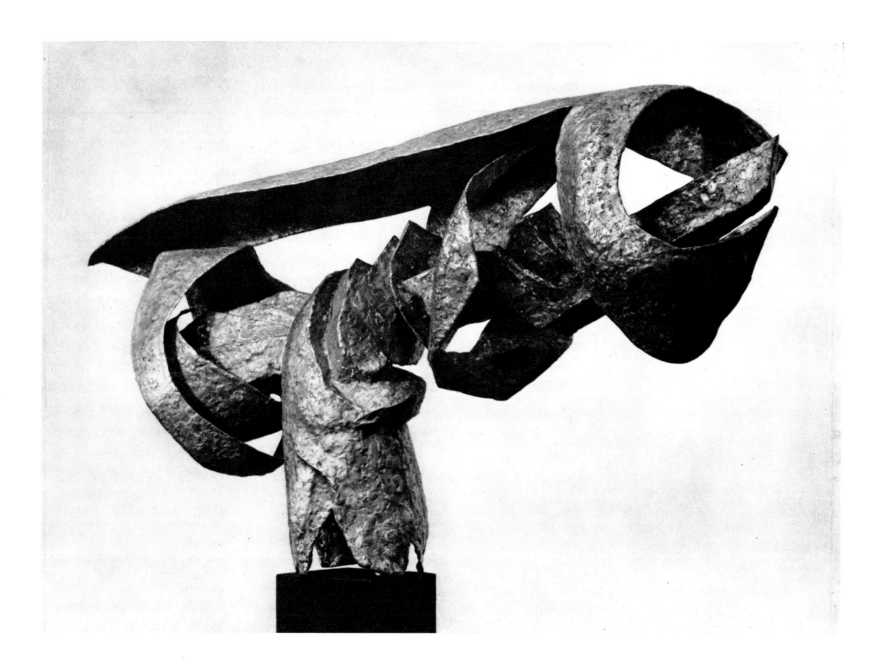

131. STORM BIRD. *1955. Nickel-silver on steel, 20×35 3/4. Private collection, New York*

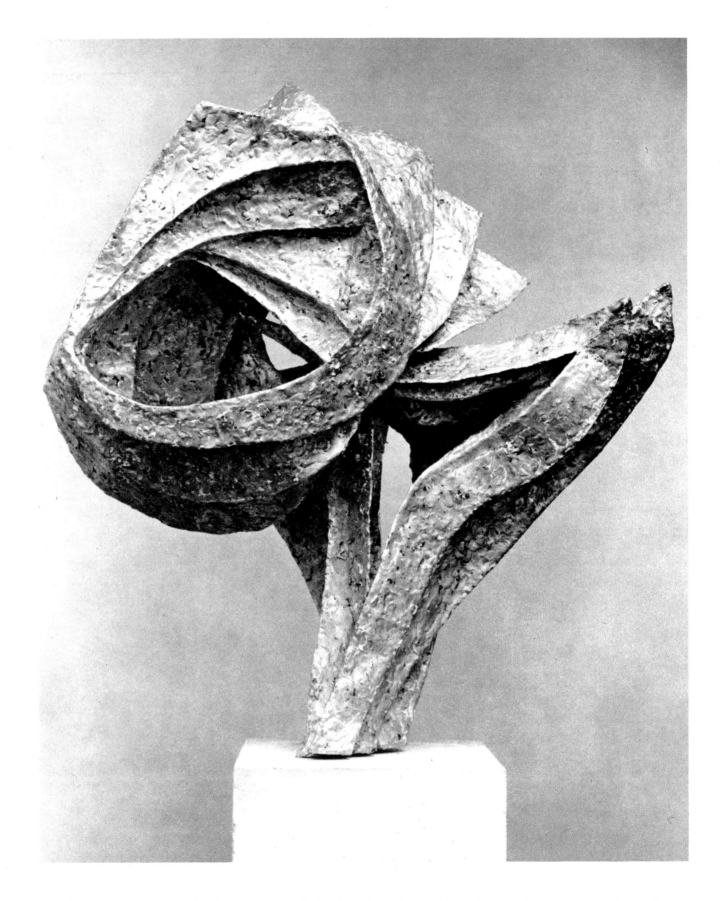

132. DESERT BRIAR. *1955. Nickel-silver on steel, height 29". Collection Mr. and Mrs. Alvin S. Lane, New York*

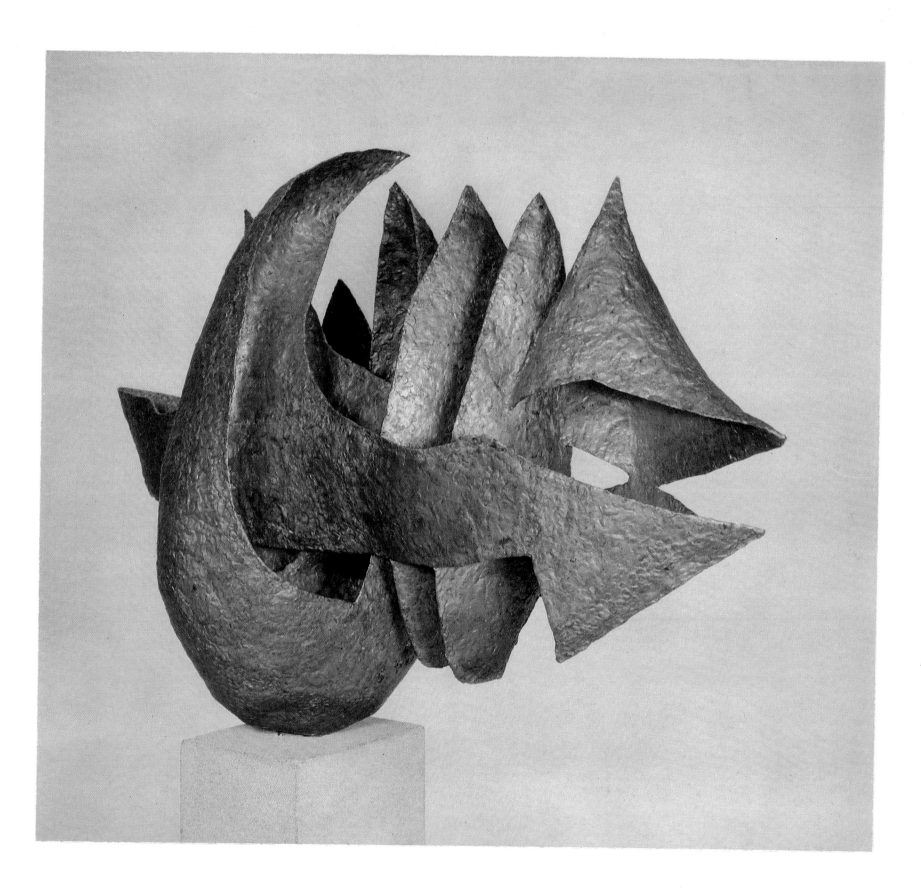

133. Sea King. *1955. Nickel-silver on Monel metal, length 42". Albright-Knox Art Gallery, Buffalo*

דרשו ה׳ בהמצאו

SEEK YE THE
LORD WHERE
HE MAY BE
FOUND

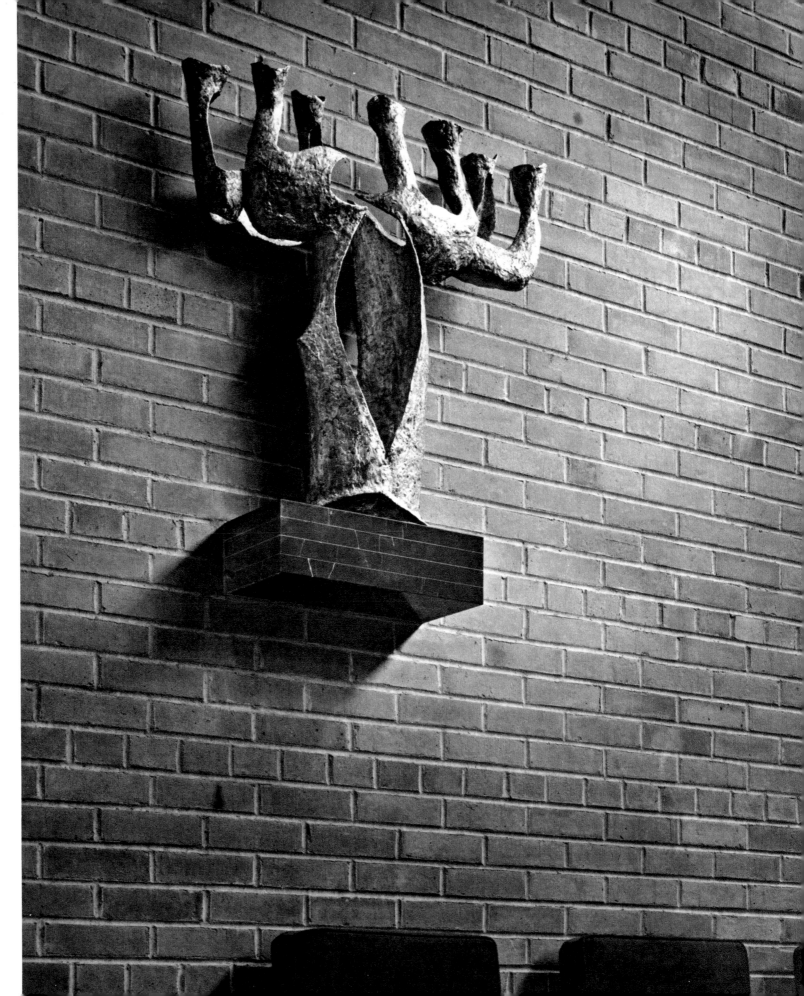

NORAH. *1956.*
kel-silver on Monel metal,
ht 30". Interior,
nple Beth El,
ry, Indiana

135.
MENORAH. *1956.*
Nickel-silver on Monel metal,
length 84". Temple Beth El,
Gary, Indiana

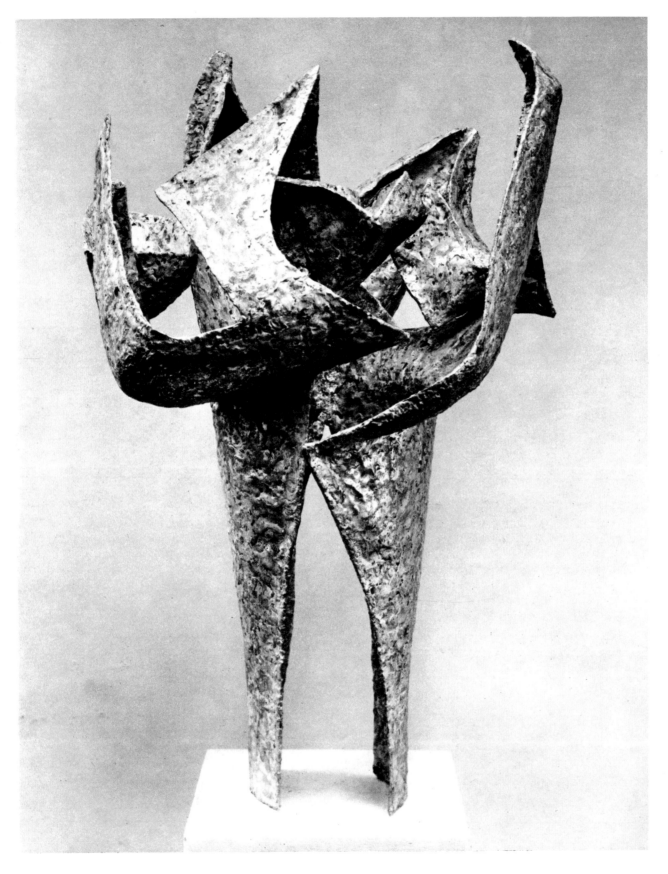

136.
REDWOOD. *1956.*
Bronze on steel, height 20".
The Nathaniel and Margaret
Wentworth Owings Collection

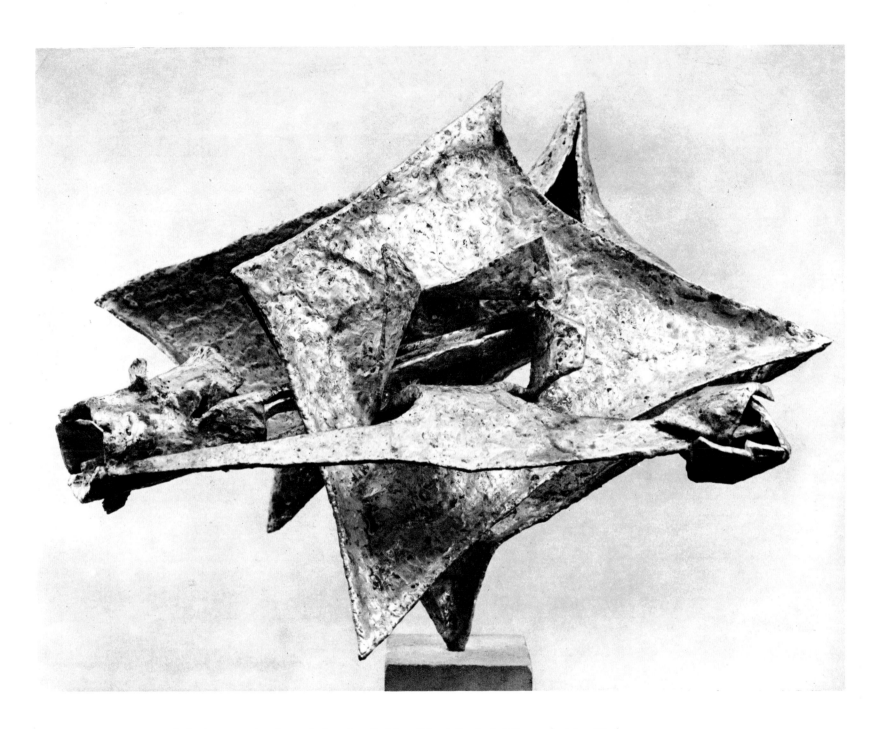

137. VIKING. 1956. Nickel-silver on Monel metal, length 32". New School for Social Research, New York

138.
NIGHT HUNTER. *1957.*
Nickel-silver on Monel metal, height 26".
Albert A. List Family Collection,
New York

139. AVENGER. *1957. Nickel-silver on Monel metal, length 23". University of Kansas Museum of Art, Lawrence*

140.
CHRYSALIS. *1957.*
Bronze on Monel metal, height 24".
Collection H. J. Heinz Company,
Pittsburgh

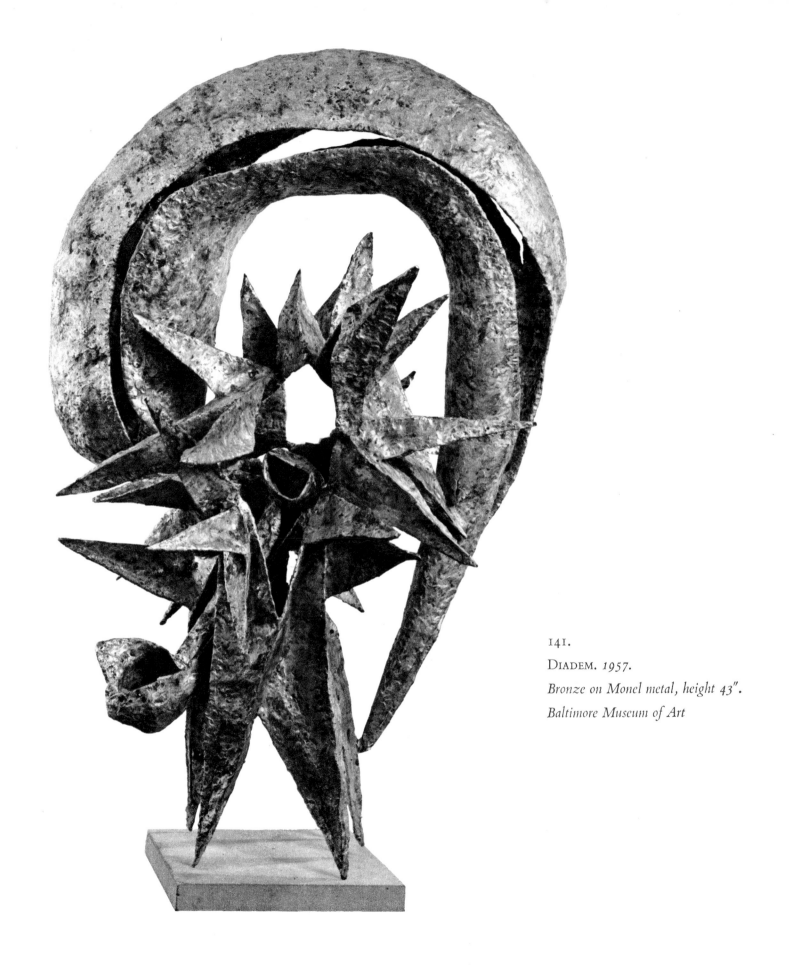

141.
DIADEM. *1957.*
Bronze on Monel metal, height 43".
Baltimore Museum of Art

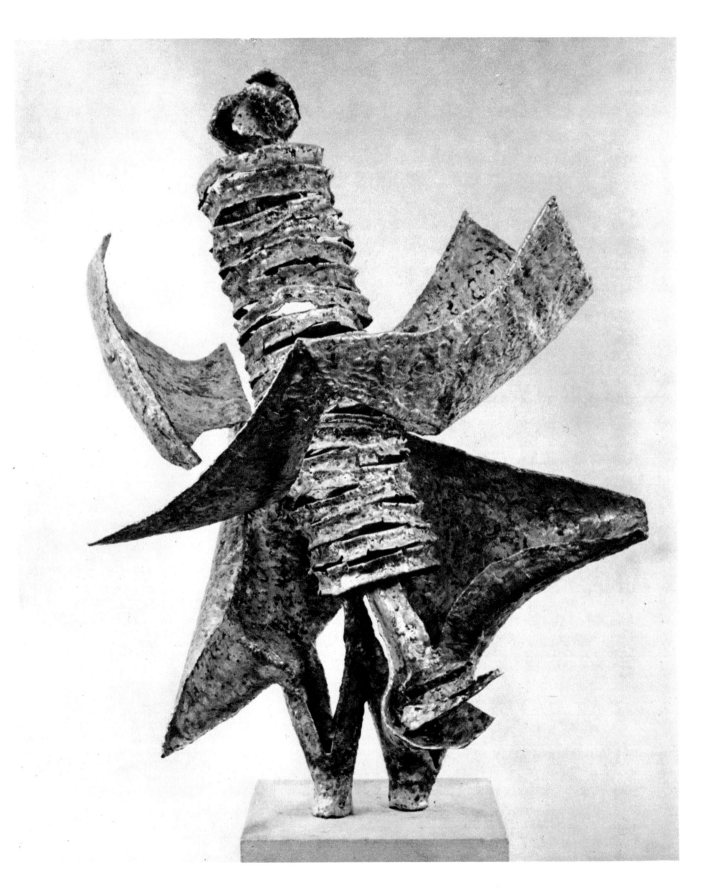

142.
Glowworm. 1957.
*Nickel-silver on Monel metal,
height 33". Collection
Mr. and Mrs. William A. M. Burden,
New York*

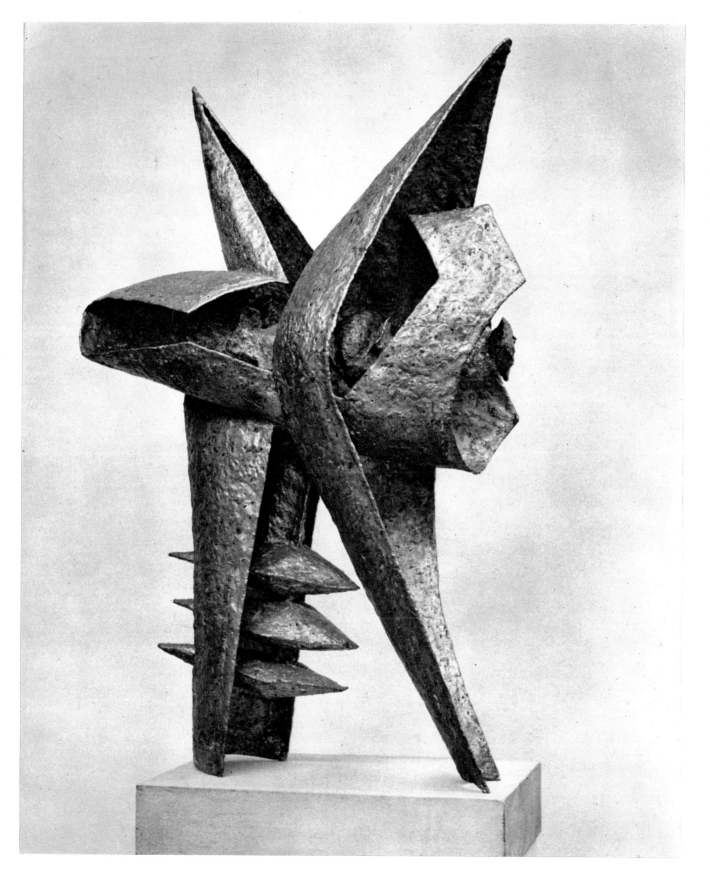

143.
KNIGHT. *1957.*
Nickel-silver on Monel metal,
height 30". Collection
Howard and Jean Lipman,
Cannondale, Connecticut

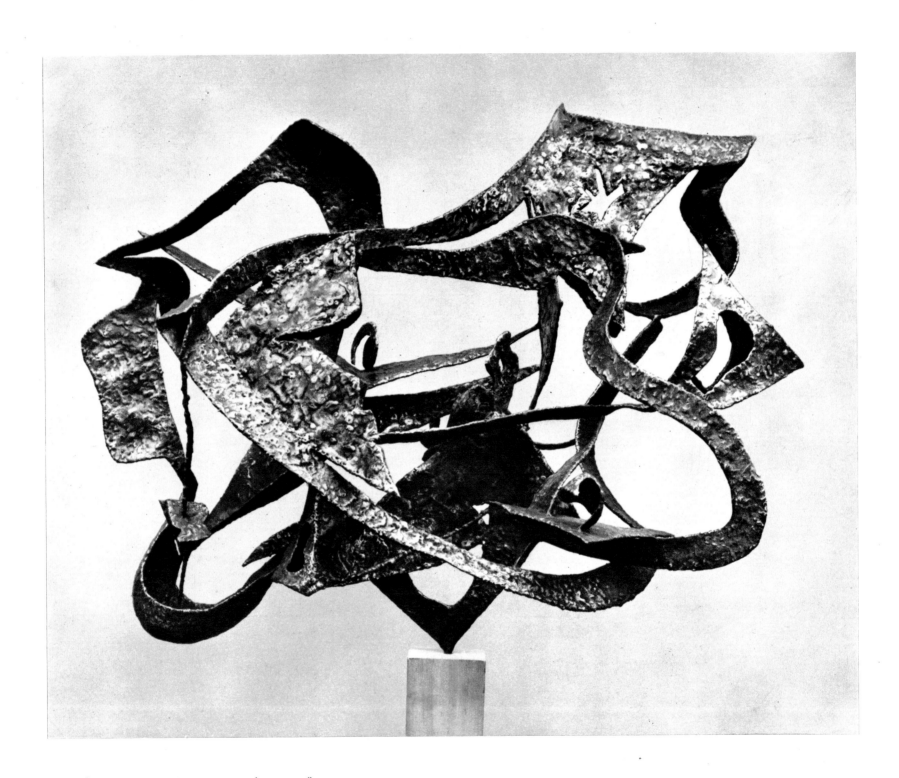

144. ODYSSEY. *1957. Bronze on steel, 27×38".*

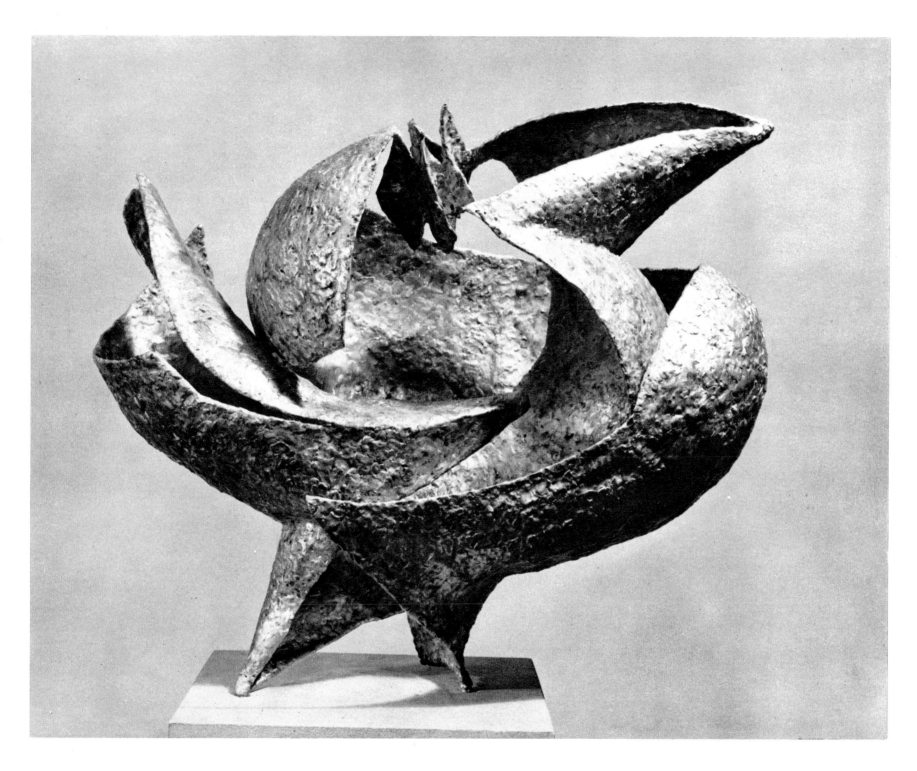

145. WINTER SOLSTICE. *1957. Nickel-silver on Monel metal, height 19". Joseph H. Hirshhorn Collection*

146. REEF QUEEN. *1957. Bronze on Monel metal, length 42′. Collection Arnold H. Maremont, Chicago*

147.

PIONEER. *1957.*

Nickel-silver on Monel metal, height 96".

The Metropolitan Museum of Art,

New York

148.
SORCERER. *1958.*
Nickel-silver on Monel metal, height 60 3/4".
Whitney Museum of American Art, New York.
Gift of Friends of the Whitney Museum of
American Art

149. CRUCIBLE. *1958. Nickel-silver on Monel metal, length 50". Collection Mrs. Albert M. Greenfield, Philadelphia*

151. EARTH LOOM. *1959. Bronze on Monel metal, length 38". The Detroit Institute of Arts*

152. MANDRAKE. *1959. Nickel-silver on Monel metal, height 36". Joseph H. Hirshhorn Collection*

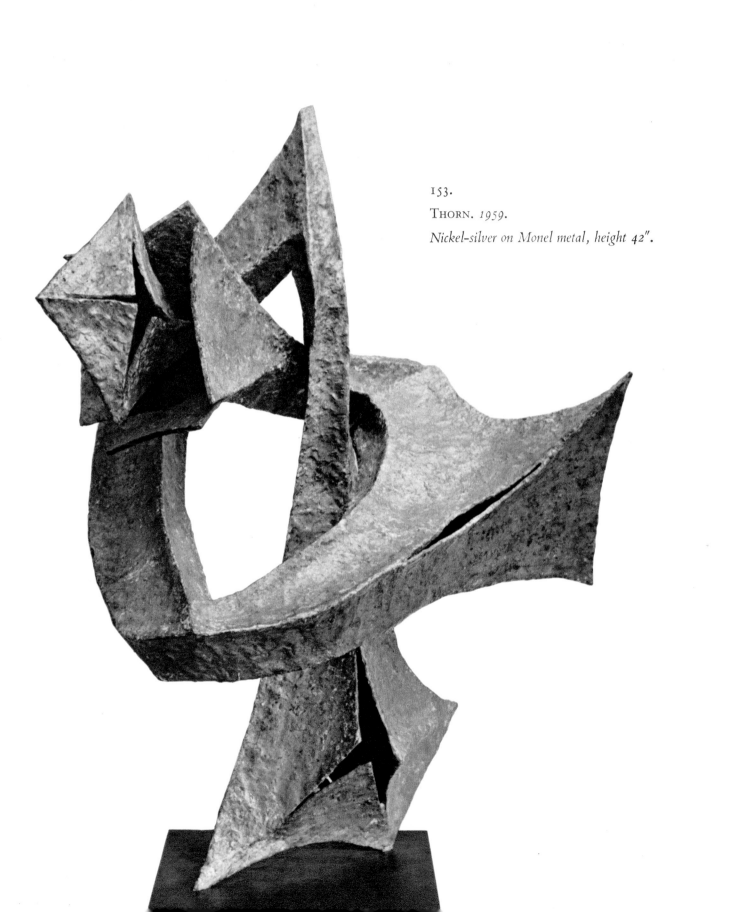

153.
THORN. *1959.*
Nickel-silver on Monel metal, height 42".

154. SEAFARER. *1959. Bronze on Monel metal, height 25". The University of Michigan Museum of Art, Ann Arbor*

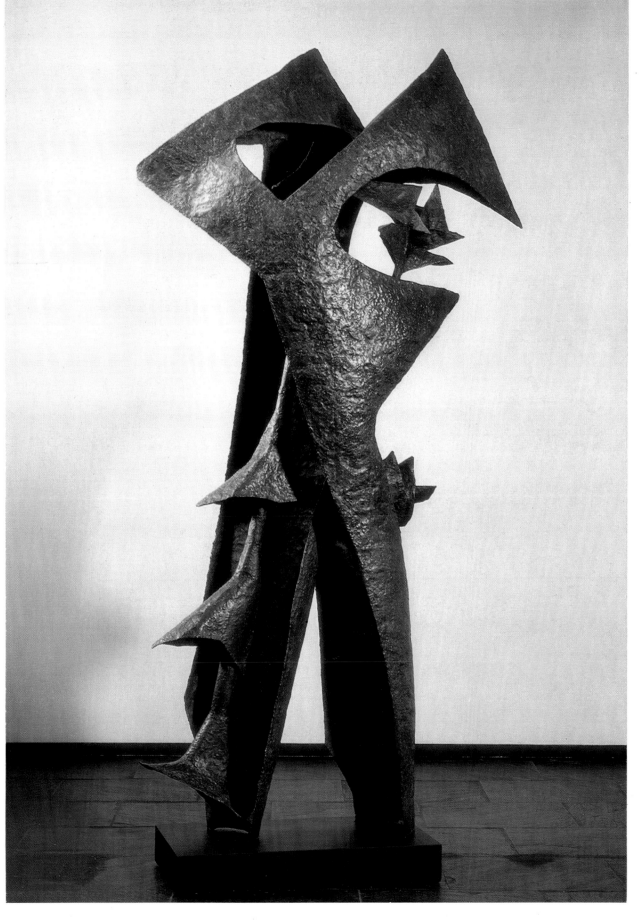

155.
PROPHET. *1959.*
Nickel-silver on Monel metal,
height 90".

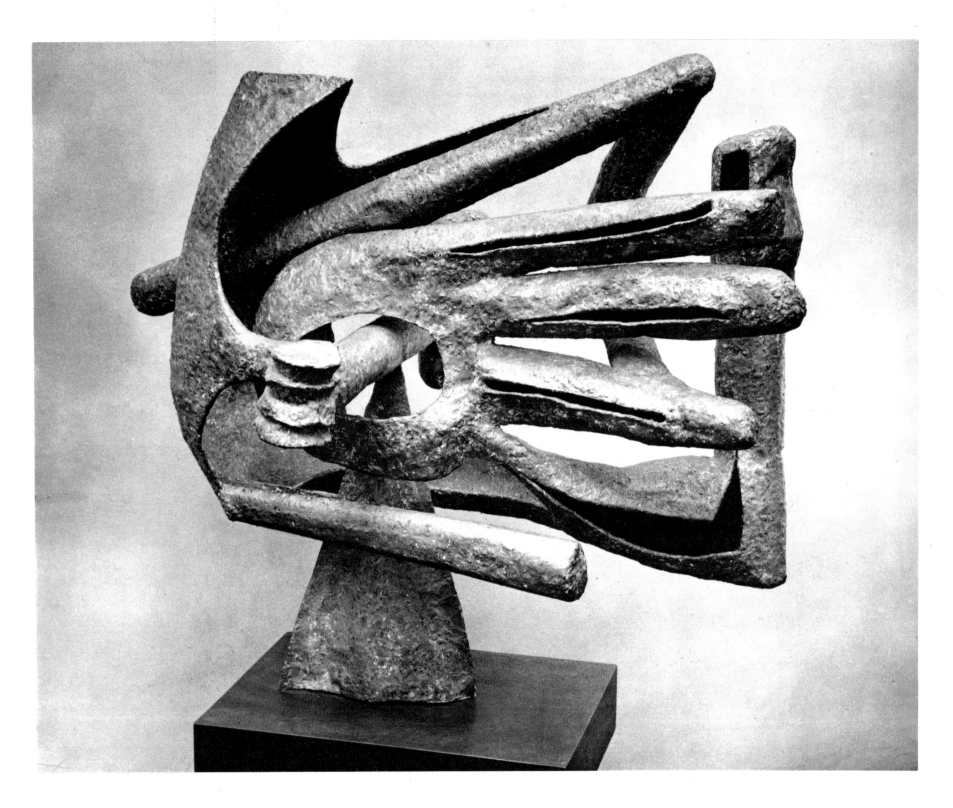

156. GAUNTLET. *1959. Nickel-silver on Monel metal, length 40".*

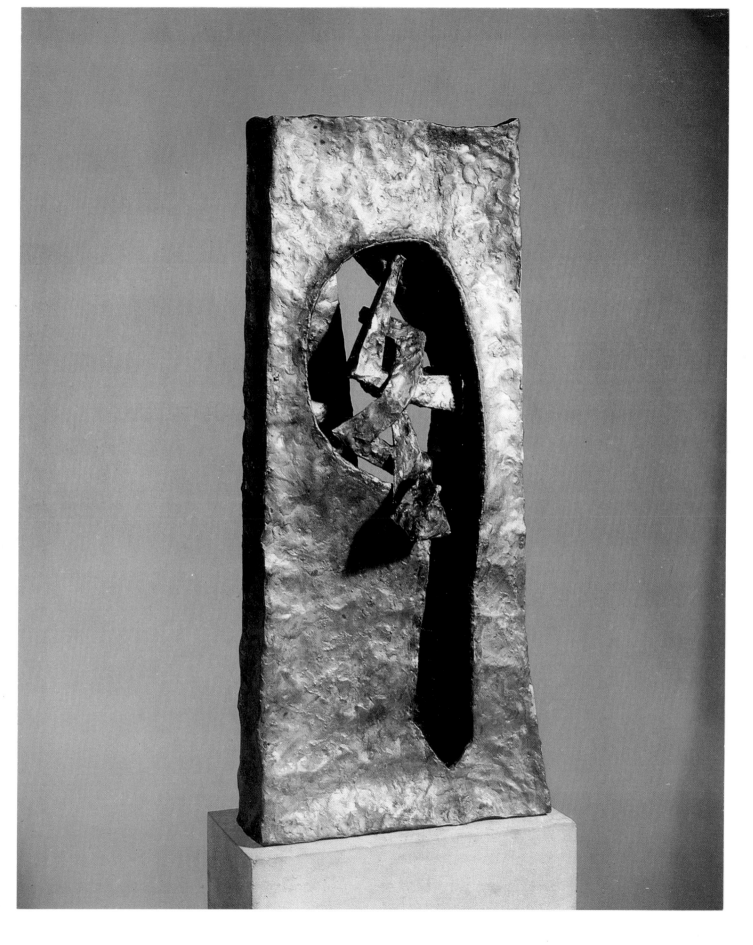

157.
SIBYL. *1959.*
Nickel-silver on Monel metal,
height 24". Andrew Dickson White
Museum of Art,
Cornell University, Ithaca

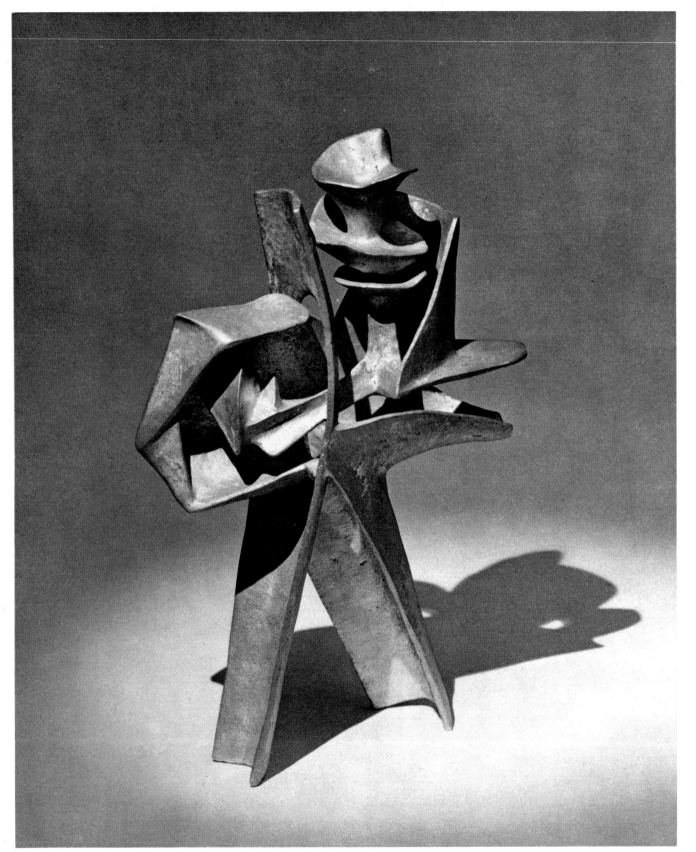

158.
HERALD. *1959.*
Cast aluminum, height 25″.
R. S. Reynolds Memorial
Award Collection

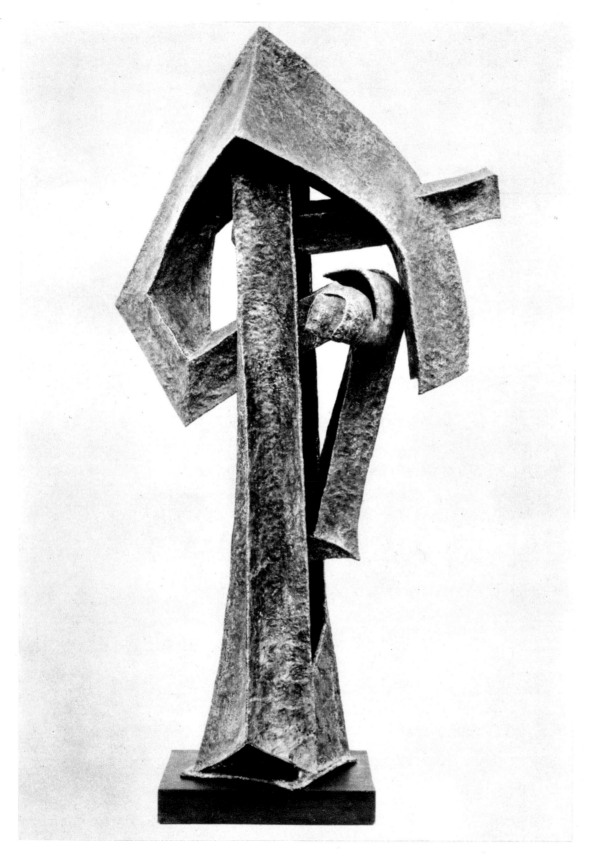

159.
SENTINEL. *1959.*
Nickel-silver on Monel metal, height 89 3/4".
Yale University Art Gallery, New Haven.
Leonard C. Hanna, Jr., Fund

160.
ANCESTOR. *1959.*
Nickel-silver on Monel metal, height 87".
The Phillips Collection,
Washington, D.C.

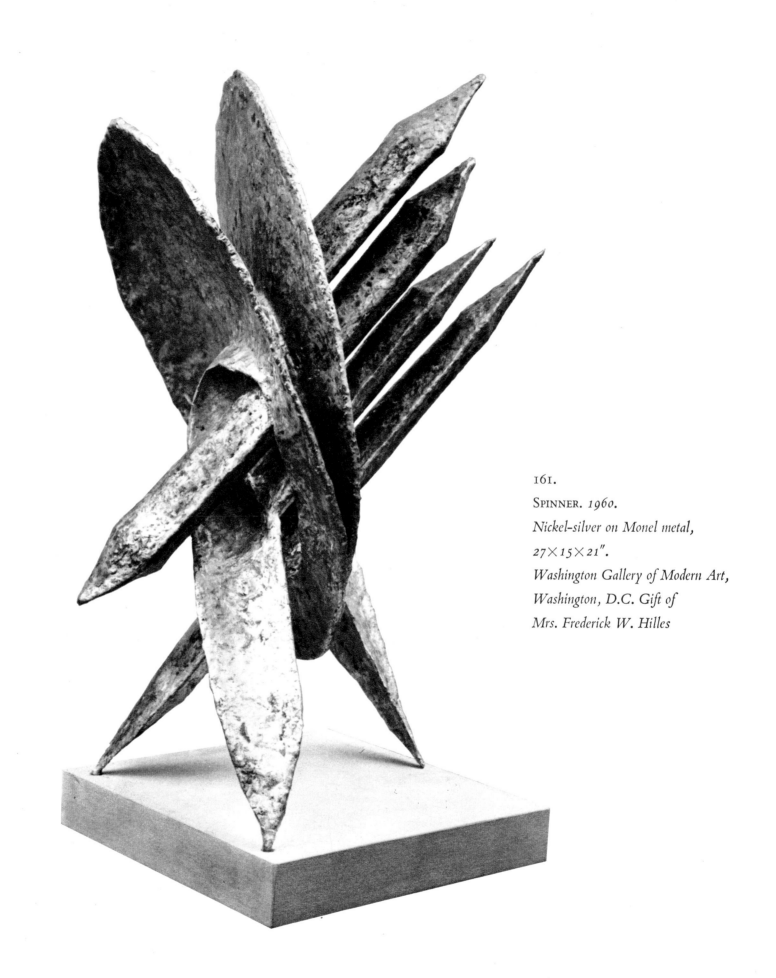

161.
SPINNER. *1960.*
Nickel-silver on Monel metal,
27×15×21".
Washington Gallery of Modern Art,
Washington, D.C. Gift of
Mrs. Frederick W. Hilles

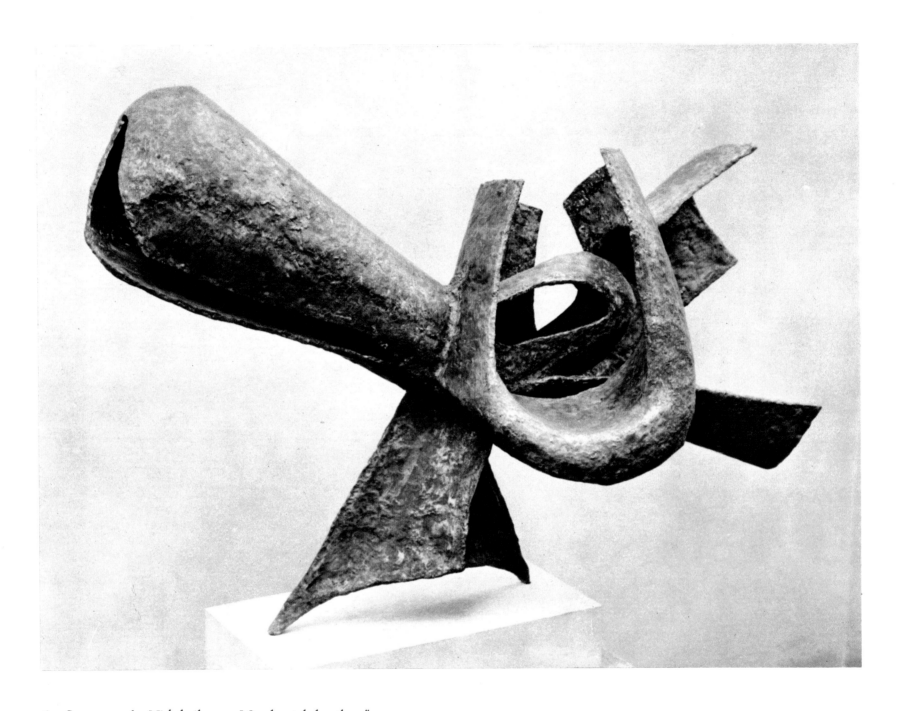

162. SOWER. *1960. Nickel-silver on Monel metal, length 44".*

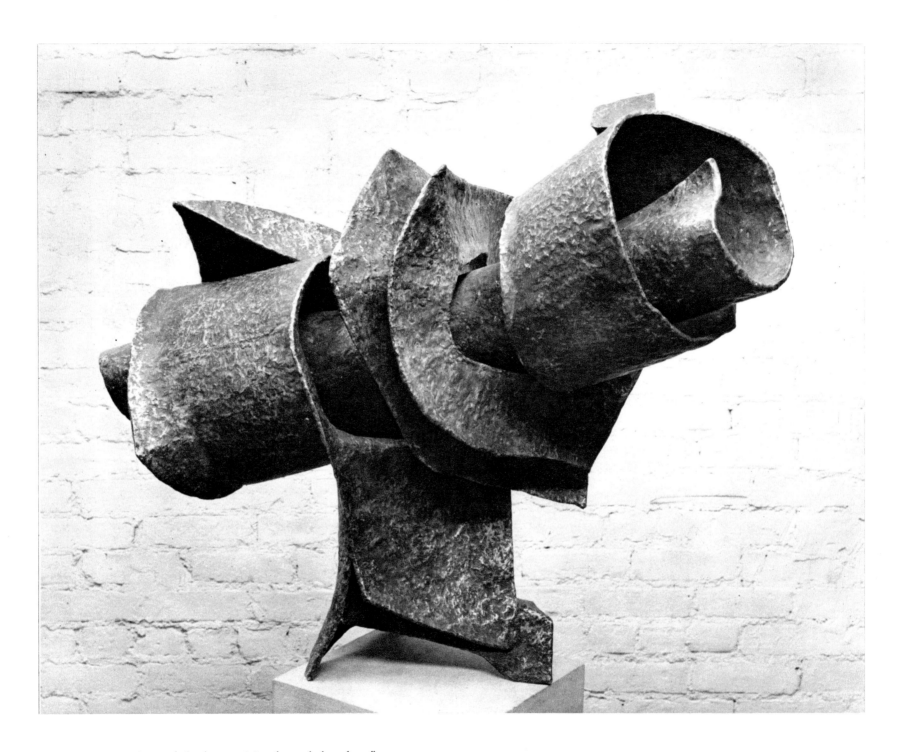

164. SCROLL. *1960. Nickel-silver on Monel metal, length 43".*

165.
HIGH PRIEST. *1960.*
Nickel-silver on Monel metal, height 38".
Collection the artist

166.
CODEX. *1961.*
Nickel-silver on Monel metal, height 49".
(Sculpture as shown in Spoleto, Italy)

167.
CODEX #2. *1961.*
Nickel-silver on Monel metal,
height 49".

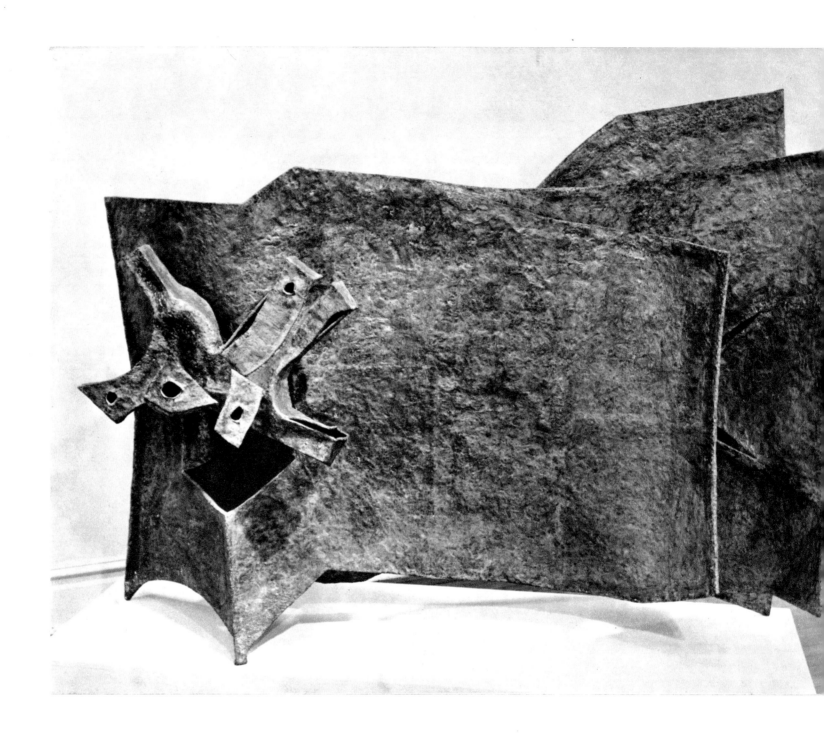

168,169

MANUSCRIPT *(two views). 1961. Bronze on Monel metal, 60 3/8 × 84 1/8 × 37 1/8".*
The Museum of Modern Art, New York. Mrs. Simon Guggenheim Fund

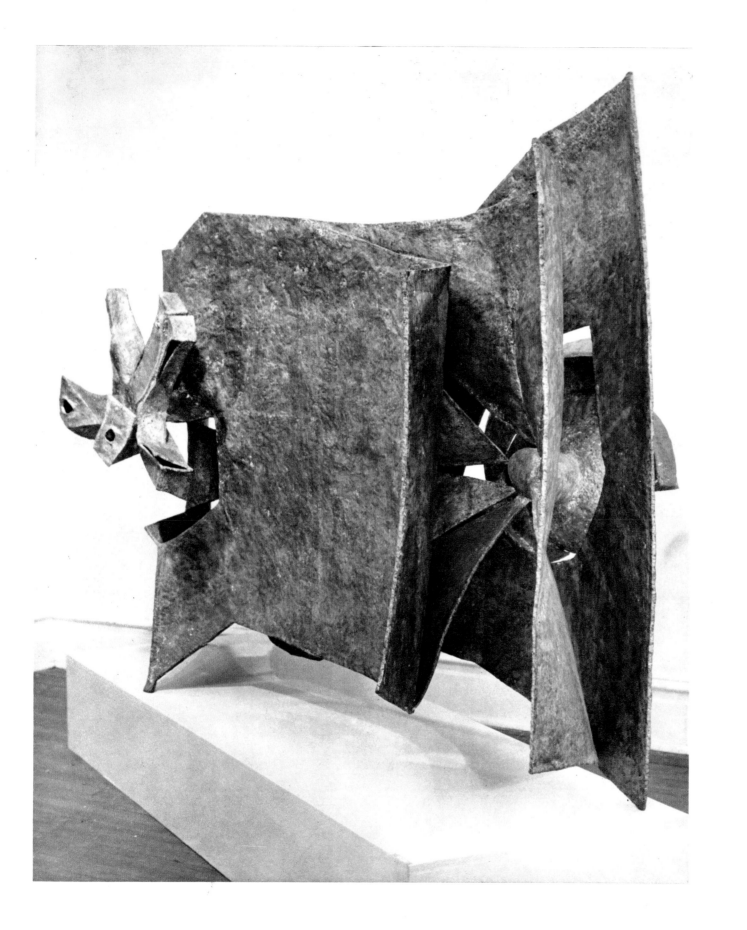

170.

SÉANCE. *1961.*

Bronze on Monel metal, length 35".

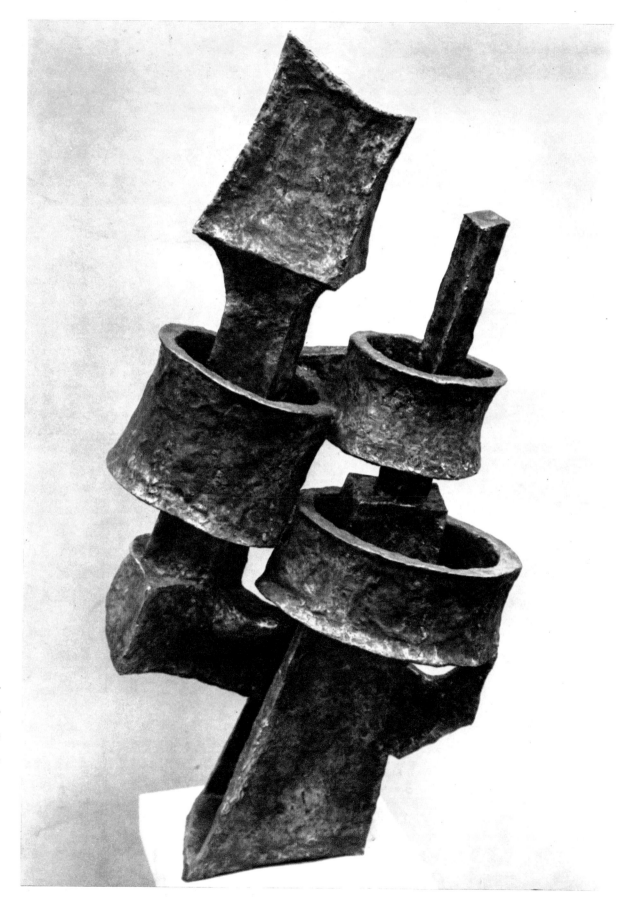

171.
JOUSTER. *1961.*
Nickel-silver on Monel metal,
height 40".

172.
MESSENGER. *1962.*
Nickel-silver on Monel metal, length 25".

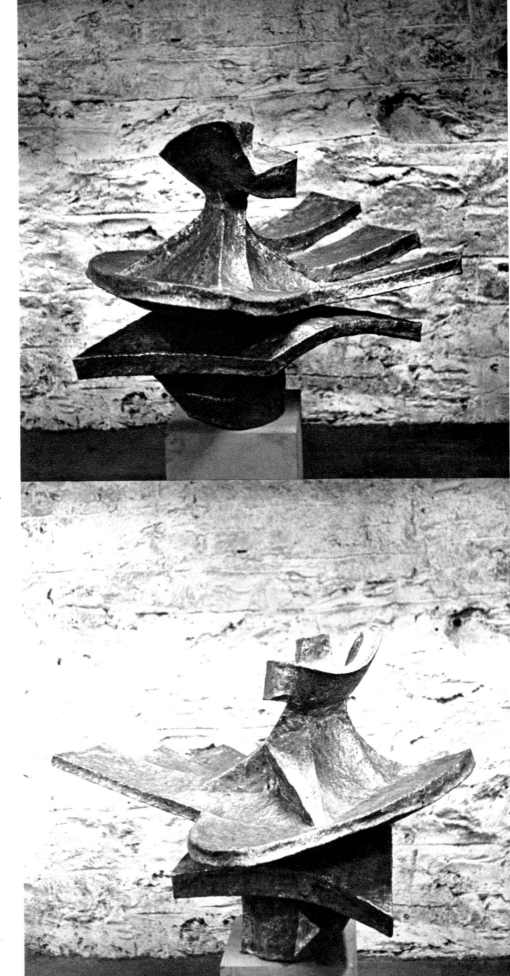

173, 174.

CHINESE BIRD. *1962.*

Nickel-silver on Monel metal, length 36".

175. ARCTIC BIRD. *1960. Nickel-silver on Monel metal, length 33″.*

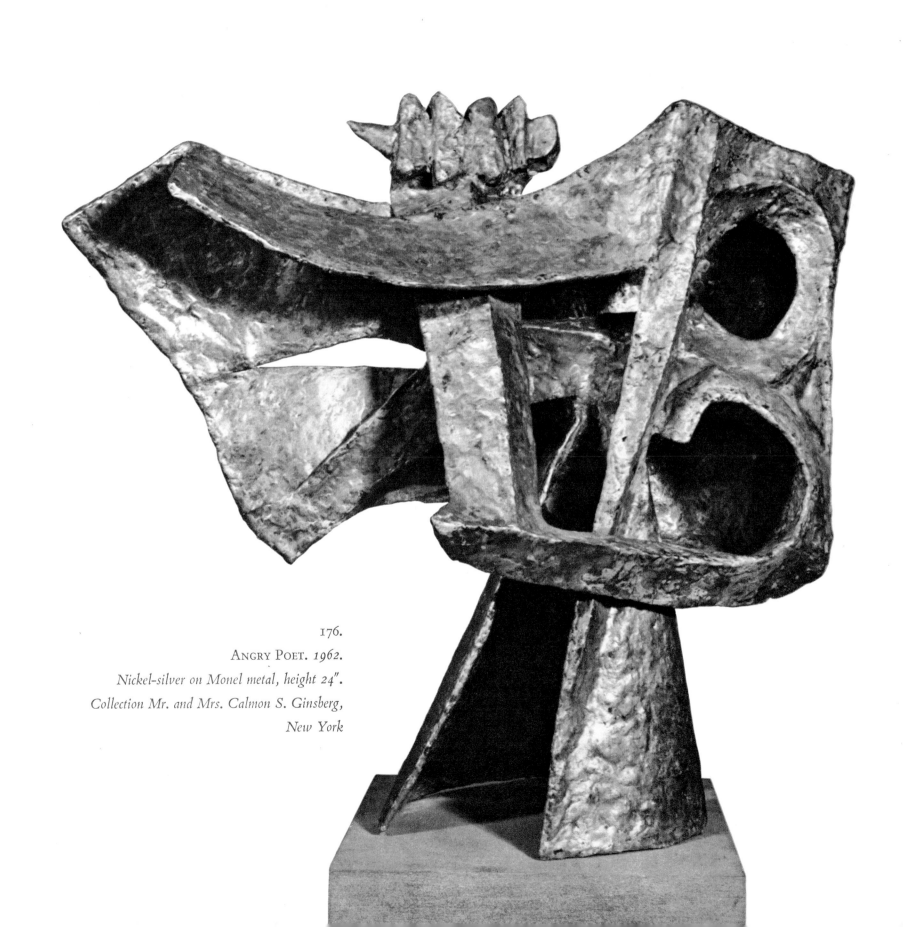

176.
ANGRY POET. *1962.*
Nickel-silver on Monel metal, height 24".
Collection Mr. and Mrs. Calmon S. Ginsberg,
New York

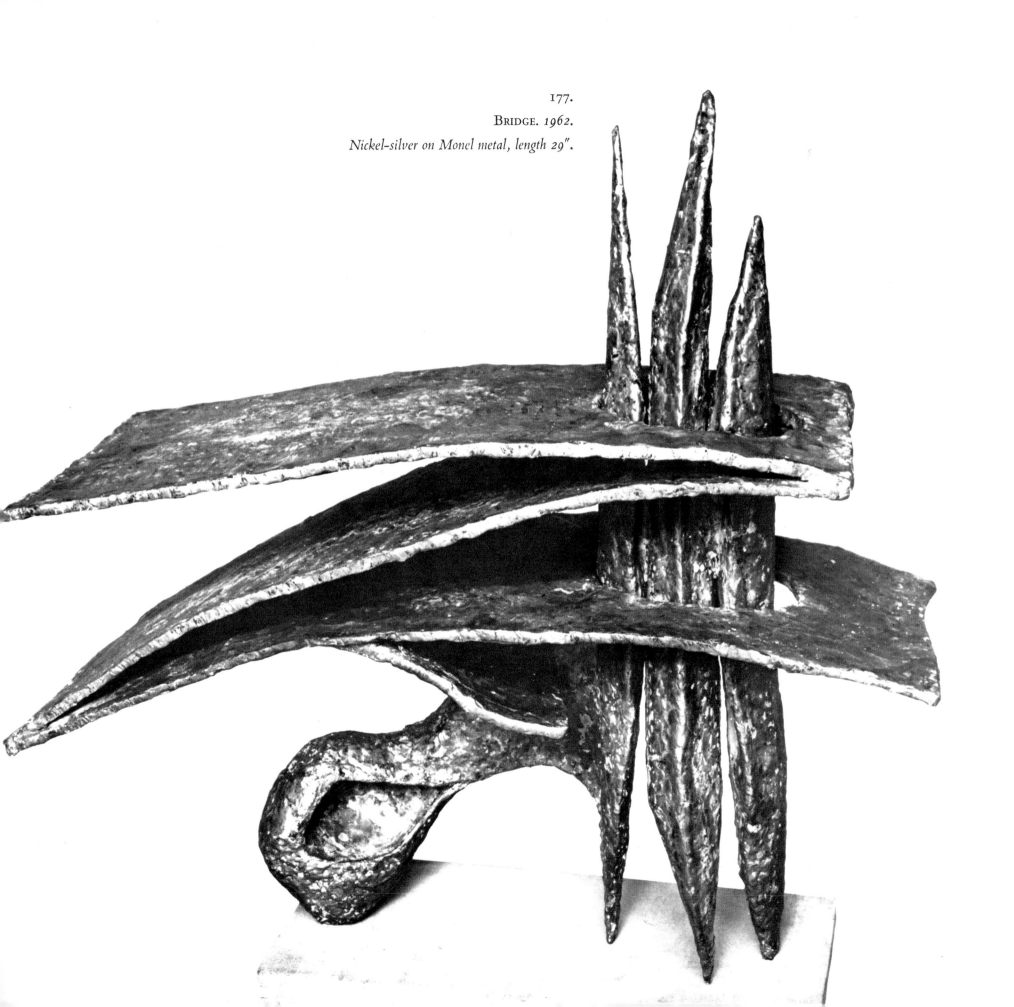

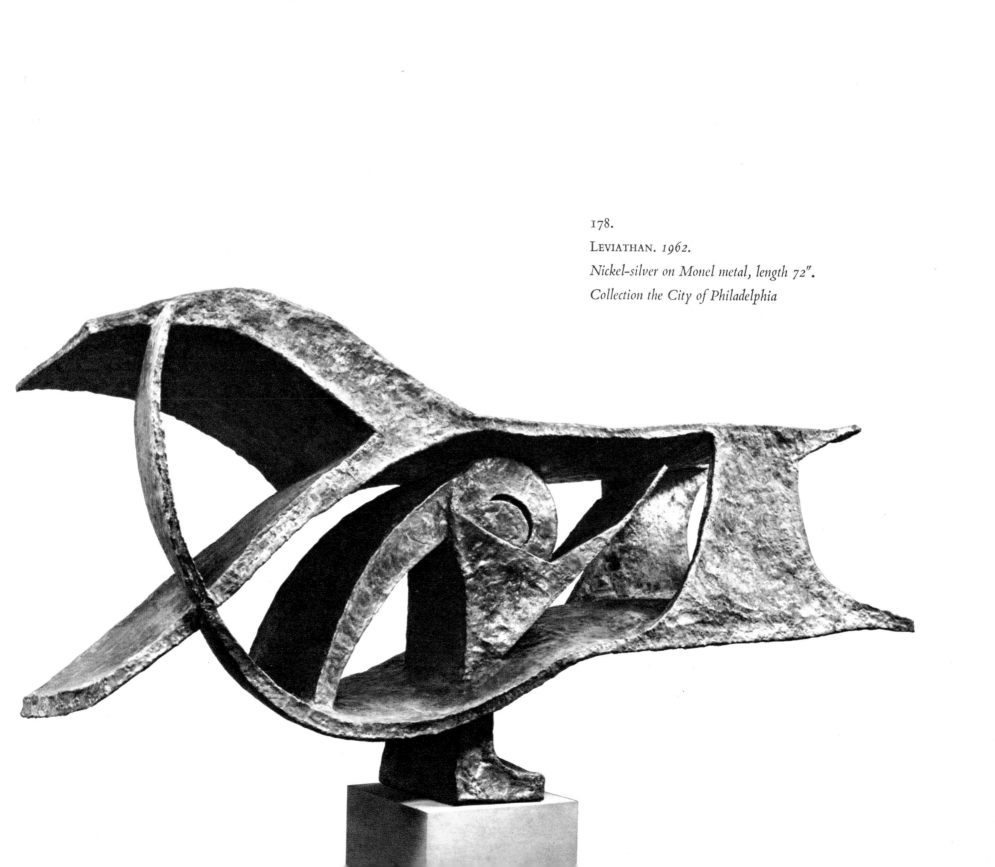

178.
LEVIATHAN. *1962.*
Nickel-silver on Monel metal, length 72".
Collection the City of Philadelphia

179.
DEFENDER. *1962.*
Nickel-silver, height 81".
Smithsonian Institution,
Washington, D.C., on loan
from the artist

180.
POINTED MASK. *1962.*
Nickel-silver on Monel metal,
height 35".

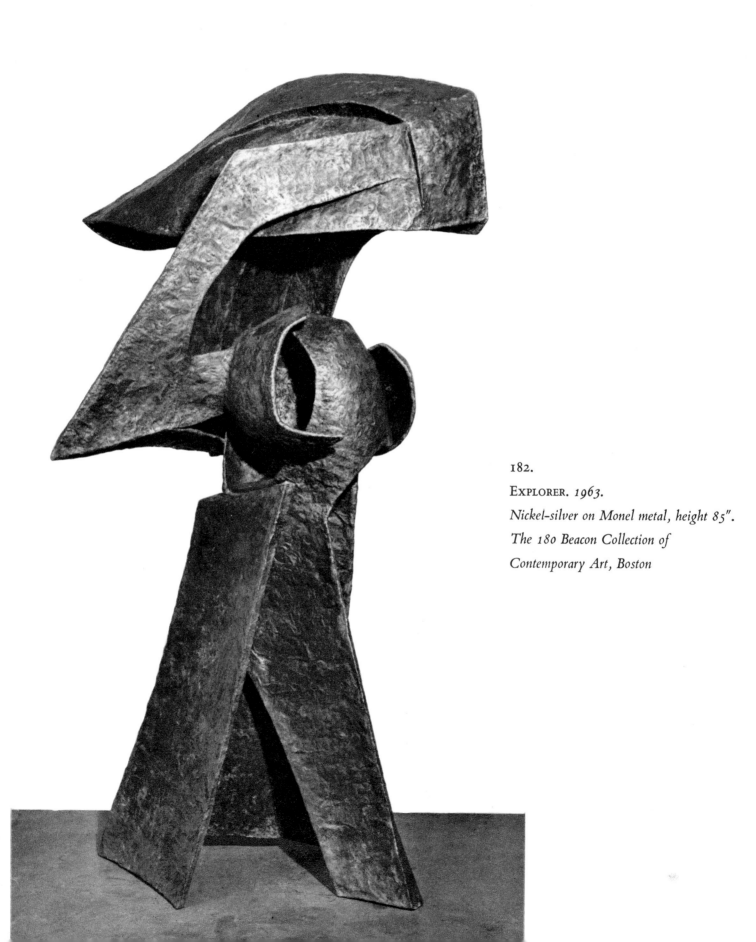

182.
EXPLORER. *1963.*
Nickel-silver on Monel metal, height 85".
The 180 Beacon Collection of
Contemporary Art, Boston

183.
Empty Room. *1964.*
Nickel–silver on Monel metal, height 76".
Private collection, New York

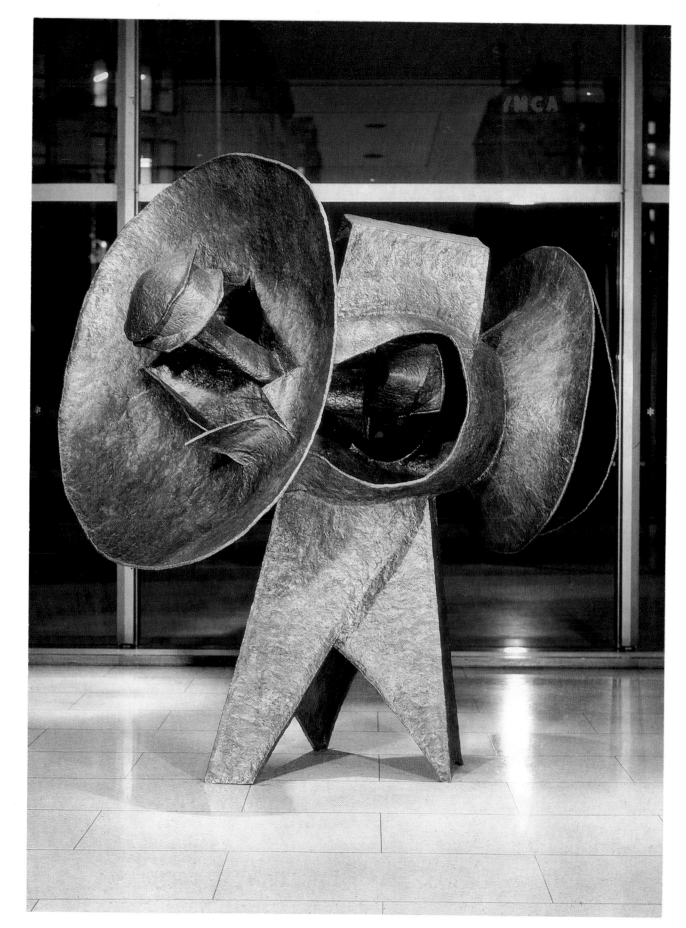

184.
ARCHANGEL. 1963–64.
Bronze on Monel metal, height 108".
Lincoln Center for the Performing Arts
(Philharmonic Hall), New York

185.
RING #1. 1963.
Bronze on Monel metal, height 41".
Collection Frank Lloyd,
London

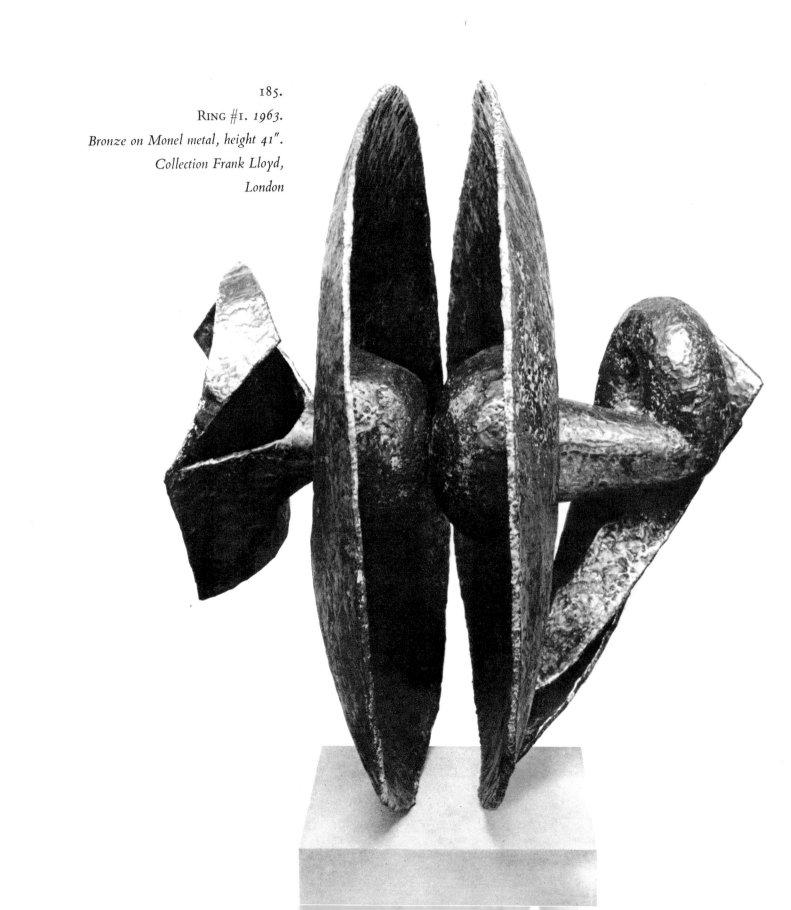

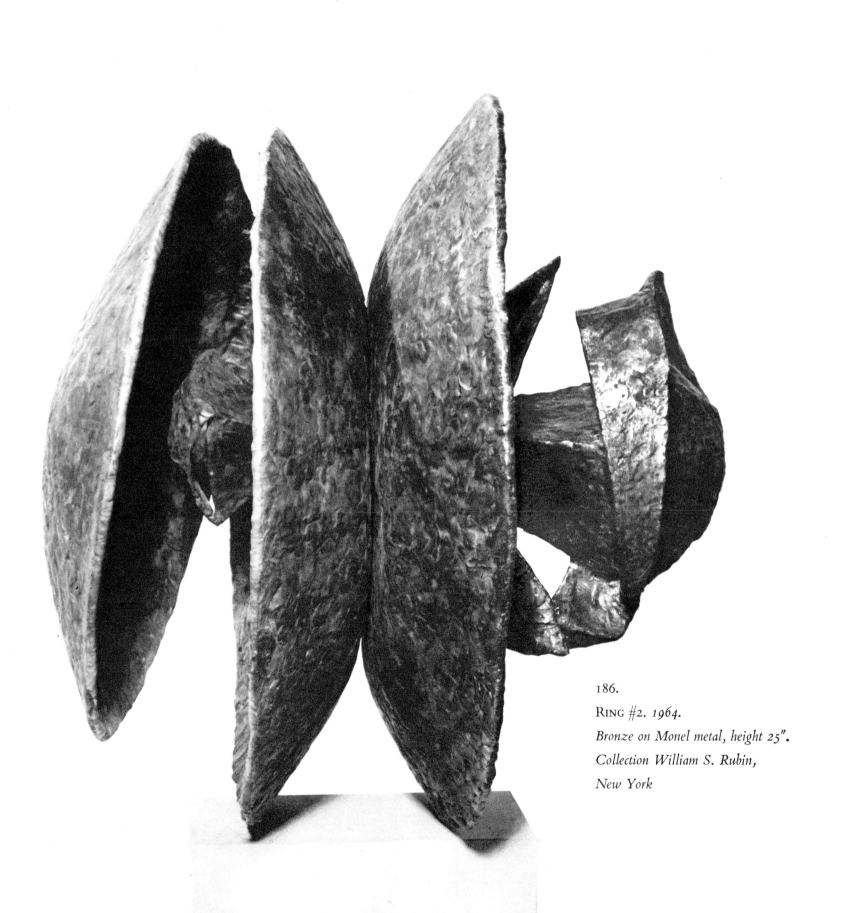

186.
RING #2. *1964.*
Bronze on Monel metal, height 25″.
Collection William S. Rubin,
New York

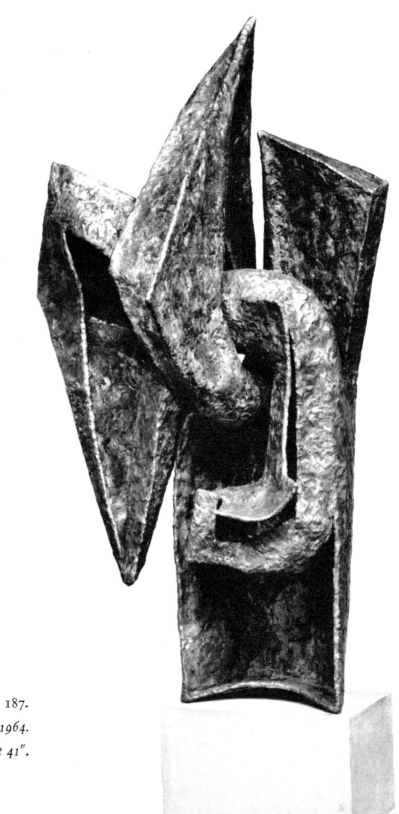

187.
CONFESSIONAL. *1964.*
Nickel-silver on Monel metal, height 41".

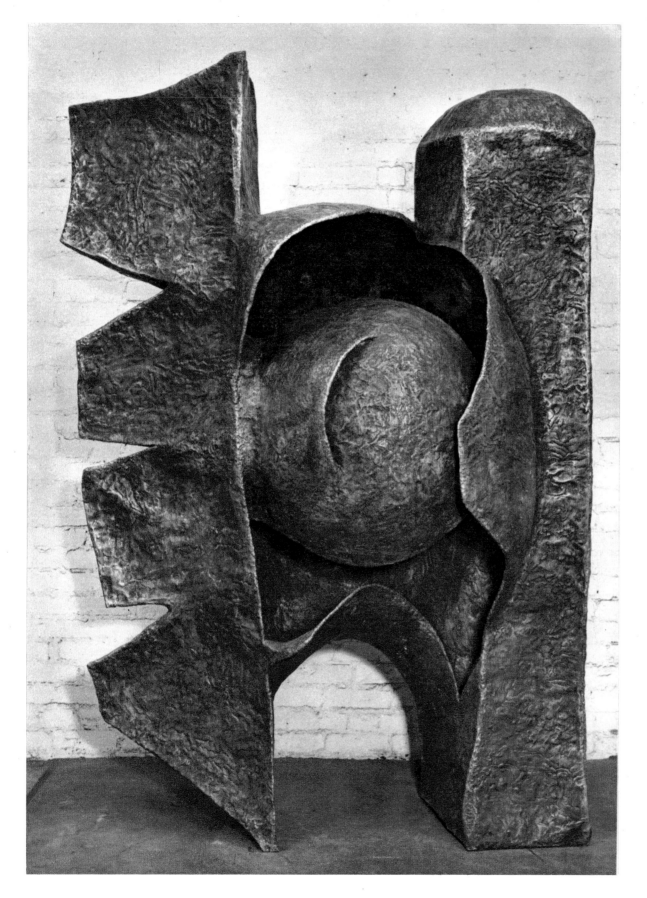

188.

GATEWAY. *1964.*

Bronze on Monel metal, height 76".

189.
MILL. *1964.*
Bronze on Monel metal, length 27".
Collection Mr. and Mrs. James Kemper,
Kansas City, Missouri

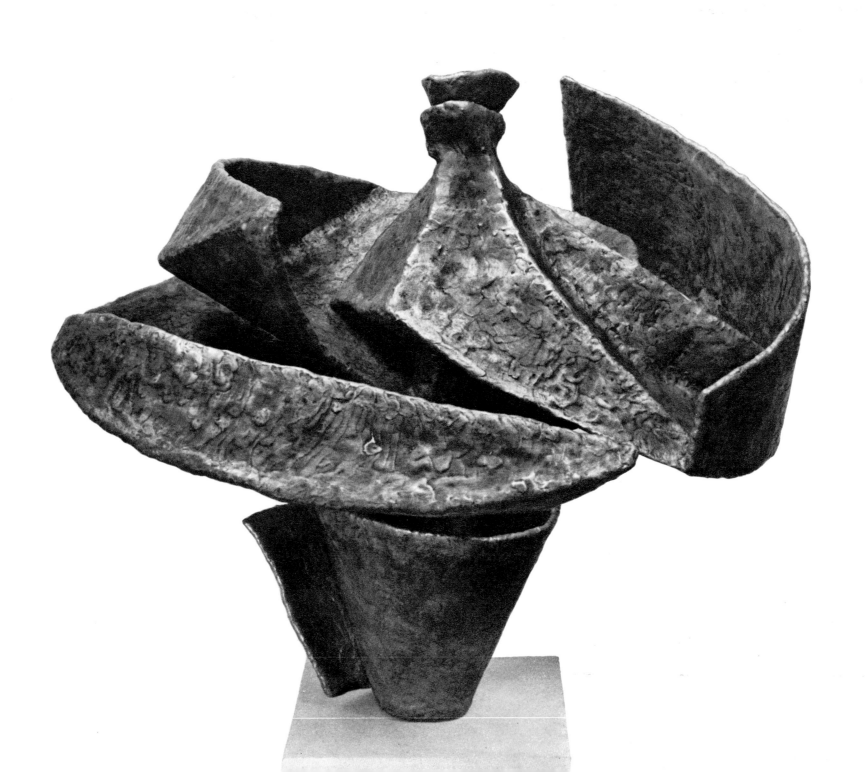

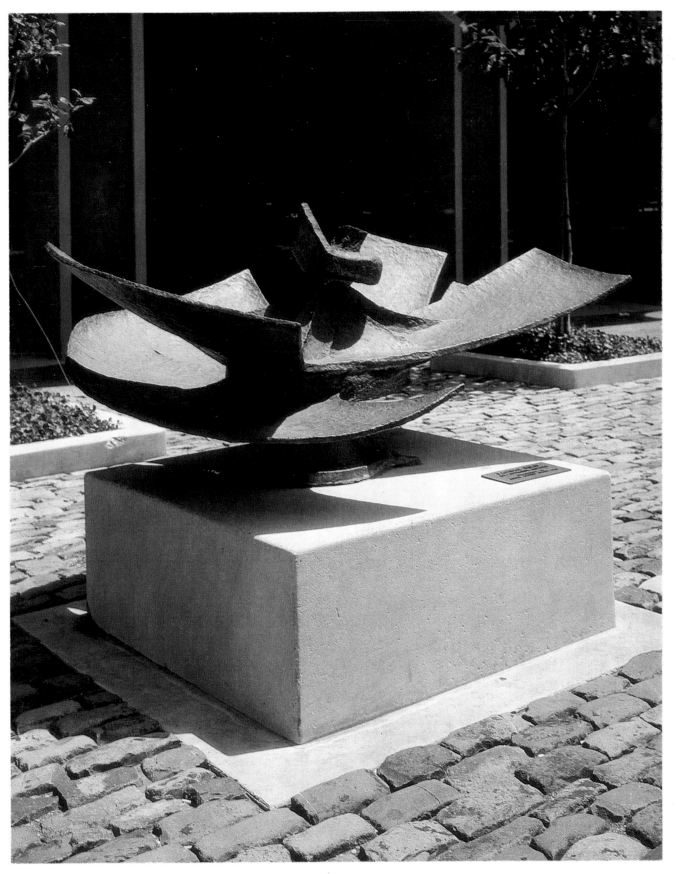

190.
PACIFIC BIRD. *1964.*
Nickel–silver on Monel metal, length 84".
Golden Gateway Center,
San Francisco

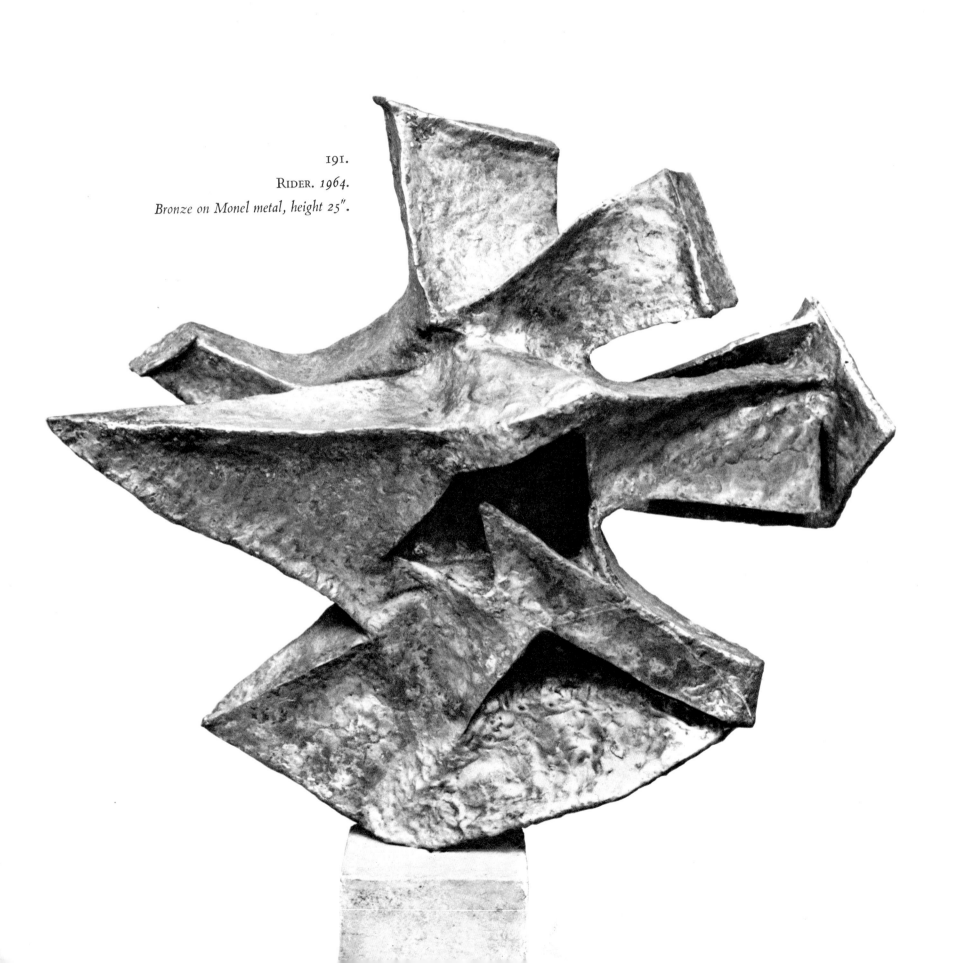

191.
RIDER. *1964.*
Bronze on Monel metal, height 25".

192. LABYRINTH. *1964. Bronze on Monel metal, length 44".*

193. VOYAGER. *1964. Nickel-silver on Monel metal, length 48".*

194.
EARTH BELL. *1964.*
Bronze on Monel metal, height 30".

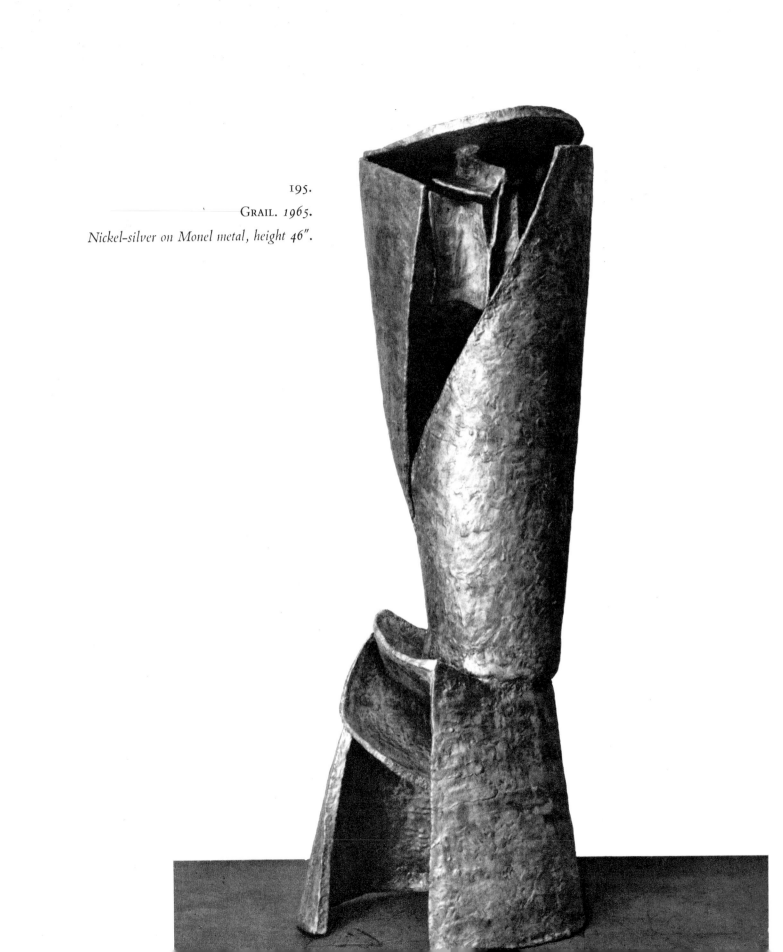

195.
Grail. *1965.*
Nickel-silver on Monel metal, height 46".

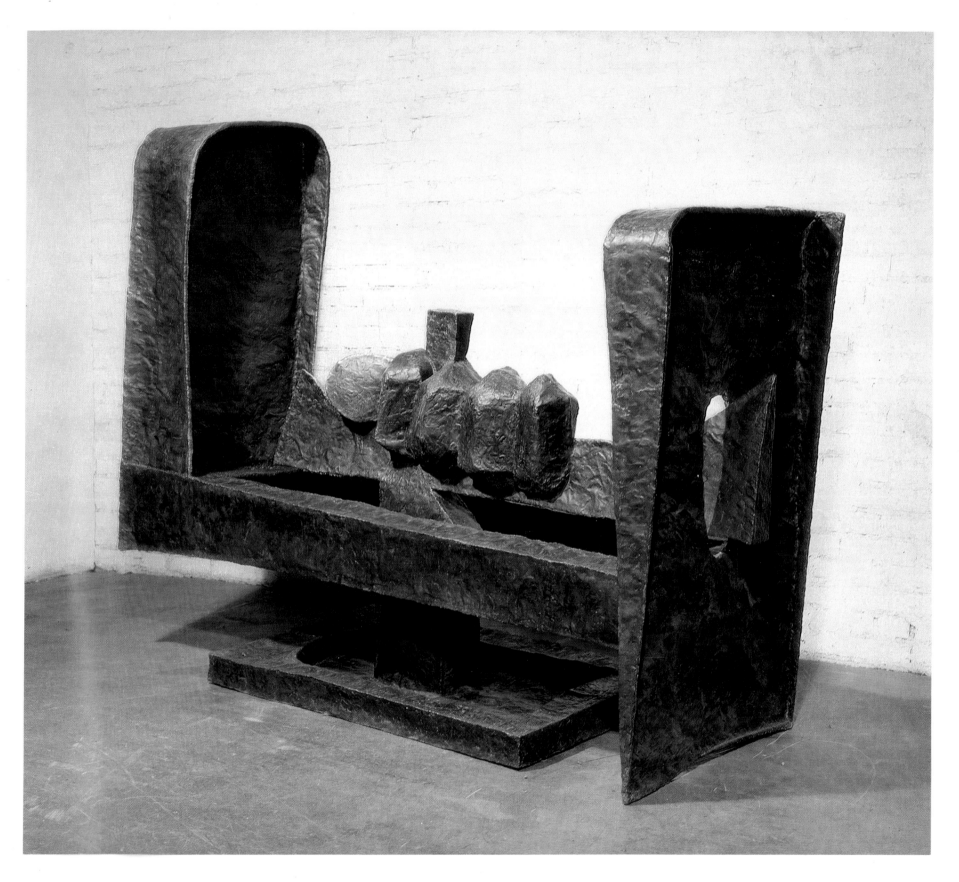

196. ALTAR. 1965. *Nickel-silver on Monel metal, length 66″.*

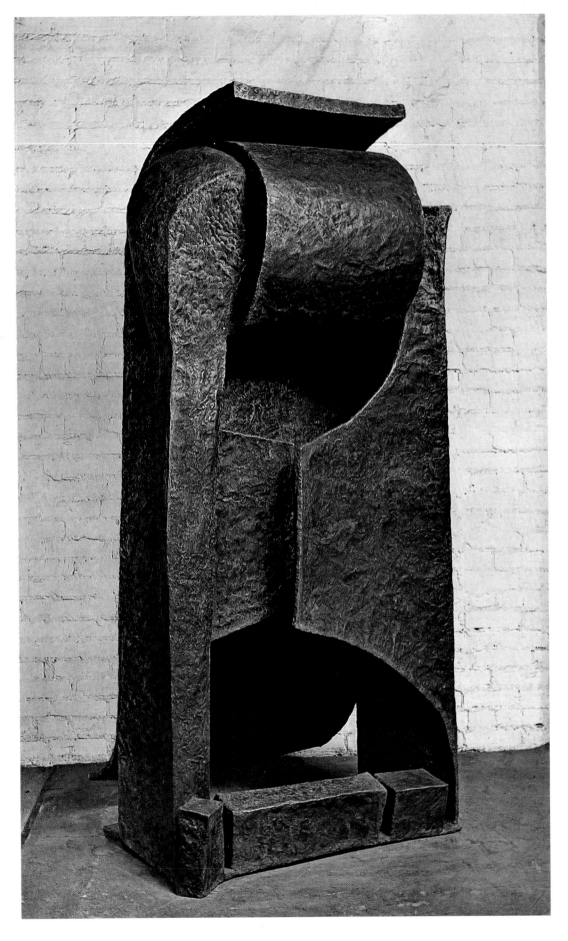

197.

INQUISITOR. *1965.*

Bronze on Monel metal, height 82".

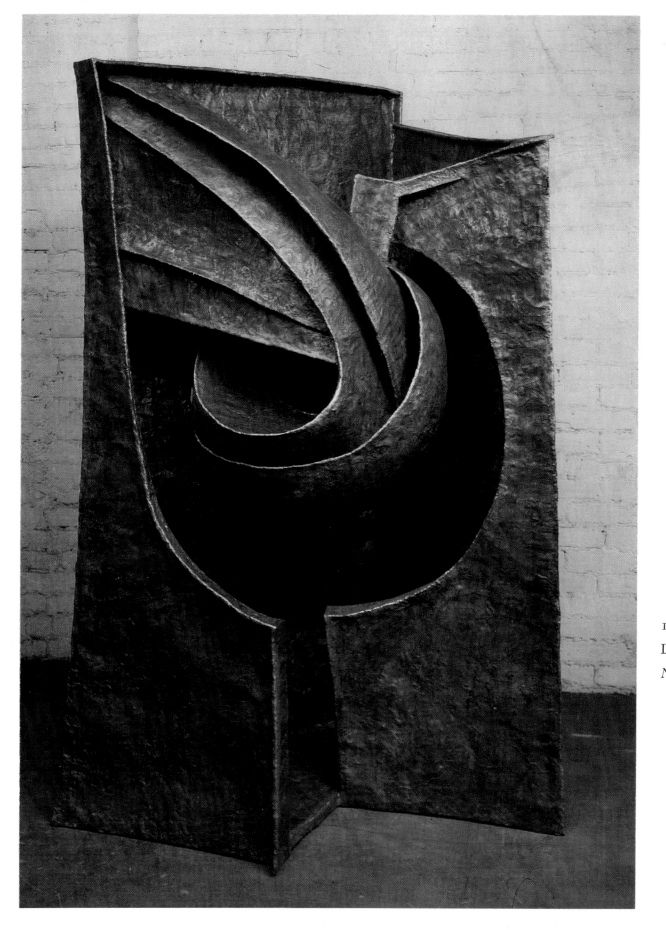

198.

LOOM. *1965.*

Nickel-silver on Monel metal, height 70".

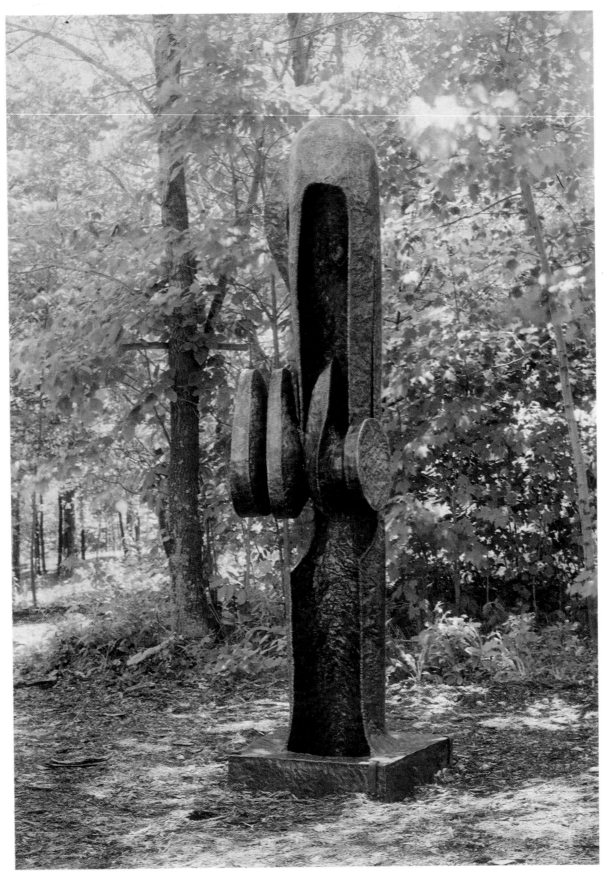

199.
ORACLE. *1965.*
Bronze on Monel metal, height 100".

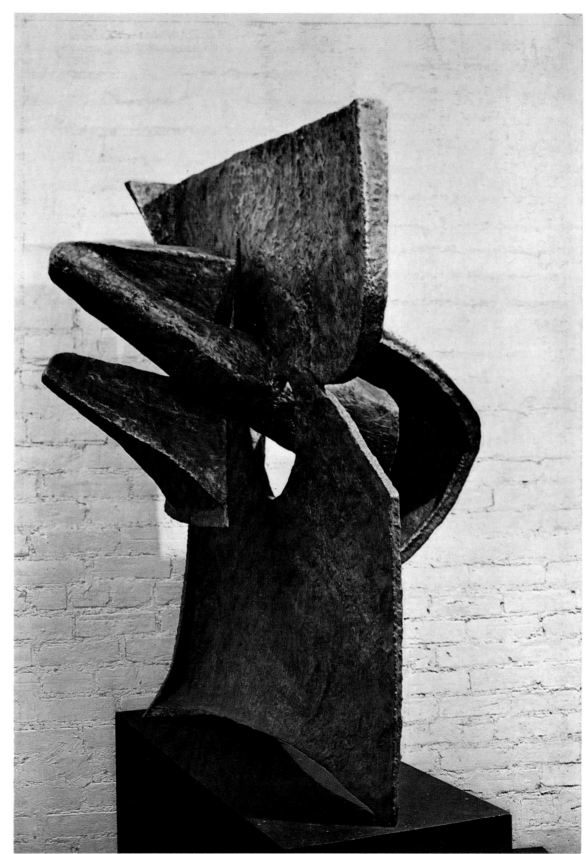

200.
PLOUGH. *1965.*
Nickel-silver on Monel metal, height 47".

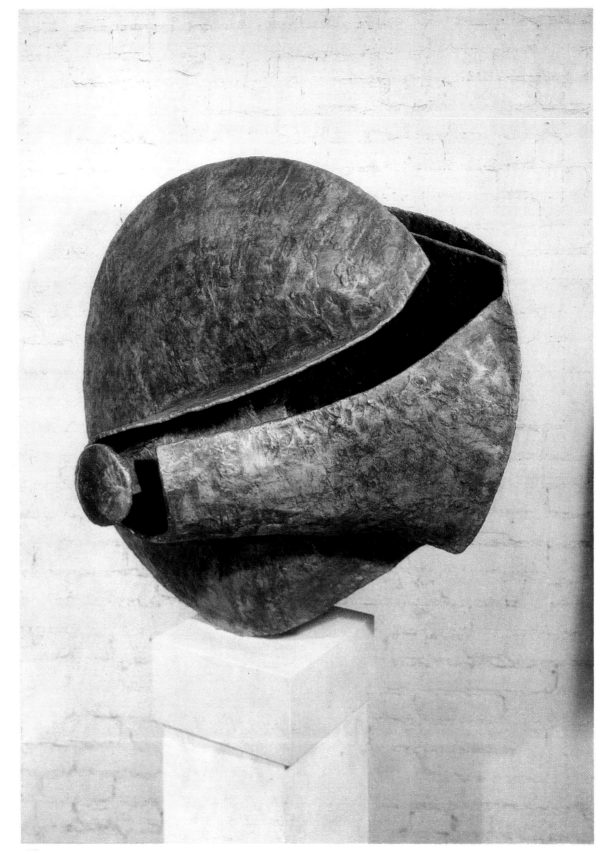

201.

WHEEL. *1965.*

Bronze on Monel metal, height 35".

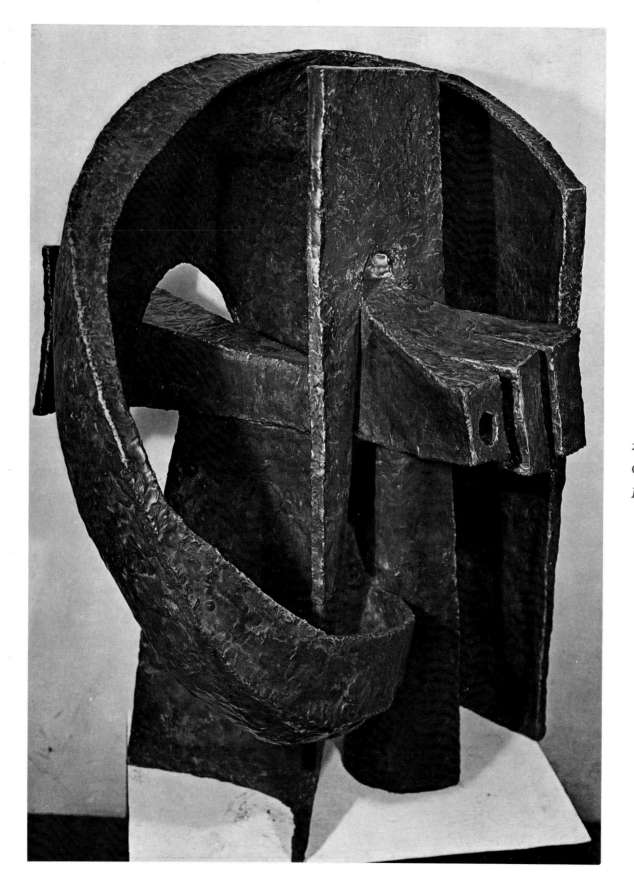

202.

CITADEL. *1966.*

Bronze on Monel metal, height 34″.

203.
BEACON. *1966.*
Nickel-silver on Monel metal,
height 25 1/2".
Collection Rhode Island
School of Design,
Providence

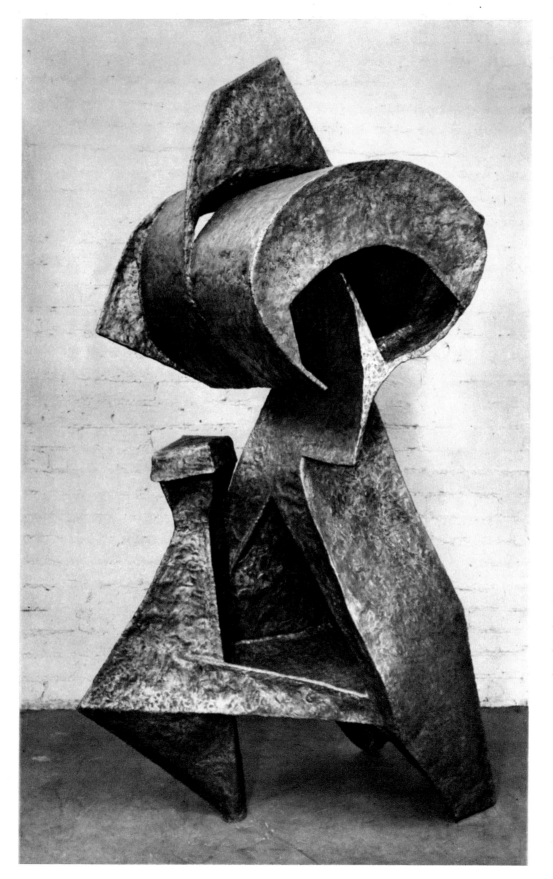

204.

DRAGON. *1966.*

Bronze, height 73".

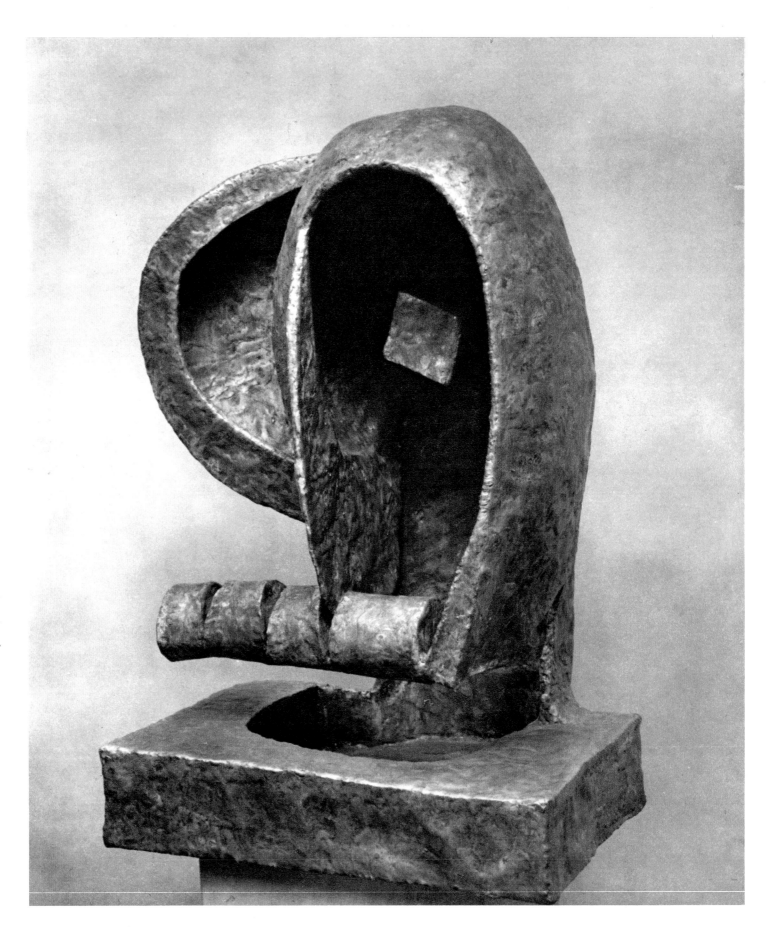

205.
MASK. *1966.*
Nickel-silver, height 28".

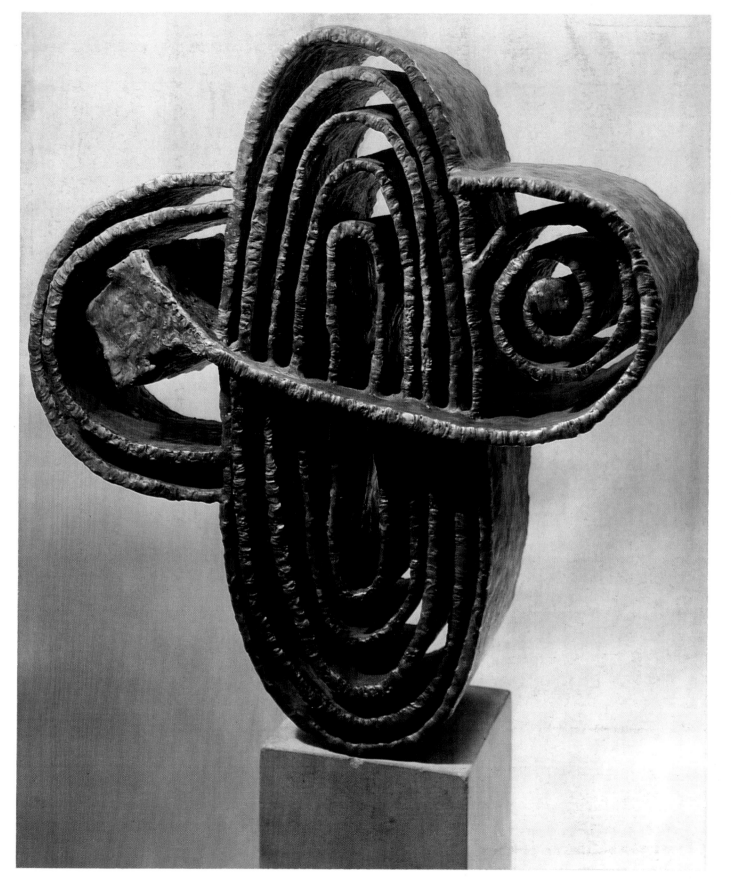

206.
BRAIN OF A POET. *1966.*
Bronze on Monel metal, height 23".

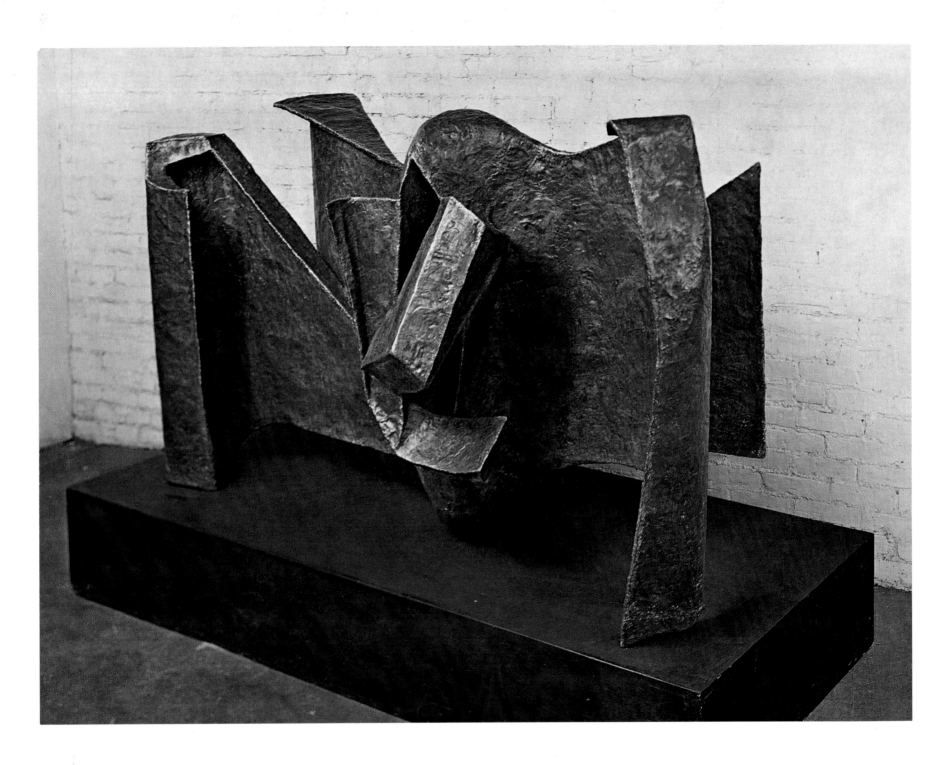

207. TRAP. *1967. Bronze on Monel metal, length 81".*

208.

CATACOMBS. *1968.*

Nickel-silver on Monel metal, height 83″.

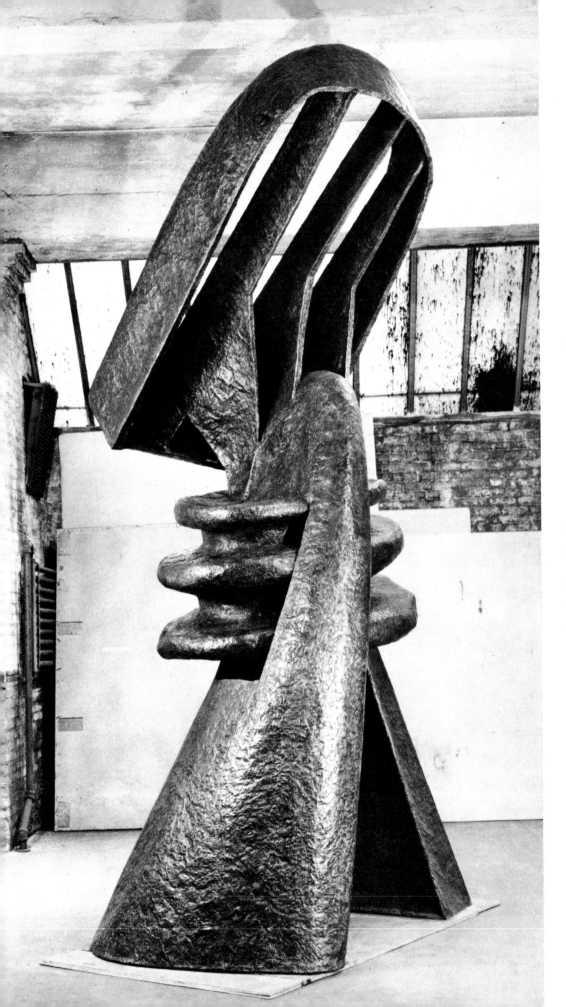

209.
LAUREATE. *1968.*
Nickel-silver on Monel metal, height 12′6″.
Milwaukee County War Memorial
Performing Arts Center. Gift of the
Allen-Bradley Company in memory of
Harry Lynde Bradley

21
BARD. *196*
Nickel-silver on Monel metal, height 4

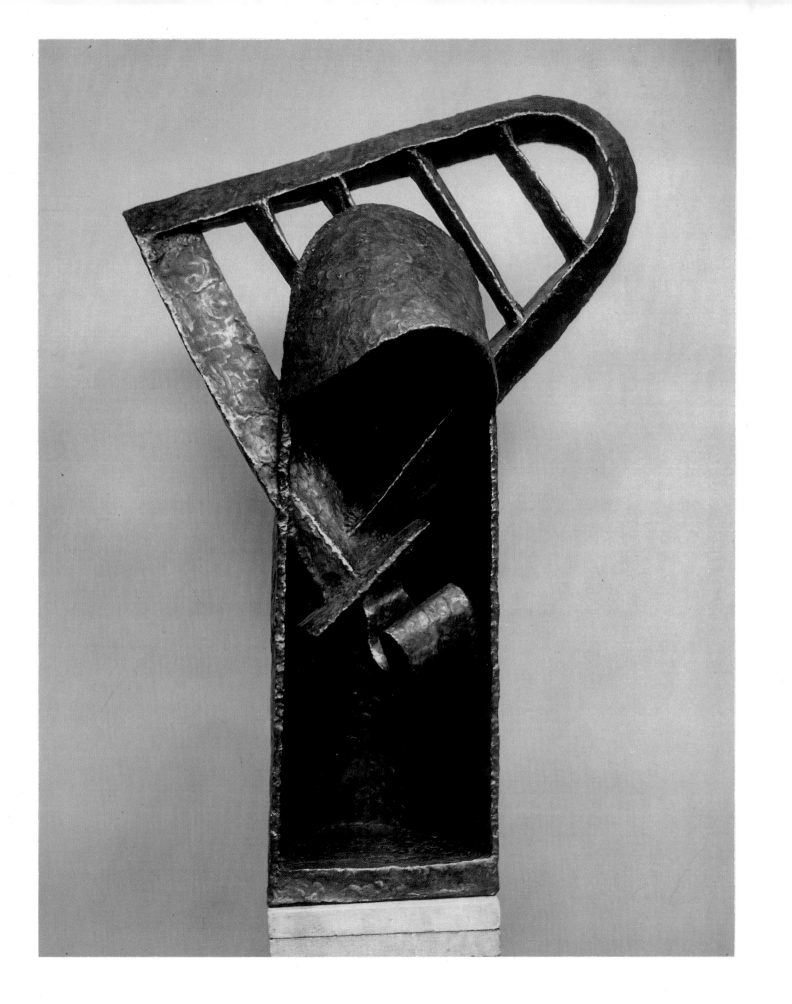

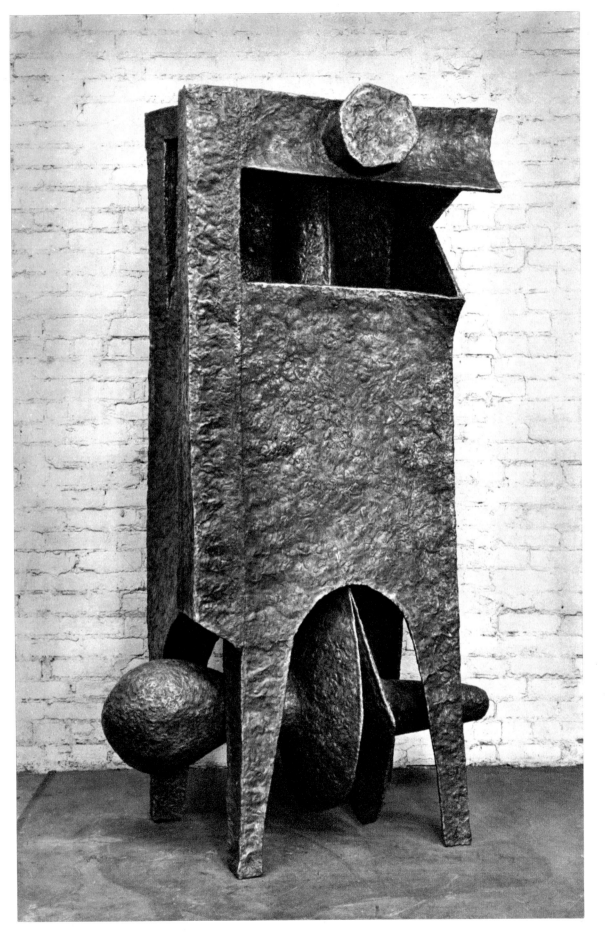

211.
CONQUISTADOR. *1968.*
Nickel-silver on Monel metal, 77×46".

212.
CLAIRVOYANT. *1969.*
Nickel-silver on Monel metal, height 43 1/2".

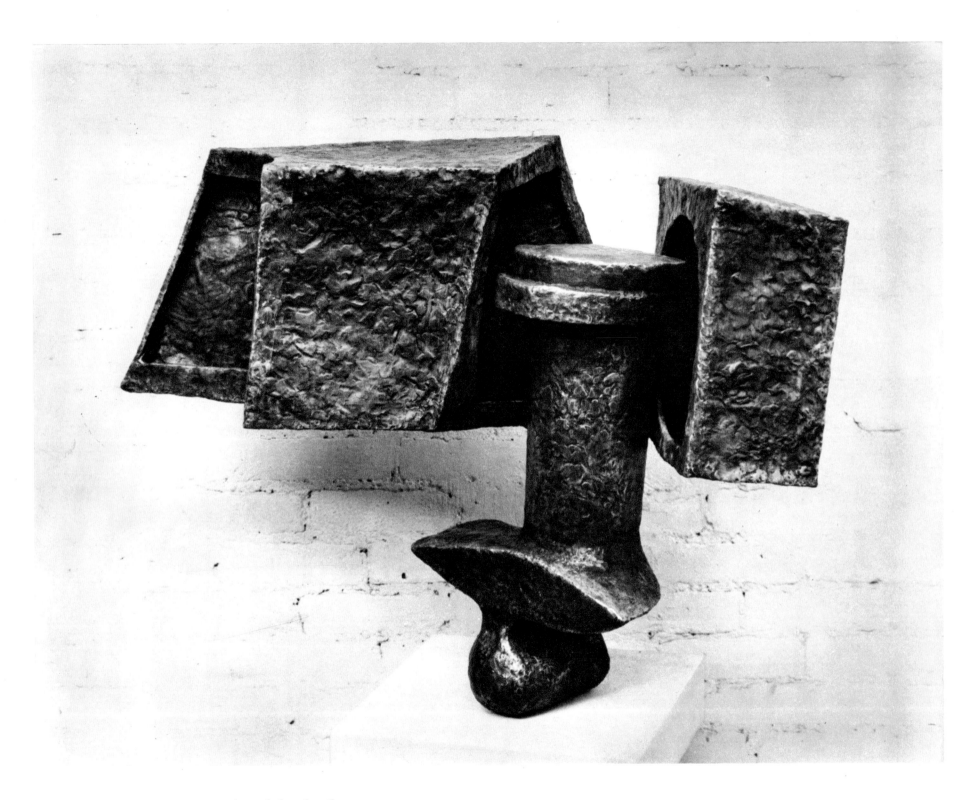

213. EYRIE. *1969. Bronze on Monel metal, length 34″.*

214.
THE BED. *1969.*
Nickel-silver on Monel metal, length 69".

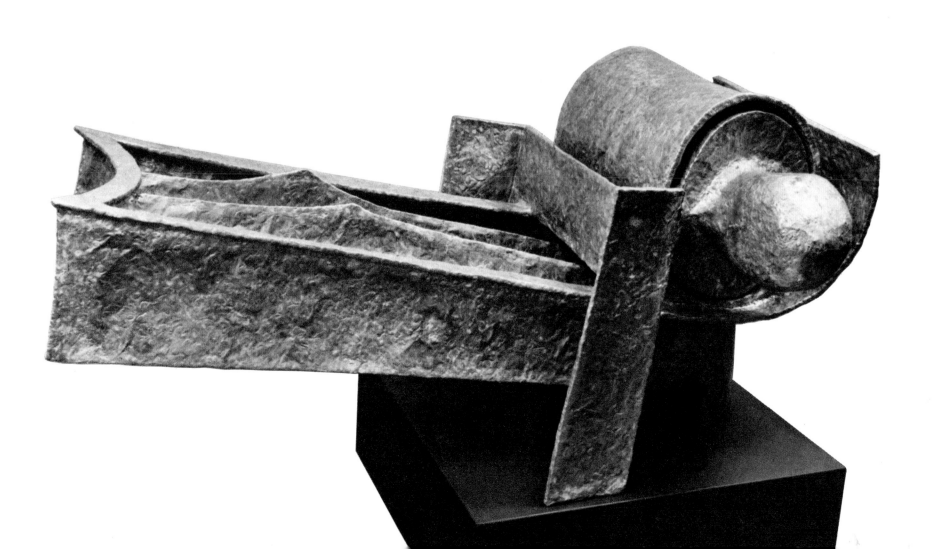

SELECTED BIBLIOGRAPHY

BOOKS

The Artist in America. Compiled by the editors of *Art in America,* New York, W. W. Norton, 1967.

Baur, John I. H. *Nature in Abstraction.* New York, Macmillan for the Whitney Museum of American Art, 1958.

Brummé, C. Ludwig. *Contemporary American Sculpture.* New York, Crown, 1948.

Burnham, Jack. *Beyond Modern Sculpture.* New York, George Braziller, 1968.

Chaet, Bernard. *Artists at Work.* Cambridge, Mass., Webb Books, Inc., 1960.

Christensen, Erwin O. *A Pictorial History of Western Art.* New York, New American Library, 1964.

Craven, Wayne. *Sculpture in America.* New York, Thomas Y. Crowell, 1968.

Elsen, Albert E. *Purposes of Art.* 2nd ed. New York, Holt, Rinehart & Winston, 1968.

Giedion-Welcker, Carola. *Contemporary Sculpture: An Evolution in Volume and Space,* rev. ed. New York, George Wittenborn, 1960.

Goodrich, Lloyd. *Three Centuries of American Art.* New York, Frederick A. Praeger for the Whitney Museum of American Art, 1966.

Hunter, Sam. *Modern American Painting and Sculpture,* New York, Dell, 1959.

Maillard, Robert (ed.). *Dictionary of Modern Sculpture.* New York, Tudor, 1960.

Mendelowitz, Daniel M. *A History of American Art.* New York, Holt, Rinehart & Winston, 1960.

Ritchie, Andrew Carnduff. *Abstract Painting and Sculpture in America.* New York, Museum of Modern Art, 1951.

————. *Sculpture of the Twentieth Century.* New York, Museum of Modern Art, 1952.

Rose, Barbara. *American Art since 1900: A Critical History.* New York, Frederick A. Praeger, 1967.

Seiberling, Frank. *Looking into Art.* New York, Henry Holt, 1959.

Seuphor, Michel. *The Sculpture of This Century.* New York, George Braziller, 1960.

PERIODICALS

Unsigned Articles, Listed Chronologically

"Reviews and Previews: Seymour Lipton," *Art News,* XLVII, 3, May, 1948.

"New Sculpture Packs a Wallop," *Look,* XIV, 16, August 1, 1950.

"Contemporary Americans: The Illinois Biennial Reveals an Interesting Cross-section of Contemporary American Art," *Arts Digest,* XXIX, 12, March 15, 1955.

"Monel in Art Nickel-Copper Alloy Used in Direct Metal Sculpture," *INCO,* February, 1957.

"Will This Art Endure?," *New York Times Magazine,* December 1, 1957.

"Greene, Lipton in Solo Shows," *New York Herald Tribune Book Review,* February 2, 1958.

"Design: Medals and Trophies," *Art in America,* XLIX, 4, 1961.

"The Contemporary Scene: Notes, Quotes and Footnotes (Guided Tour)," *Arts,* XXXIX, 7, April, 1965.

Signed (and Initialed) Articles, Listed Alphabetically by Author

Ahlander, Leslie Judd. "Lipton's Show Generates a Glow," *Washington Post,* January 16, 1965.

242

Ashton, Dore. "New Sculpture Fresh in Old Techniques," *Studio International*, CLXIX, 866, June, 1965.

Bernstein, Gerald S. "Seymour Lipton: A Pioneer in Direct Metal Sculpture," *The Register of the Museum of Art, The University of Kansas*, II, 8, April, 1962.

Brach, Paul. "Gallery Previews," *Pictures on Exhibit*, XV, 2, November, 1952.

Brummé, C. Ludwig. "Contemporary Sculpture: A Renaissance," *Magazine of Art*, XLII, 6, October, 1949.

Canaday, John. "Art: Acquisitions of Yale Gallery," *New York Times*, January 10, 1961.

———. "An 'Archangel' Adorns Philharmonic Hall," *New York Times*, February 19, 1964.

Chaet, Bernard. "Studio Talk: Direct-Metal Sculpture: Interview with Seymour Lipton," *Arts*, XXXII, 7, April, 1958.

Chanin, A. L. "Machine Age in Sculpture," *New York Times Magazine*, May 3, 1959.

Coates, Robert M. "The Art Galleries," *The New Yorker*, XXX, 40, November 20, 1954.

Devree, Howard. "Modern Diversity," *New York Times*, October 16, 1949.

———. "Shows by O'Keeffe, Lipton," *New York Times*, October 22, 1950.

———. "Transition Sculpture: Whitney Annual Reveals New Tendencies," *New York Times*, March 21, 1954.

———. "Modern Surveys; Development Since 1920 Seen in 3 Shows; Americans in 'The New Decade' at the Whitney," *New York Times*, May 15, 1955.

Edwards, Folke. "Biennalen 1958," *Paletton*, 3, 1958.

Elsen, Albert. "Seymour Lipton: Odyssey of the Unquiet Metaphor," *Art International*, V, 1, February 1, 1961.

———. "Seymour Lipton's Sea King," *Albright-Knox Art Gallery, Gallery Notes*, XXIV, 2, Summer, 1961.

———. "Lipton's Sculpture as Portrait of the Artist," *Art Journal*, XXIV, 2, Winter, 1964/65.

———. "The Sculptural World of Seymour Lipton," *Art International*, IX, 1, February, 1965.

Fischer, Klaus J. "Die 29. Biennale in Venedig," *Das Kunstwerk*, XII, 1–2, July–August, 1958.

Fitzsimmons, James. "Lipton on a Mythic Level," *Art Digest*, XXVII, 2, October 15, 1952.

———. "Space and the Image in Art (à propos of the 29th Biennale of Venice)," *Quadrum*, VI, 1959.

Fitzsimmons, Robert (ed.). "A-S 'Living Bronze' Stands at IBM Research Center," *News Dispenser*, October, 1962.

G[enauer], E[mily]. "Art: Modern Museum Show," *New York Herald Tribune*, June 3, 1956.

G., L. "Fortnight in Review: Seymour Lipton," *Art Digest*, XXIX, 4, November 15, 1954.

Genauer, Emily. "Lipton's Sculpture Show Among Week's Best Events," *New York World-Telegram*, November 5, 1938.

———. No title. *New York Herald Tribune Book Review*, February 2, 1958.

———. "Art and Artists: The Rediscovery of Spring," *New York Herald Tribune*, March 19, 1961.

———. "Sensation and Sensibility," *New York Herald Tribune*, March 21, 1965.

———. "New 'Indispensables' at the Modern Museum," *New York Herald Tribune*, August 29, 1965.

Getlein, Frank. "Phillips Opens Major Show by Contemporary Americans," *Sunday Star* (Washington, D.C.), January 12, 1964.

———. "The Seriousness of Seymour Lipton," *The New Republic*, CLII, 15, April 10, 1965.

Gonzales, Boyer. "The Visual Arts: Uniformly High Quality Marks U.S.I.A. Show at Museum," *Seattle Times*, January 20, 1957.

Goodnough, Robert. "Reviews and Previews: Seymour Lipton," *Art News*, XLIX, 6, October, 1950.

Grossberg, Jacob. "In the Galleries: Seymour Lipton," *Arts*, XXXIX, 9, May–June, 1965.

Guest, Barbara. "Reviews and Previews: Seymour Lipton," *Art News*, LI, 7, November, 1952.

Hofmann, Werner. "Vier amerikanische Metallplastiker," *Werk*, XLV, 4, April, 1958.

Hunter, Sam. "Seymour Lipton," *Das Kunstwerk,* XX, 3–4, December, 1966–January, 1967.

Kaufman, Edgar, Jr. "The Inland Steel Building and Its Art," *Art in America,* XLV, 4, Winter, 1957–58.

Krasne, Belle. "Lipton Metals," *Art Digest,* XXV, 3, November 1, 1950.

Kroll, Jack. "Reviews and Previews: Seymour Lipton," *Art News,* LX, 2, April, 1961.

Kuh, Katherine. "Metaphor in Metal," *Saturday Review,* XLVII, 9, February 29, 1964.

L., J. "Sculpture in Wood: A First Showing by S. A. Lipton," *Art News,* XXXVII, 6, November 5, 1938.

Lipton, Seymour. "Some Notes on My Work," *Magazine of Art,* XL, November, 1947.

———. "The Web of the Unrhythmic," in "The Ides of Art: 14 Sculptors Write," *The Tiger's Eye,* I, 4, June, 1948.

———. "Experience and Sculptural Form," *College Art Journal,* IX, 1, Autumn, 1949.

———. "Seymour Lipton in Illuminating Commentary on Modern Sculpture," *The Woodstock Press,* Thursday, August 25, 1955.

———. "A Problem in Sculpture: The Question of Intensity and the 'Total Image'," *The Register of the Museum of Art, The University of Kansas,* II, 8, April, 1962.

———. "Art in the U.S.A.: Artists Say," *Art Voices,* IV, 2, Spring, 1965.

McLanathan, Richard B. K. "American Art in Moscow," *The Atlantic,* CCV, 5, May, 1960.

Meyer, Charles E. "Seymour Lipton and His Place in Twentieth Century Sculpture," *The Register of the Museum of Art, The University of Kansas,* II, 8, April, 1962.

Miesel, Victor H. "Avenger," *The Register of the Museum of Art, The University of Kansas,* II, 8, April, 1962.

Munro, Eleanor. "Explorations in Form," *Perspectives USA,* 16, Summer, 1956.

Offin, Charles E. "Gallery Previews in New York," *Pictures on Exhibit,* XIII, 2, November, 1950.

Ragon, Michel. "L'Art actuel aux Etats-Unis" (Art Today in the United States), *Cimaise,* VI, 3, January–February–March, 1959.

Reed, Judith Kaye. "Two Modern Sculptors," *Art Digest,* XXII, 15, May 1, 1948.

Rigg, Margaret. "Seymour Lipton," *Motive,* April, 1960.

Ritchie, Andrew Carnduff. "Seymour Lipton," *Art in America,* XLIV, Winter, 1956/57.

S., M. "In the Galleries: Seymour Lipton," *Arts,* XXXV, 8–9, May–June, 1961.

Sandler, Irving. "Reviews and Previews: Seymour Lipton," *Art News,* LVI, 10, February, 1958.

Soby, James Thrall. "The Fine Arts: Twelve Americans," *Saturday Review,* XXIX, 23, June 9, 1956.

Streeter, Tal. "The Sculptor's Role: An Interview with Seymour Lipton," *The Register of the Museum of Art, The University of Kansas,* II, 8, April, 1962.

Szulc, Tad. "Seymour Lipton of U.S. Wins Sculpture Prize at São Paulo," *New York Times,* September 18, 1957.

T., P. "3 Worth Noting—Lipton: Inside and Out," *Art News,* LIII, 7, November, 1954.

Toniato, Toni. "XXIX Biennale," *Evento,* 3–4, 1958.

Traba, Marta. "Arte Norteamericano 1957," *Prisma,* October–November, 1957.

V., G. L. "Arti figurative," *L'Arena,* July 4, 1958.

Werner, Alfred. "Art and Artists," *Congress Weekly,* XXI, 34, December 13, 1954.

EXHIBITION CATALOGUES

El Arte Moderno en los Estados Unidos. Barcelona, 1955.

The New Decade: 35 American Painters and Sculptors, ed. J. I. H. Baur. New York, Whitney Museum of American Art, 1955.

12 Americans, ed. D. C. Miller. New York, Museum of Modern Art, 1956.

La Biennale di Venezia (with article on Lipton by Frank O'Hara). Venice, 1958.

Exhibition of Art by the Faculty and Visiting Artists of the Skowhegan School of Painting and Sculpture, Waterville, Me., Colby College Art Museum, 1961.

244

Seymour Lipton: A Loan Exhibition. Washington, D.C., The Phillips Collection, 1964.

Seymour Lipton (with article on Lipton by Sam Hunter). New York, Marlborough-Gerson Gallery, 1965.

Art in Science. Albany, N.Y., Albany Institute of History and Art, 1965.

Art of the United States: 1670–1966, text by L. Goodrich. New York, Whitney Museum of American Art, 1966.

Seymour Lipton. New Paltz, N.Y., State University Teachers College, n.d.

Visions of Man in Twelve Aluminum Sculptures. New York, Reynolds Metals Company, n.p., n.d.